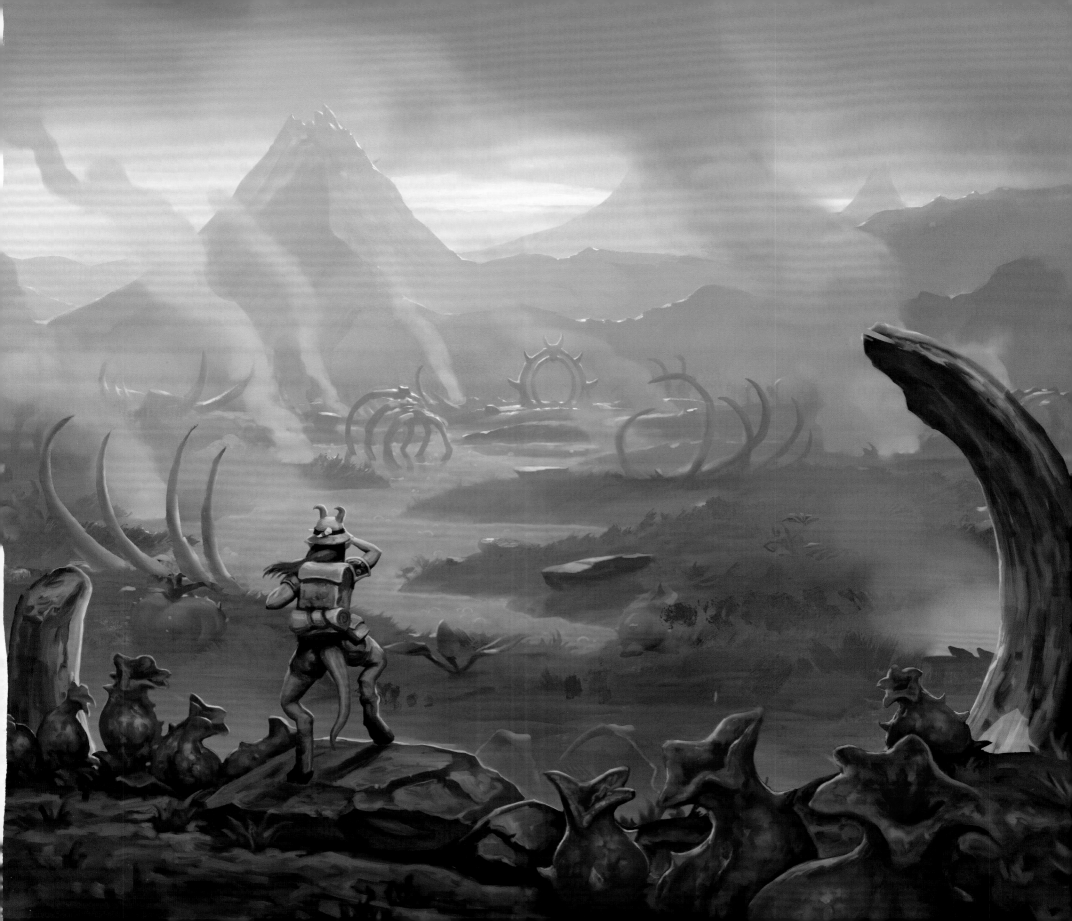

The Art of
HEARTHSTONE

Volume III:
Year of the Mammoth

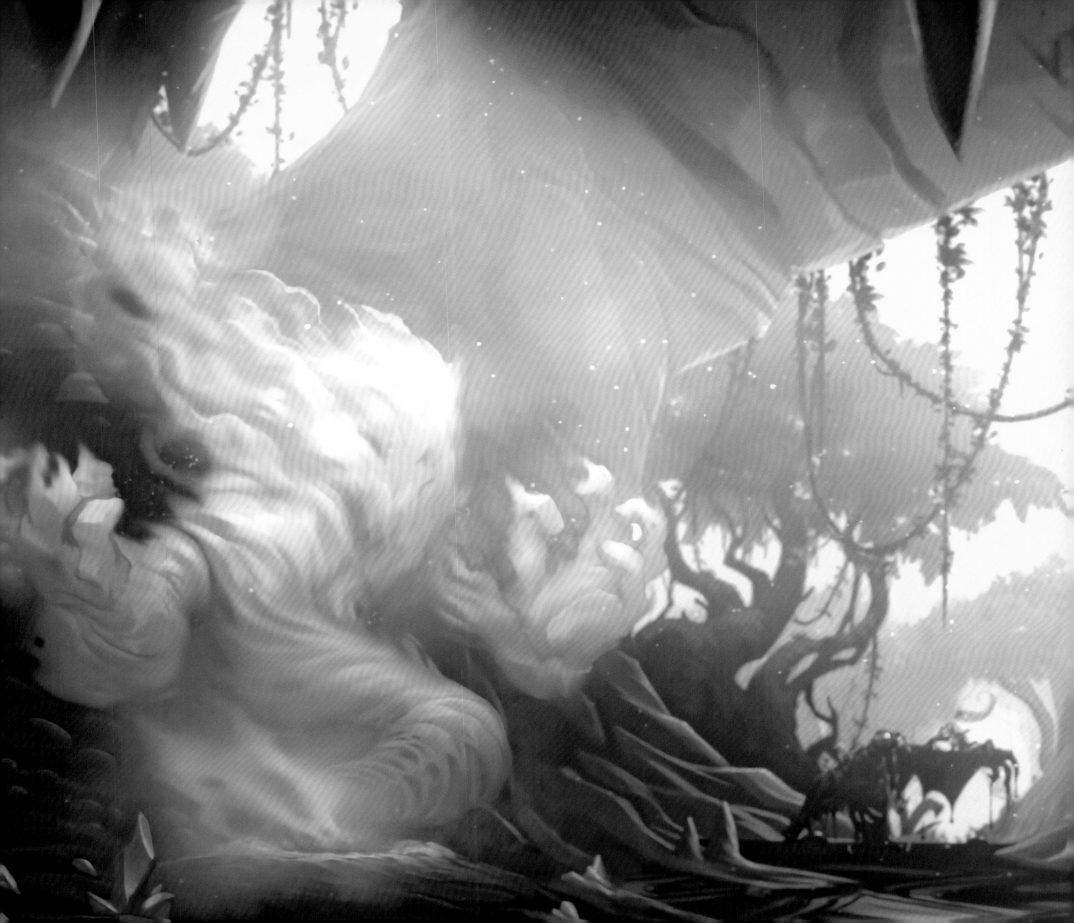

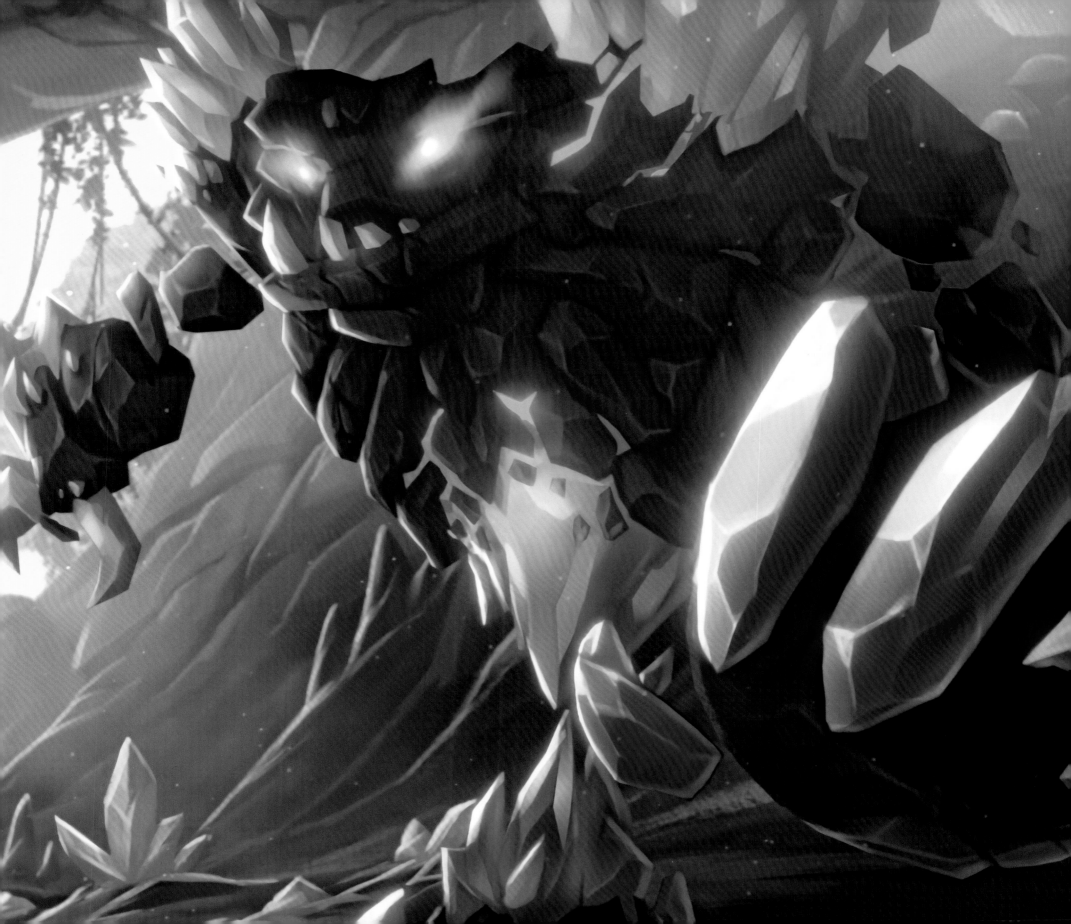

BLIZZARD ENTERTAINMENT
Written By: Robert Brooks
Editors: Chloe Fraboni, Allison Irons,
Paul Morrissey
Game Team Direction: Jeremy Cranford,
Bree Lawlor, Ben Thompson
Creative Consultation: Dave Kosak
Lore Consultation: Madi Buckingham,
Sean Copeland, Christi Kugler, Justin Parker
Production: Brianne Messina,
Derek Rosenberg, Anna Wan
Director, Consumer Products: Byron Parnell
Director, Creative Development: David Seeholzer
Special Thanks: Linus Flink, Lorenzo Micana,
Charlene Le Scanff

DESIGN BY CAMERON + COMPANY
Publisher: Chris Gruener
Creative Director: Iain R. Morris
Art Director: Suzi Hutsell
Designer: Rob Dolgaard & Amy Wheless

Visit us at gear.blizzard.com

Published by Blizzard Entertainment

Print run 10 9 8 7 6 5 4 3 2 1

Library of Congress Cataloging-in-Publication
Data available.

ISBN: 9781950366224

Manufactured in China

PAGE 1 Konstantin Turovec
PREVIOUS SPREAD Robert Sevilla
RIGHT Story and Franchise Development

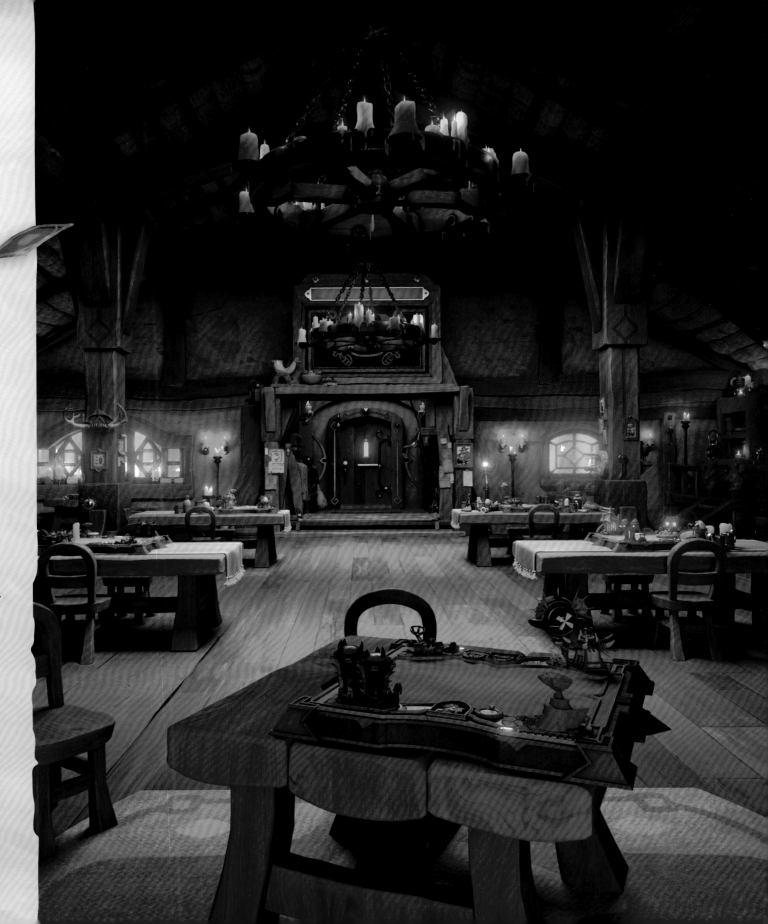

CONTENTS

INTRODUCTION
Welcome back, friend!

Oh, don't you worry about the mess. When a kraken comes to your tavern, it's only natural to expect a little bit of a fracas. It's nothing a couple enchanted brooms can't clean up—and lucky for me, Medivh left some behind!

But the kraken's had its fun. Its sigil in the stars has faded. Its year has come to an end.

And I've been watching the night sky to see who—or what— might be strolling by next. I don't know about you, but my feet are feeling a little bit itchy. A wee bit of traveling might do some good.

I hear rumors of an underground empire filled with gold.

I feel a bitter chill on the wind, calling me to the frozen north.

But I'm seeing something else first. Something mammoth in size.

I think we're going to make a trip out to the jungle. Who knows what adventures are waiting for us out there . . . ?

—HARTH STONEBREW, THE INNKEEPER

RIGHT Peter Stapleton

8

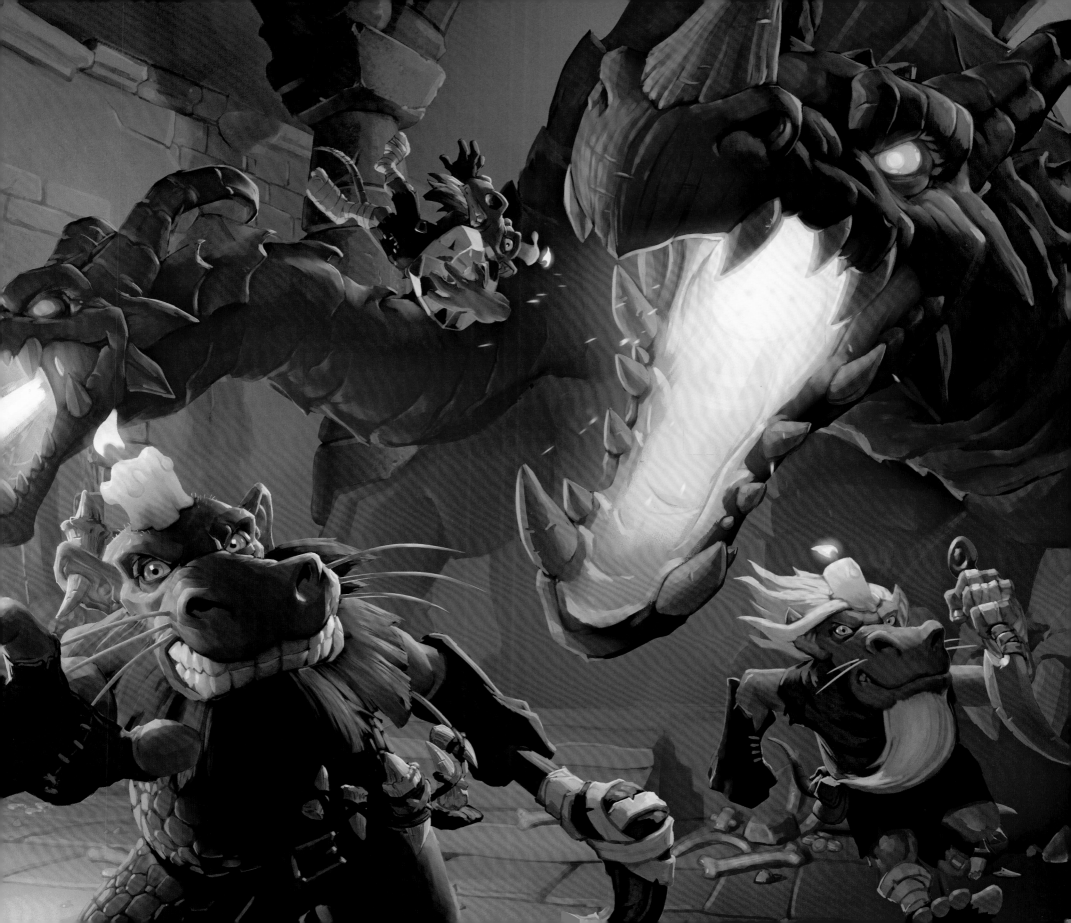

1

YEAR OF THE MAMMOTH

Always remember . . .
that power is a double-edged blade.

—Jaina Proudmoore, the Frost Lich

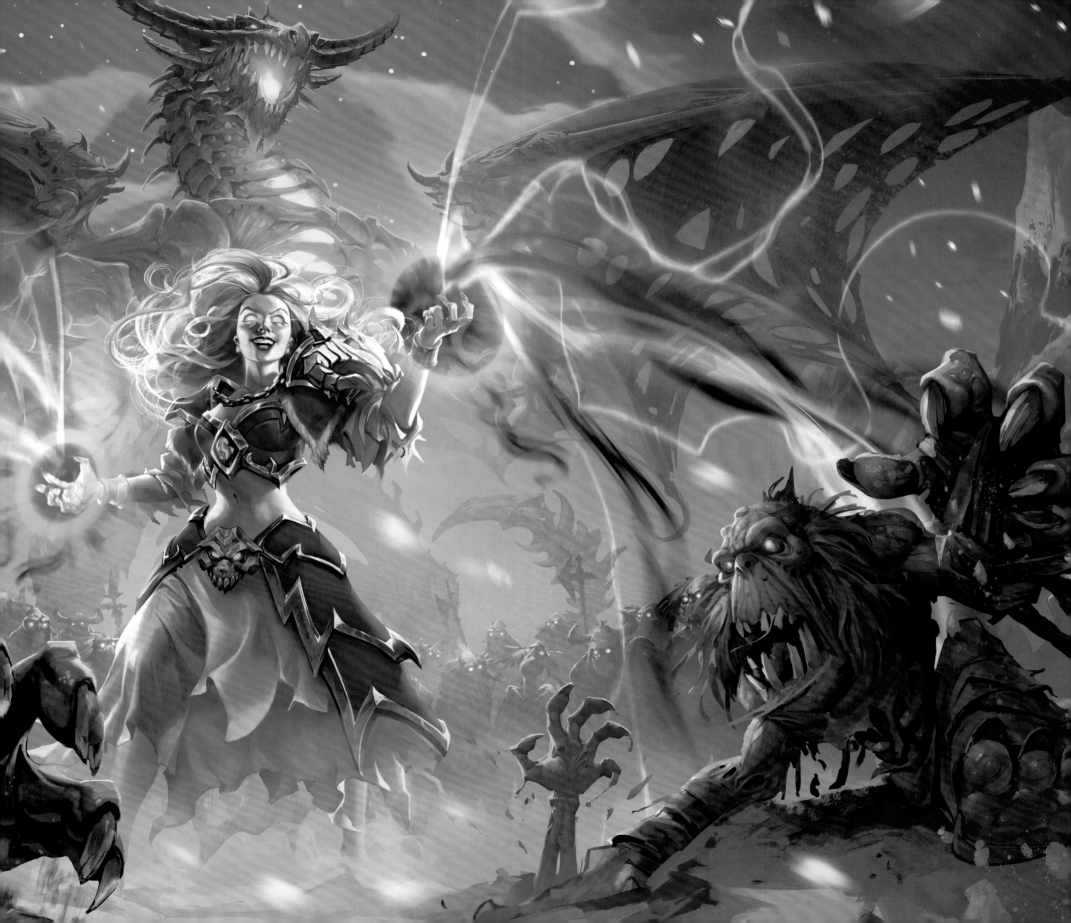

A MAMMOTH TASK

To understand where the Hearthstone team wanted to go in the Year of the Mammoth, one must first understand how far they had already come.

After launching the game in 2014, a relatively small development group had taken on the most aggressive release schedule any Blizzard game had yet attempted. Three full content drops in a year, *every* year, was a challenge that put every department to the test. The art team was no exception.

In the earliest days of the game's development, the team had assumed there was enough existing Warcraft art to repurpose as card illustrations. Indeed, a significant portion of the basic and classic card sets were drawn from that archive. But by the first full expansion, *Goblins vs Gnomes*, the team understood that their art style was not going to perfectly align with *World of Warcraft*. *Hearthstone* was a little lighter and a little goofier. It still wanted to maintain the franchise's epic foundation, but it also wanted to forge a slightly different path. Going forward, more and more art would have to be created from scratch.

To ship several hundred fresh illustrations every single year, Blizzard worked with dozens of external artists to create a colorful, vibrant, charming world that seemed instantly familiar, uniquely peculiar, and welcoming to all who wanted to play. Year after year, veteran Blizzard artists and new faces alike have helped create a style that has drawn more than 100 million players to the tavern.

PREVIOUS PAGE
Will Murai

RIGHT
Sam Nielson

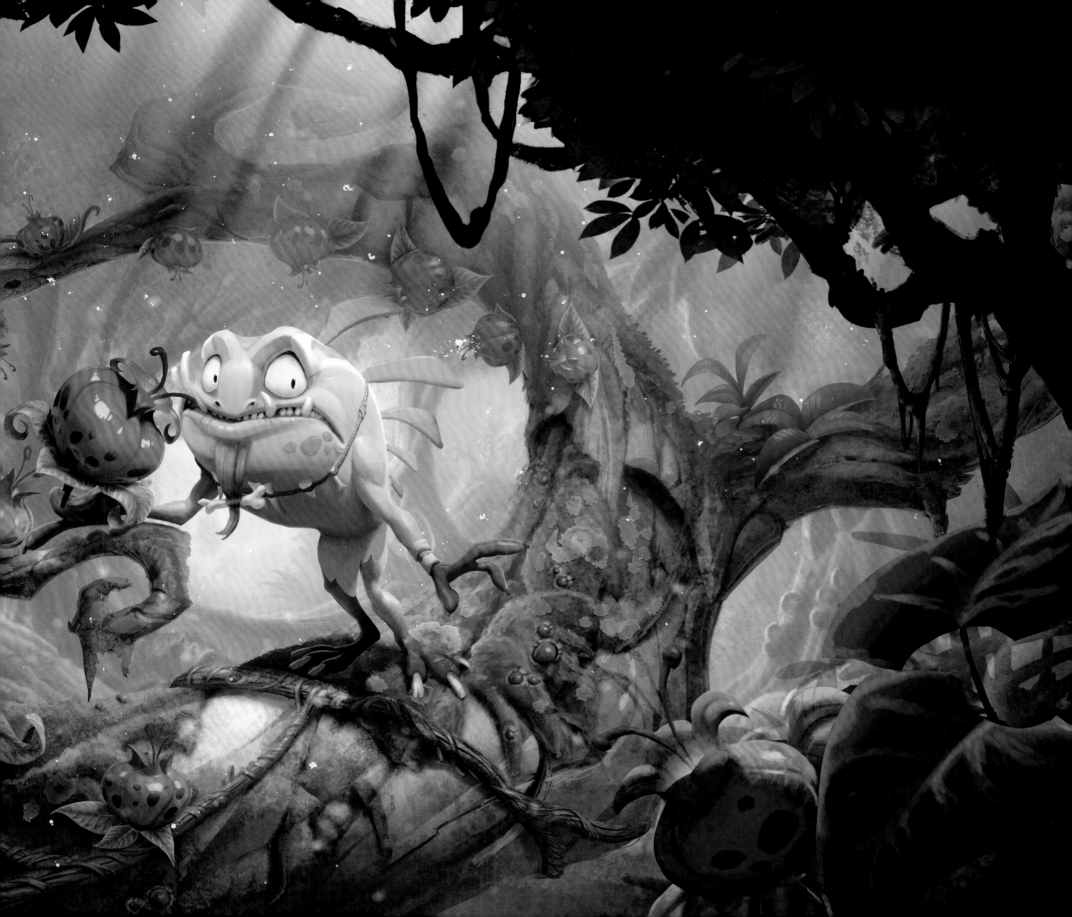

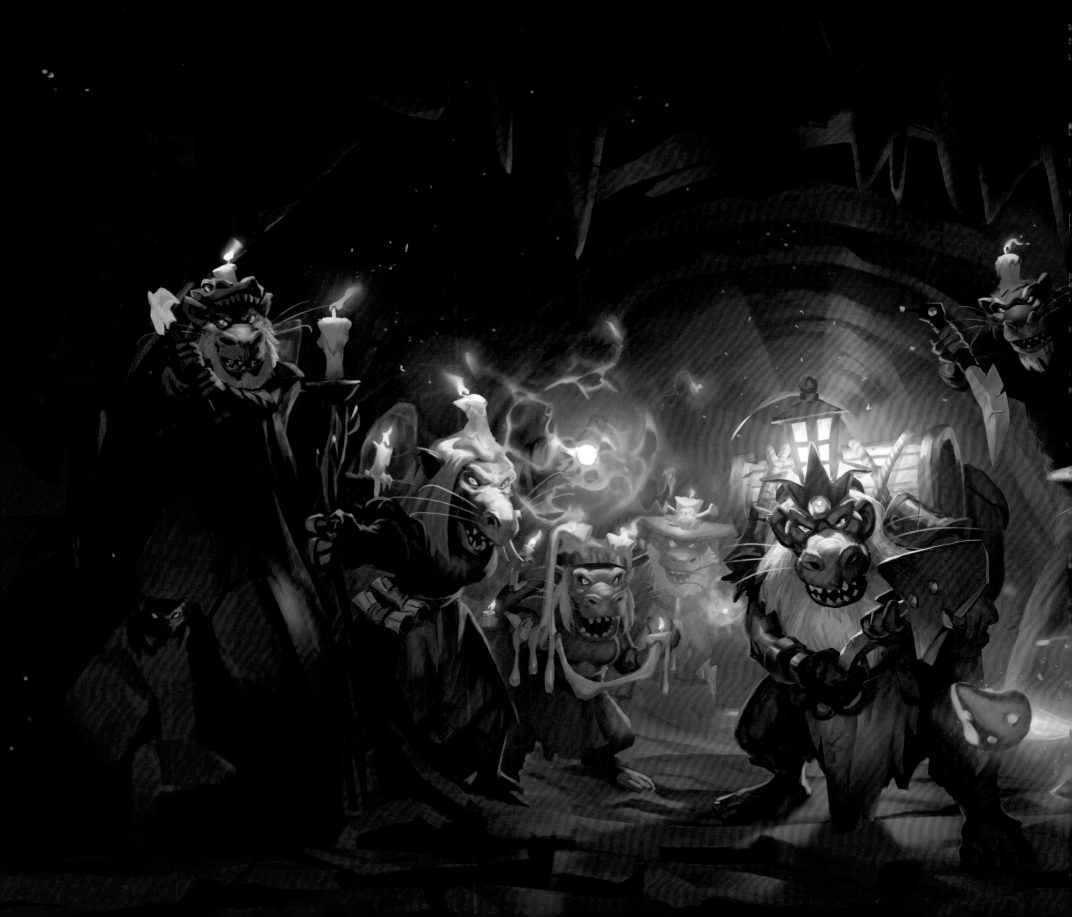

By the time the Year of the Kraken had wrapped up, the Hearthstone team had shipped more than 1,200 illustrations in collectible and uncollectible cards.

In the Year of the Mammoth, the Hearthstone team was planning on releasing three full expansion sets in a single year. And for the first time, the Hearthstone team was releasing a brand-new format for single-player content, one that would shape the future of the game for years.

"Things could have gotten scary this year," said senior art manager Jeremy Cranford. "When things work well, it's easy to fall into a rut. Fortunately, we work with a bunch of artists who keep delivering."

The year's three expansions yielded nearly five hundred illustrations, depicting a journey that began in the jungle crater of Un'Goro, roamed into Northrend to challenge the Lich King on his Frozen Throne, and then finally delved deep into cavernous depths to plunder a kobold empire.

The successes of the Year of the Mammoth would set the pace of development for years to come, both on the competitive ladder and in single-player gameplay.

LEFT
Arthur Bozonnet

JOURNEY TO UN'GORO™

This is not like any of our previous expeditions. This will be far more ambitious . . . so don't. Touch. Anything.

—ELISE STARSEEKER

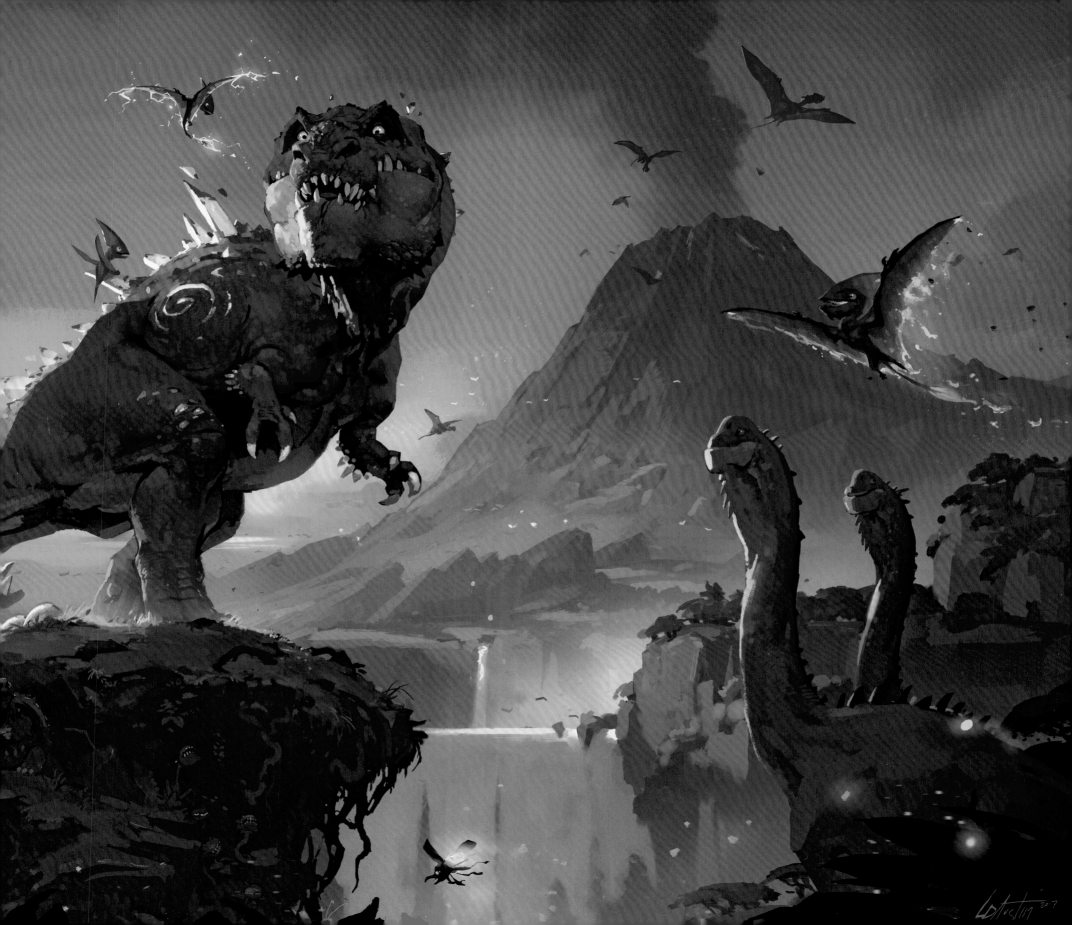

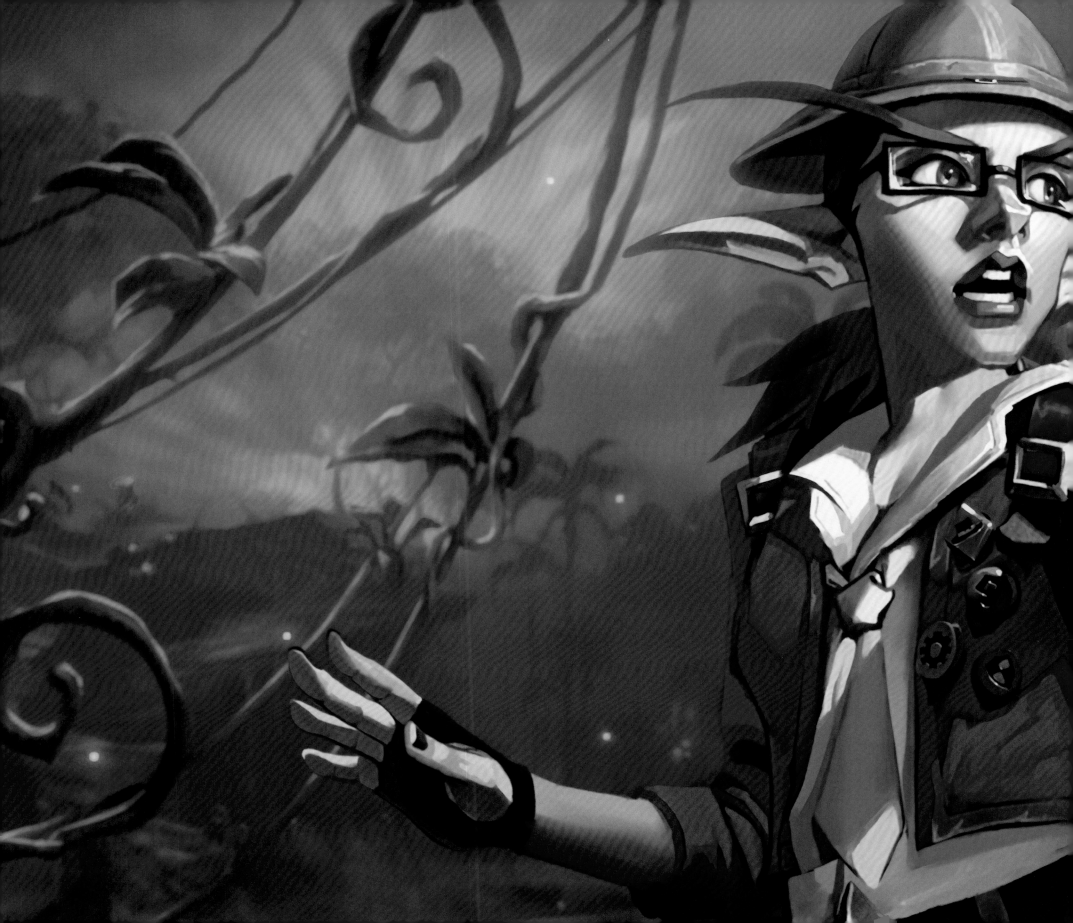

AN IDEA WITH TEETH

"With every *Hearthstone* set, it's important there's a hook everyon[e] can immediately grasp," said lead narrative designer Dave Kos[ak.] With a grin, he added, "Something with teeth, so to speak."

Though each set will have countless ideas and innovations in the fin[al] release—ranging from the card mechanics that will shape the meta to th[e] technical advancements that keep things running smoothly behind the scenes—a single, clear idea can give direction to the entire team's instinc[ts] during the early days of the set's development. Sometimes it's a gamepla[y] idea that provides the first spark. Other times it's an iconic Warcraft loca[tion] that anchors an expansion. It can even be a particular character that get[s] artists and developers excited (as you'll see later in this book). But the fi[rst] expansion of the Year of the Mammoth was not born from a location or a[n] character or a gameplay mechanic.

"With *Journey to Un'Goro*, the hook was so simple: dinosaurs. But wi[th] exclamation point! And all caps! 'D-I-N-O-S-A-U-R-S!'" Kosak remember[ed.]

"And nobody was arguing," added senior art manager Jeremy Cranfo[rd.]

Dinosaurs had shown up in *Hearthstone* before, but they had neve[r] been the spotlight of a set. Pairing big, angry lizards with the over-th[e-] top style of *Hearthstone* was an absolute no-brainer, according to cre[ative] director Ben Thompson.

"We saw that word—*DINOSAURS!*—on the whiteboard and just started nodding. 'Okay. Yes. That's the next expansion,'" said Thompson. "Now, what else do we need to make this work? That's where the idea for the set location came from."

It didn't take too many hours of brainstorming for team developers to float the idea of setting the entire expansion inside Un'Goro Crater, a memorable zone dating back to the first days of *World of Warcraft*.

The team was especially drawn to the shared experience of entering Un'Goro for the first time. After fighting in the desolate Tanaris Desert for several levels, players were drawn toward the green foliage on the horizon, slowly realizing that this was not an oasis but a gigantic jungle almost bursting out of a huge crater. By the time a player reached the crater floor, they realized Un'Goro was unlike any jungle they had seen thus far in the game. The dense, humid zone was filled with the ancient elemental forces, long-abandoned titan facilities, and yes, huge dinosaurs!

"Everyone had the same feeling when they entered Un'Goro for the first time: 'This is amazing.' The place felt strange and mysterious. We wanted to capture that for our game," Cranford said.

It was the perfect place to begin the Year of the Mammoth.

While you may be excited to see the local fauna, you might want to make sure they don't see you.

—ELISE STARSEEKER

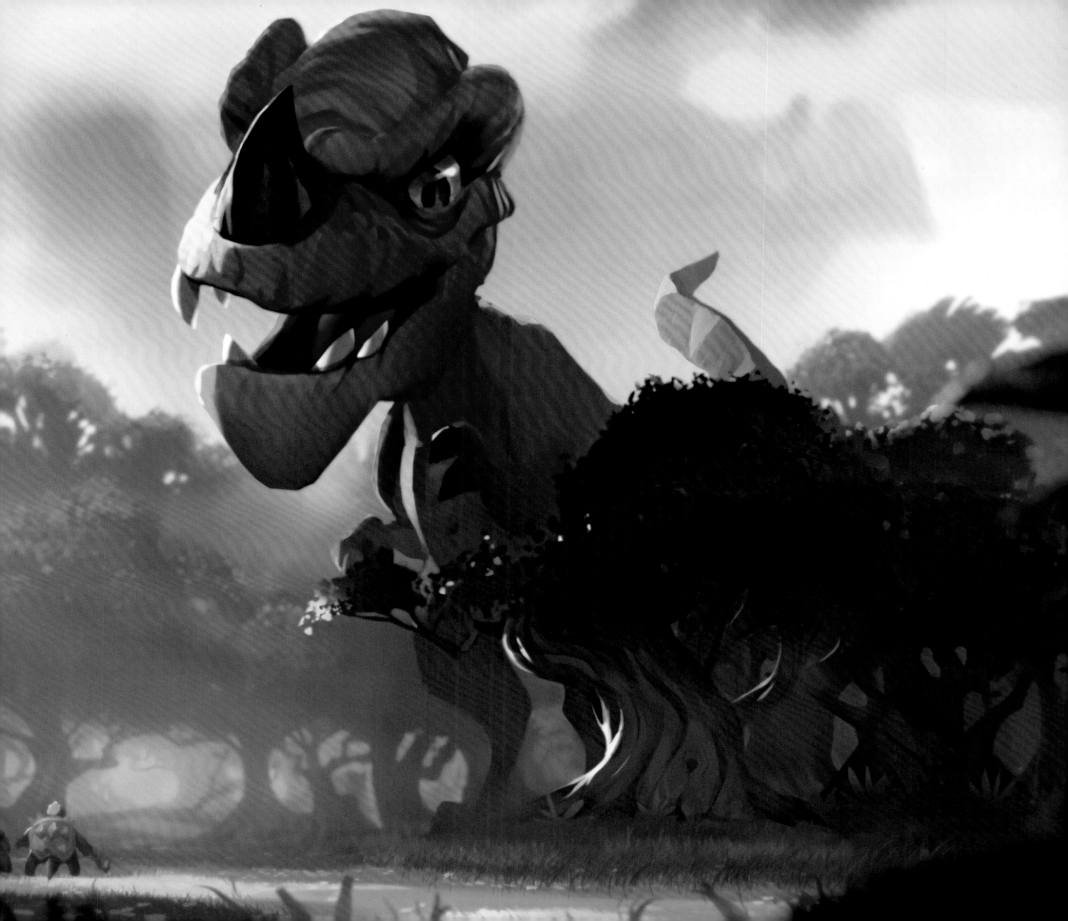

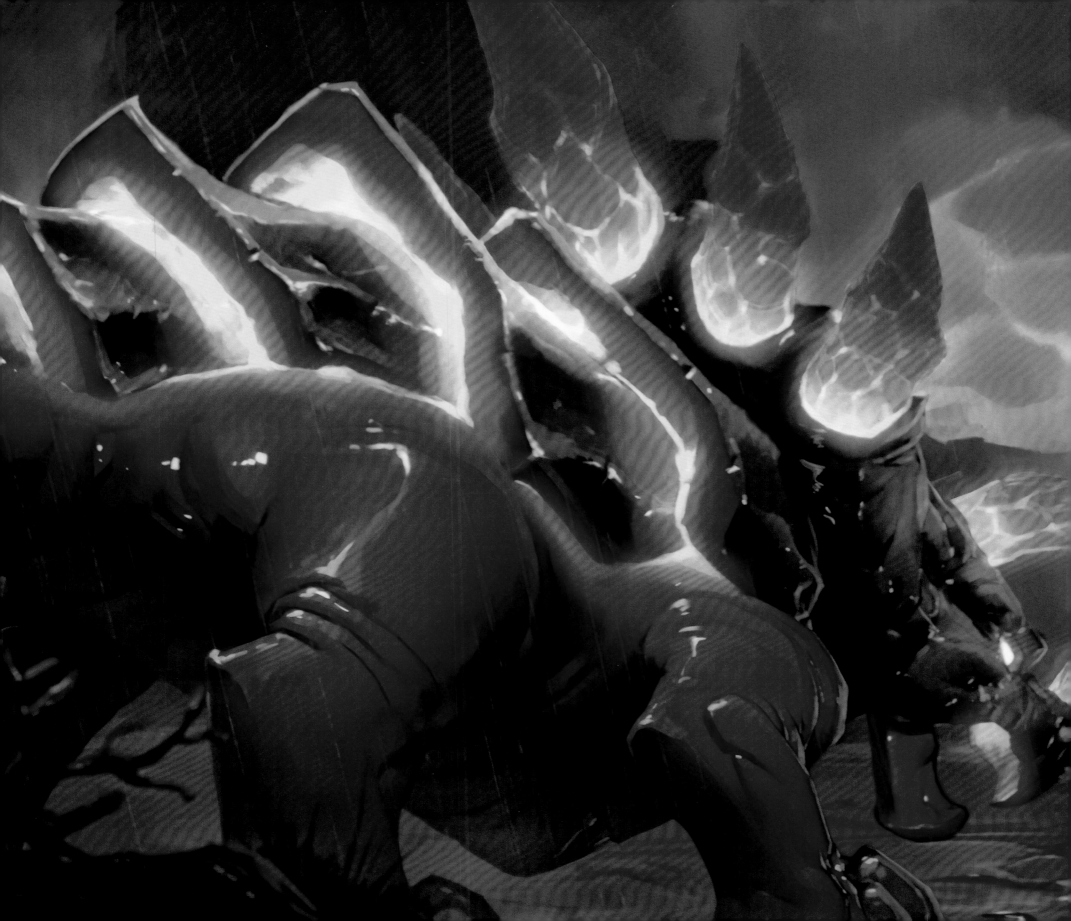

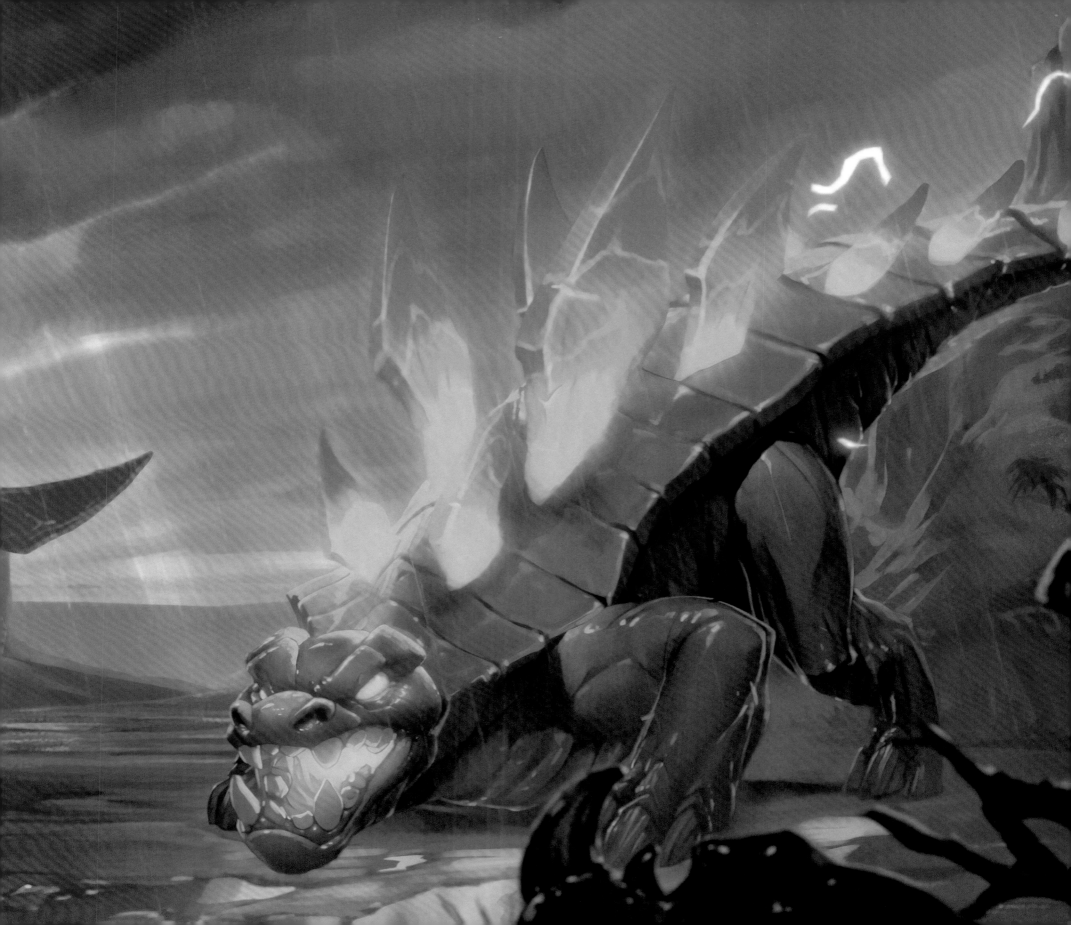

Make no mistake:
we will be tested at every turn.
But, if we stay on our guard . . .
we might just survive.

—ELISE STARSEEKER

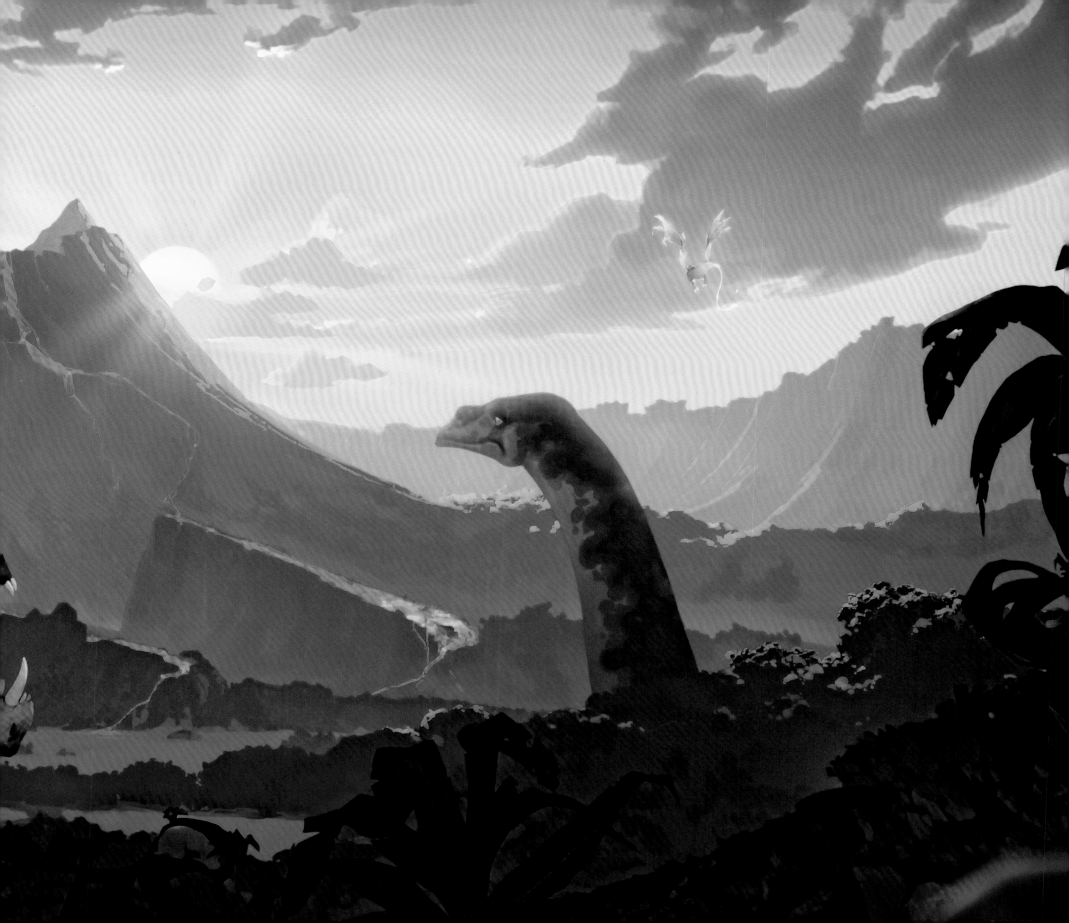

AN EVOLVING STYLE

The original quests in *World of Warcraft's* Un'Goro Crater focused on the ancient, primordial state of the environment. The design of its plants and wildlife called back to earthly prehistoric ages, drawing upon ancient tar pits, boiling pools of magma, hostile and oversize plant life, and extinct animals.

But Un'Goro wasn't simply a land that time forgot. The ancient beasts were strange, with unusual adaptations. Quest lines would reveal the crater was a place where the servants of the titans conducted experiments on Azeroth's wildlife, creating bizarre creatures through directed evolution.

This led directly to one of the major new game mechanics: **Adapt**. Certain dinosaur minions could gain player-selected buffs that offered a range of offensive or defensive capabilities when they entered the battlefield. In the initial game design, ideas for more than twenty different adaptations were floated, but the number of options was later cut down to ten.

Concept artists developed a common visual language for all ten of those different options, deciding to focus the design aspects of those adaptations on one source: elemental power.

The dinosaurs of Un'Goro Crater weren't just big, toothy monsters stomping through the jungle; they had lived in the primordial power of Azeroth's elements for ages. Their claws glowed with the power of fire, their bodies crackled and sparked with lightning, and they could protect themselves by spontaneously growing crystalline carapaces. These design foundations were codified in the *Journey to Un'Goro* style guide, the holy scripture for the huge group of external artists who would soon be delivering close to two hundred illustrations for the expansion set (including collectible and uncollectible cards).

"Design themes can feel almost subliminal," said Cranford. "I doubt many players wrote essays about how all those dinosaur cards had the same design elements on them, but it kept the set cohesive, even when different artists brought their own style to it."

The same style guide laid out the other native creatures of Un'Goro Crater. There were the primordial elementals rising from tar pits, magma pools, and ancient crystalline formations. There were carnivorous plants full of toothy grins and whiplike arms to ensnare their prey. There was even a tribe of murlocs with caveman attributes.

"Everything needed to look uniquely dangerous," said senior concept artist Charlène Le Scanff, "not only to communicate the dangers of the environment but to separate it from other jungles scattered across Azeroth."

But the artists also had to keep in mind *Hearthstone*'s overall charm, of course.

"Even when creatures appear cartoonish, you'll see what makes them dangerous. Huge thorns, sharp teeth, just with some exaggerated proportions," said Le Scanff.

Peter Stapleton, the artist who illustrated the card **Direhorn Hatchling** (along with many others in the Year of the Mammoth), said the key to creating an adorable yet dangerous baby dinosaur was to focus on what would make it different from its more threatening parents.

"Their horns would be much smaller and rounded, and their skin would be smoother and less marked," said Stapleton. "But I also thought they could be chubby, like human babies are."

Un'Goro's color palette and lighting were important parts of the style guide. "We imagined the land being filled with deep green colors, almost like the jungle canopy is so dense the sun never quite reaches the crater floor," Le Scanff added. "That also means the backgrounds needed pools of dark shadows, where all sorts of dangerous creatures might hide."

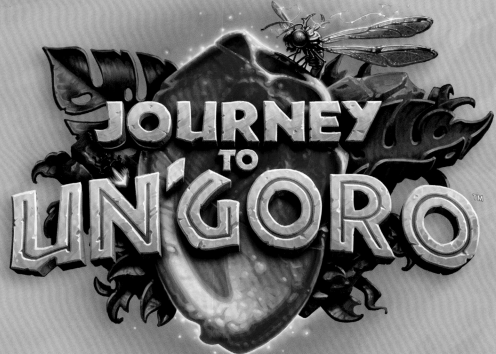

EXPLORERS, ASSEMBLE!

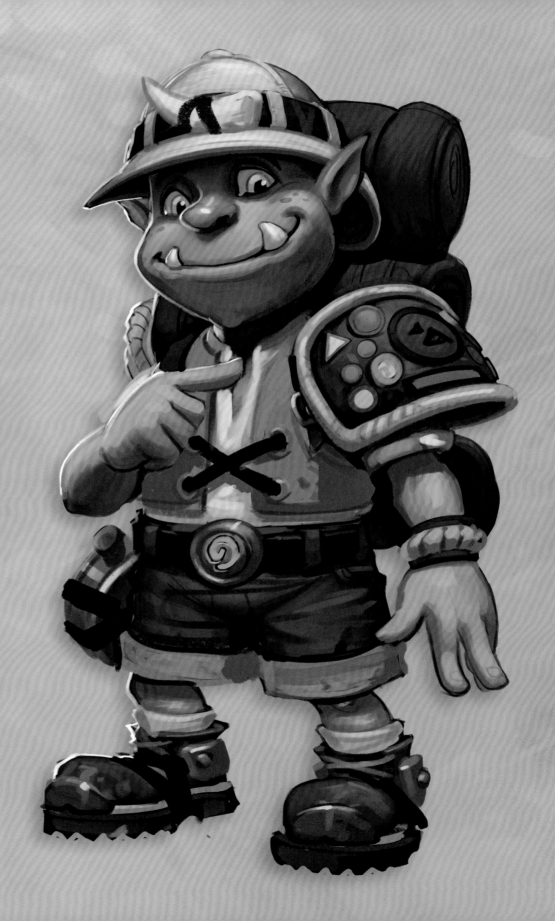

It wasn't enough to design an uncharted land. There wouldn't be much point in filling a jungle with dangerous plant life, hidden power, and dinosaurs if you weren't going to give the audience a chance to explore it.

And that's what led the Hearthstone team to take a very small step in a very new direction. In the years since the game's 2014 launch, the development team had adapted many characters from the Warcraft universe, and they had created plenty of their own. But until *Journey to Un'Goro*, the team had never tried to expand upon their own mythology.

Elise Starseeker, one of the members of 2015's adventure *League of Explorers*, returned to *Hearthstone* to lead the expedition into Un'Goro Crater. She served as the main character of the announcement cinematic—leading a cadre of young explorers-in-training—and as a legendary card that could be played by any class.

"Any member of the Explorers' League would have worked in the cinematic, but using Elise was a chance to show her evolving as a character," said Kosak.

In *League of Explorers*, Elise was a twist on the librarian archetype, portrayed as a well-spoken bookworm who could—surprise!—fight quite capably against any villain that threatened her turf. In returning to her character, it was more interesting to show her working out in the field.

"She really knows what she's doing," said Kosak, "so much so that she can guide a group of kids through a place as dangerous as Un'Goro."

The kids themselves—members of a group known internally as the Junior Explorers—were initially concepted to have a much bigger presence in the card illustrations for the set. They didn't become playable minions because, well, it felt strange to have kids brawling with dragons on the game board. The Junior Explorers had to settle for a starring role in the cinematic and a few appearances in the art for another new feature: **Quests**.

ABOVE
Journey to Un'Goro tavern sign

RIGHT
Character exploration from style guide

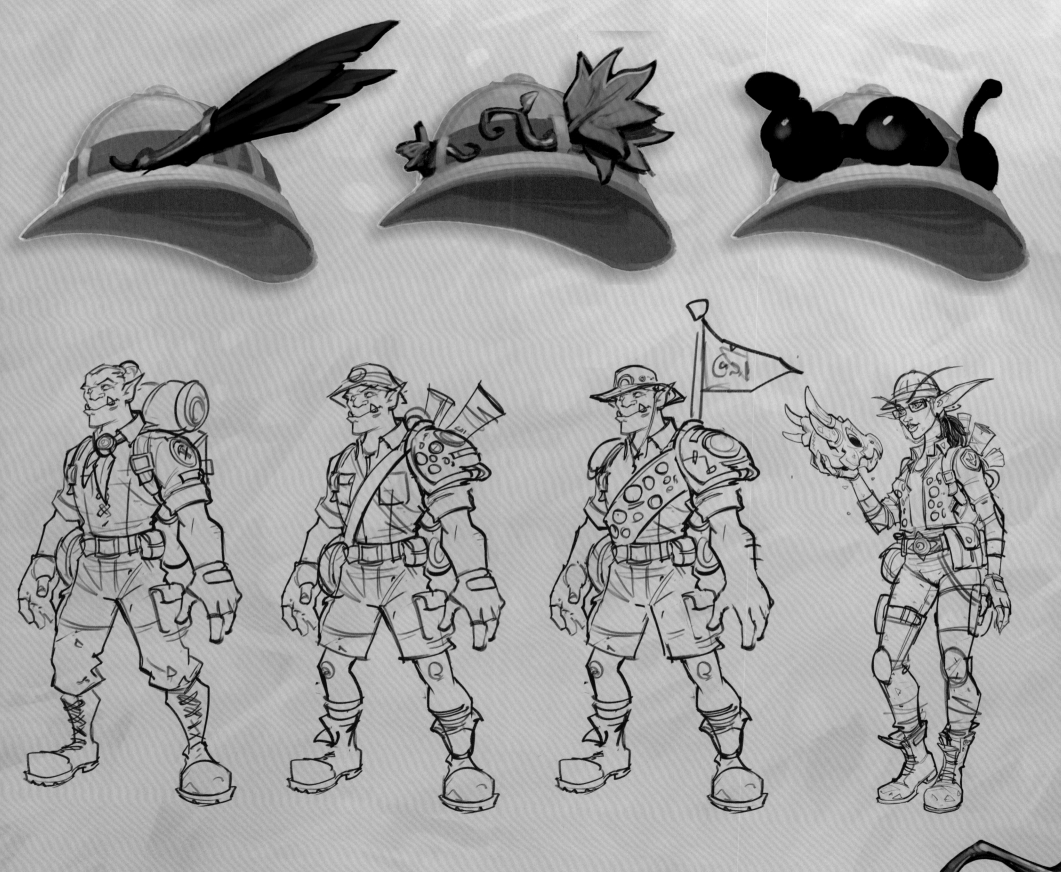

ABOVE
Journey to Un'Goro store card tray

OPPOSITE
The final *Journey to Un'Goro* game board

Waiting...

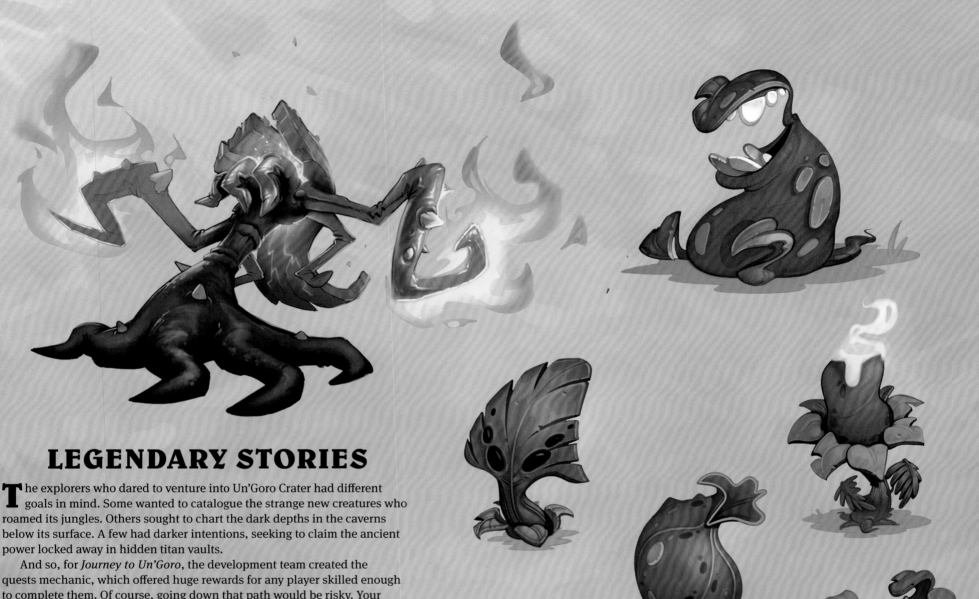

LEGENDARY STORIES

The explorers who dared to venture into Un'Goro Crater had different goals in mind. Some wanted to catalogue the strange new creatures who roamed its jungles. Others sought to chart the dark depths in the caverns below its surface. A few had darker intentions, seeking to claim the ancient power locked away in hidden titan vaults.

And so, for *Journey to Un'Goro*, the development team created the quests mechanic, which offered huge rewards for any player skilled enough to complete them. Of course, going down that path would be risky. Your opponent would know your strategy from your very first turn.

"*Hearthstone* is about creating stories for the player," said Kosak. "Each match should have its own twists and turns, and each move or countermove should feel like it advances the story."

In the Year of the Kraken, **C'Thun** had shown what was possible when *both* players could see what was happening with the card's mechanic. As the Old God's power ramped up, both players would see it lurking at the side of the board, making it feel like a ticking time bomb that could explode at any moment. Quests took that idea to another level. Not only would both players see the quest's progress but they would see it coming from the very first turn of the match.

"When a quest begins, you know what your opponent's strategy will be, so you know how to play against it," said Kosak. "When the quest *finishes* . . . oh boy. You better have your endgame in place because your opponent already does."

THIS SPREAD
Flora and fauna concepts from style guide

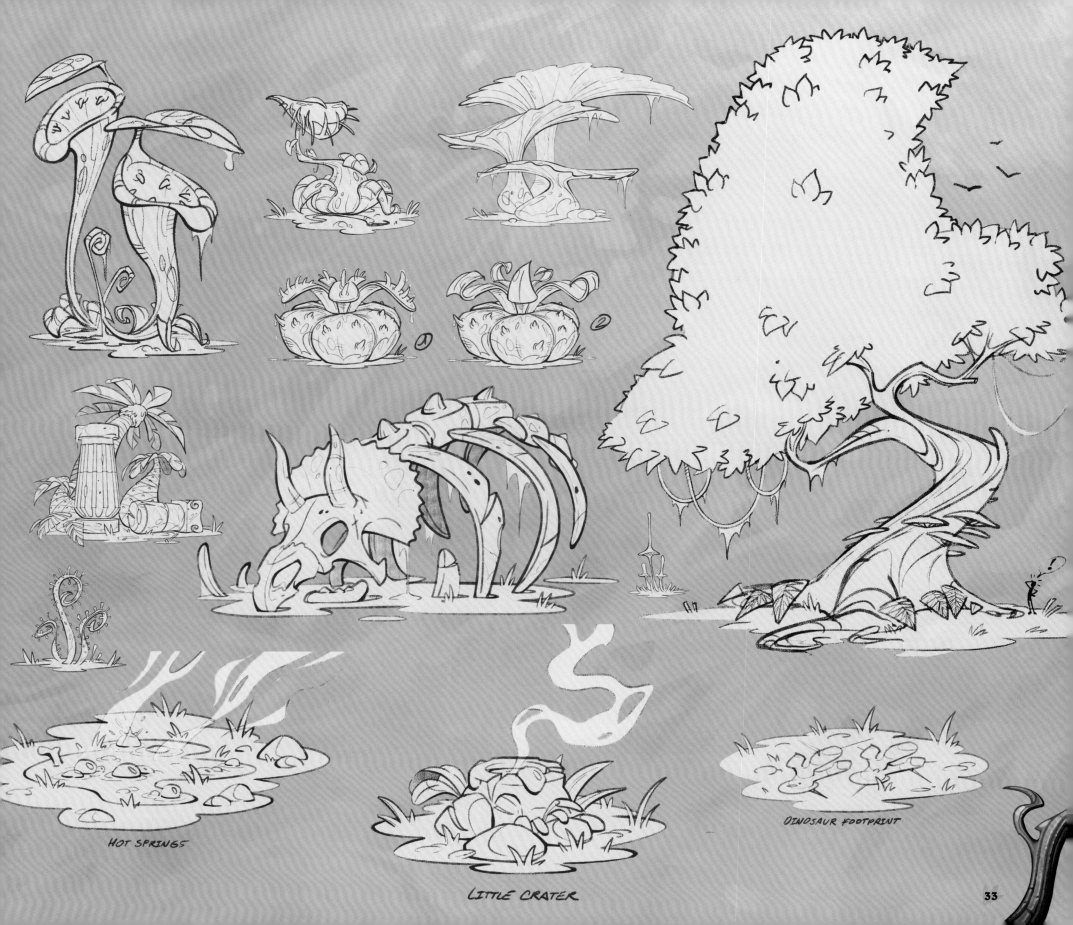

HOT SPRINGS

LITTLE CRATER

DINOSAUR FOOTPRINT

33

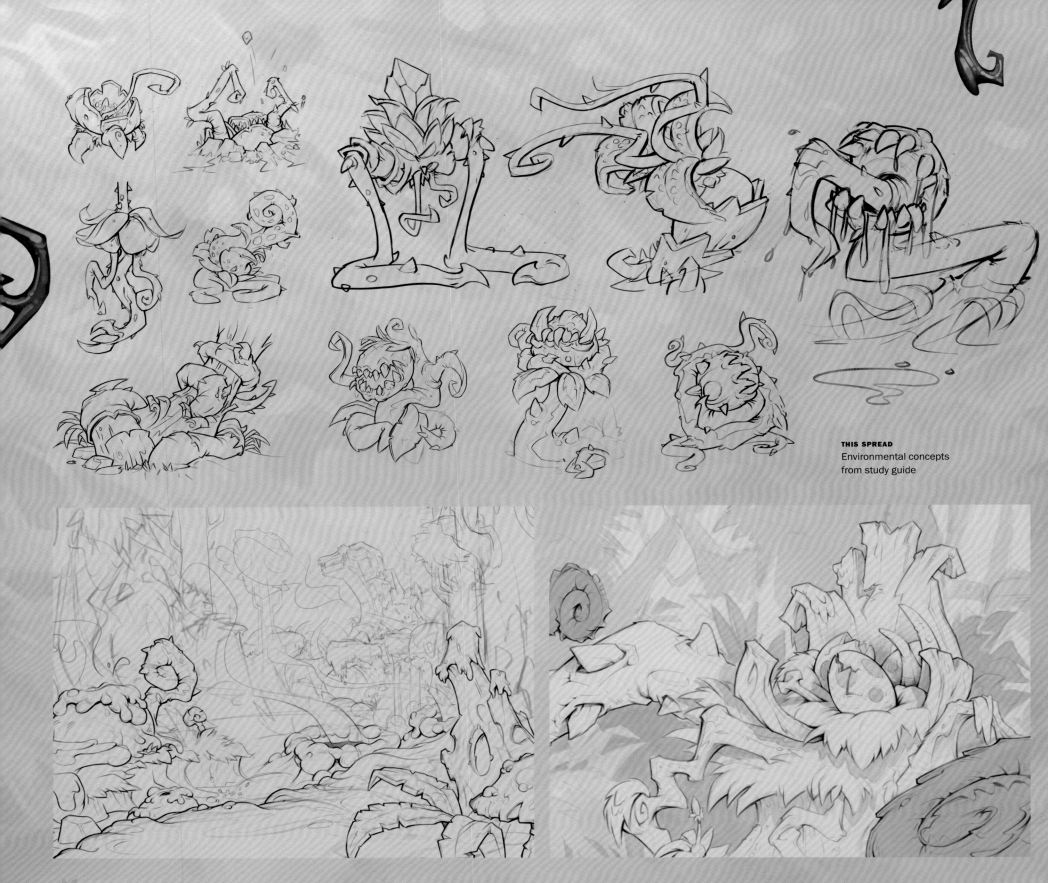

THIS SPREAD
Environmental concepts from study guide

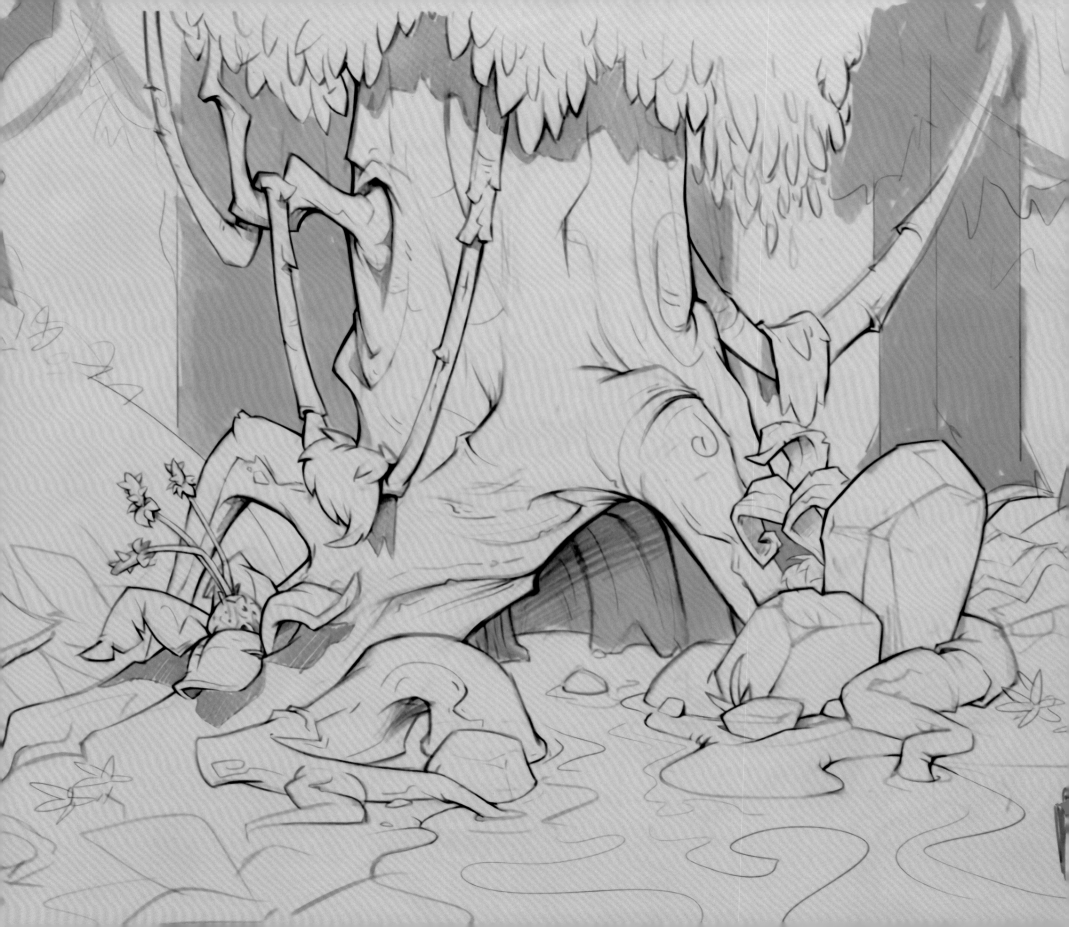

As the art team began to design the art for the nine quests in *Journey to Un'Goro*, they batted around several ideas about how to show the quest progress to the players. "At one point, we discussed patches—like Boy Scout merit badges—to track quests," said Cranford.

Eventually, the art team realized there was a different kind of storytelling opportunity in this set. Each quest offered a reward, which would generate an entirely different card. If artists treated those two cards as a single story—a beginning and an end—they could show the audience what the explorers in Un'Goro were finding on their journeys.

To give a sense of scale, the quest cards focused on the landscapes stretching out before a single explorer, often shown as tiny in comparison to the massive environment before them. The priest quest (**Awaken the Makers**) showed a hidden titan facility at the beginning and then summoned an ancient titan keeper (**Amara, Warden of Hope**) for a big healing wave. The rogue quest (**The Caverns Below**) showed an explorer finding hints of huge, menacing silhouettes hidden in a dark cave before stumbling across perfectly preserved giant creatures in the **Crystal Core** at the end.

Konstantin Turovec, who worked on many illustrations for the Year of the Mammoth, said that fitting a sprawling vista into the confines of a card portrait frame was not always easy but that it was helpful to experiment and seek feedback from the development team about what they needed the art to achieve.

"If something becomes difficult to do, you can always ask for help. That's why I really enjoy working on *Hearthstone*," said Turovec. "In order to create something really great, you have to work as a team."

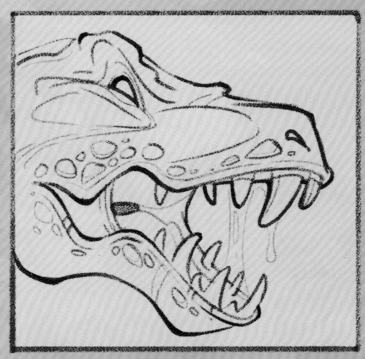

GAIN +1/+1

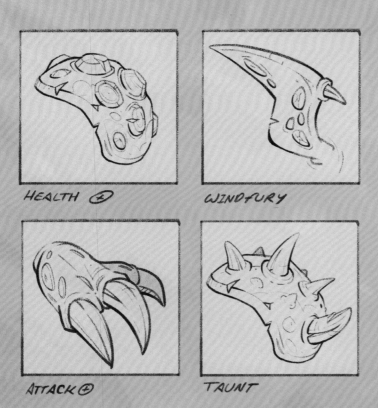

HEALTH ⊕

WINDFURY

ATTACK ⊕

TAUNT

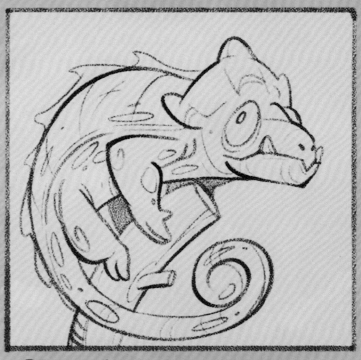

STEALTH

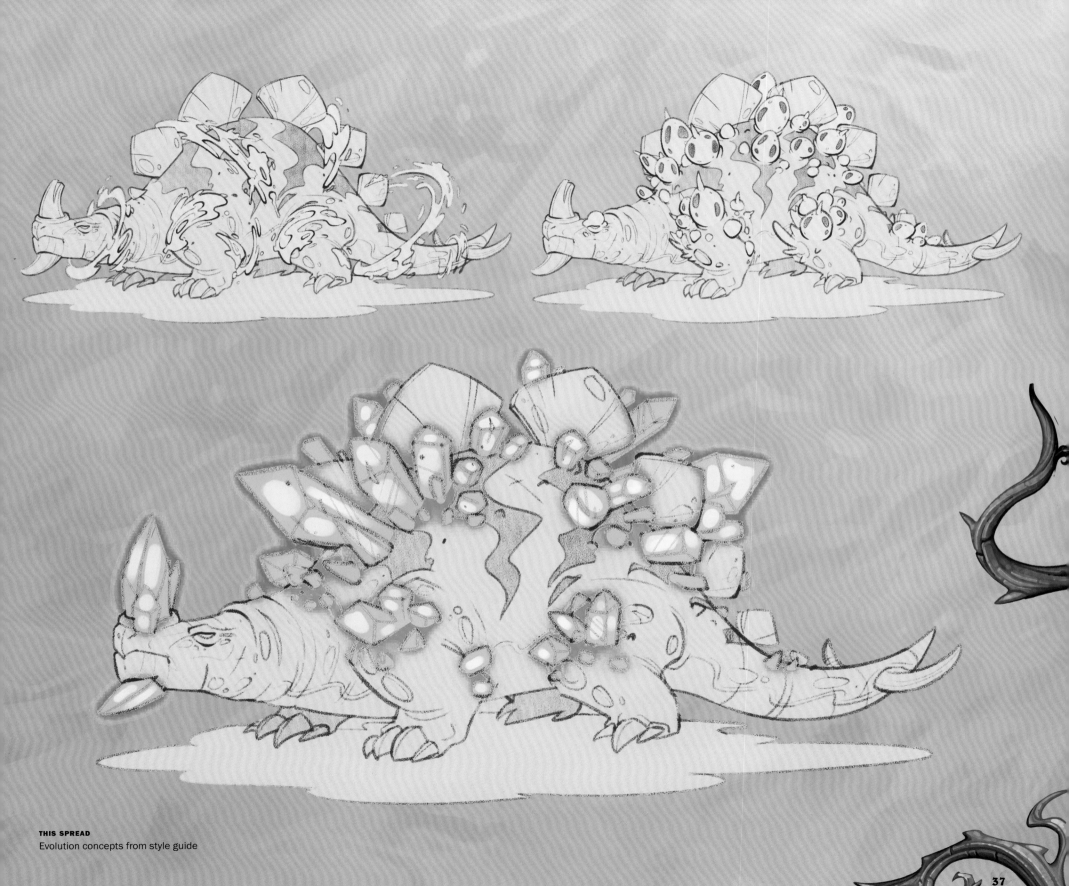

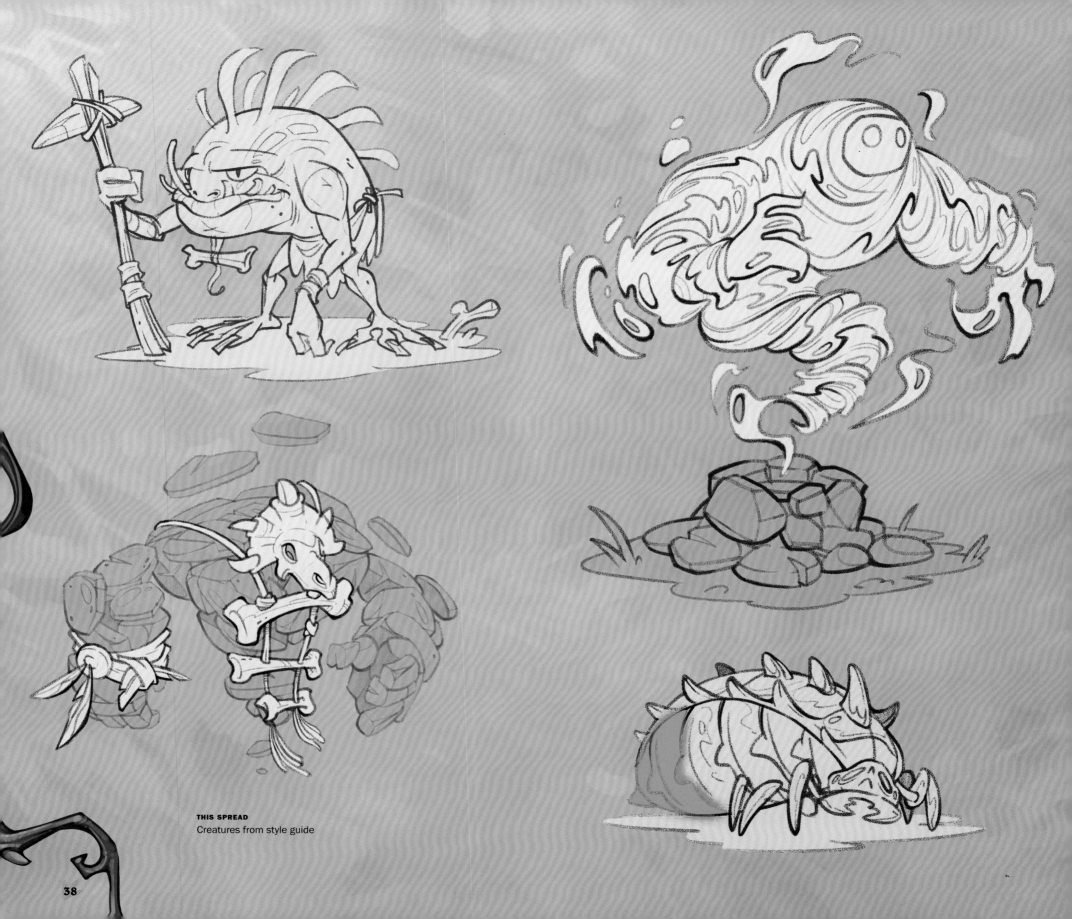

THIS SPREAD
Creatures from style guide

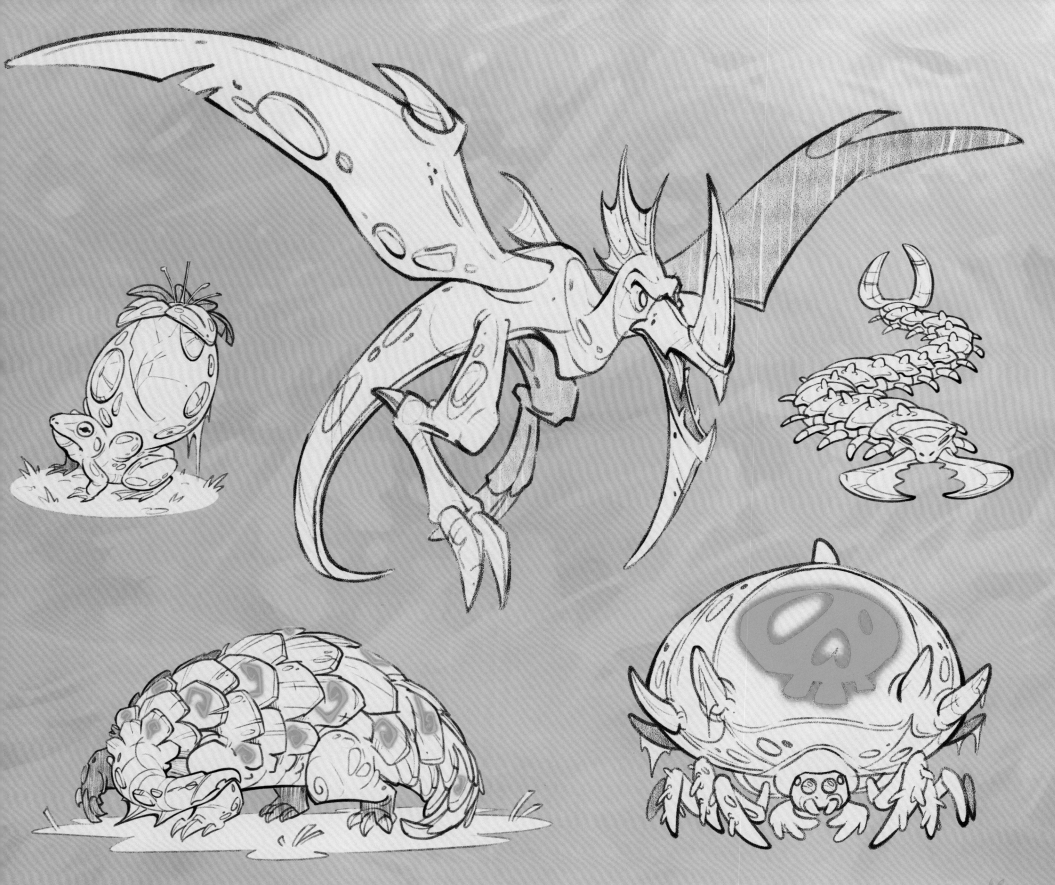

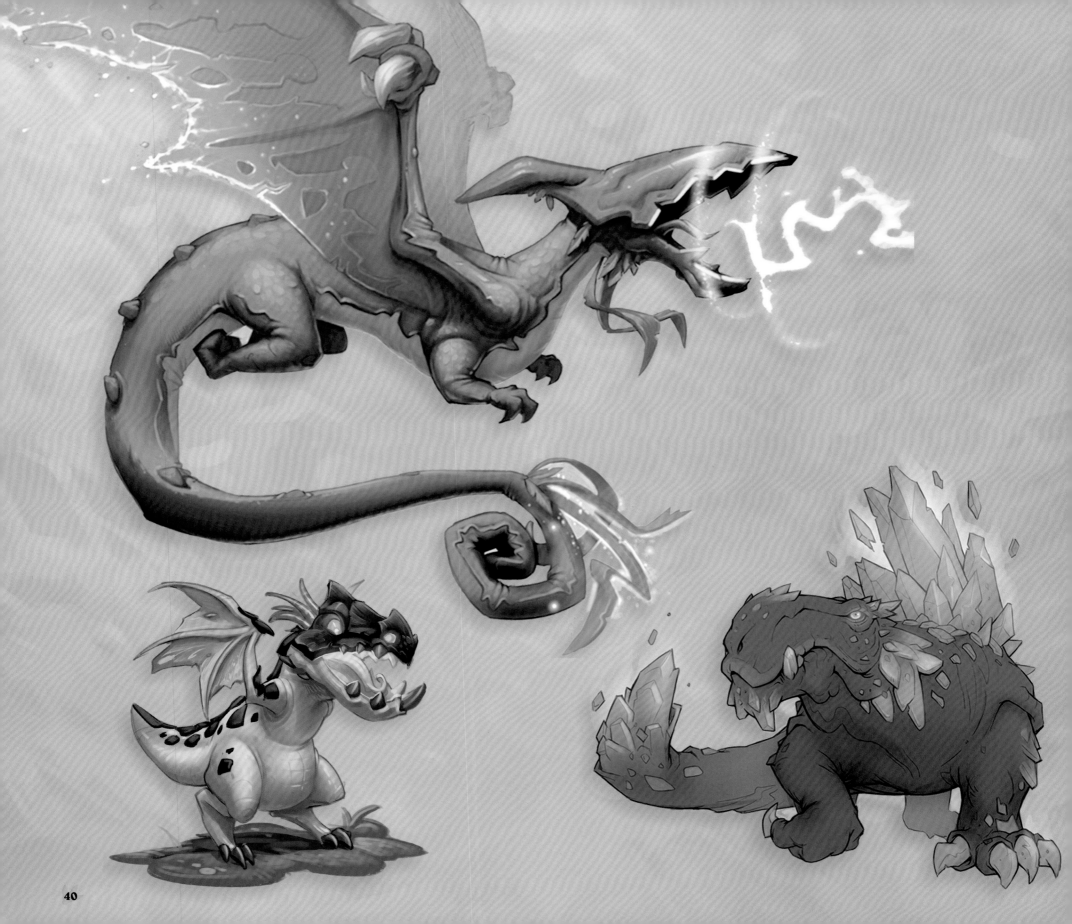

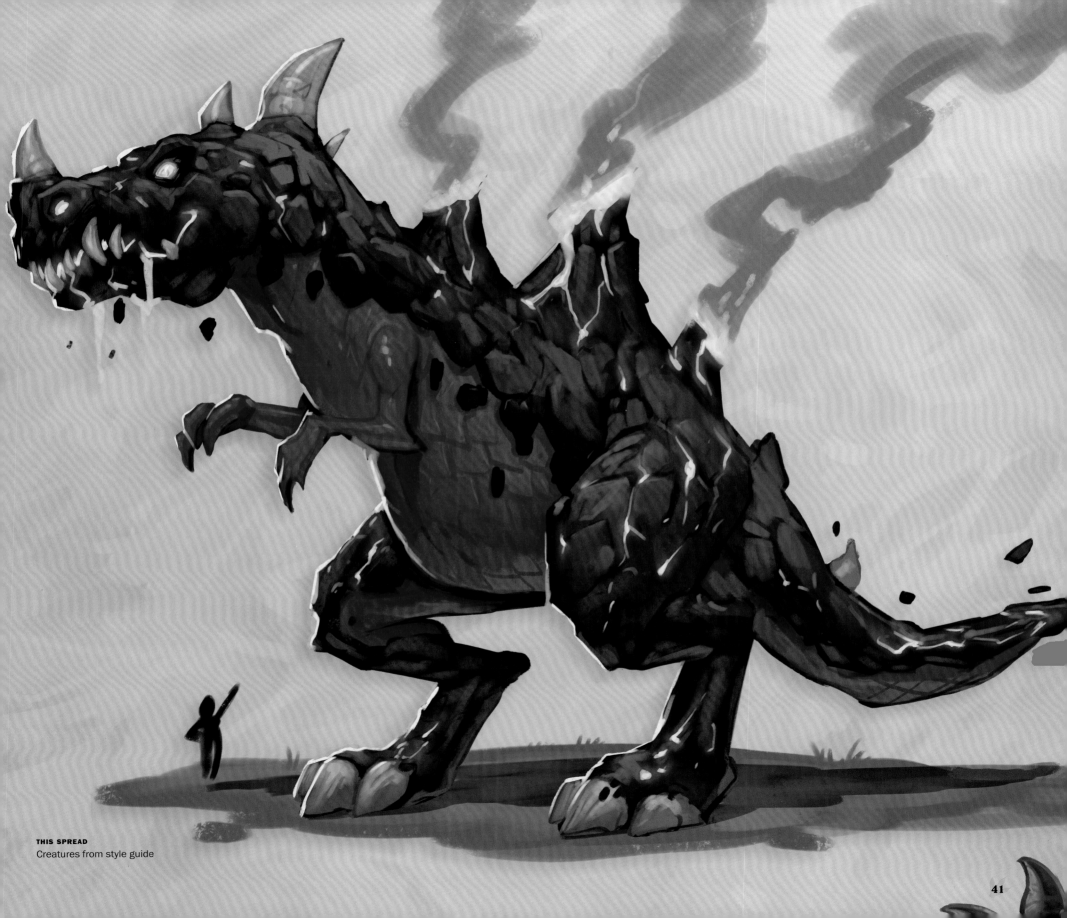

Journey to Un'Goro card pack ideation, opening concept, and final art

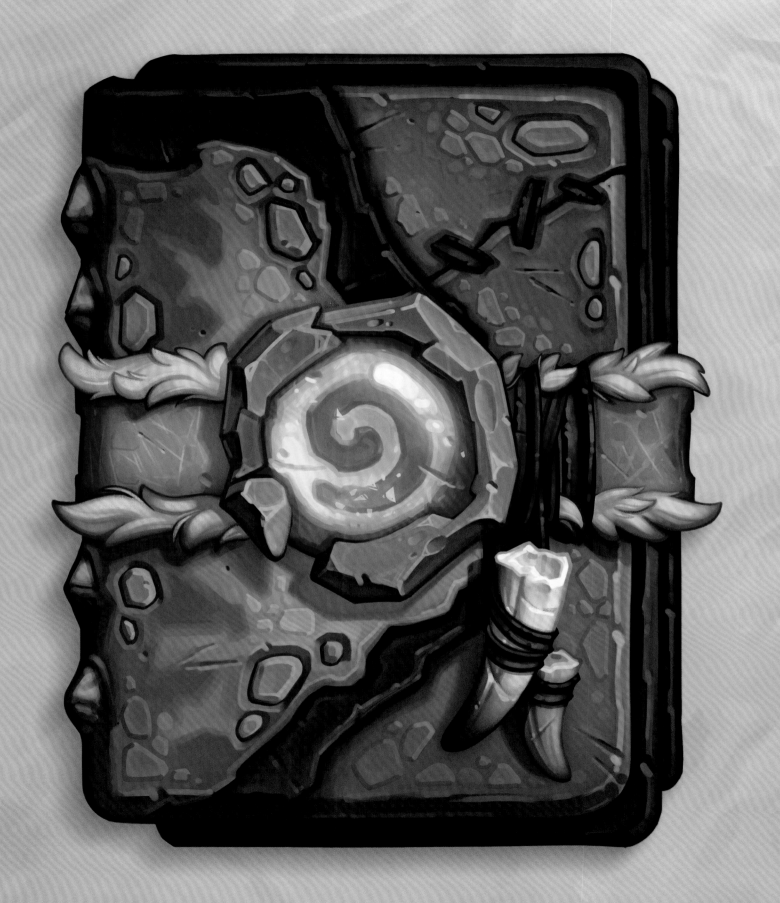

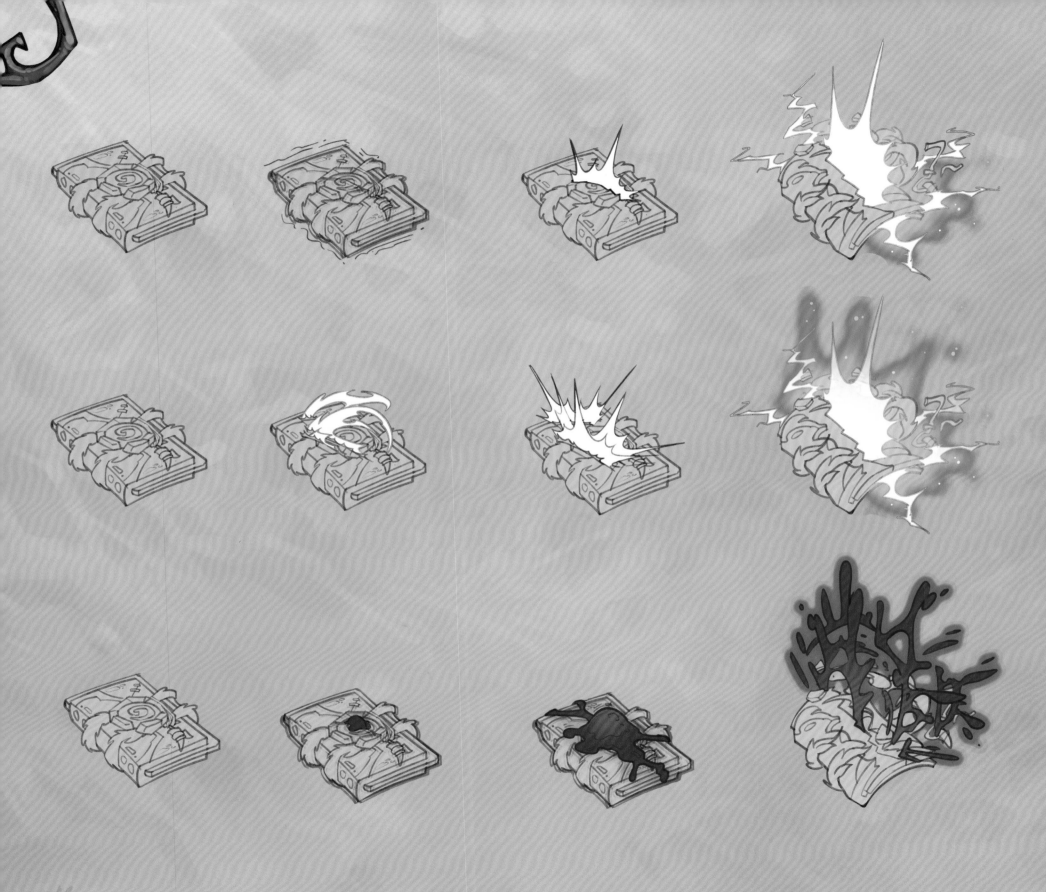

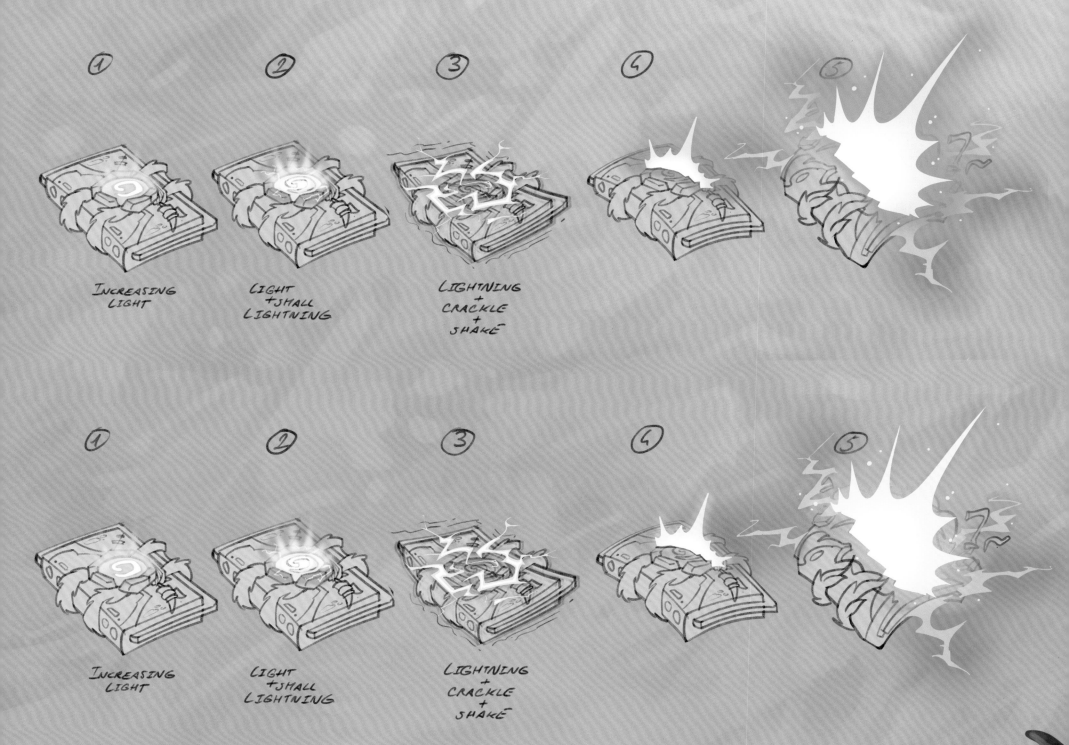

① INCREASING LIGHT

② LIGHT +SMALL LIGHTNING

③ LIGHTNING + CRACKLE + SHAKE

④

⑤

① INCREASING LIGHT

② LIGHT +SMALL LIGHTNING

③ LIGHTNING + CRACKLE + SHAKE

④

⑤

THIS SPREAD
Card pack opening ideation

CLOSER LOOK:
THE HUNTER QUEST

The story of the hunter-class quest in *Journey to Un'Goro* was told across three different cards. The first, **The Marsh Queen**, depicts a tauren Junior Explorer arriving in the dense, humid jungle and being stalked by several juvenile dinosaurs. The situation already feels dangerous even though the dinosaurs are relatively small. But when the quest is completed, the big matriarch, **Queen Carnassa**, comes thundering out of the gloom, bringing with her fifteen more of her children, **Carnassa's Brood**, to attack any intruders.

"I tried to give Queen Carnassa a dominating presence with a perspective that puts the viewer at her feet, hopelessly looking up at her ferocious power," said artist A. J. Nazzaro. "You can see a couple of her brood behind her—hoping to clean up the leftovers of her next victim. I used the same color palette for both cards so that they might immediately read as linked in-game."

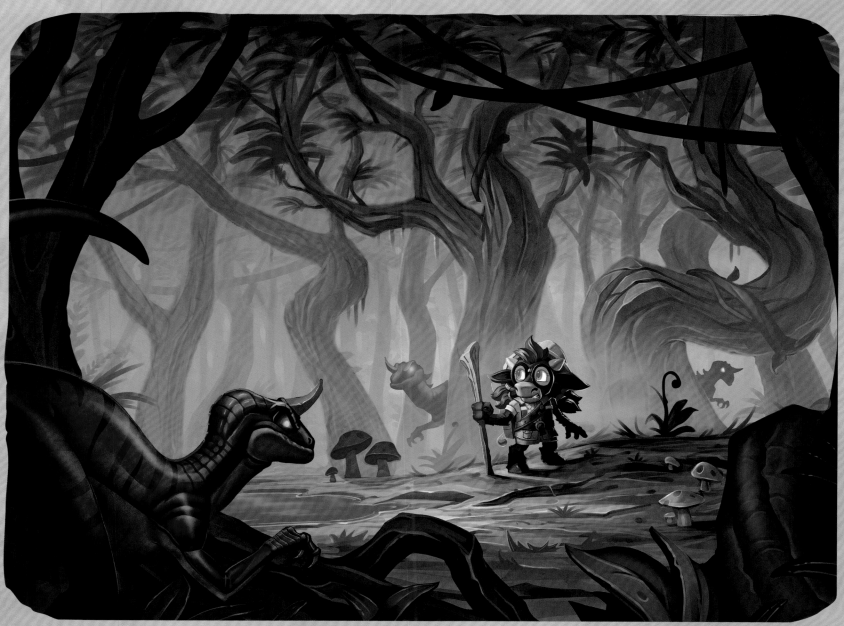

LEFT
The Marsh Queen
A.J. Nazzaro

OPPOSITTE
Queen Carnassa
A.J. Nazzaro

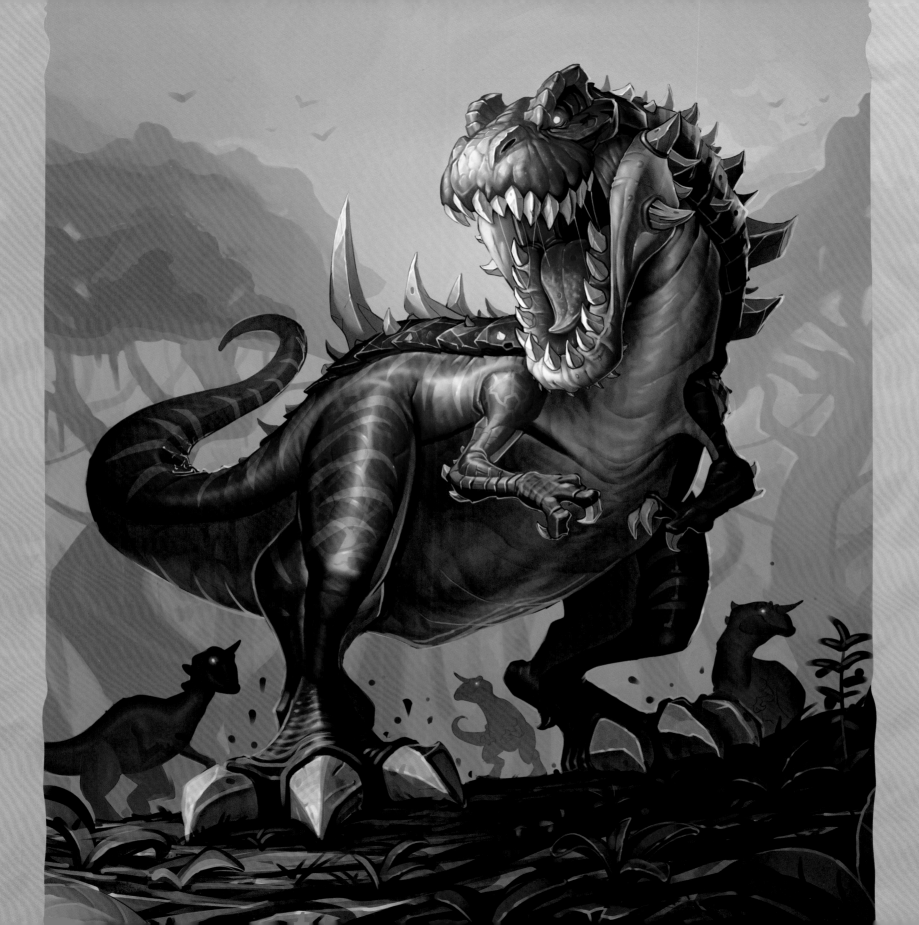

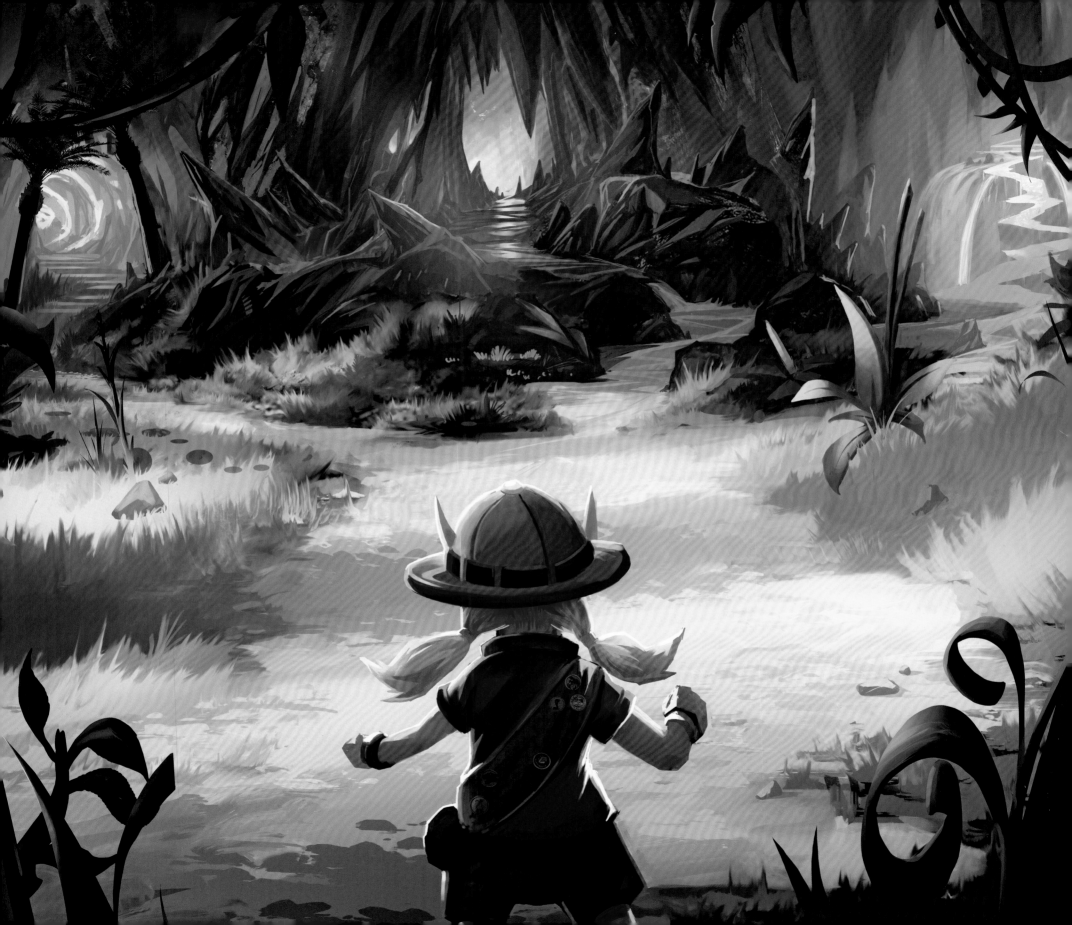

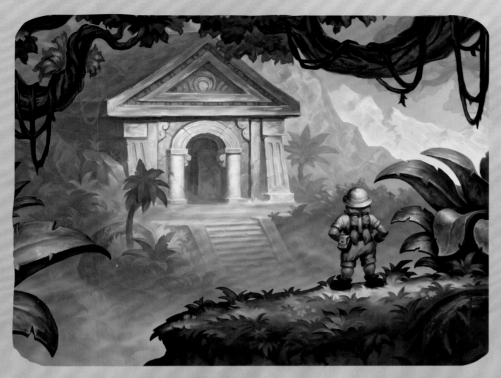

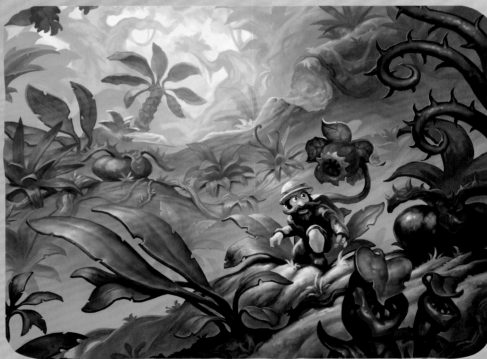

OPPOSITE
Choose Your Path
James Paick

LEFT ABOVE
Awaken the Masters
Konstantin Turovec

LEFT BOTTOM
Open the Waygate
Rafael Zanchetin

RIGHT ABOVE
Invocation of Water
Zoltan Boros

RIGHT BOTTOM
Jungle Giants
Konstantin Turovec

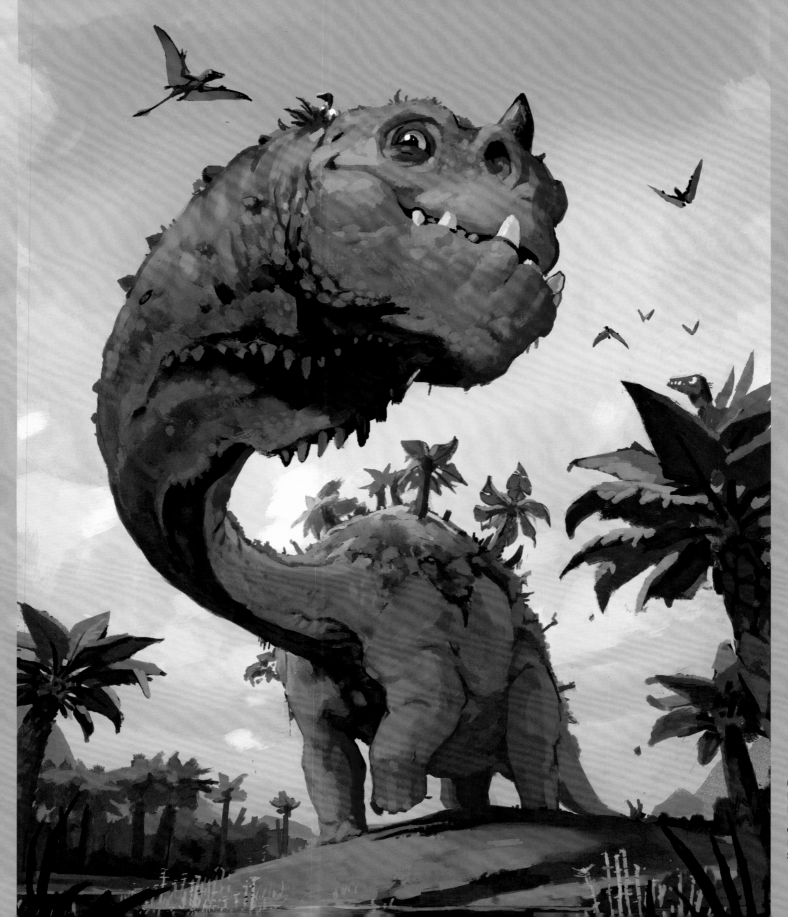

LEFT
Ultrasaur
Laurel Austin

OPPOSITE
Barnabus the Stomper
Sean McNally

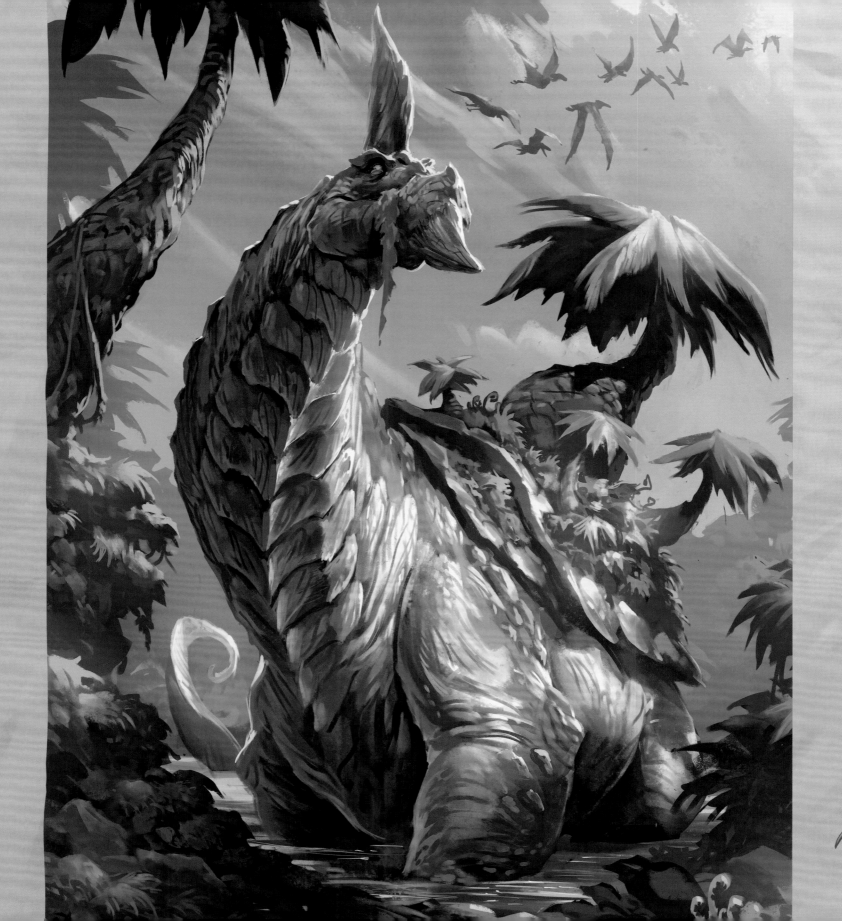

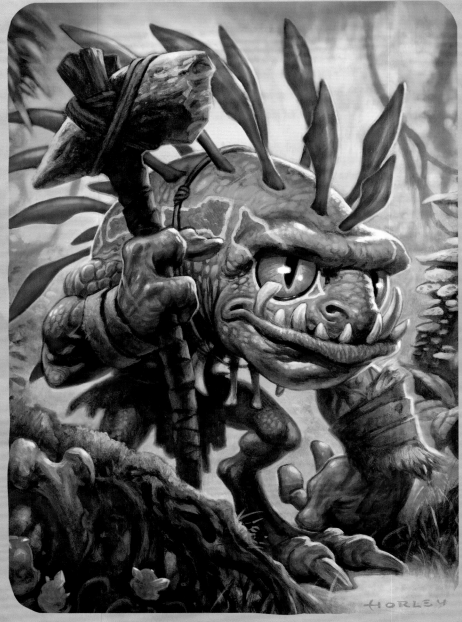

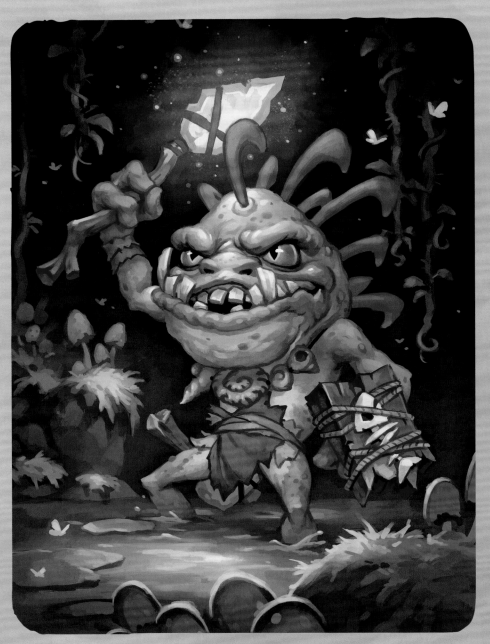

ABOVE
Rockpool Hunter
Alex Horley

ABOVE
Primalfin Champion
Matt Dixon

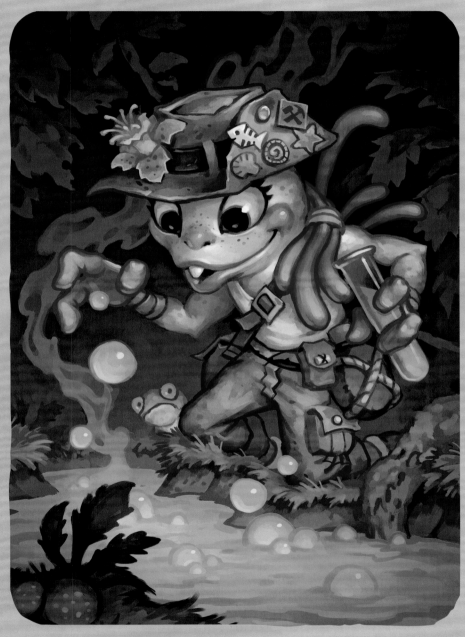

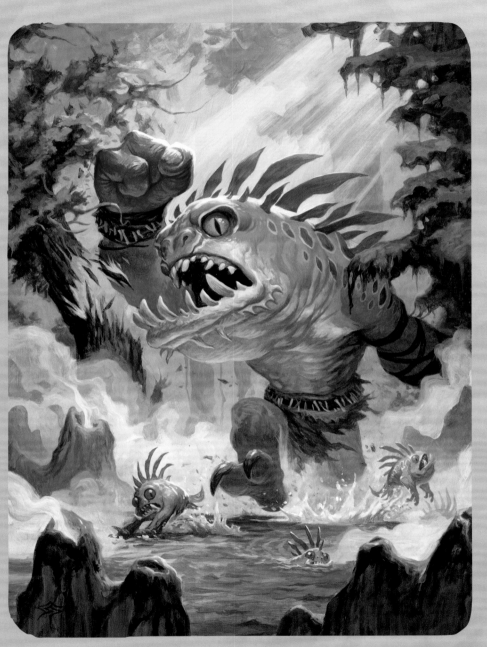

ABOVE
Hydrologist
Matt Dixon

ABOVE
Megafin
Steve Prescott

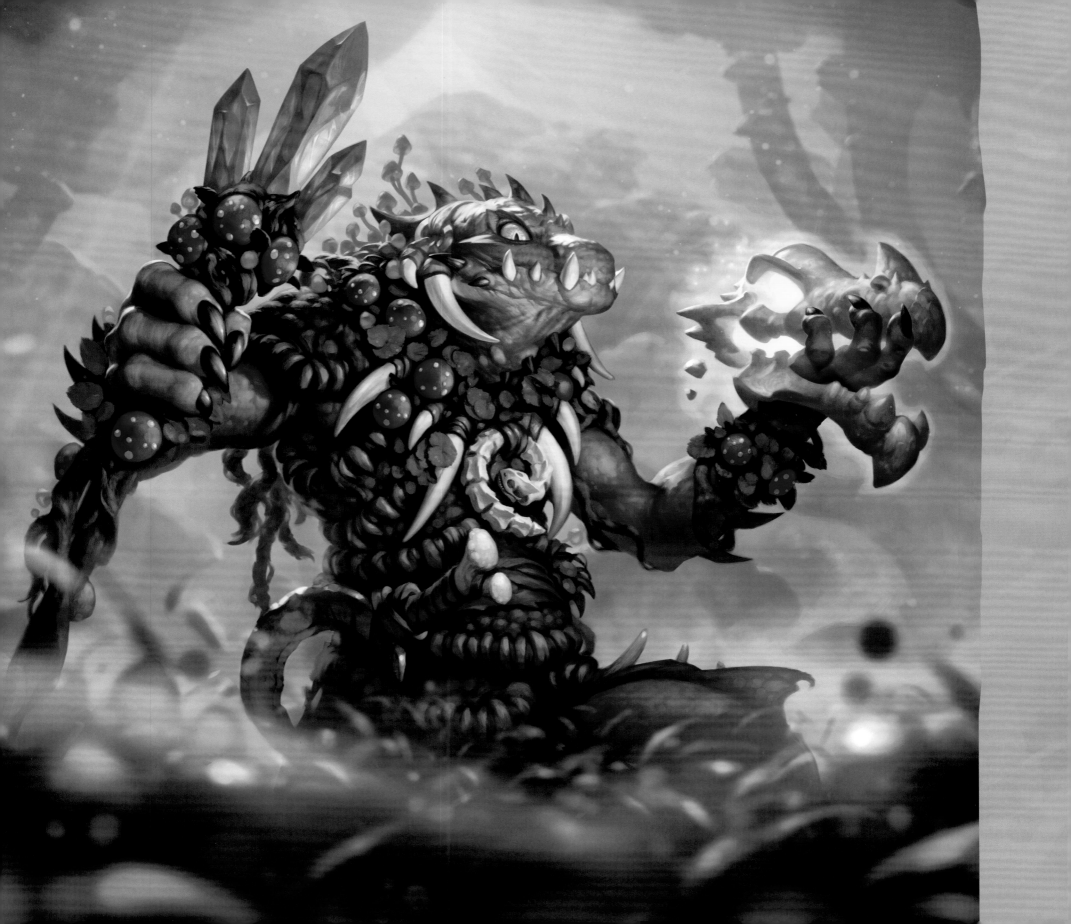

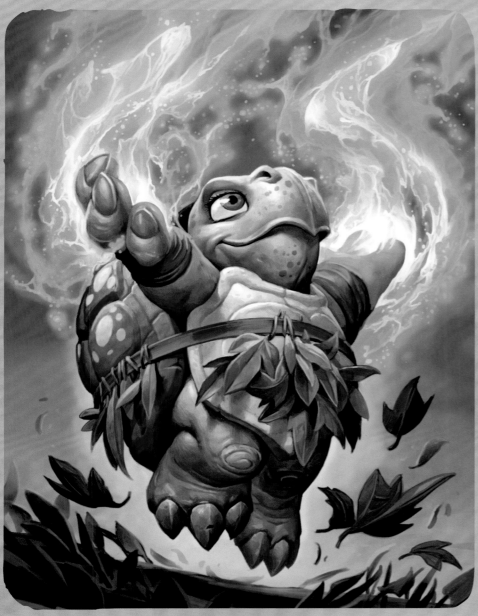

ABOVE
Tortollan Primalist
Zoltan Boros

OPPOSITE
Dinomancy
Arthur Bozonnet

ABOVE
Shellshifter
Matt Dixon

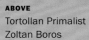

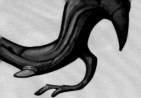

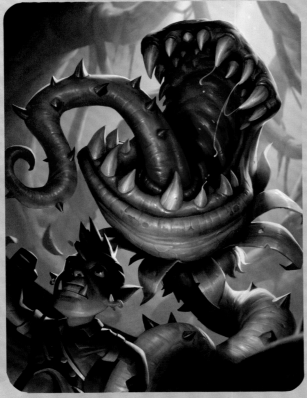

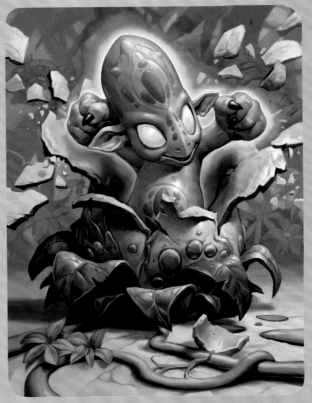

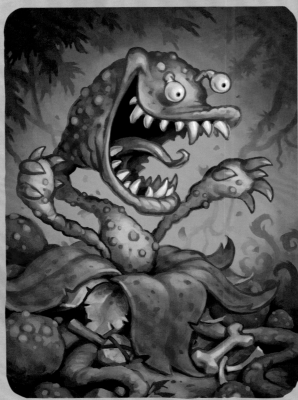

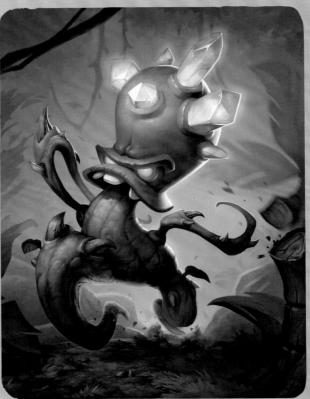

LEFT ABOVE
Humongous Razorleaf
Tooth

RIGHT ABOVE
Plant
Zoltan Boros

LEFT BOTTOM
Sherazin, Corpse Flower
Matt Dixon

RIGHT BOTTOM
Curious Glimmerroot
Servando Lupini

OPPOSITE
Mimic Pod
Zoltan Boros

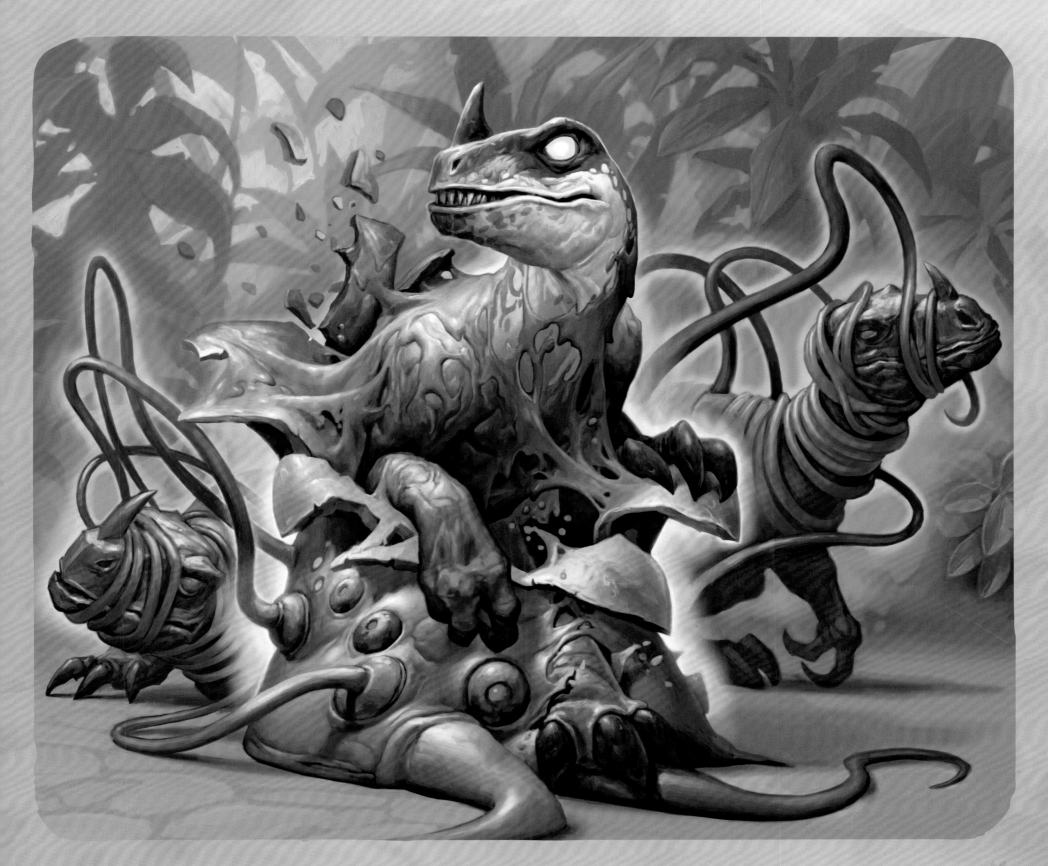

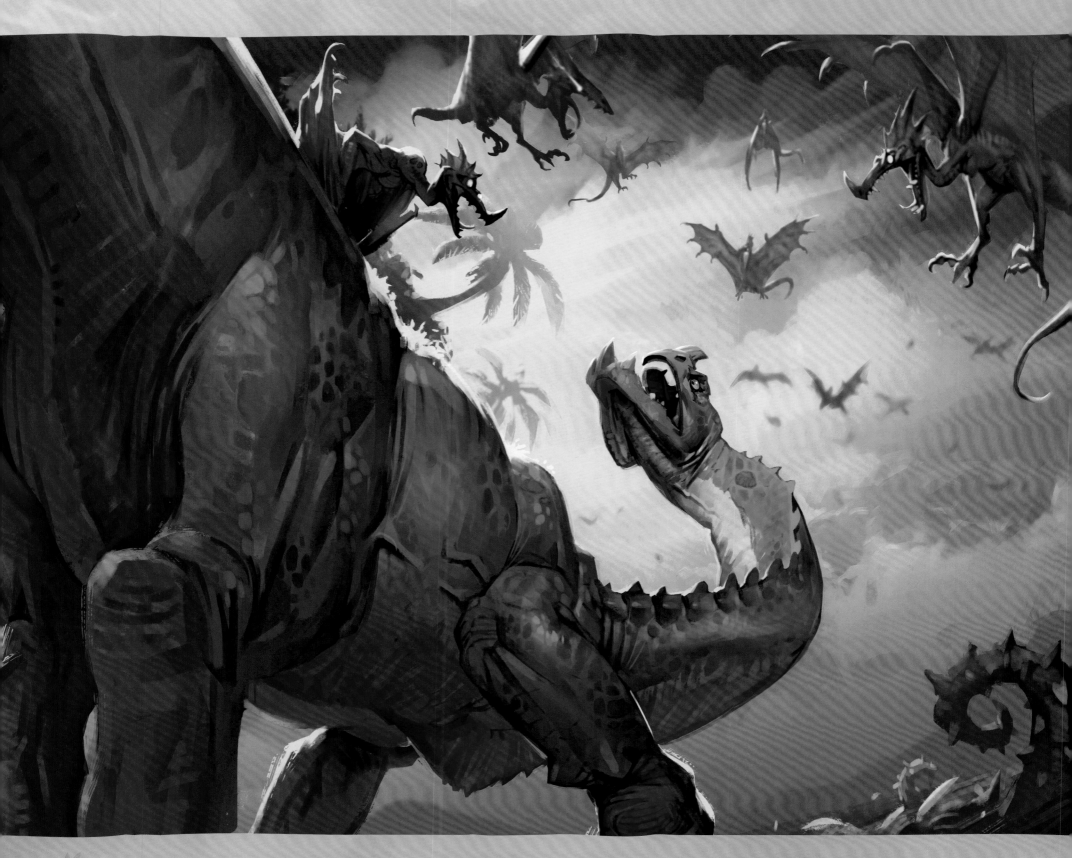

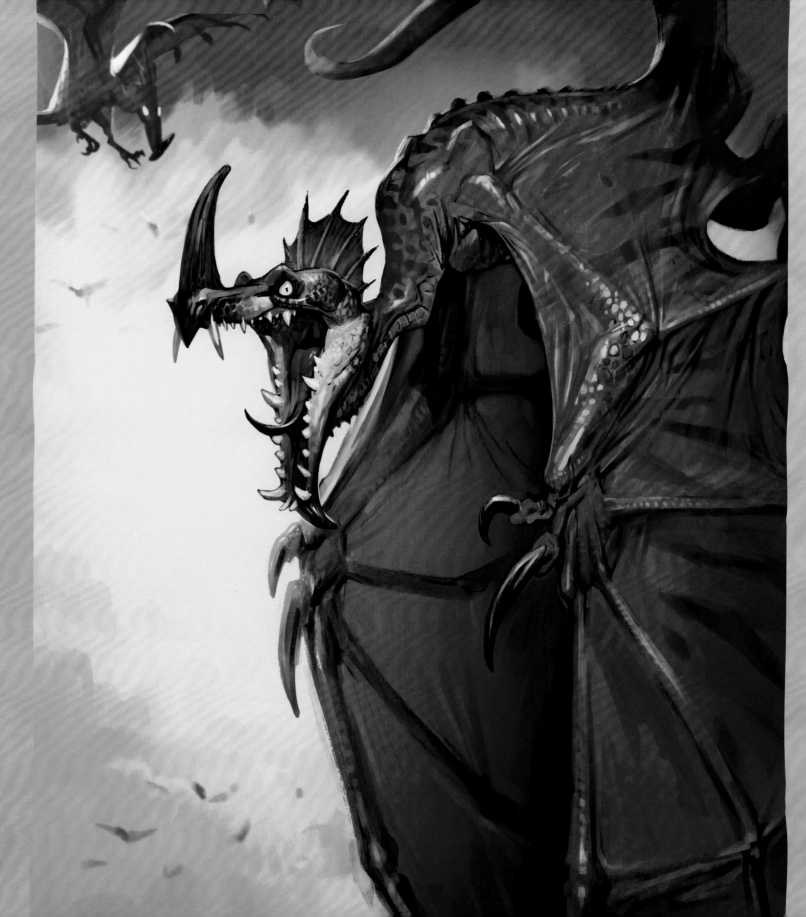

OPPOSITTE
Feeding Time
Jaemin Kim

RIGHT
Pterrordax
Jaemin Kim

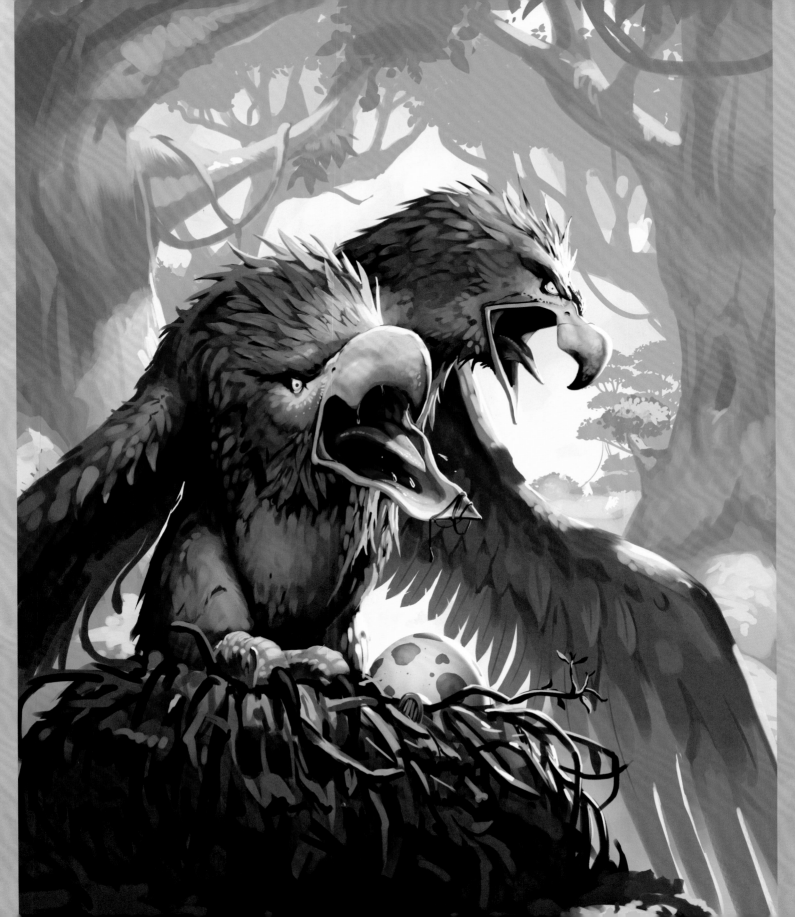

LEFT
Nesting Roc
Paul Mafayon

OPPOSITE
Explore Un'Goro
Jerry Mascho

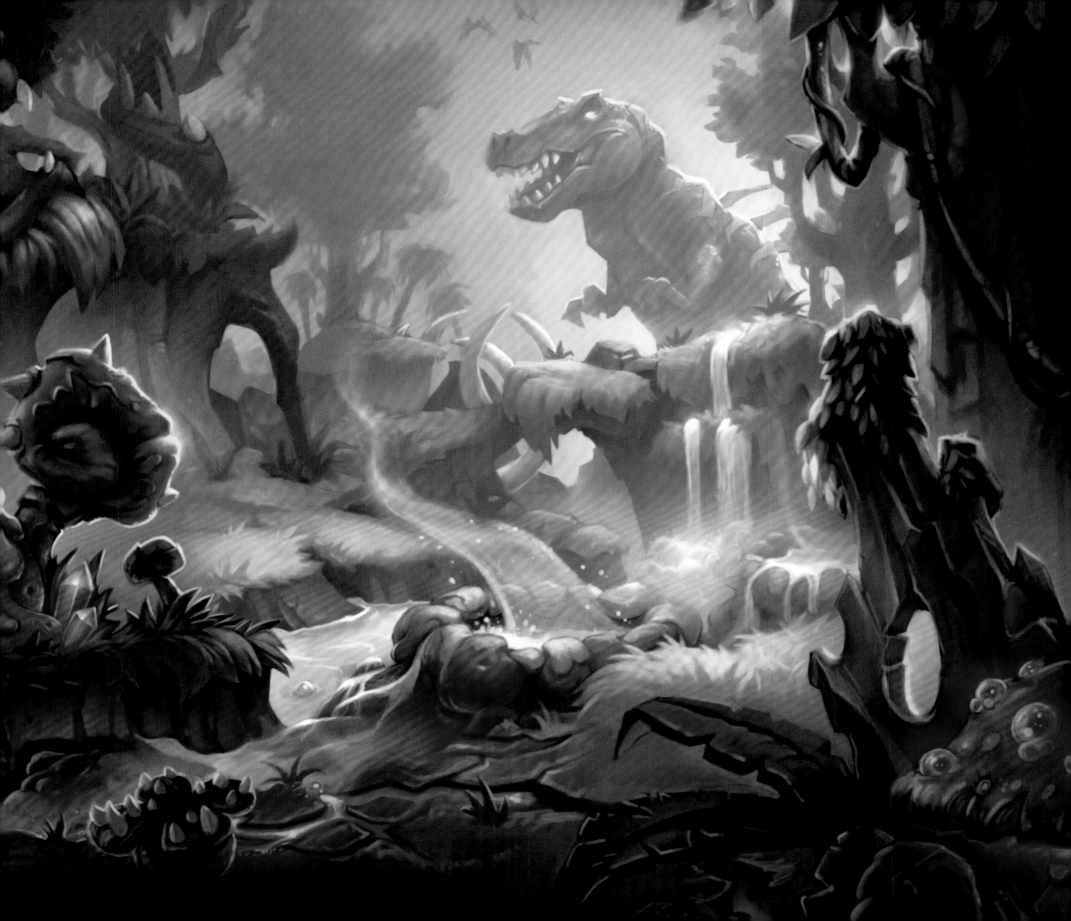

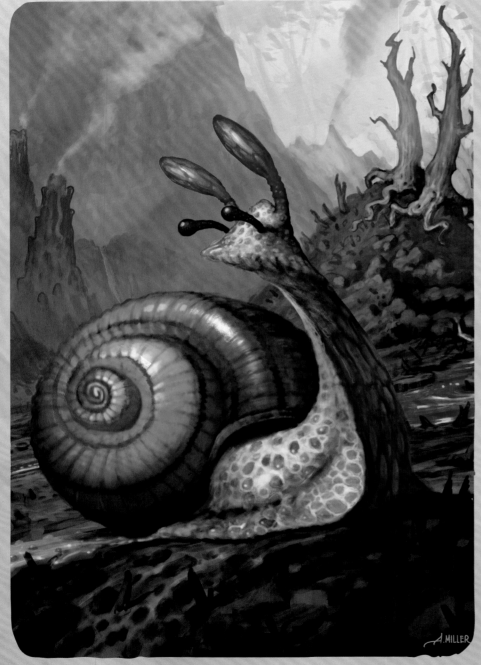

ABOVE
Stubborn Gastropod
Aaron Miller

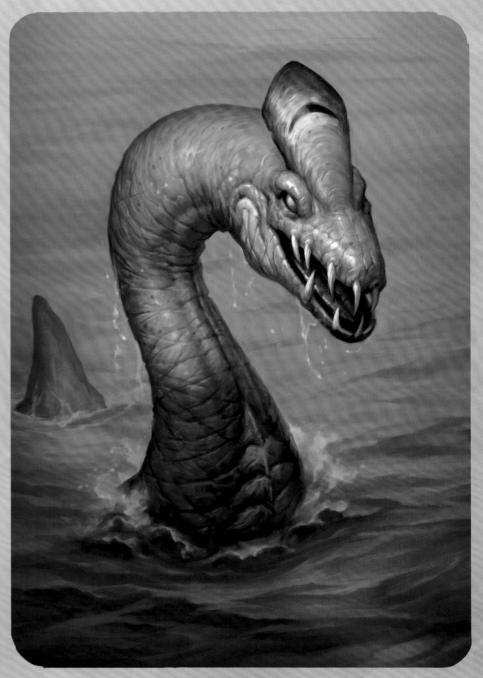

ABOVE
Sated Threshadon
James Ryman

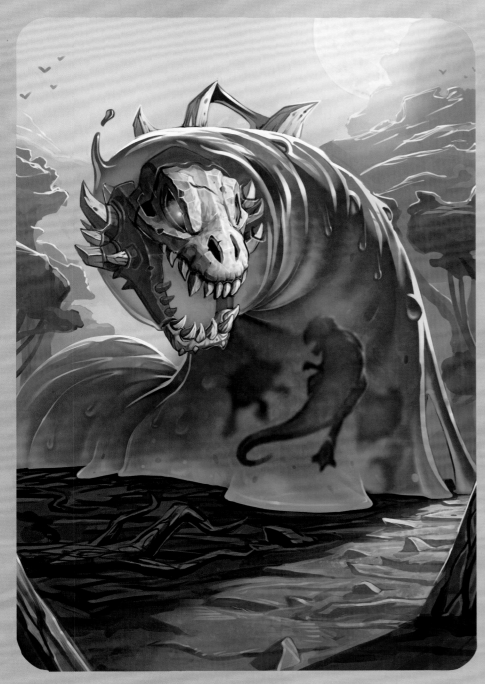

ABOVE
Gluttonous Ooze
A.J. Nazzaro

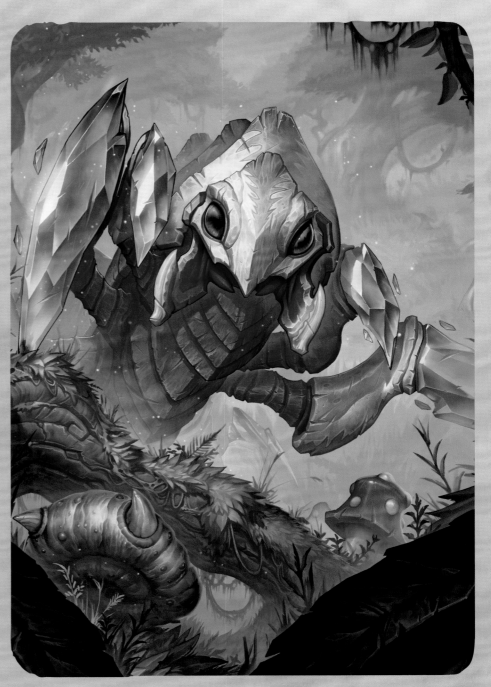

ABOVE
Emerald Reaver
Rafael Zanchetin

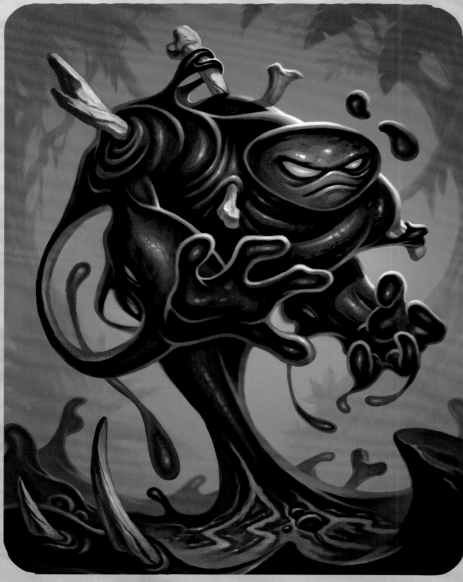

ABOVE
Tar Creeper
Jim Nelson

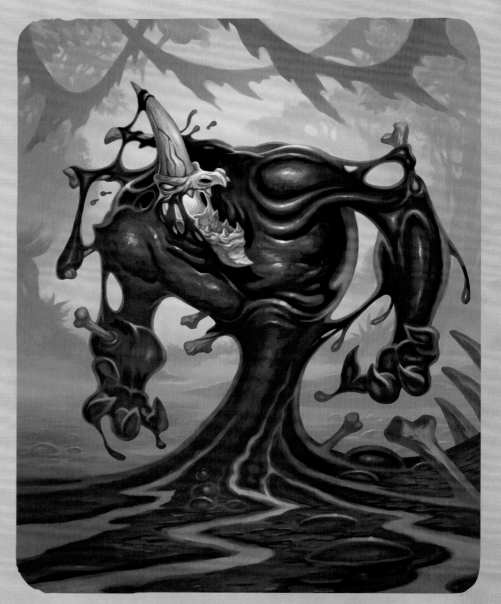

ABOVE
Tar Lurker
Jim Nelson

OPPOSITE
Tar Lord
Jim Nelson

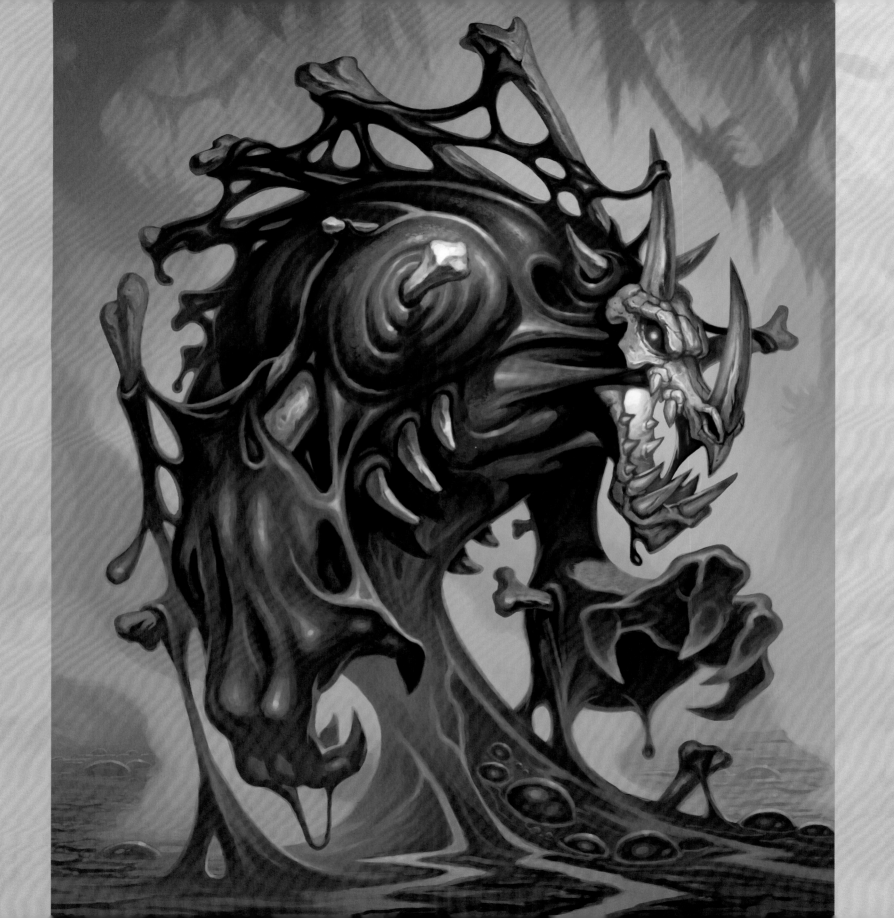

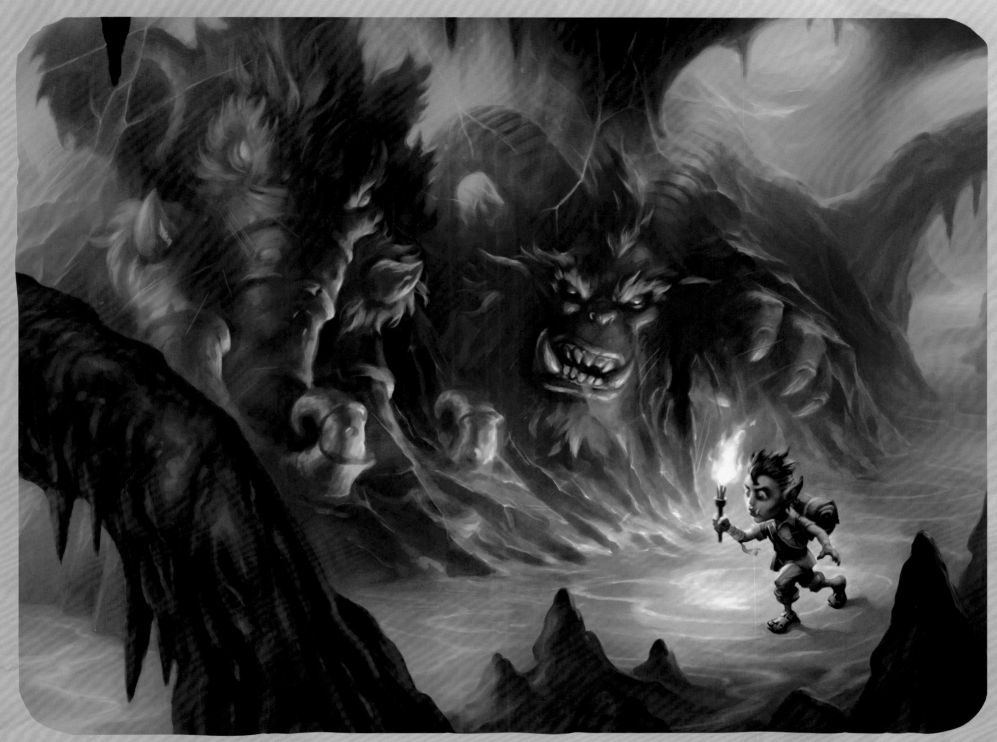

LEFT ABOVE
Vinecleaver
Joe Wilson

RIGHT ABOVE
Molten Blade
James Ryman

LEFT BOTTOM
Obsidian Shard
Konstantin Turovec

RIGHT BOTTOM
Primordial Glyph
Matthew O'Conner

OPPOSITE
Free From Amber
Anton Kagounkin

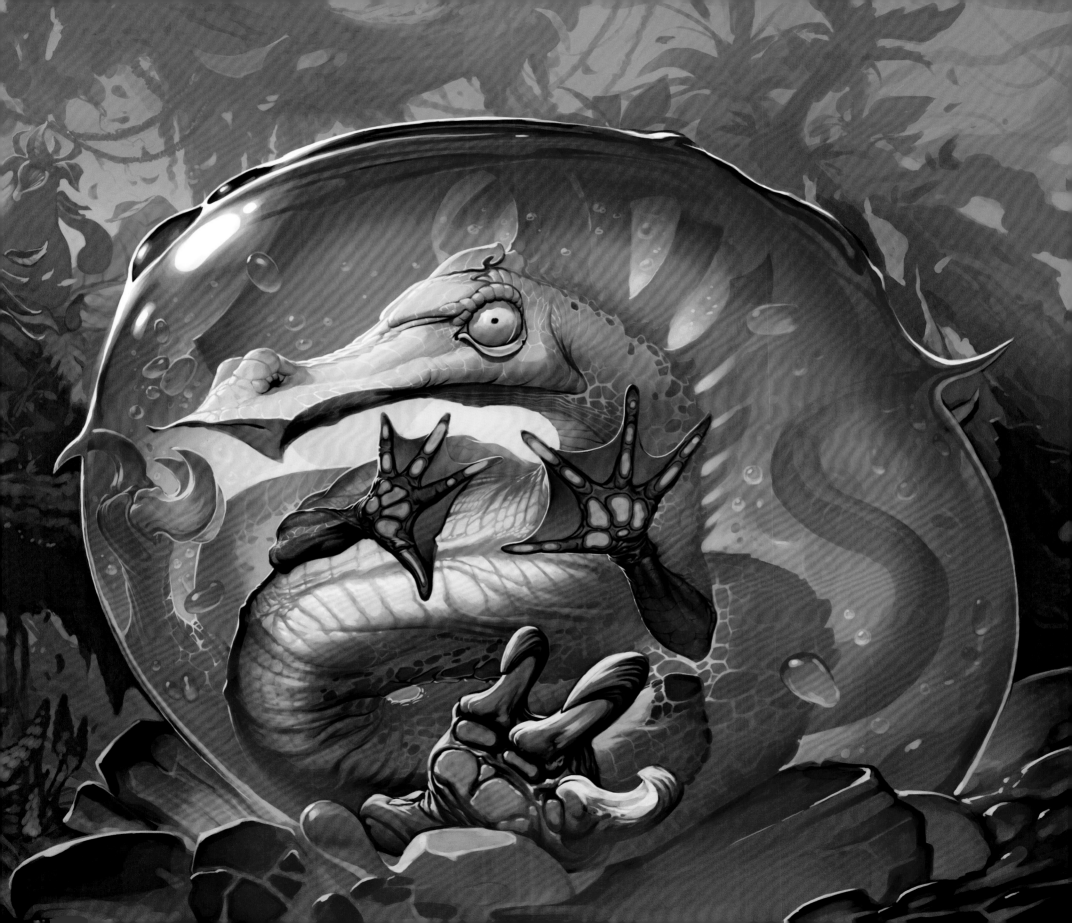

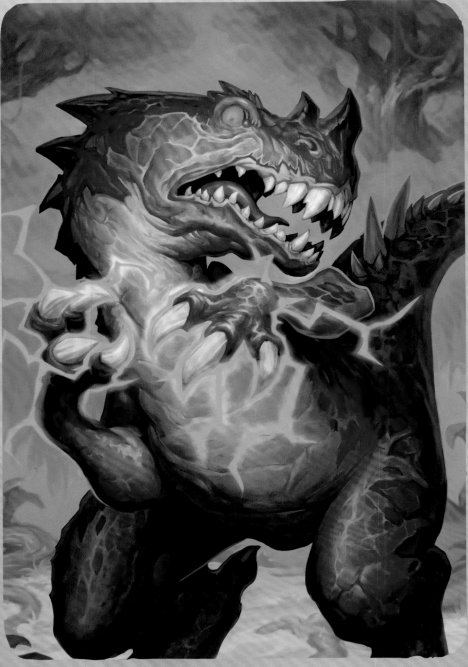

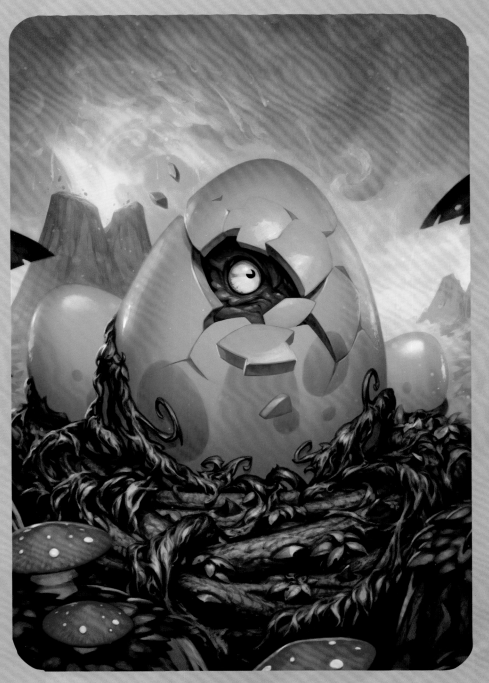

Crackling Razormaw
Ludo Lullabi and Konstantin Turovec

Devilsaur Egg
Arthur Bozonnet

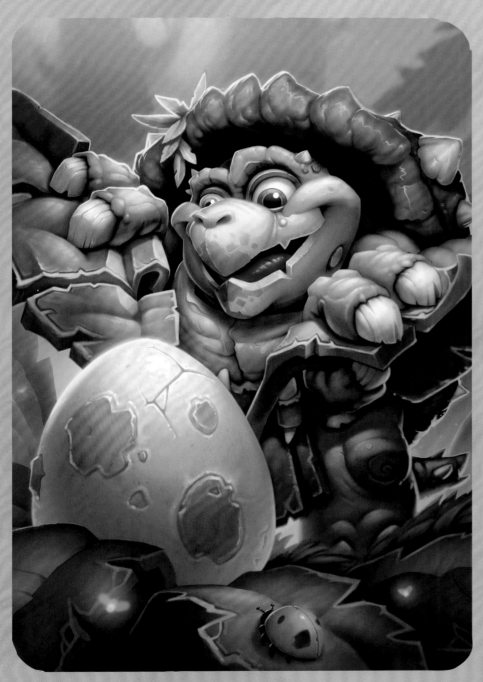

ABOVE
Tortollan Forager
Jerry Mascho

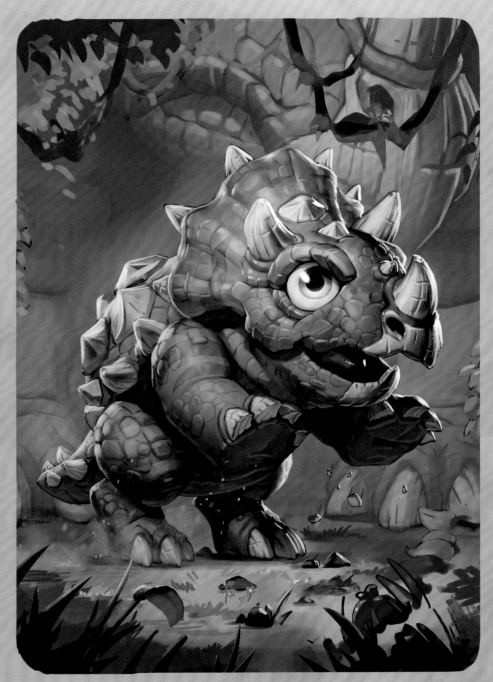

ABOVE
Direhorn Hatchling
Peter Stapleton

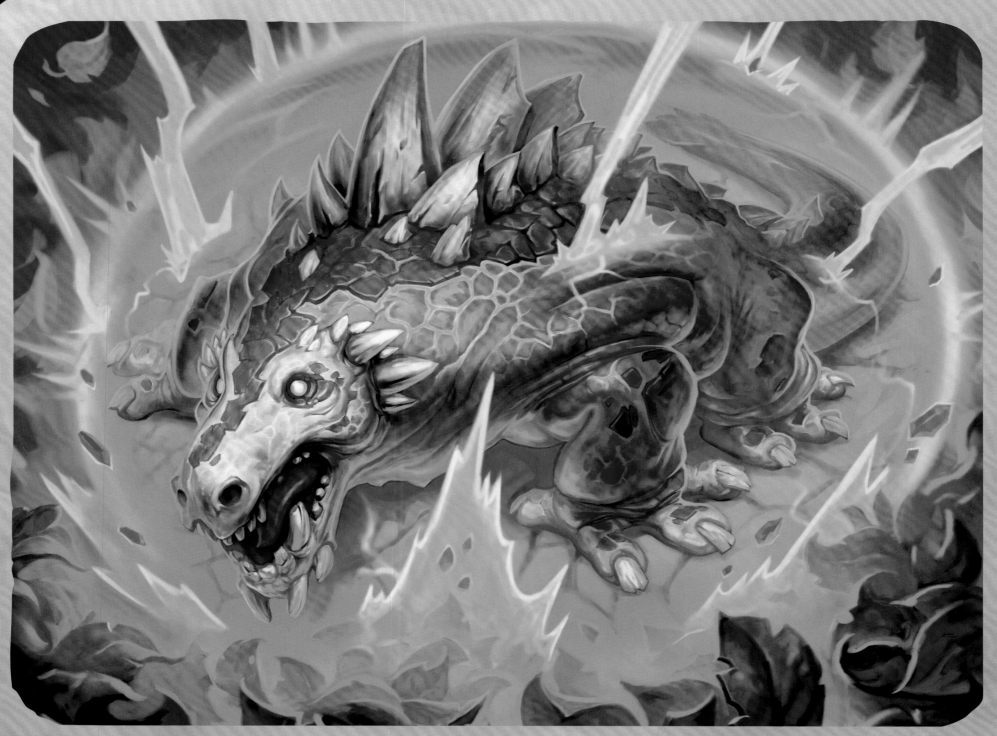

ABOVE
Crackling Shield
Ludo Lullabi and Konstantin Turovec

OPPOSITE
Swamp King Dred
Alex Horley

72

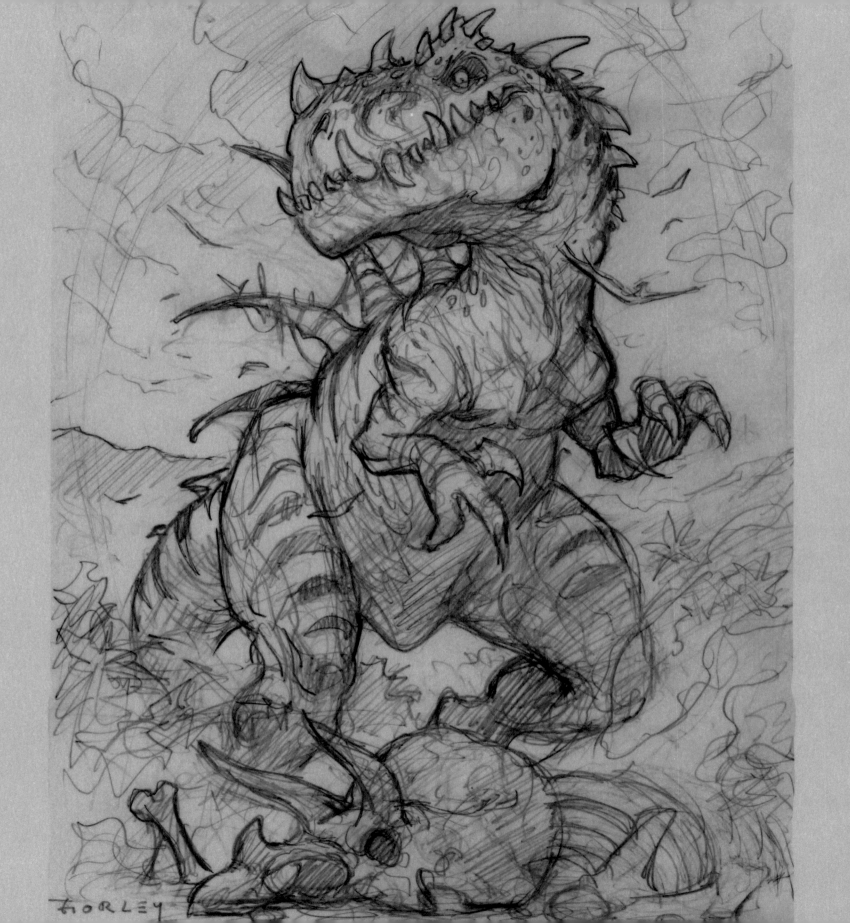

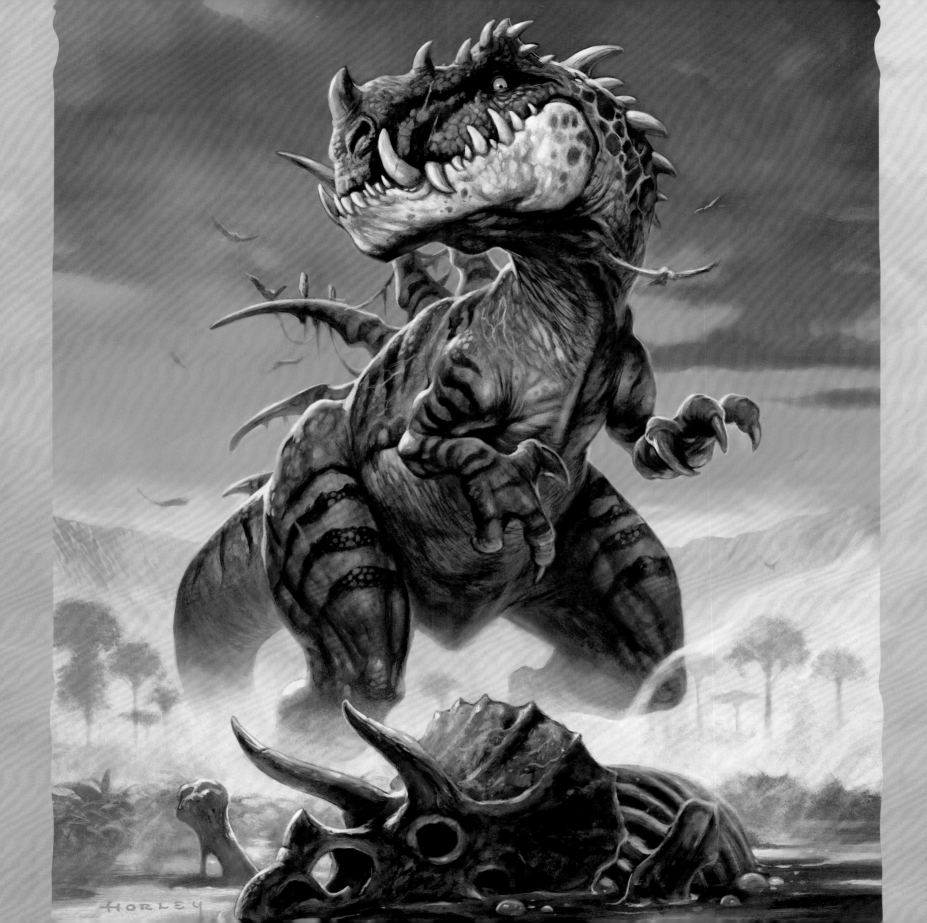

HORLEY

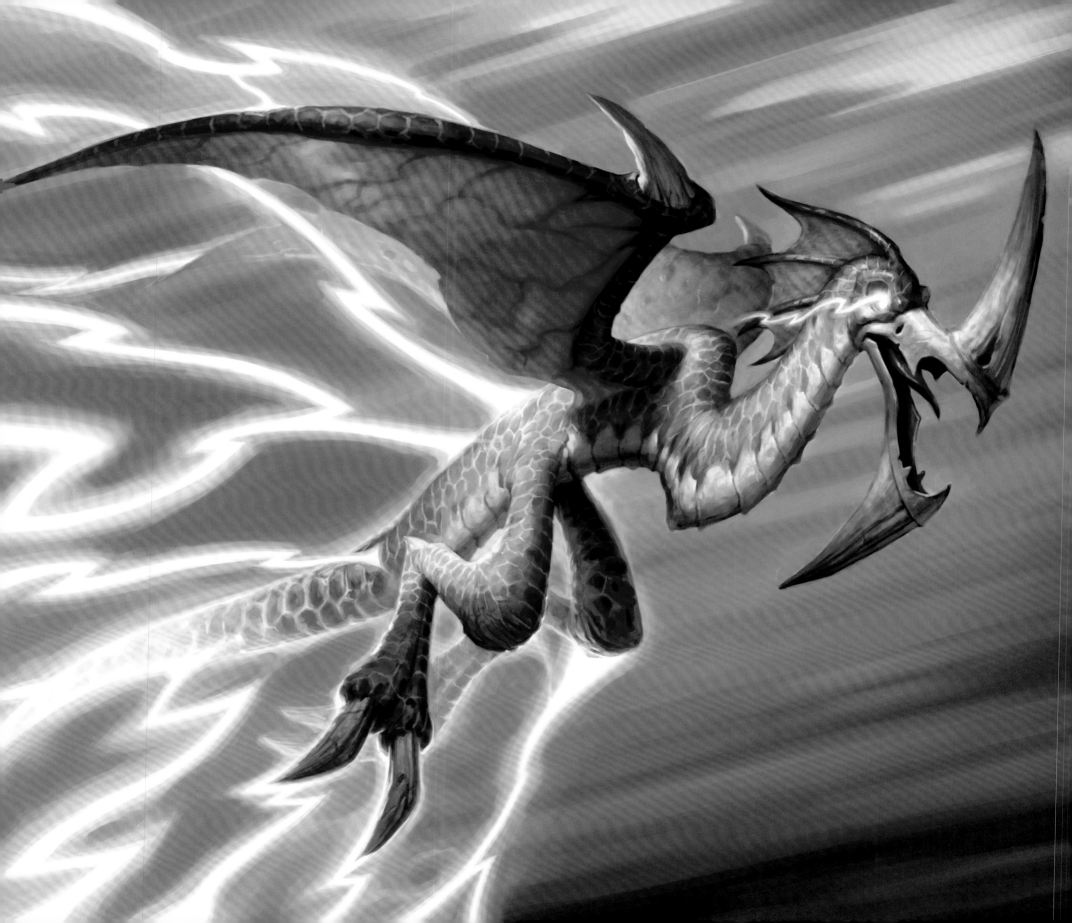

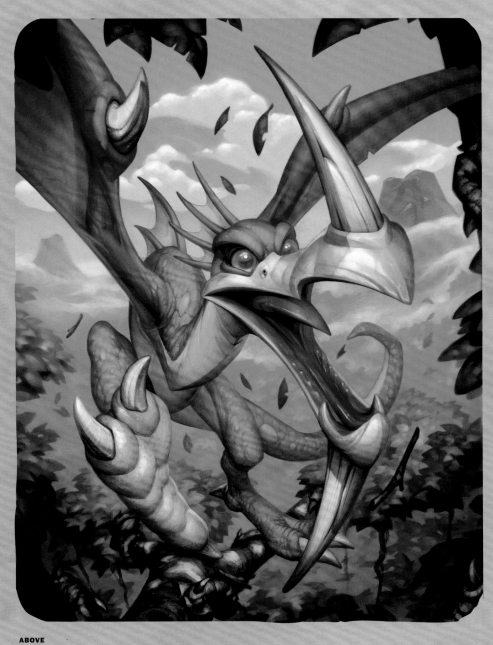

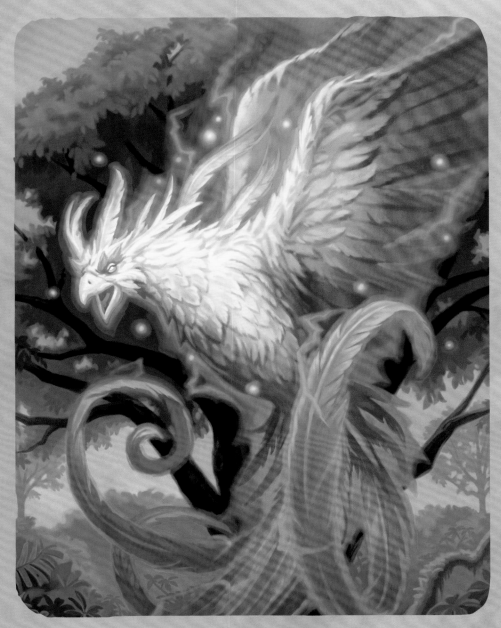

ABOVE
Viscious Fledgling
Arthur Bozonnet

OPPOSITE
Lightning Speed
James Ryman

ABOVE
Pyros
Mike Sass

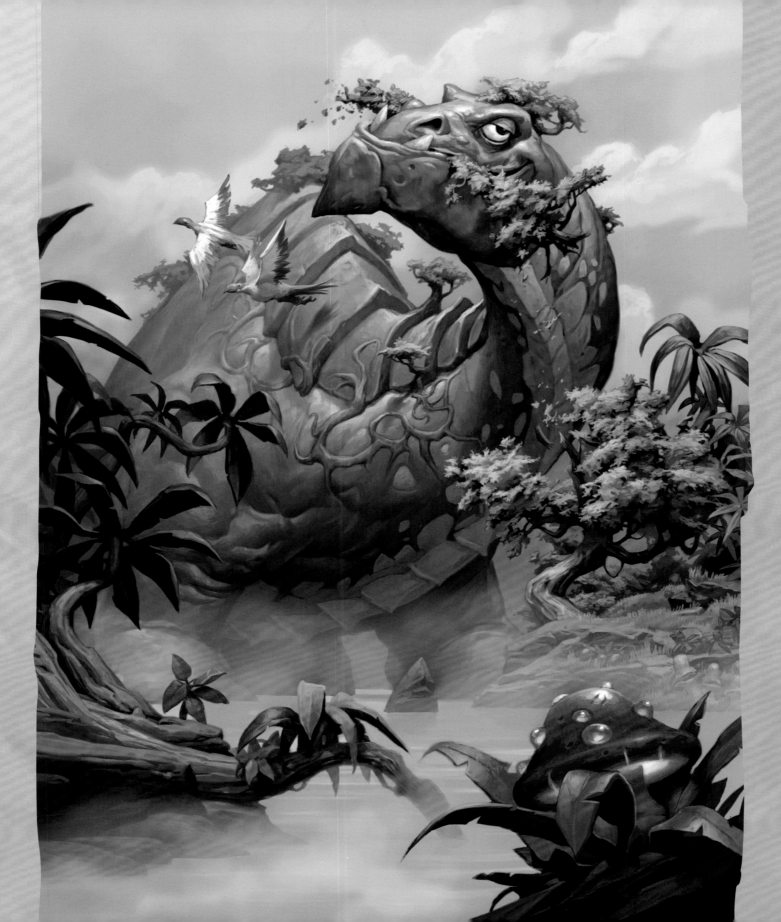

LEFT
Verdant Longneck
Zoltan Boros

OPPOSITE
Iron Hide
Phil Saunders

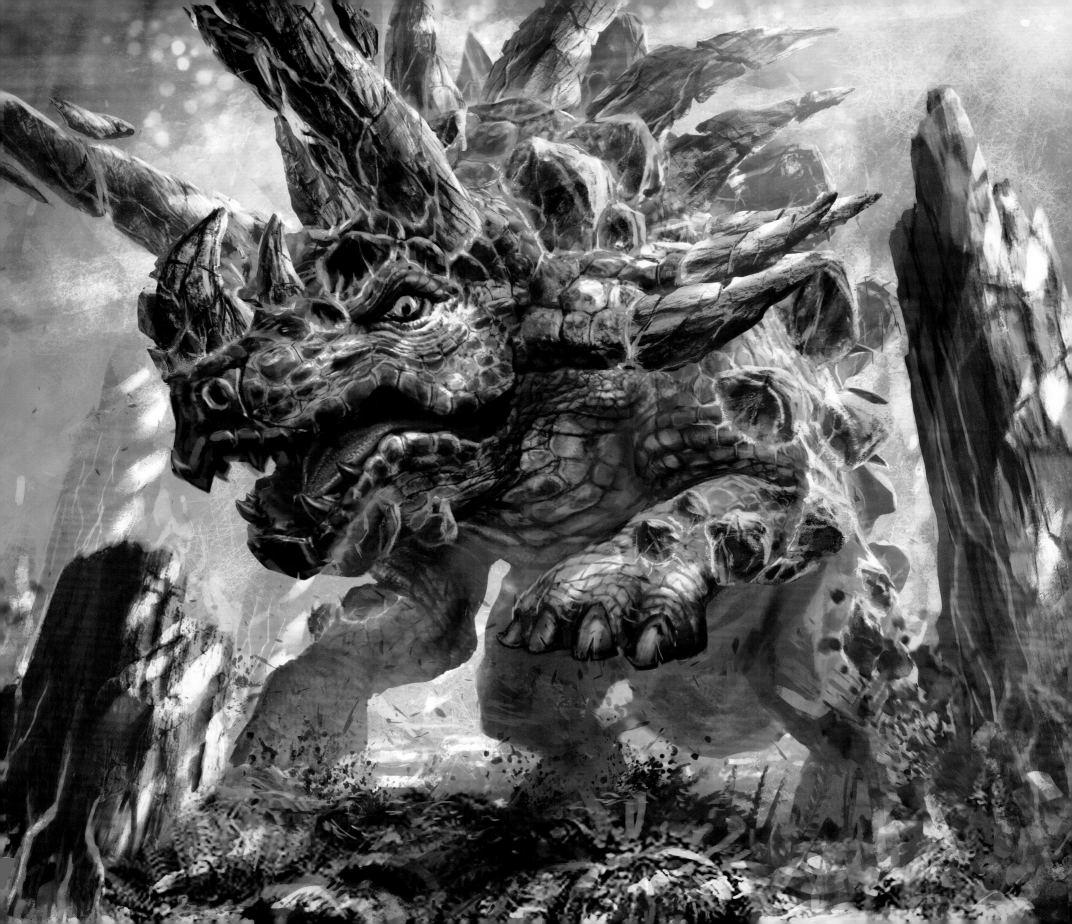

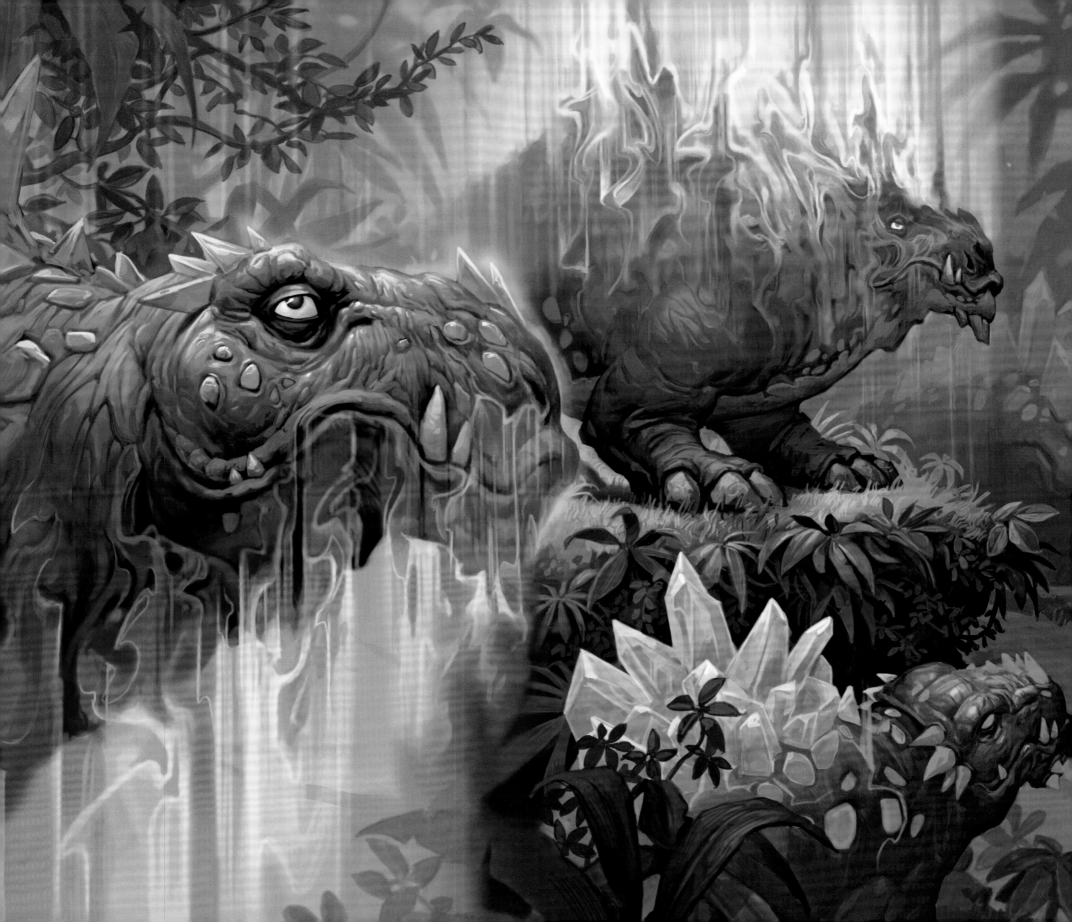

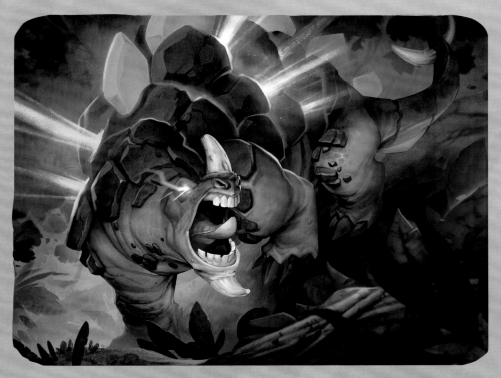

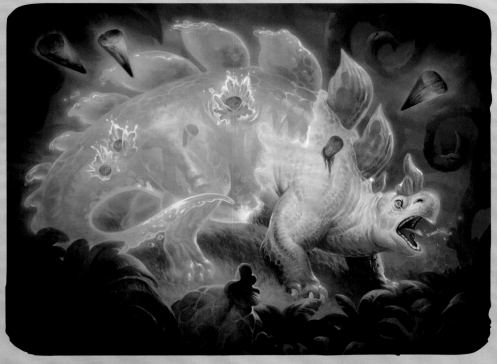

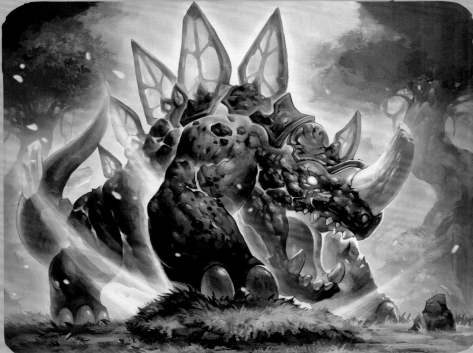

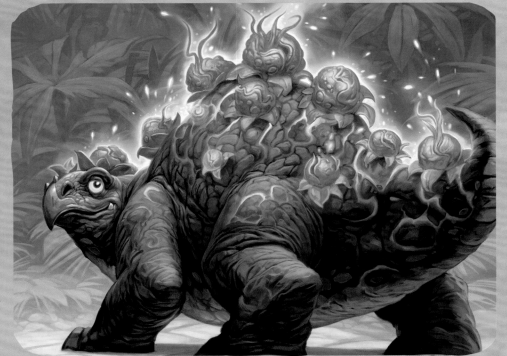

OPPOSITE
Sudden Genesis
Zoltan Boros

LEFT ABOVE
Rocky Carapace
Arthur Gimaldinov

LEFT BOTTOM
Adaptation
Hideaki Takamura

RIGHT ABOVE
Liquid Membrane
Jakub Kasper

RIGHT BOTTOM
Living Spores
Zoltan Boros

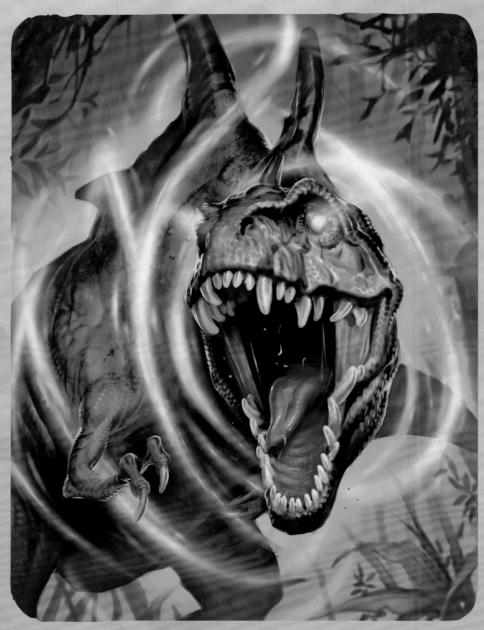

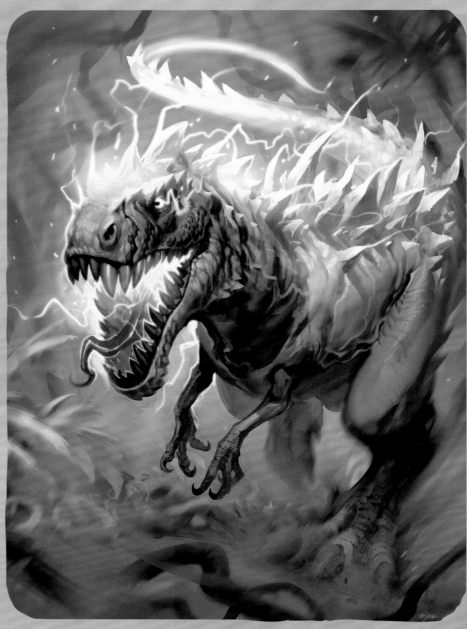

ABOVE
Grievous Bite
Slawomire Maniak

ABOVE
Charged Devilsaur
Luke Mancini

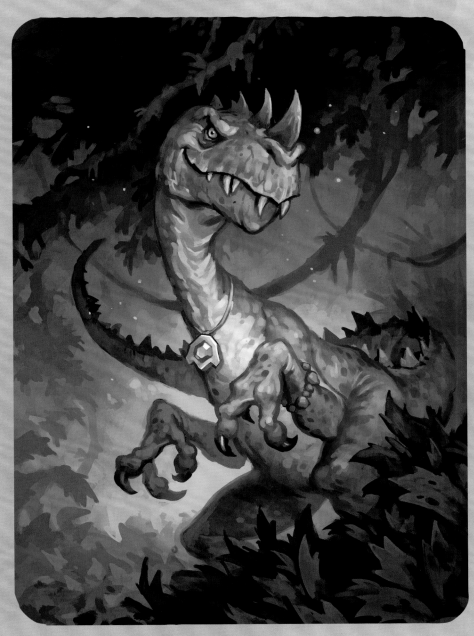

ABOVE
Shellshifter
Matt Dixon

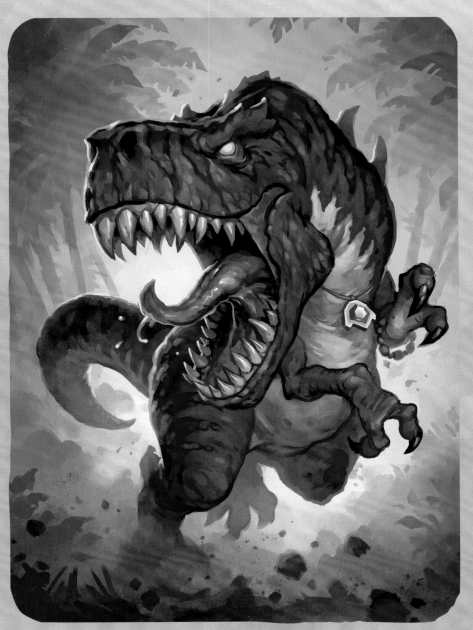

ABOVE
Shellshifter
Matt Dixon

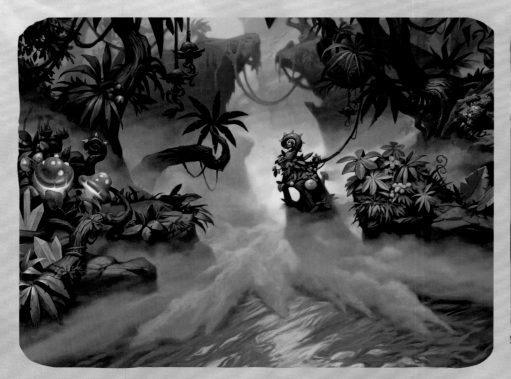

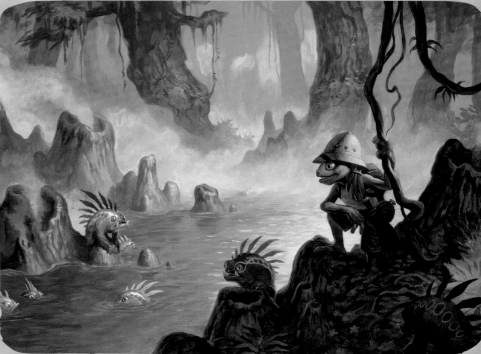

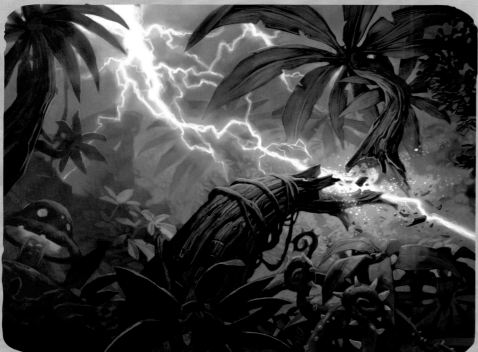

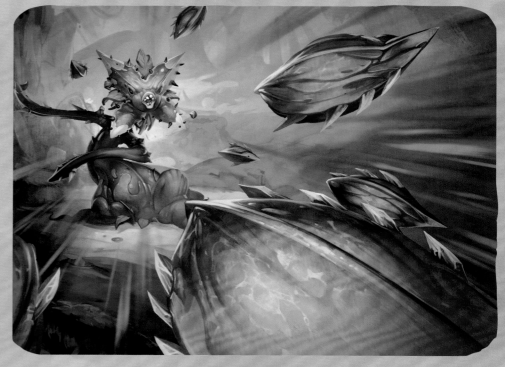

LEFT ABOVE
Corrupting Mist
Zoltan Boros

LEFT BOTTOM
Invocation of Air
Zoltan Boros

RIGHT ABOVE
Unite the Murlocs
Steve Prescott

RIGHT BOTTOM
Razorpetal Volley
Chanchai Luechaiwattanasopon

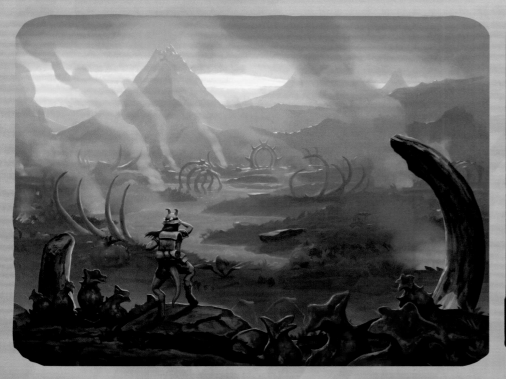

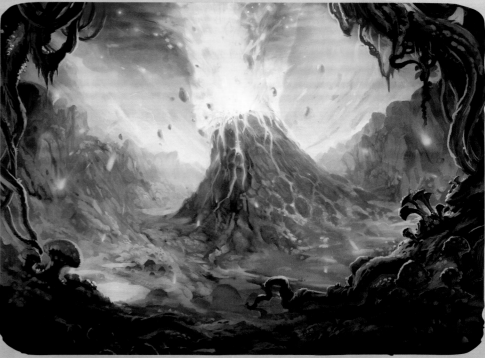

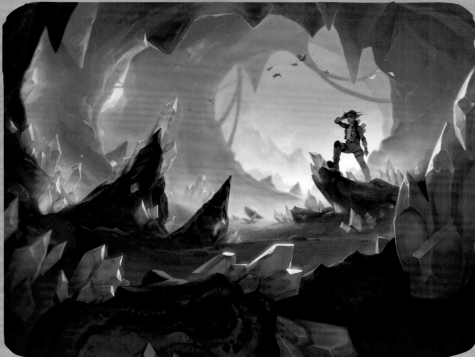

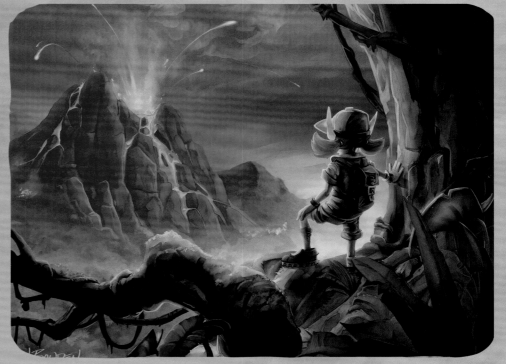

LEFT ABOVE
Lakkari Sacrifice
Konstantin Turovec

LEFT BOTTOM
The Last Kaleidosaur
Arthur Gimaldinov

LEFT ABOVE
Volcano
Gustav Schmidt

LEFT BOTTOM
Fire Plume's Heart
Nate Bowden

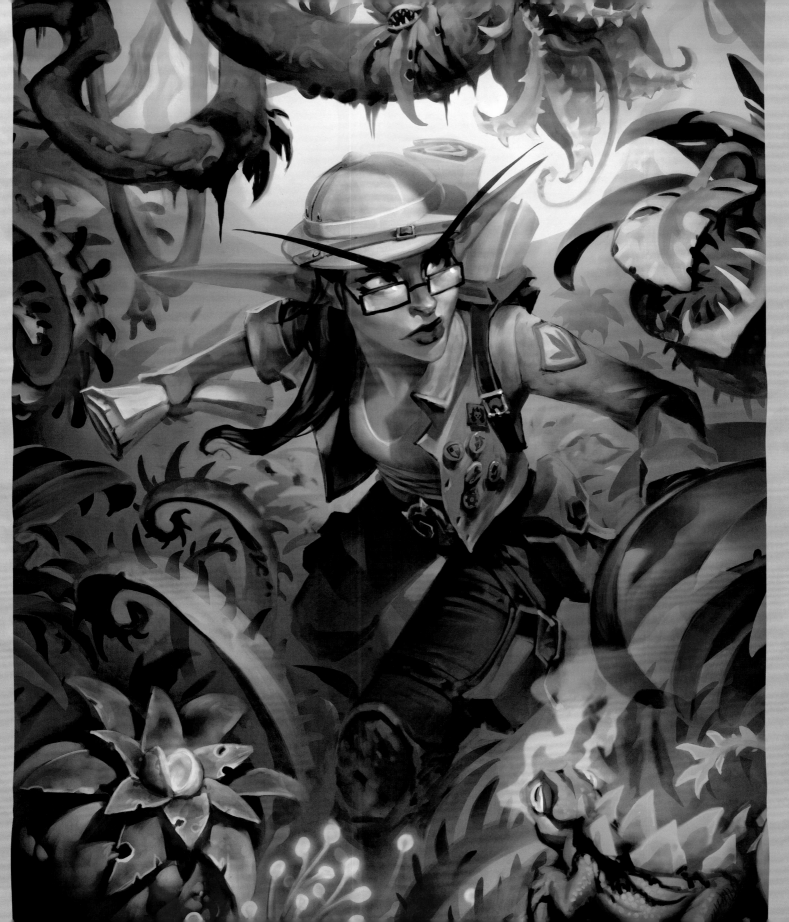

LEFT
Elise the Trailblazer
Luke Mancini

OPPOSITE
Arcanologist
Eva Widermann

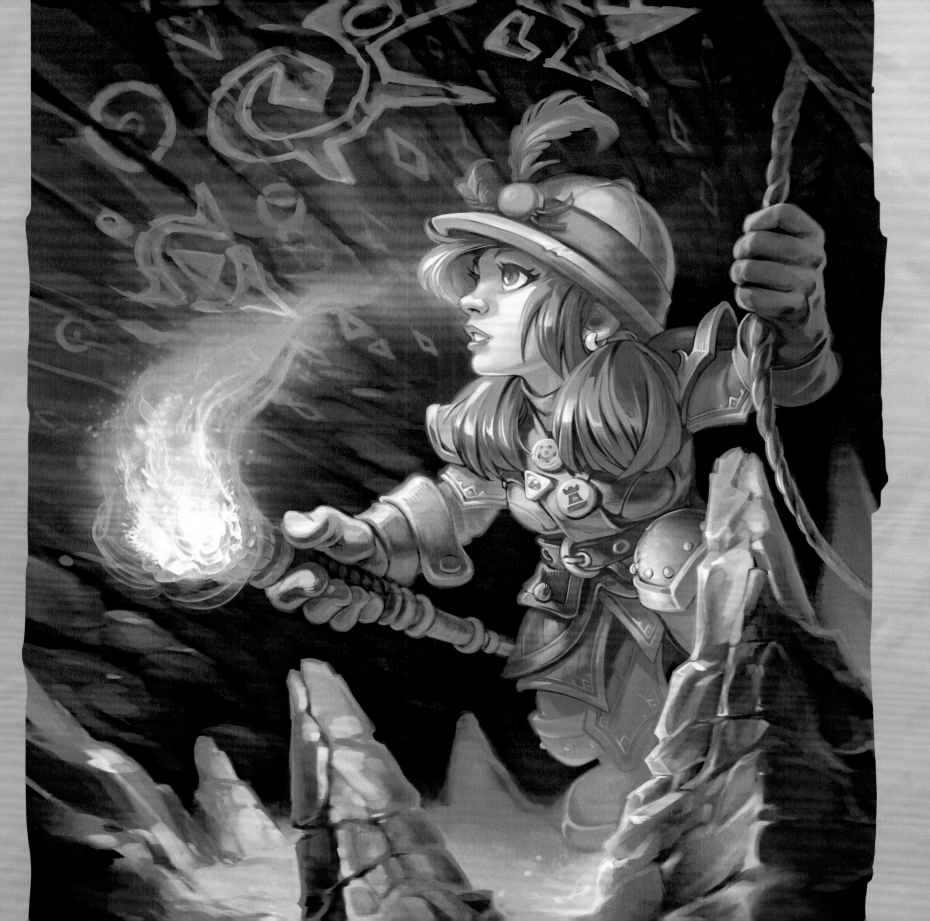

3

KNIGHTS OF THE FROZEN THRONE

Do not fear power. . .
fear those who wield it!

—Jaina Proudmoore, The Frost Lich

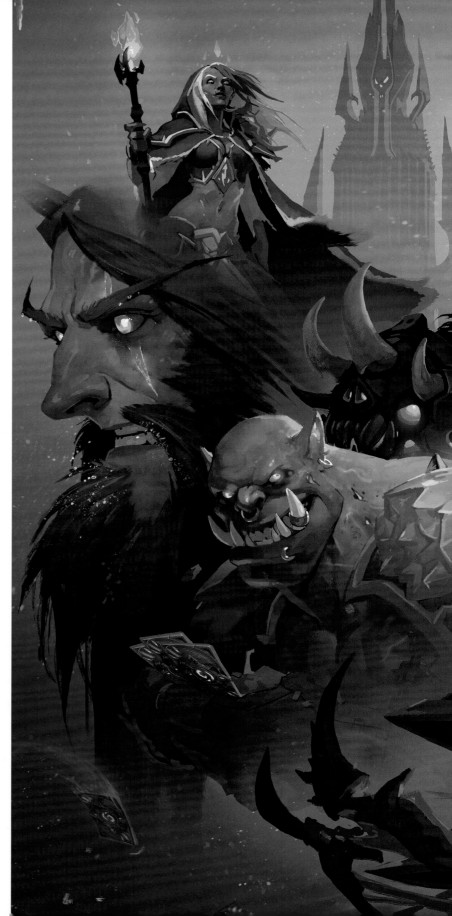

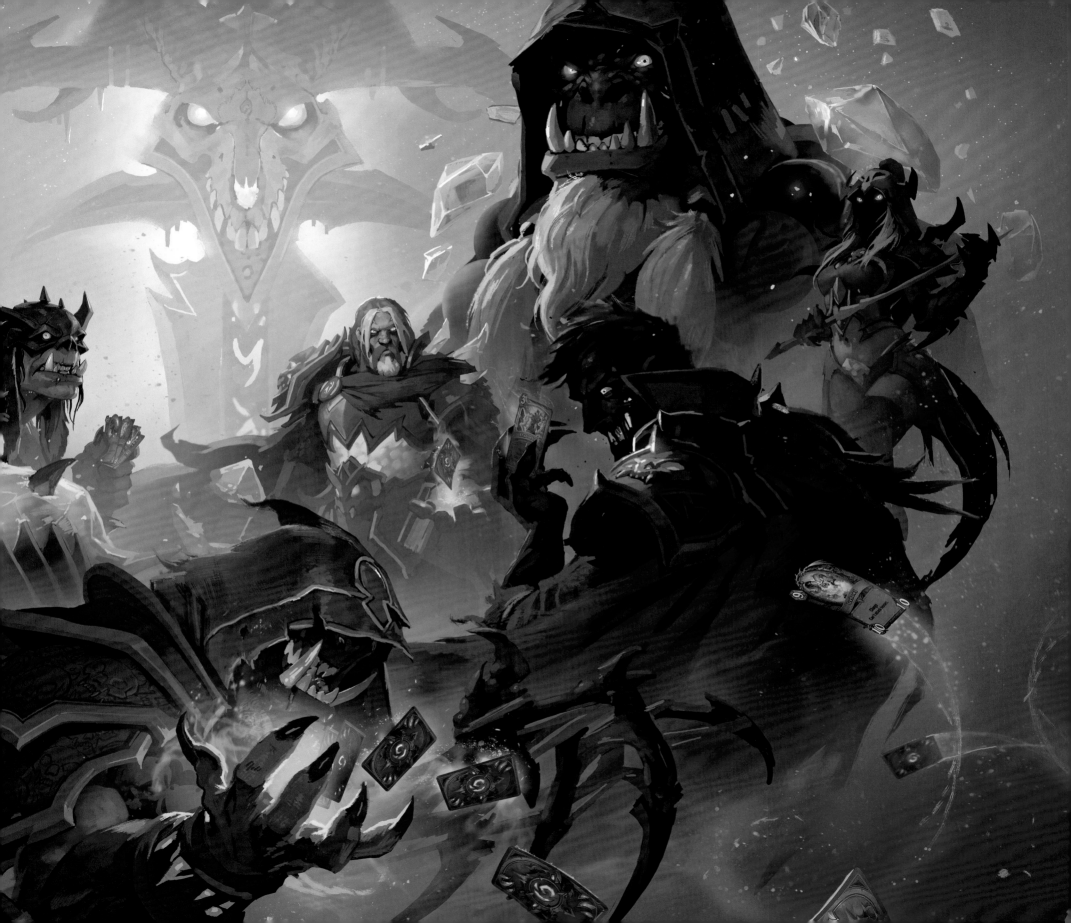

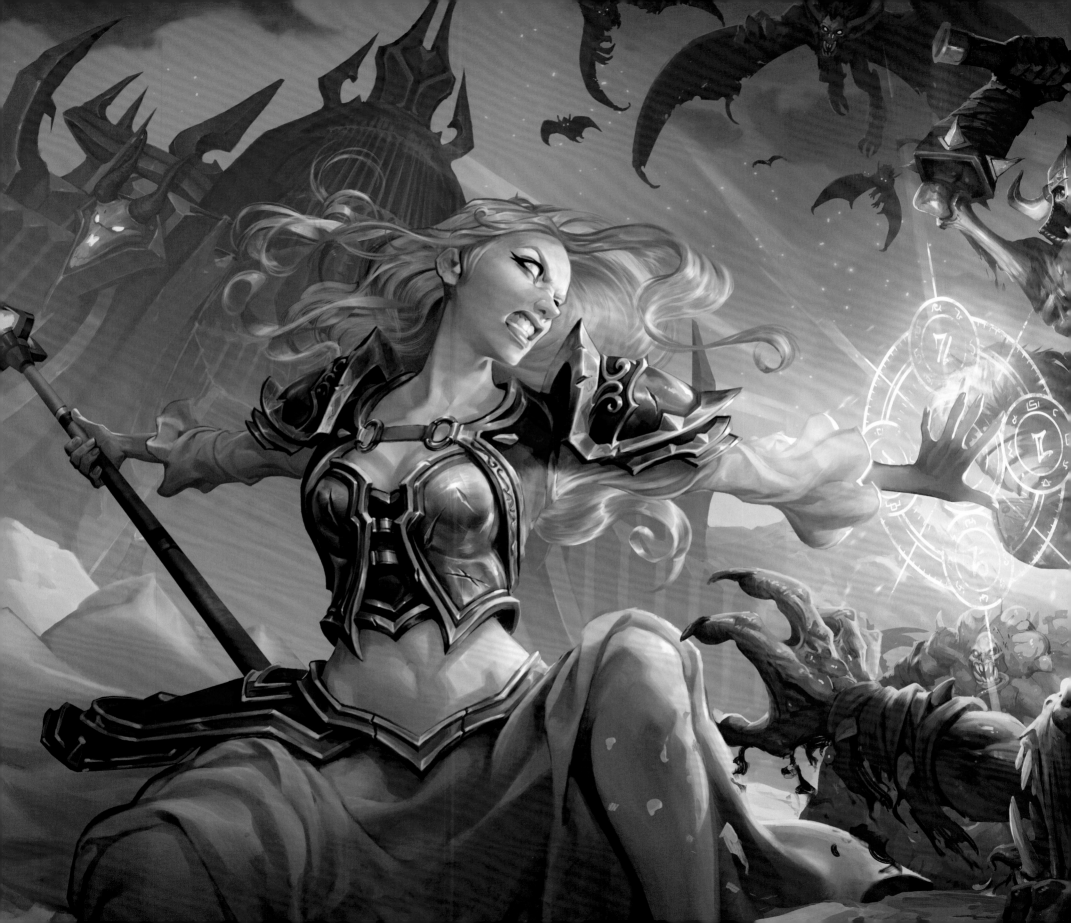

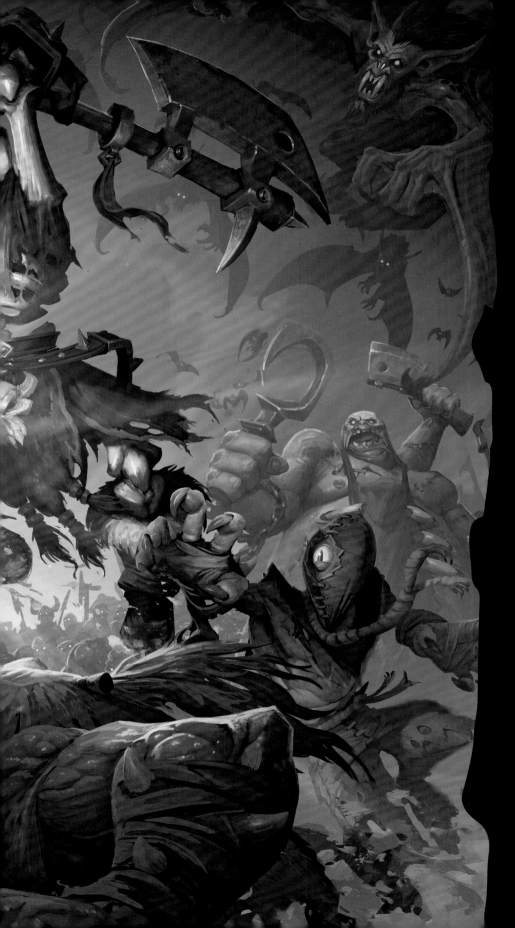

A PLAGUE OF UNDEATH

Years ago, a noble paladin named Arthas Menethil waged a war against an overwhelming tide of corruption and evil, vowing to stop it at any cost. Alas, Arthas could not resist the temptation to seize the might of undeath for himself, and he was lost to its darkness.

Later, a group of adventurers—reports indicate somewhere between ten to twenty-five of them, with indeterminate backgrounds, faction allegiance, and transmogs—marched to Arthas's doorstep to end his reign of chaos and steal his horse.

Both *Warcraft III* and *Wrath of the Lich King* were pivotal moments for the Warcraft franchise that explored a massive character arc for one of Blizzard's most iconic villains. And since *Hearthstone* draws its inspiration from Warcraft lore, there was no doubt that Arthas would eventually show up. But what would it mean for the game? How would his presence change the way the game played . . . and for how long?

The age of the Lich King finally arrived with the second expansion of Year of the Mammoth: *Knights of the Frozen Throne*. And it needed to have compelling answers to all those questions.

"This expansion was a huge moment for the Hearthstone team, in the same way that *Wrath of the Lich King* was important to the Warcraft team," said lead narrative designer Dave Kosak.

The first and most important issue to tackle: How would *Hearthstone* handle death knights?

PREVIOUS PAGE
Laurel Austin

LEFT
Jonathan Fletcher, Will Murai, and Yewon Park

Wrath of the Lich King introduced the first new player class since *World of Warcraft* first launched: the death knight. These undead soldiers who had broken free of the Lich King's command found instant popularity with players.

Did the *Hearthstone* team discuss adding a full death knight class to their game? "Very, very briefly," said creative director Ben Thompson. "It didn't get all that much traction with the team at the time."

The Year of the Mammoth was only three years after the game's official launch. Adding a tenth class to *Hearthstone* would have been a gigantic shift in the way the game played. It felt too early in the game's life span to make that leap. (The first new class, the demon hunter, wasn't added to the game until 2020.)

"Arthas might just be the biggest character Warcraft has ever produced, but if we had brought him in as the hero of a brand-new class, this was going to become his expansion," said Thompson. "We soon figured out we wanted to make an expansion *with* him but not *about* him."

Most importantly, introducing a single death knight would have kept the plague of undeath contained to one class, and the team was bursting with ideas for all nine classes. "What if *all* our heroes became death knights, not just one?" said Kosak.

The question of "What if?" drove almost every aspect of the visual design in *Knights of the Frozen Throne*. What if Jaina Proudmoore had joined Arthas as he purged Stratholme? What if Valeera were to abandon physical form entirely in exchange for power? What if Gul'dan would choose a new corrupting power to pair with the fel?

There is a price to be paid for such a gift. And many eagerly accept the bargain.

–Jaina Proudmoore, the Frost Lich

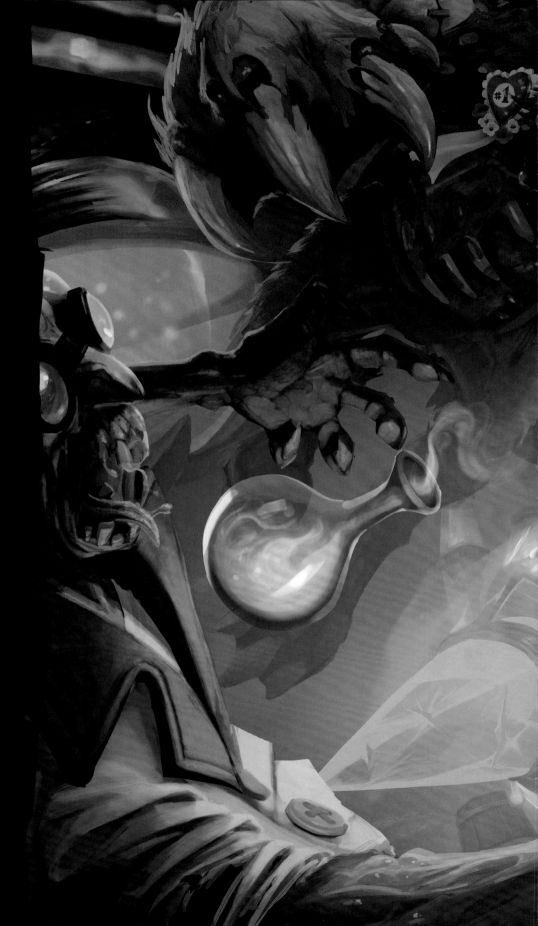

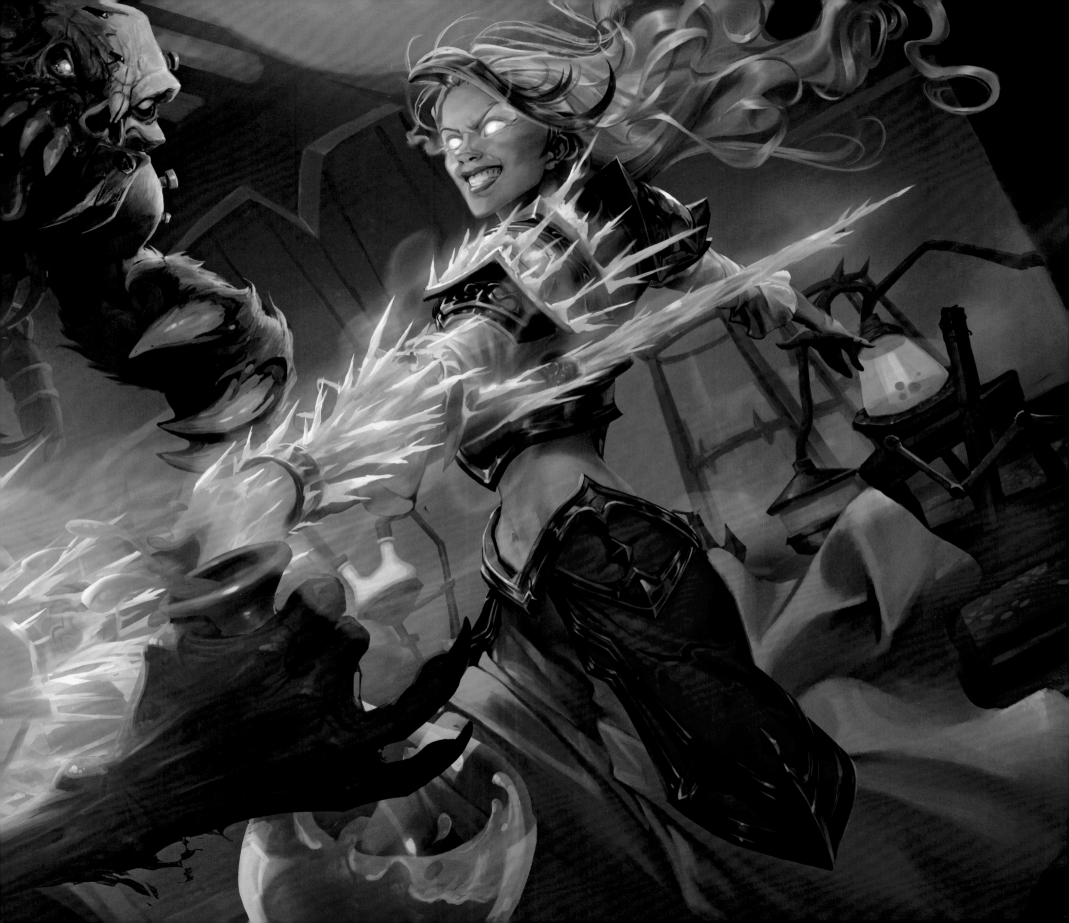

Early concept art began to explore the corruption of the original nine *Hearthstone* heroes, showing how each of the classes would exemplify a unique take on undeath. Malfurion (druid) would become a herald of pestilence and plague; Rexxar (hunter) would stitch together unnatural abominations out of nature's wild animals; Anduin (priest) would become a worshipper of shadow magic, and so on.

"We've seen what paladin death knights look like, but the moment we started chatting about rogue death knights and hunter death knights and mage death knights, we knew we had to chase that," added Kosak.

As the visual development progressed, so did design prototypes. The ideas of letting a player corrupt their own deck or strike a bargain in exchange for power were explored very early on.

"There was one mechanic that would have shuffled overpowered death knights into your deck while destroying the rest of your cards," said lead designer Peter Whalen. "The best of those cards actually made it into the game. We used them as the rewards the **Lich King** generates when he's in play."

The final expression of undeath corruption was the death knight "hero card," one for each class—a powerful late-game card that would obliterate the uncorrupted hero and enact dramatic changes to the board state.

Each hero card was the answer to a "What if?" question and would show exactly how each class would twine the Lich King's gifts with their own unique powers.

The most technically challenging death knight was **Deathstalker Rexxar**, who allowed players to combine beasts into strange and powerful new creatures. These new abominations needed to show their effects and attributes in a standard card text box, a task that was difficult in English and shockingly hard in many other languages.

"You can't just glue the different text boxes together and expect it to work in a lot of languages," said Whalen. "There were no shortcuts. It was almost a brute force problem, and I'm still so impressed our localization team pulled it off."

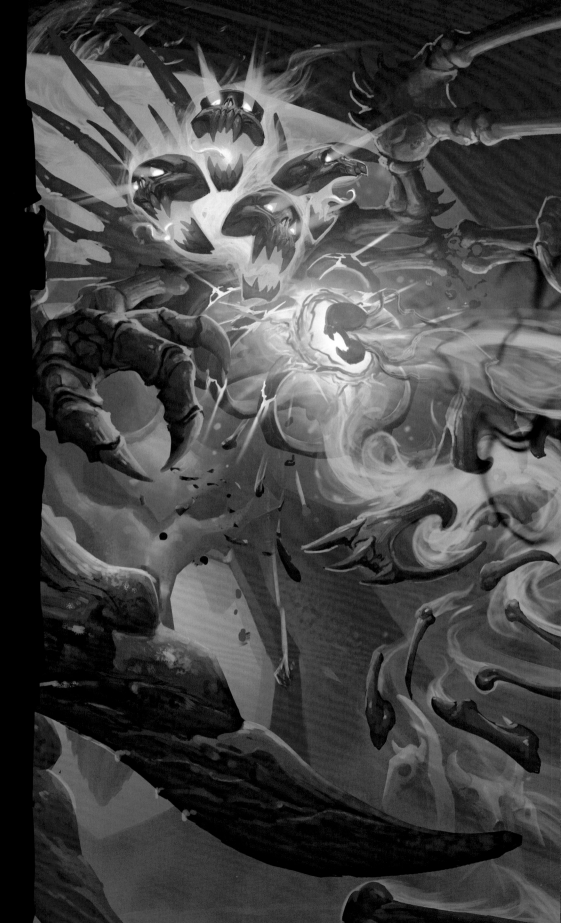

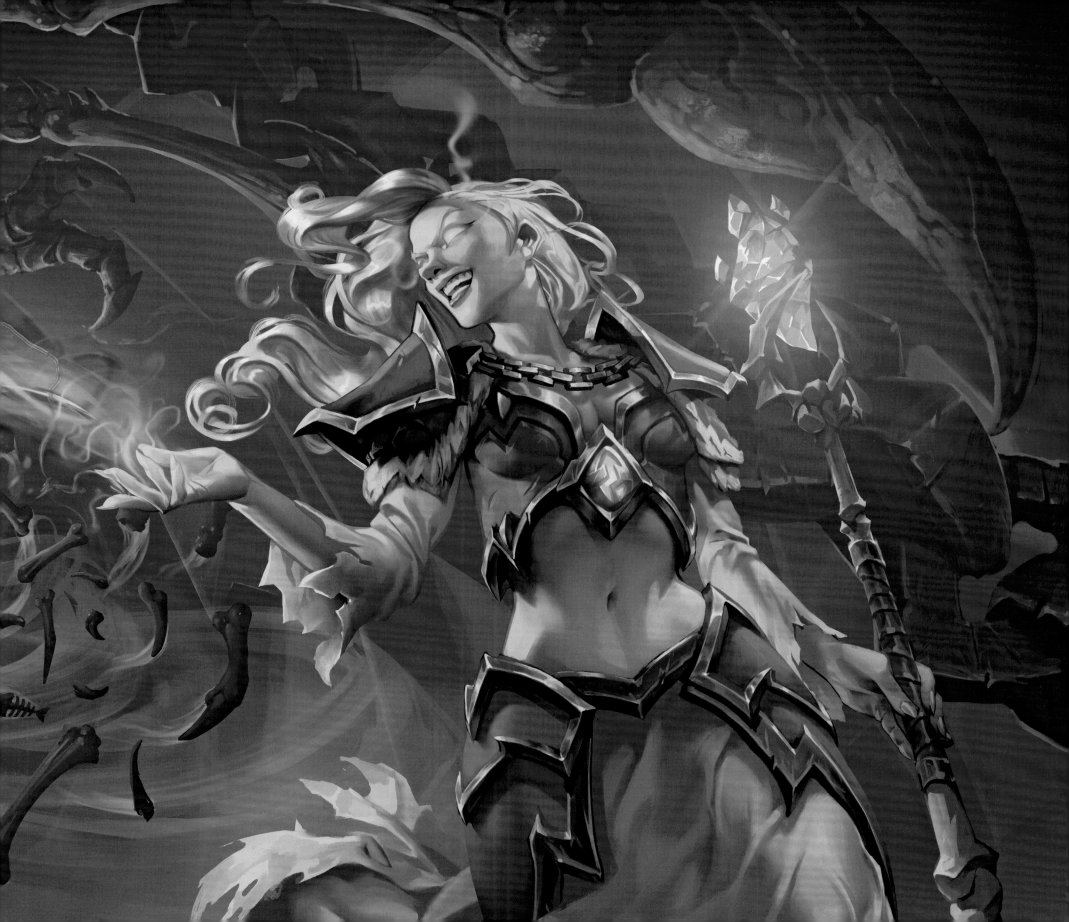

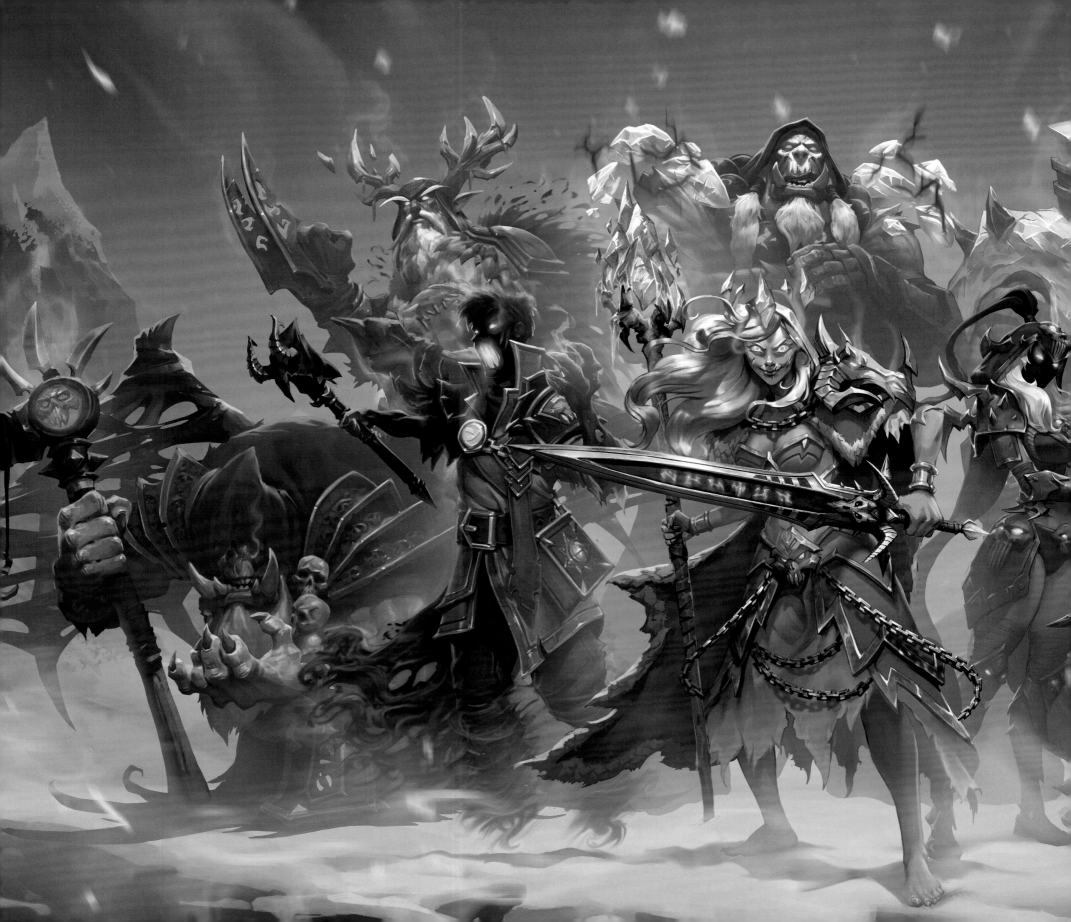

The art style of the new hero cards also sparked a lively debate. The first idea was fairly simple: perhaps the original hero portrait could be given a special coloration and shader treatment after they accepted the Lich King's power. It would have borne some similarities to the classic priest card **Shadowform**, which affects Anduin's art with a deep-purple hue that ripples with barely contained power.

Then came a much more ambitious idea: to create brand-new hero art for every single death knight. The logistics of creating that much art resulted in some fairly unforgiving deadlines, and the initial response from the team was, "That's crazy!"

But the team also admitted that it would be very, very awesome.

"And that was the victory. For me, 'That's crazy!' means it's a great idea. It might be hard, but it's great. We just had to figure out how to pull it off," said senior art manager Jeremy Cranford.

Many of those hero cards were illustrated by the same artists who designed the original nine hero portraits, allowing the style and look to feel as authentic as possible, even in this newly corrupted state. And it was achieved without forcing a delay to the game's release.

"That's how you know our team is amazing," said Cranford. "They turned 'That's crazy!' into 'freaking cool.'"

The righteous and the meek
may recoil at its cost . . .
but they have no vision!

—JAINA PROUDMOORE, THE FROST LICH

LEFT
Jonathan Fletcher, Will Murai,
and Yewon Park

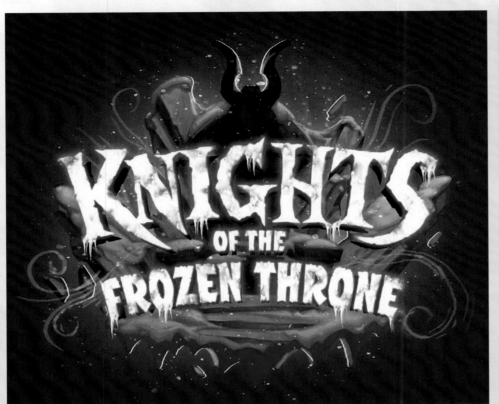

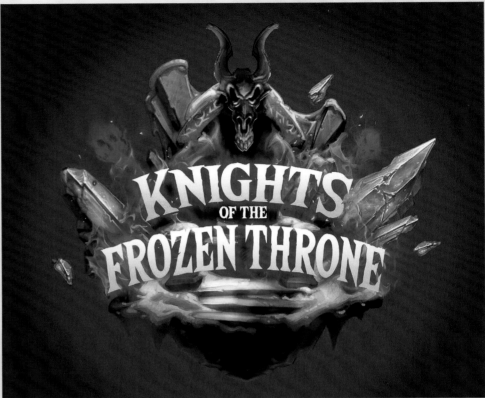

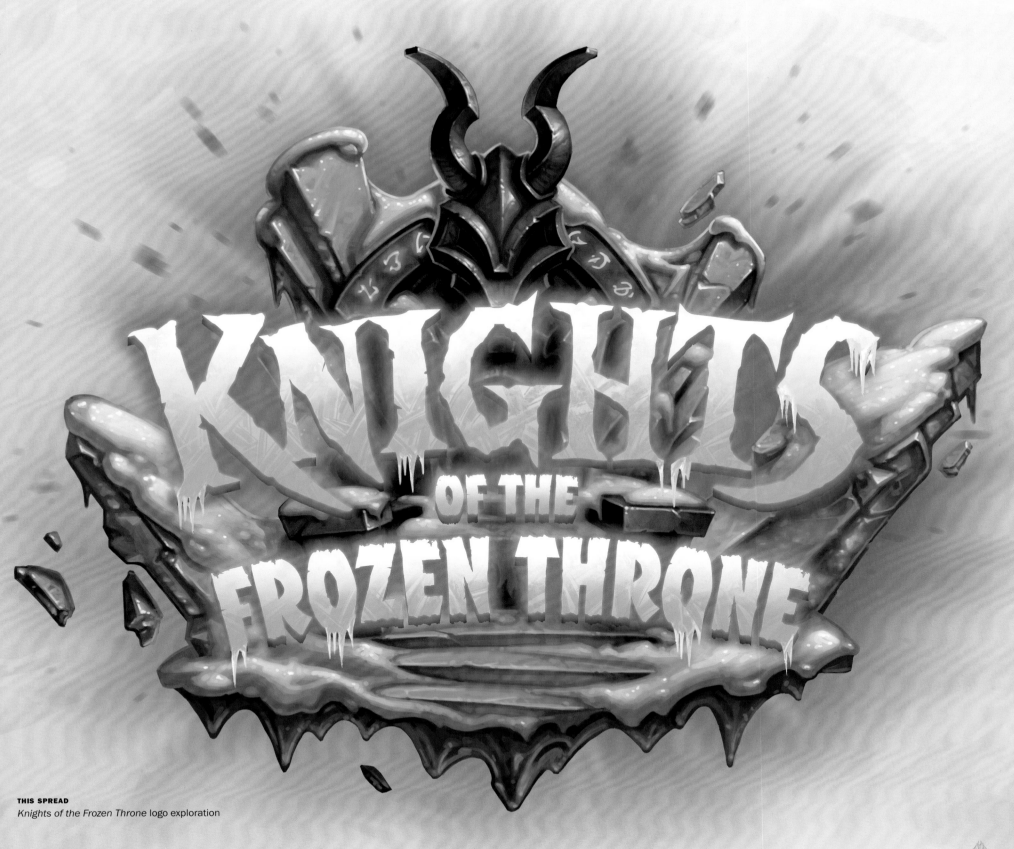

THIS SPREAD
Knights of the Frozen Throne logo exploration

TOP
Armand Serrano

ABOVE
Knights of the Frozen Throne store card tray ideation

OPPOSITE
Knights of the Frozen Throne Throne game board

THE FROZEN NORTH

Knights of the Frozen Throne had a major single-player component set in the Lich King's stronghold, Icecrown Citadel. (The single-player campaign will be explored in greater detail in chapter 5.) With that in mind, the art style of the 130-plus cards released in the full set would have to be set in Northrend, particularly in the snowy and barren wastes surrounding the citadel proper.

That meant the environment in the cards needed to be suitably icy, cold, and chilly. "Even in the cinematic, the primary color palette were deep blues. Everything needed to look cold and dangerous, dark and shadowy," said senior concept artist Charlène Le Scanff.

While the cool colors undoubtedly ruled the set, concept artists also needed to define how illustrators could strategically break out of the blues. The style guide for *Knights of the Frozen Throne* showed how warm colors could sneak in by staging scenes at sunset, while whites and violets could be used in displays of powerful magic. Greens could come in through an aurora borealis or some of the corrupted nature magic that some death knights might use.

"It's okay for a set to have a visual theme, but giving artists room to play is important too," said Le Scanff.

Because the Lich King and the existing characters within Icecrown were so well known, it became important to make sure artists were staying faithful to the menacing raid bosses that had tormented *Warcraft* players for months on end. That still left plenty of room to take the rest of the art in a very *Hearthstone* direction. Players saw a parade of surprisingly adorable minions during this expansion, ranging from a death knight murloc to a Scourge tuskarr to snowboarding penguins to dogs who are champions at playing (un)dead.

Matching up macabre subject matter with endearing appearances was a challenge that several artists loved taking on.

"'Cute' is an elusive quality, in my opinion," said illustrator Matt Dixon. "I think a lot of cuteness is communicated through a character's expression. Not just the face; the body can also be very expressive."

It was also important to emphasize minions as being death knights, not simply undead. "We arguably did an entire undeath expansion with *Curse of Naxxramas*," said Thompson. "We had a lot more room to interpret the denizens of Icecrown if we kept the ranks of Scourge to a minimum."

The final set, which offered more than 130 collectible cards, created a metashattering expansion that lived up to the sinister legacy of the Lich King.

THIS SPREAD
Creature exploration
from style guide

FROST ANCIENT

FROST DEATH KNIGHT MURLOC

BONE HARPOON

BONE HOOK

ARMOR FOR TUSK

101

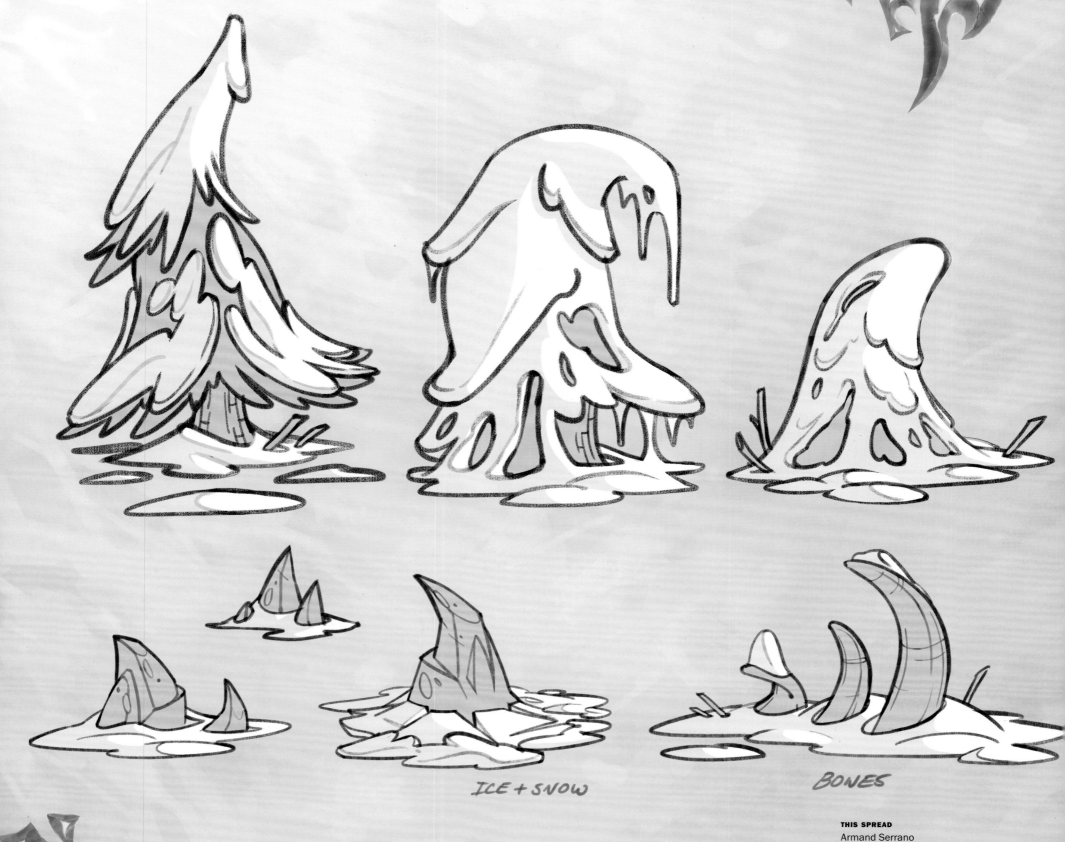

ICE + SNOW

BONES

THIS SPREAD
Armand Serrano
Environment exploration from style guide

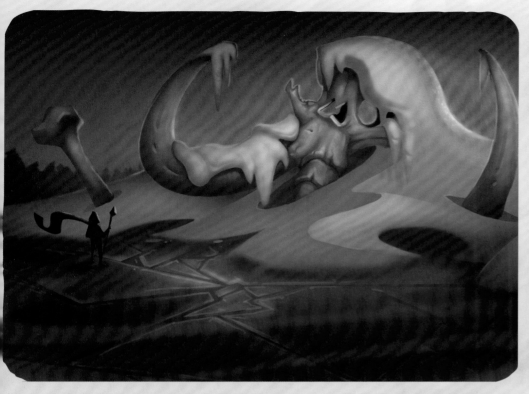

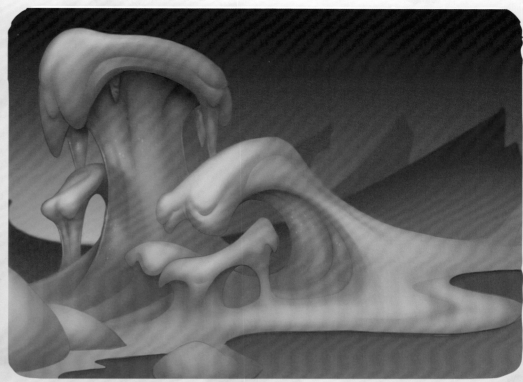

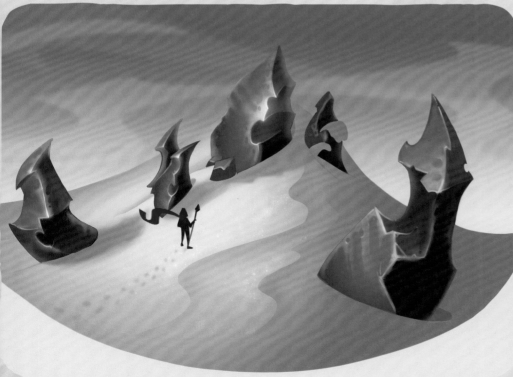

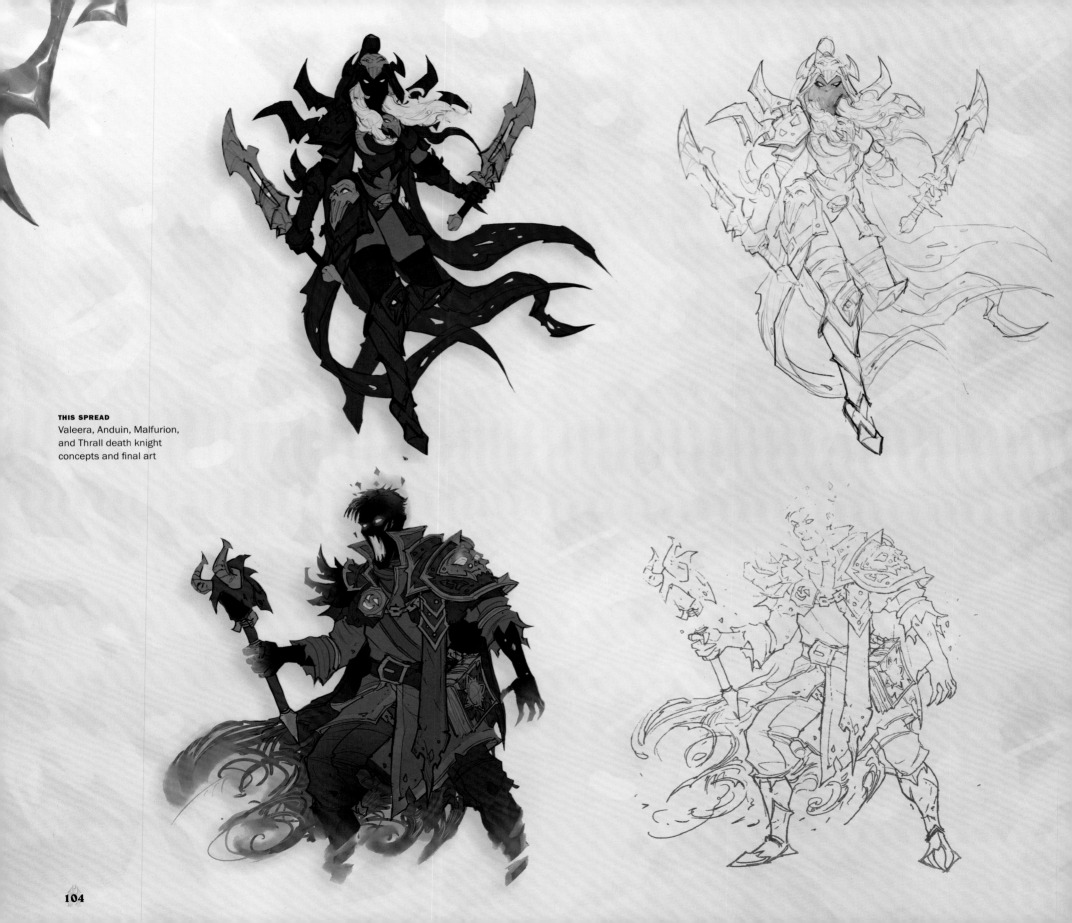

THIS SPREAD
Valeera, Anduin, Malfurion,
and Thrall death knight
concepts and final art

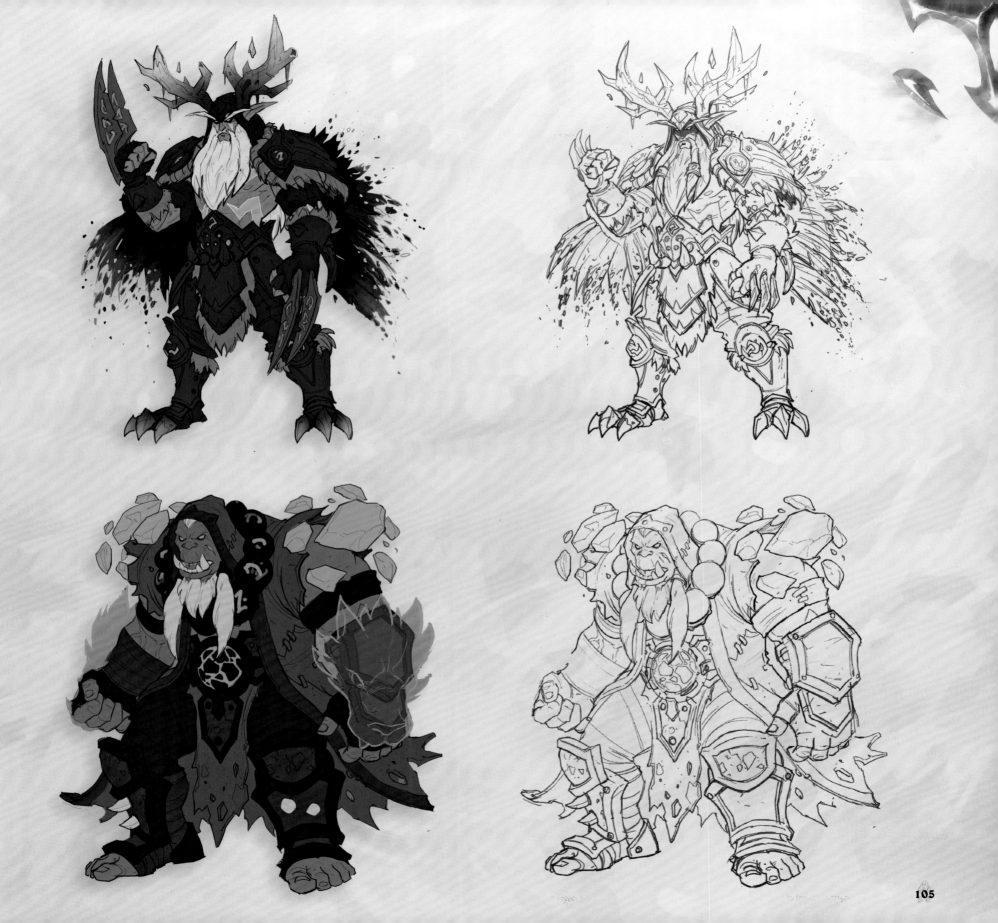

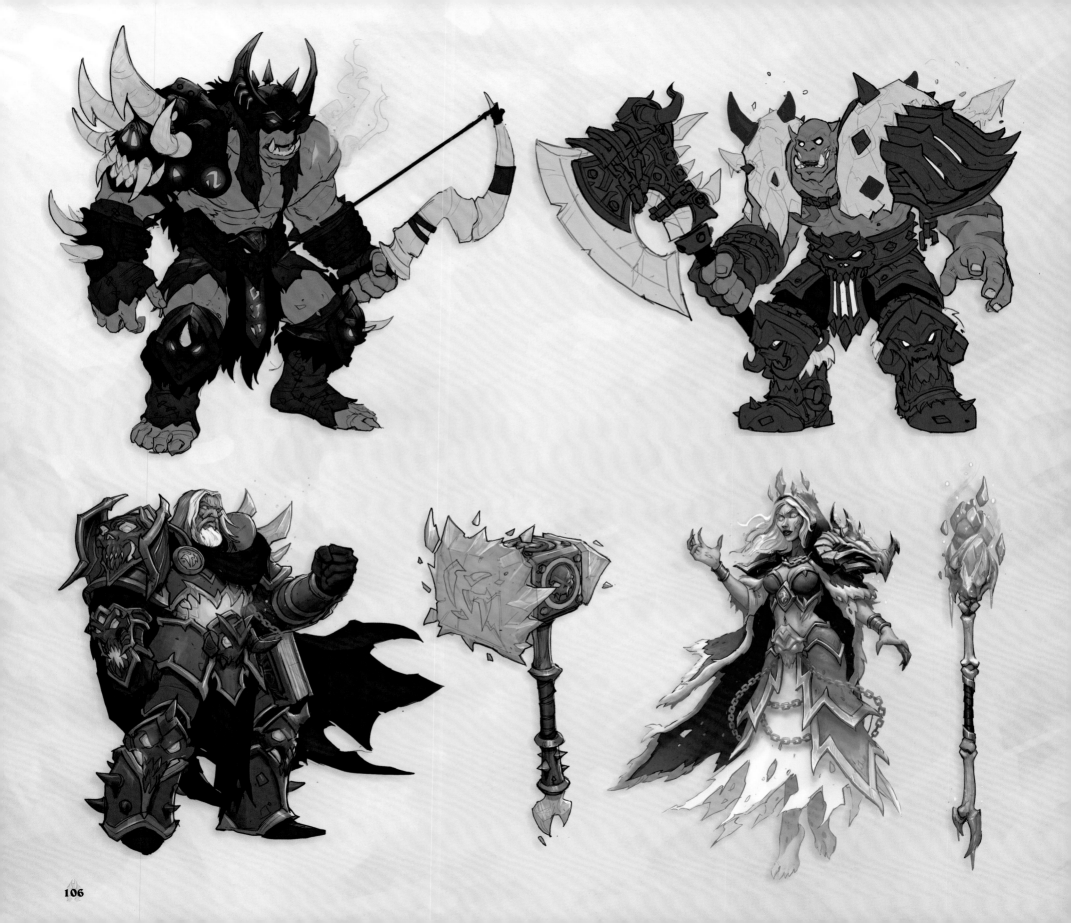

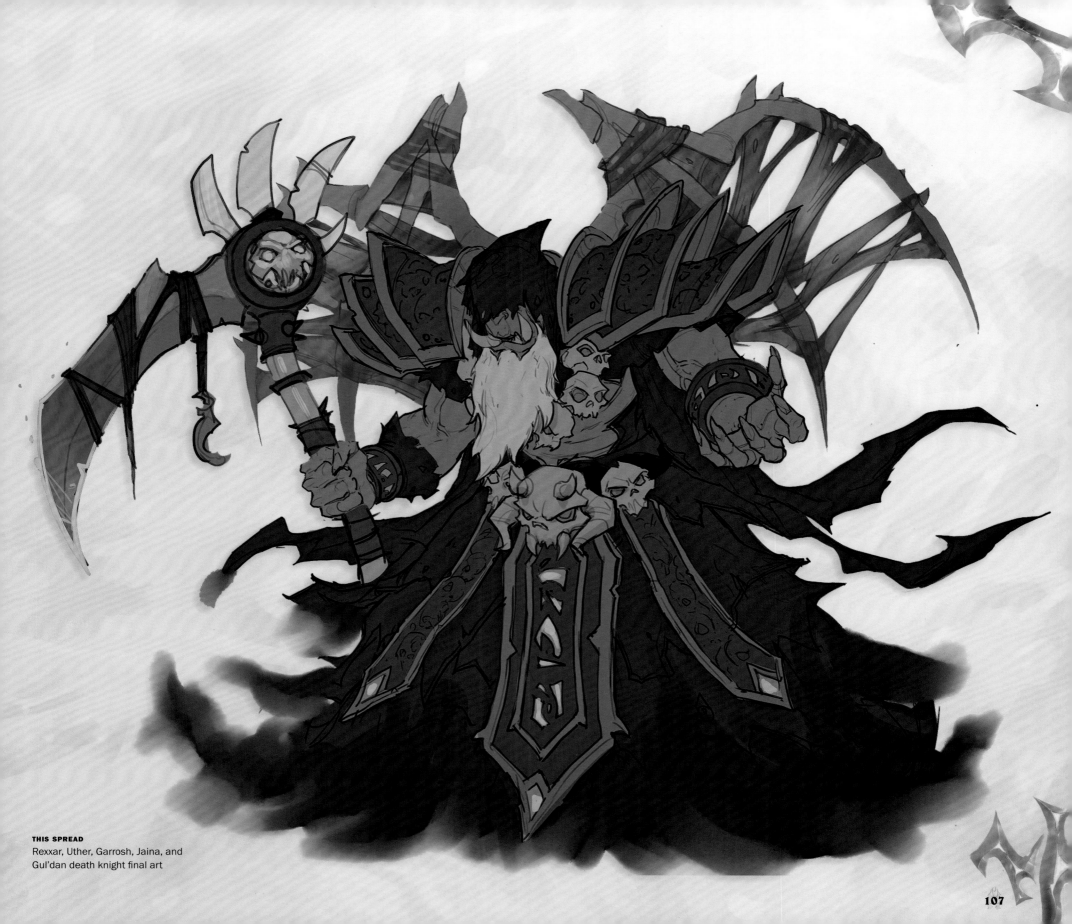

THIS SPREAD
Rexxar, Uther, Garrosh, Jaina, and
Gul'dan death knight final art

①

②

BLUE SMOKE/
FLAMES START
TO TURN
AROUND THE PACK

③

ICE ADDED
TO THE
BLUE FX

④

ICE BLOCK
POPS UP

⑤

SWIRL
STARTS TO
SHINE

⑥

HUGE
LIGHT FROM
SWIRL

⑦

BURSTS

ABOVE
Abominable Bowman
Ludo Lullabi and Konstantin
Turovec

ABOVE
Stitched Tracker
Steve Prescott

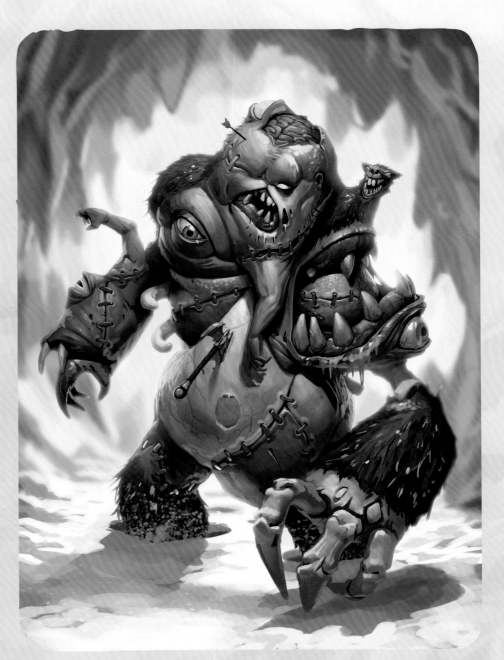

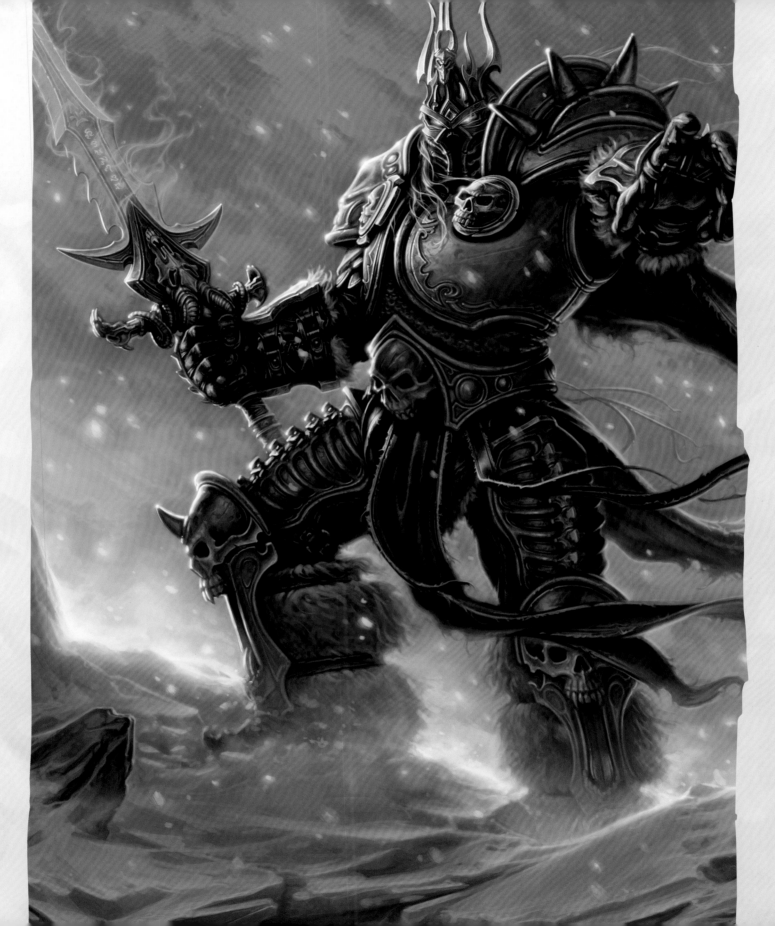

OPPOSITE
The Hunted
Ben Thompson

RIGHT
Drakkari Enchanter
Steve Prescott

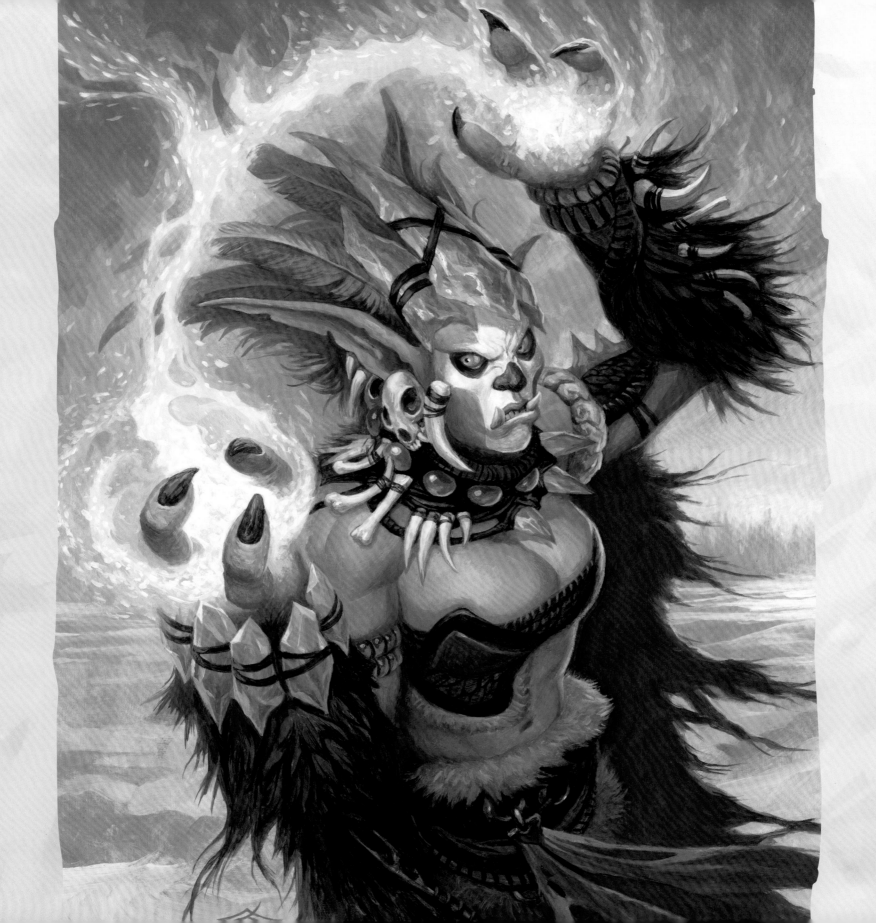

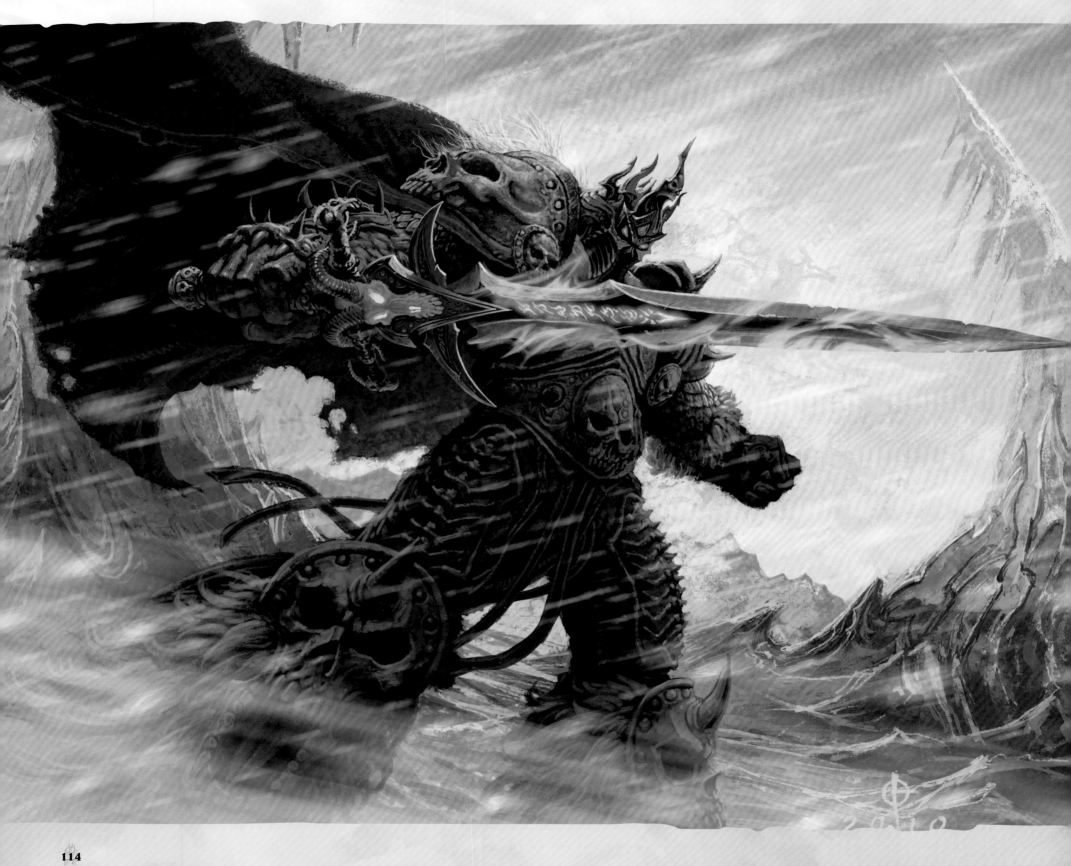

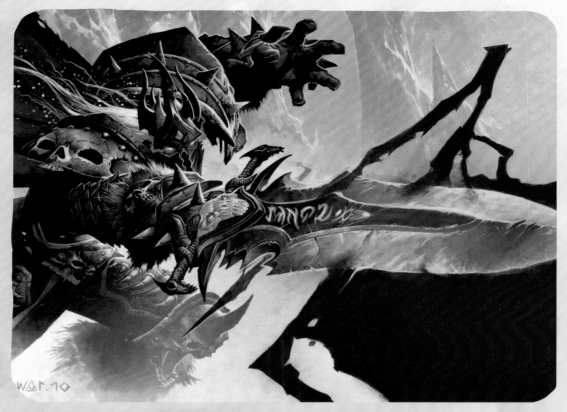

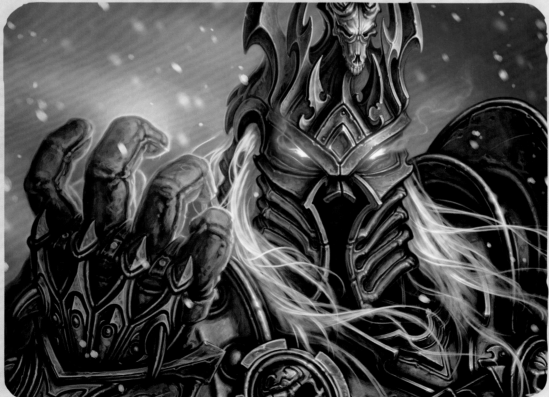

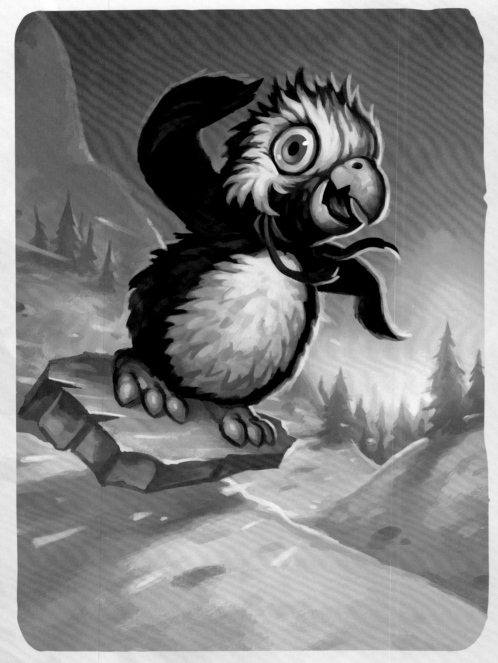

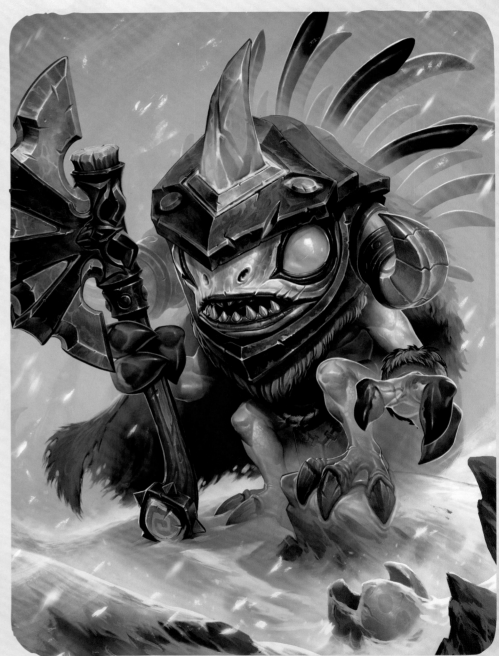

ABOVE
Snowflipper Penguin
Matt Dixon

ABOVE
Deadscale Knight
Rafael Zanchetin

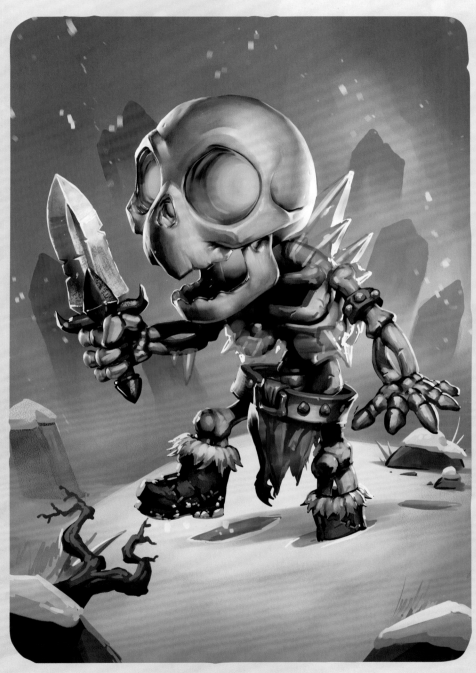

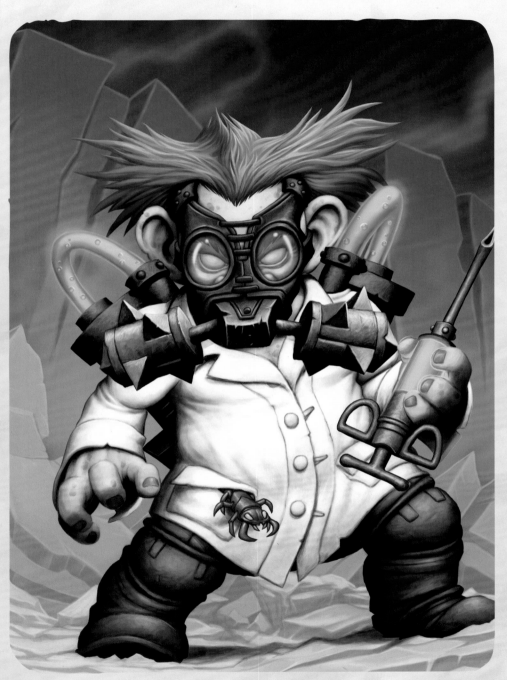

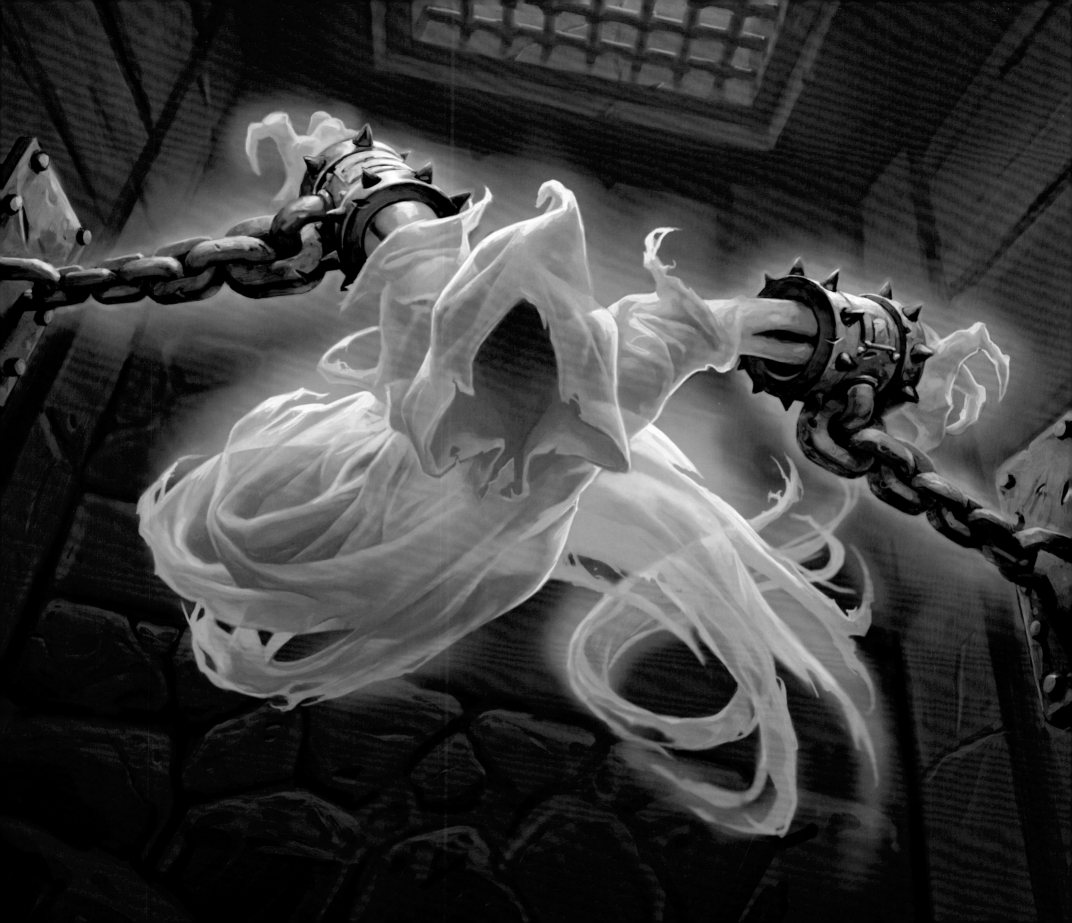

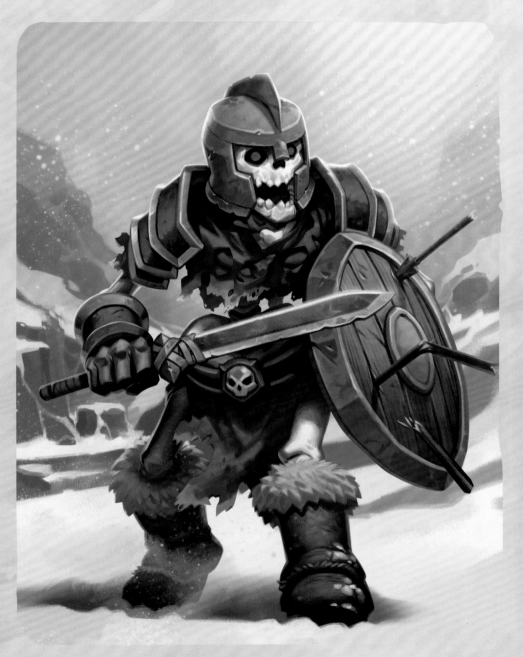

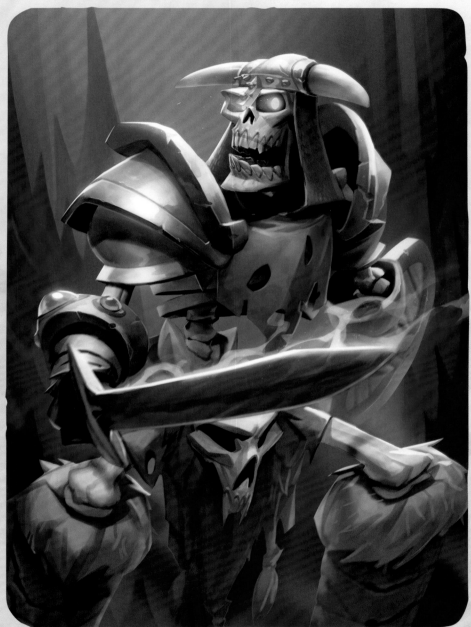

ABOVE
Skeleton
Andrew Hou

OPPOSITE
Eternal Servitude
Zoltan Boros

ABOVE
Skeletal Knight
Max Grecke

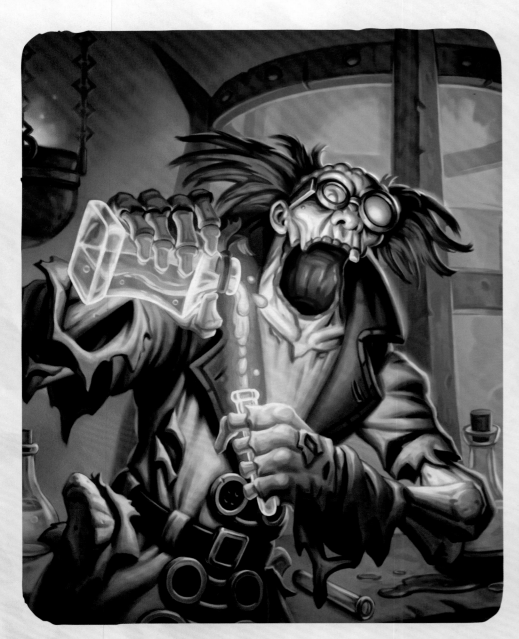

ABOVE
Professor Putricide (Hero Portrait)
Mike Sass

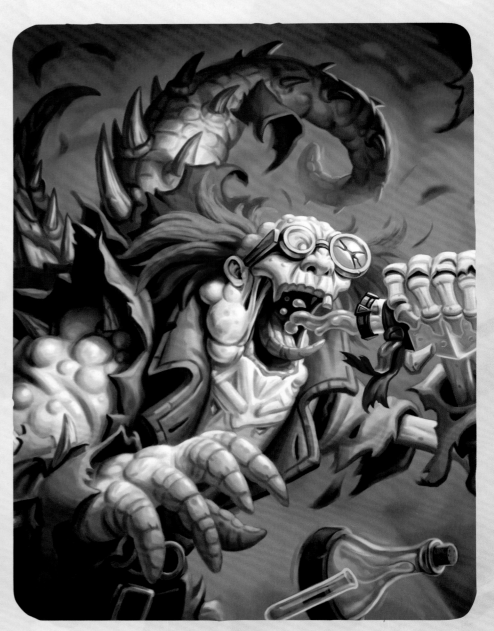

ABOVE
Professor Putricide
Mike Sass

OPPOSITE
Professor Putricide (Hero Portrait)
Mike Sass

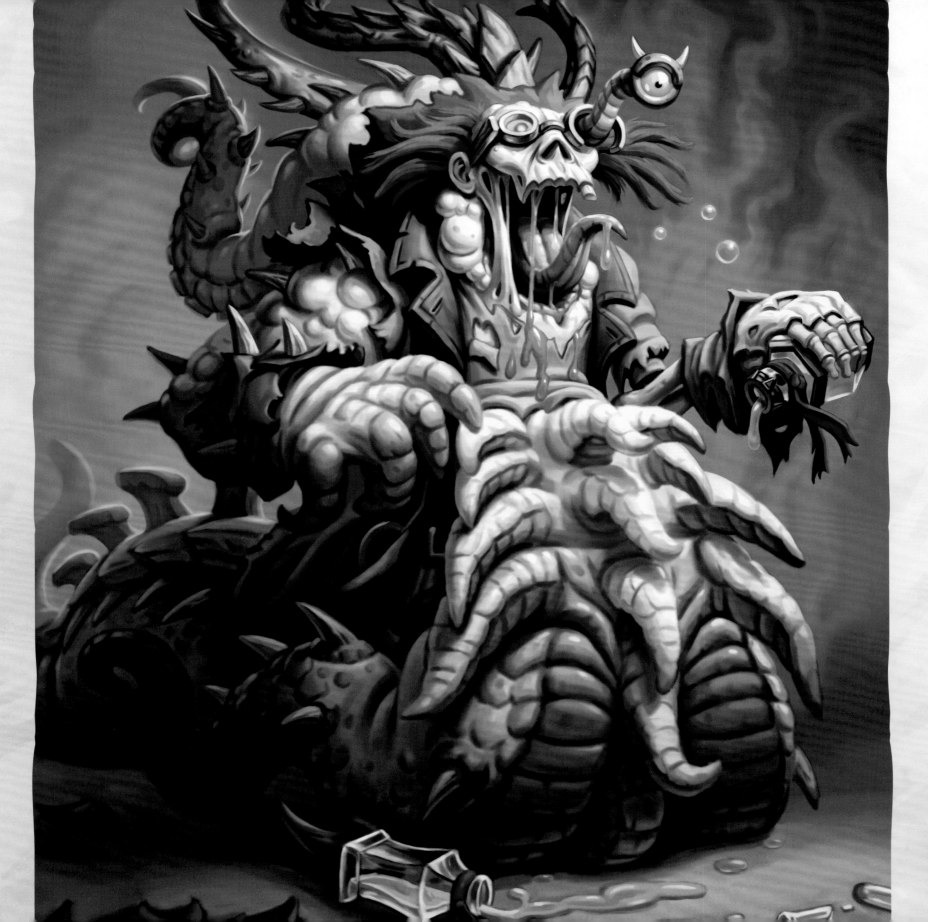

ABOVE
Druid of the Swarm
Zoltan Boros

ABOVE
Druid of the Swarm
Zoltan Boros

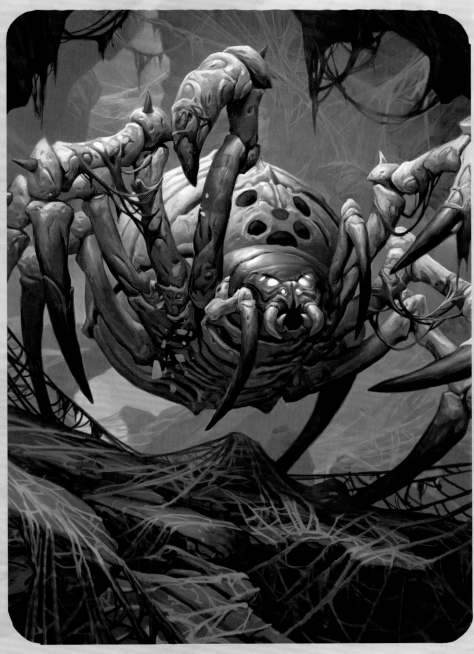

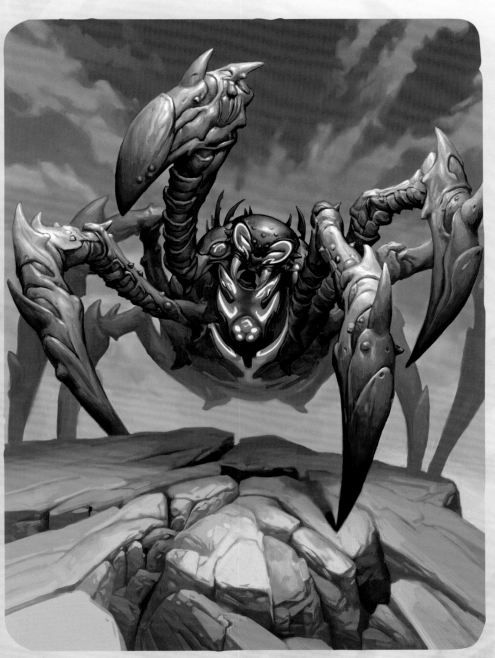

ABOVE
Hadronox
Zoltan Boros

ABOVE
Druid of the Swarm
Zoltan Boros

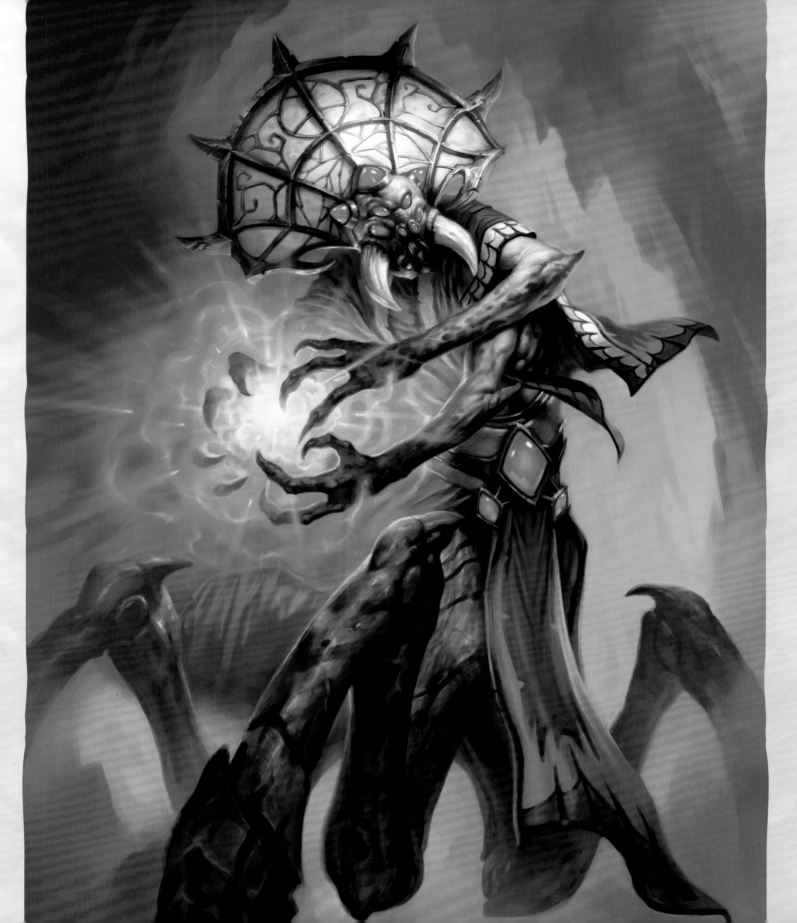

OPPOSITE
Venomancer
James Ryman

RIGHT
Crypt Lord
James Ryman

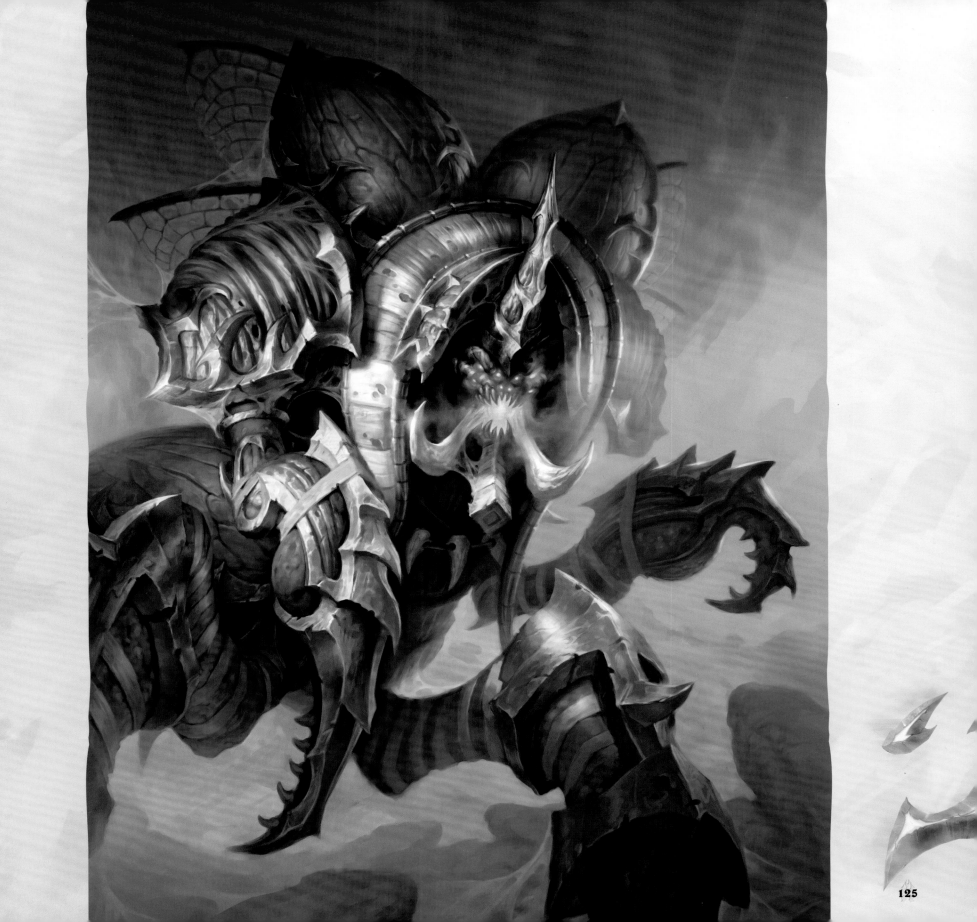

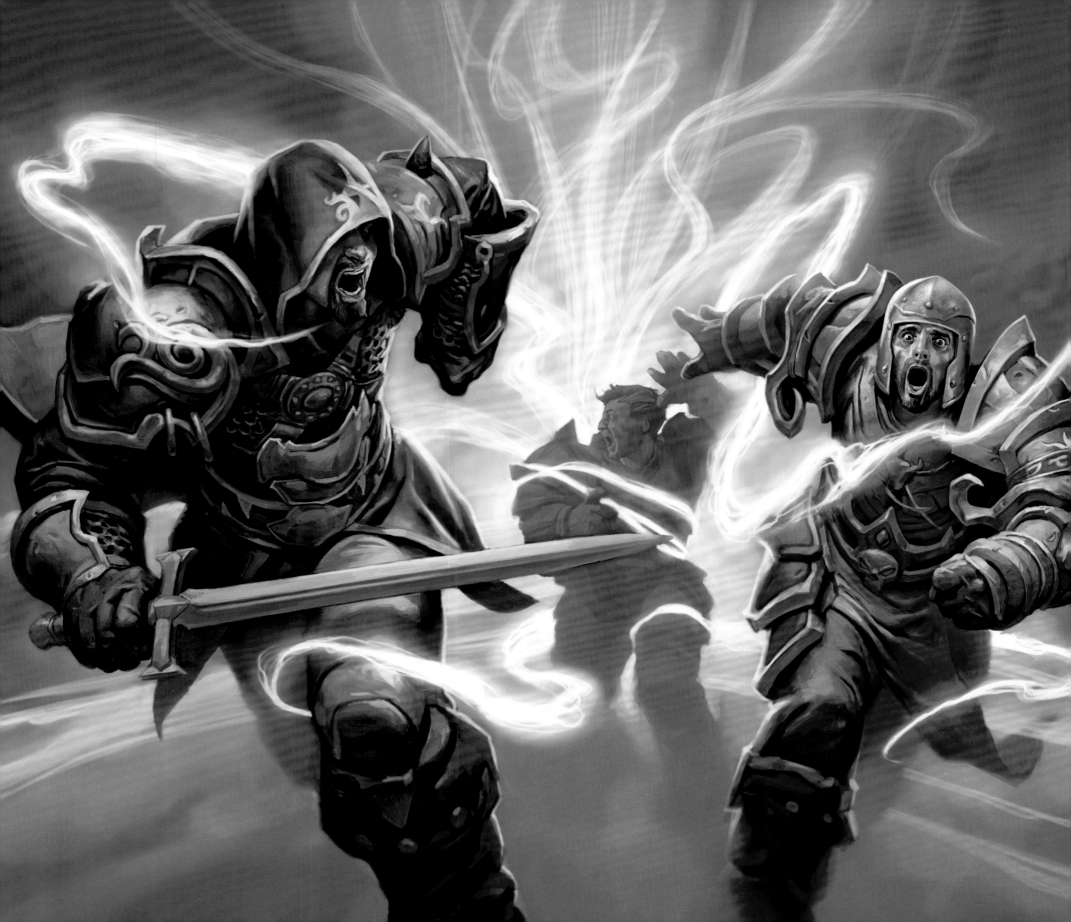

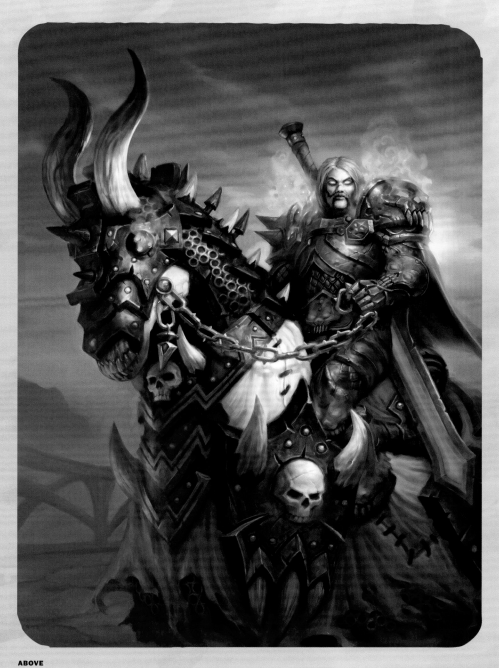

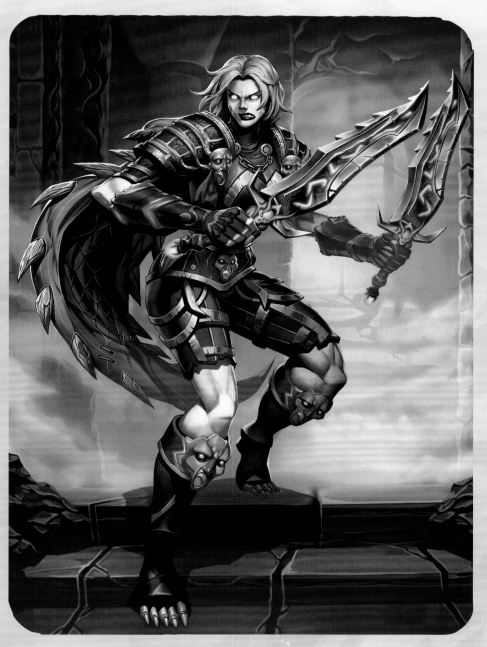

ABOVE
Thoras Trollbane
James Ryman

OPPOSITTE
Spirit Lash
Zoltan Boros

ABOVE
Lilian Voss
Gonzalo Ordonez

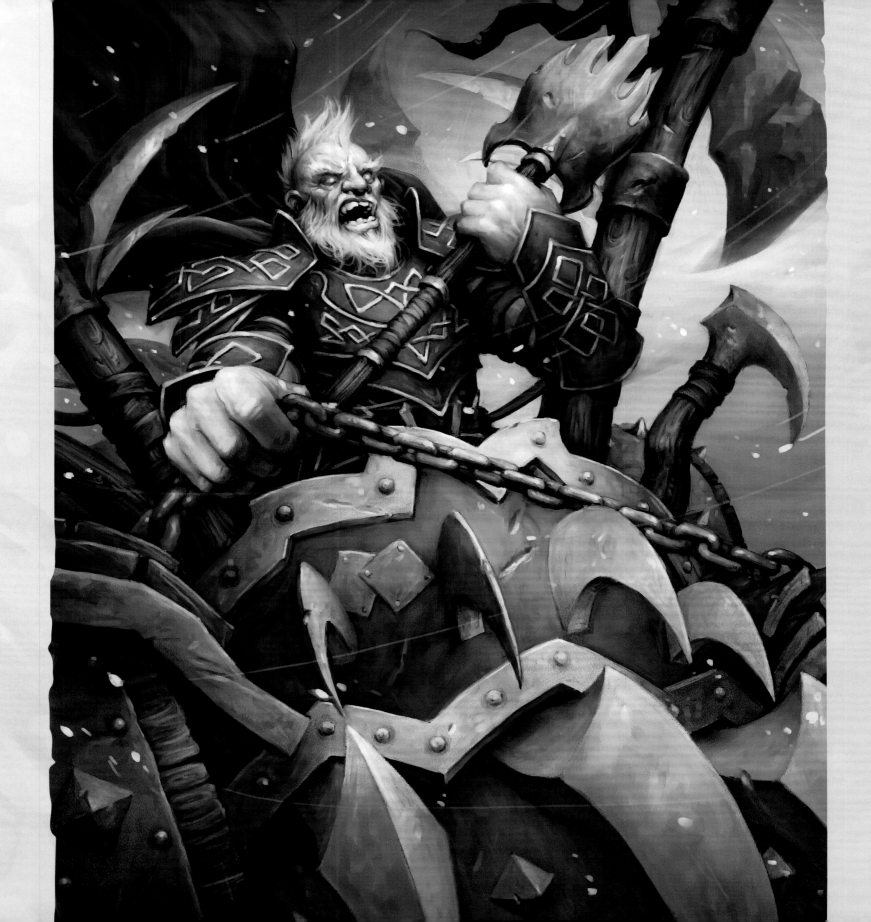

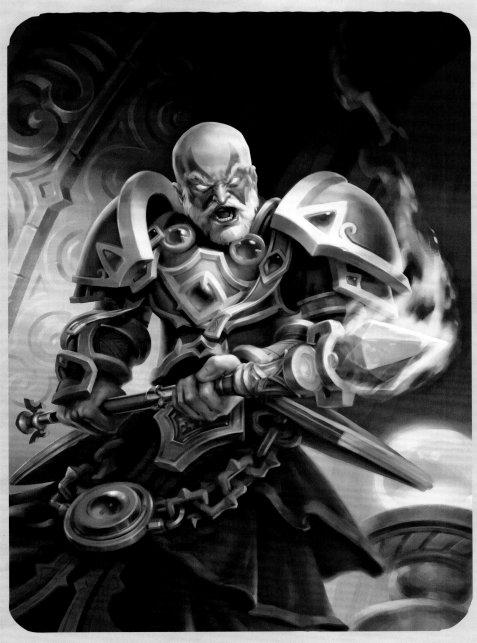

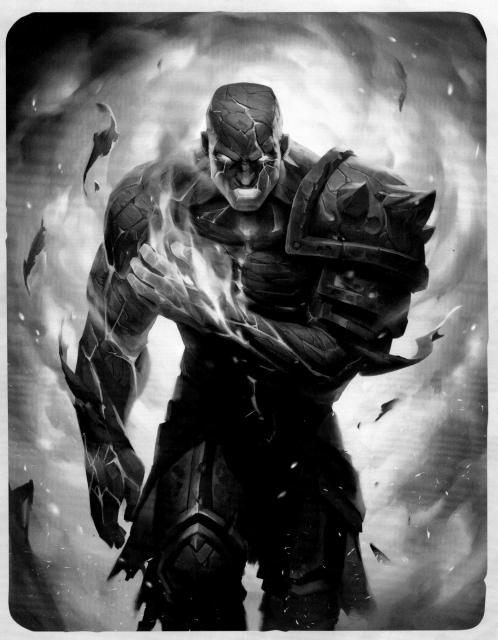

ABOVE
Archbishop Benedictus
Eugene Dlinnov

OPPOSITE
Bone Baron
Brian Despain

ABOVE
Bolvar Fordragon
Tooth

129

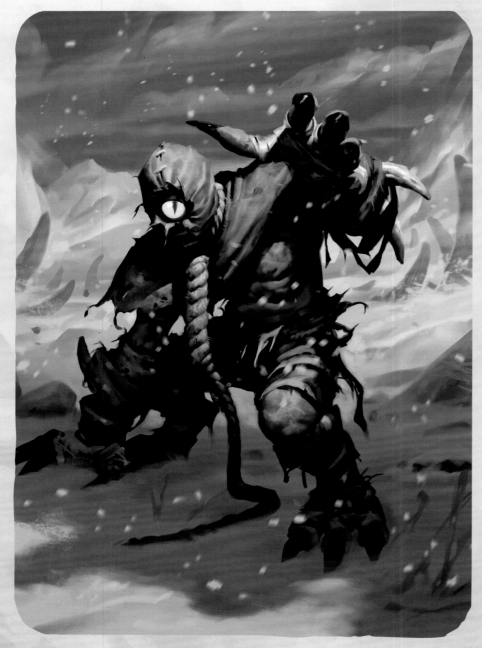

ABOVE
Runeforge Haunter
Slawomir Maniak

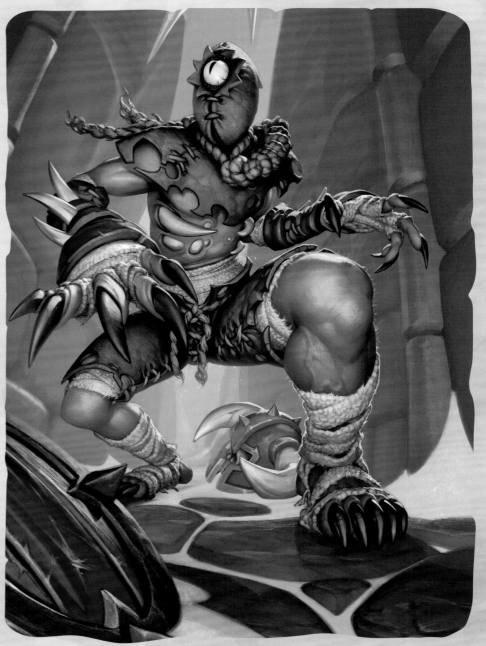

ABOVE
Tomb Lurker
Arthur Bozonnet

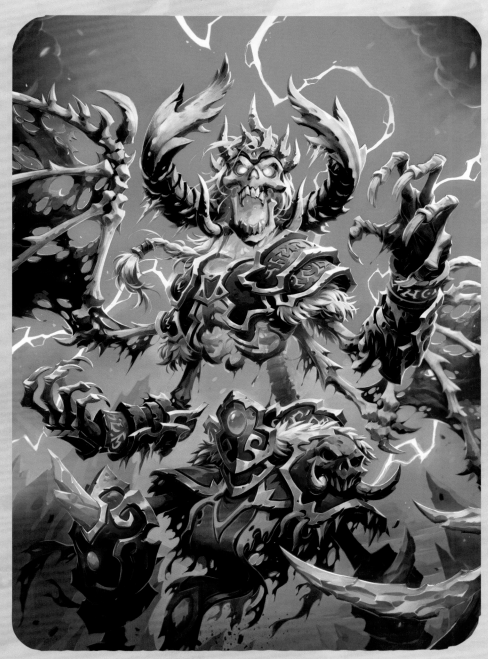

ABOVE
Wicked Skeleton
Nicola Saviori

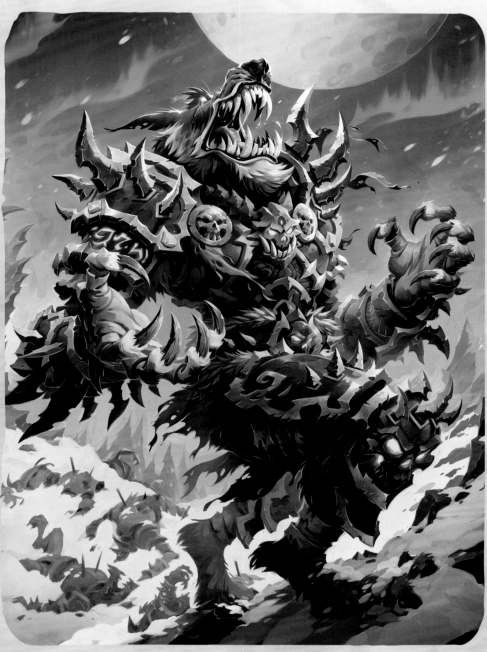

ABOVE
Night Howler
Nicola Saviori

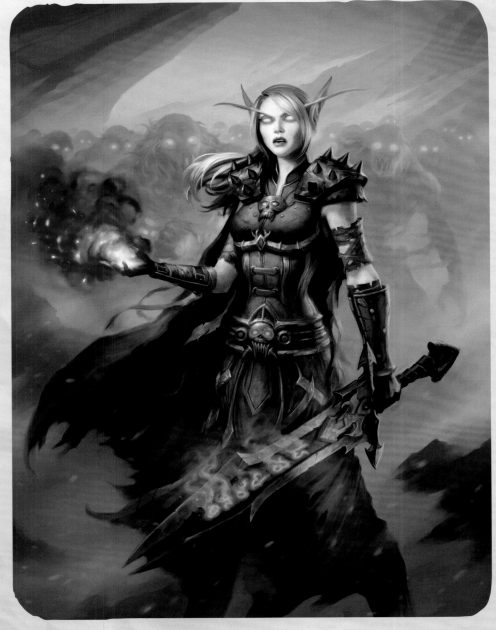

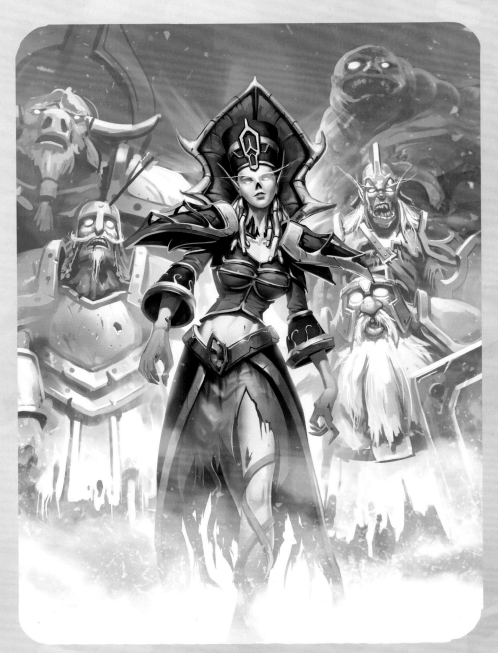

ABOVE
Corpsetaker
James Ryman

ABOVE
Ghastly Conjurer
Paul Mafayon

OPPOSITE
Frost Lich Jaina
Glenn Rane

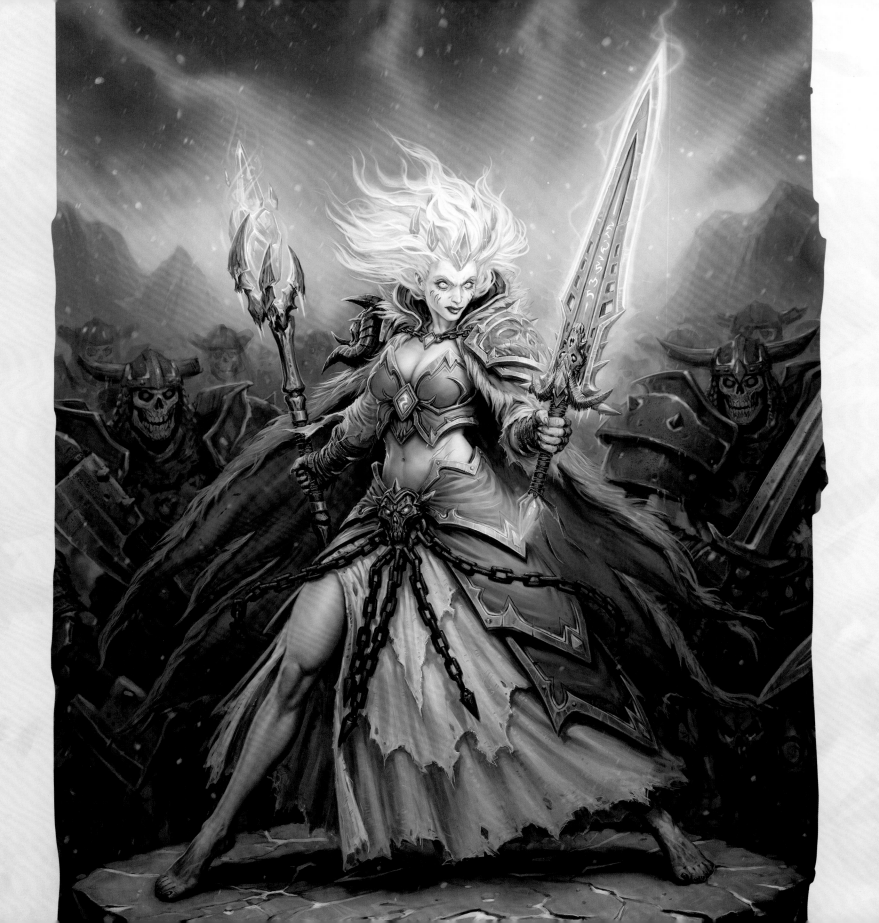

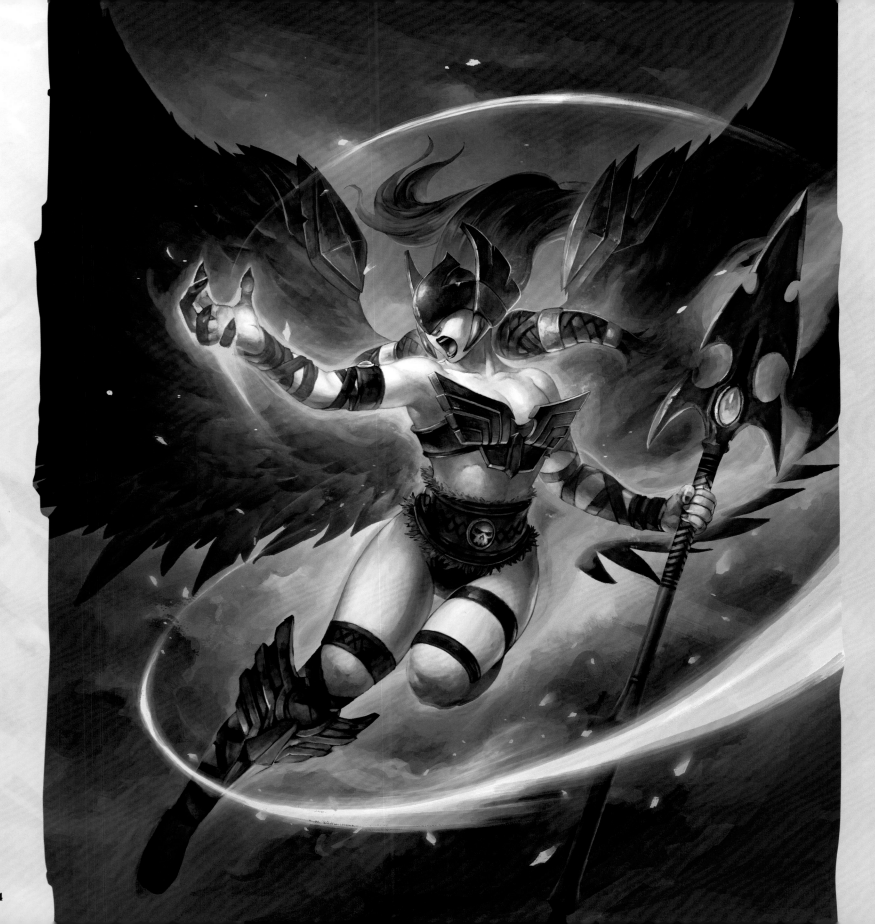

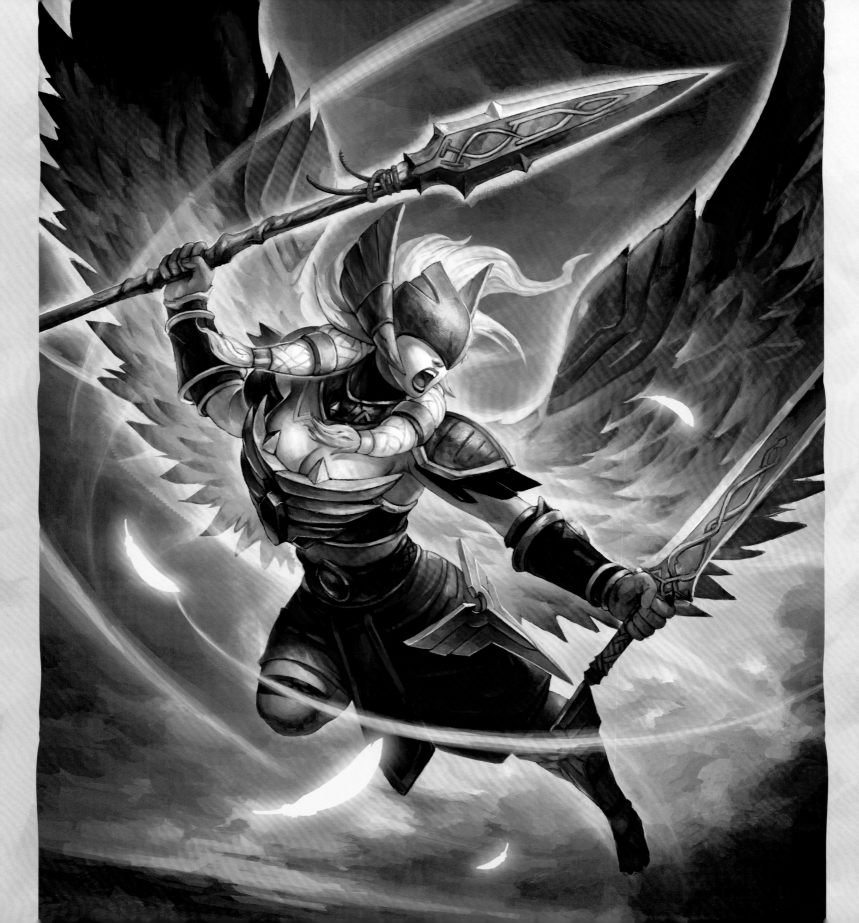

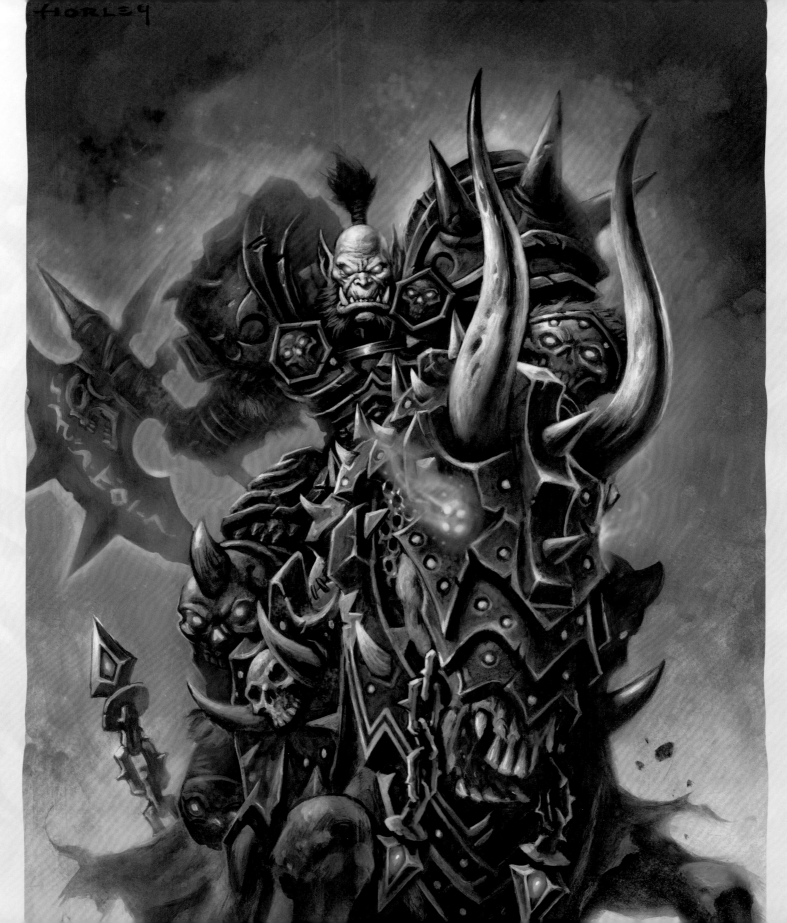

HORLEY

LEFT
Deathlord Nazgrim
Alex Horley

OPPOSITE
Inquisitor Whitemane
Luke Mancini

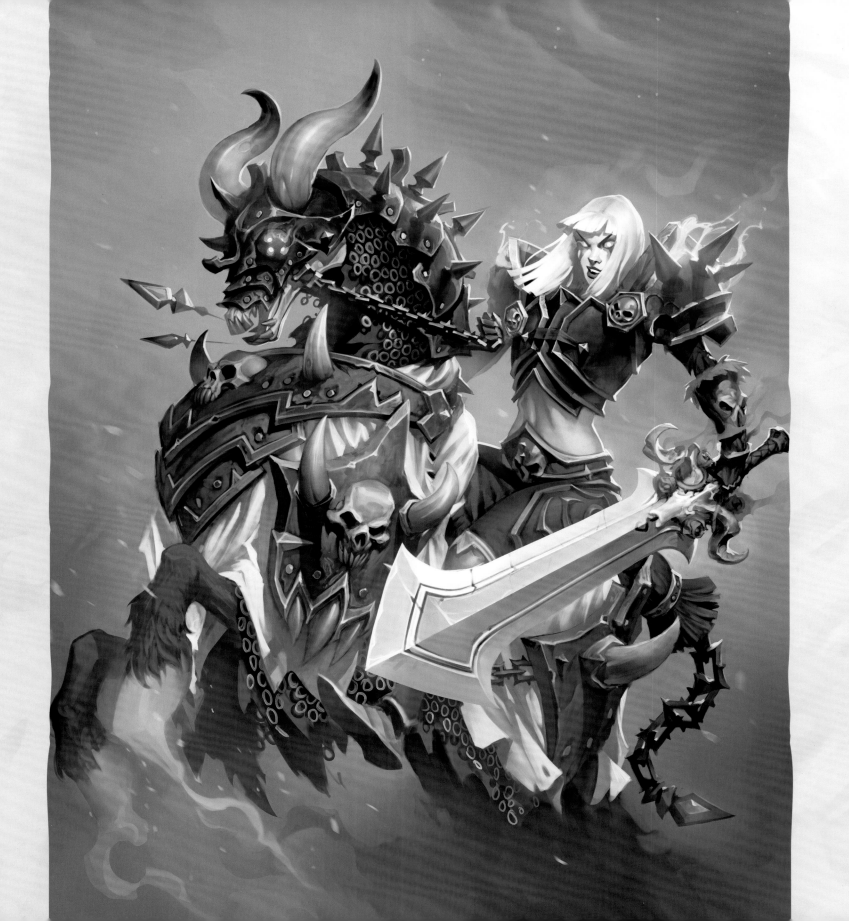

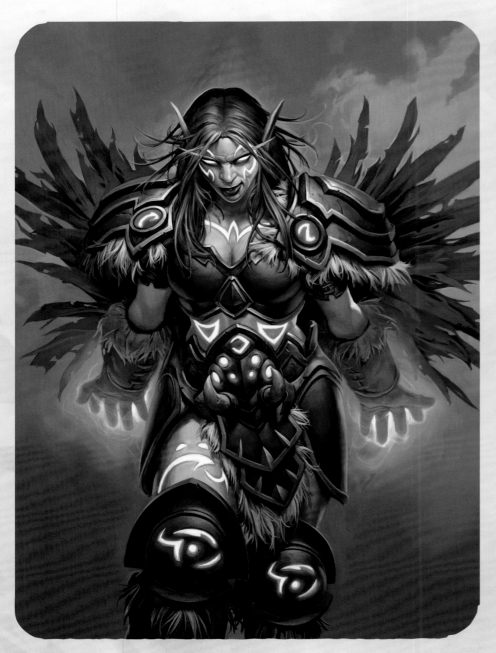

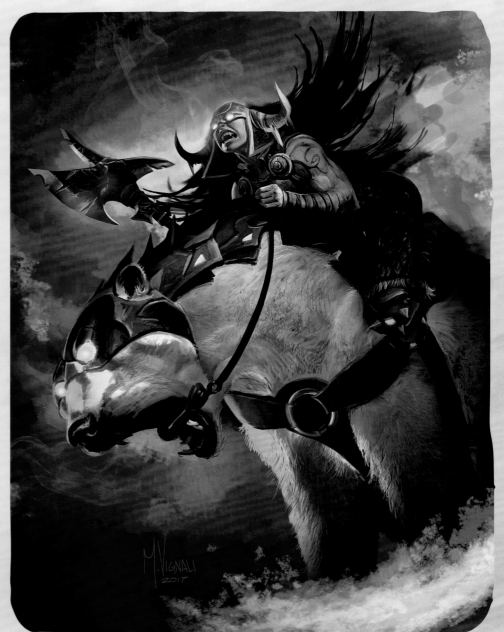

ABOVE

Druid of the Swarm

Zoltan Boros

ABOVE

Hyldnir Frostrider

Marcelo Vignali

OPPOSITE

Bite of the Blood-Queen

Arthur Bozonnet

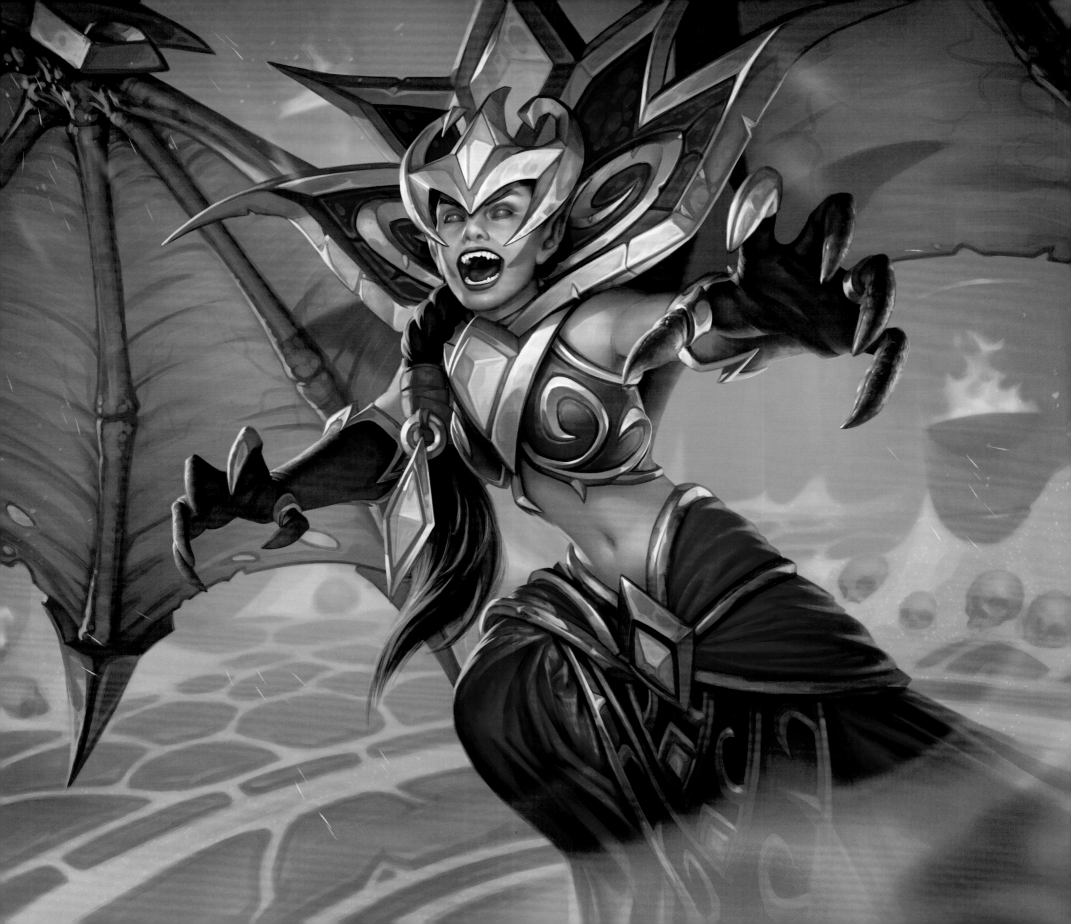

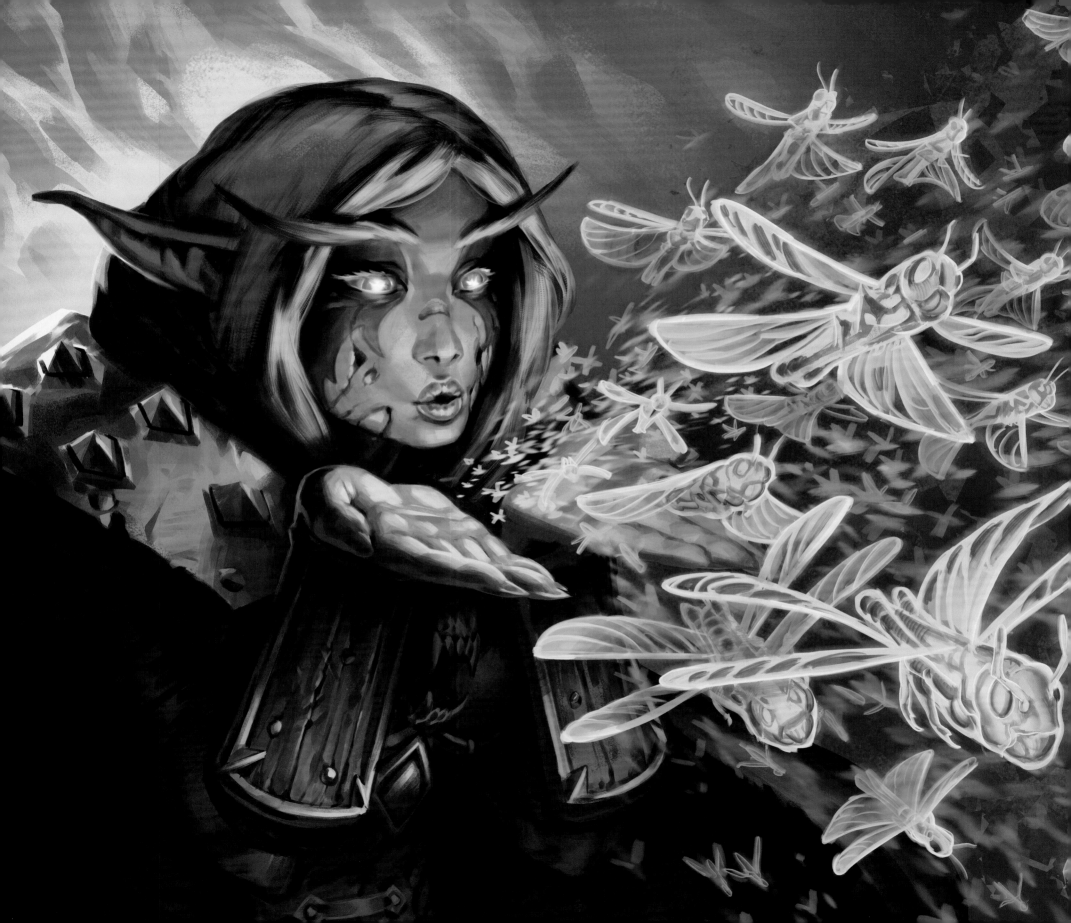

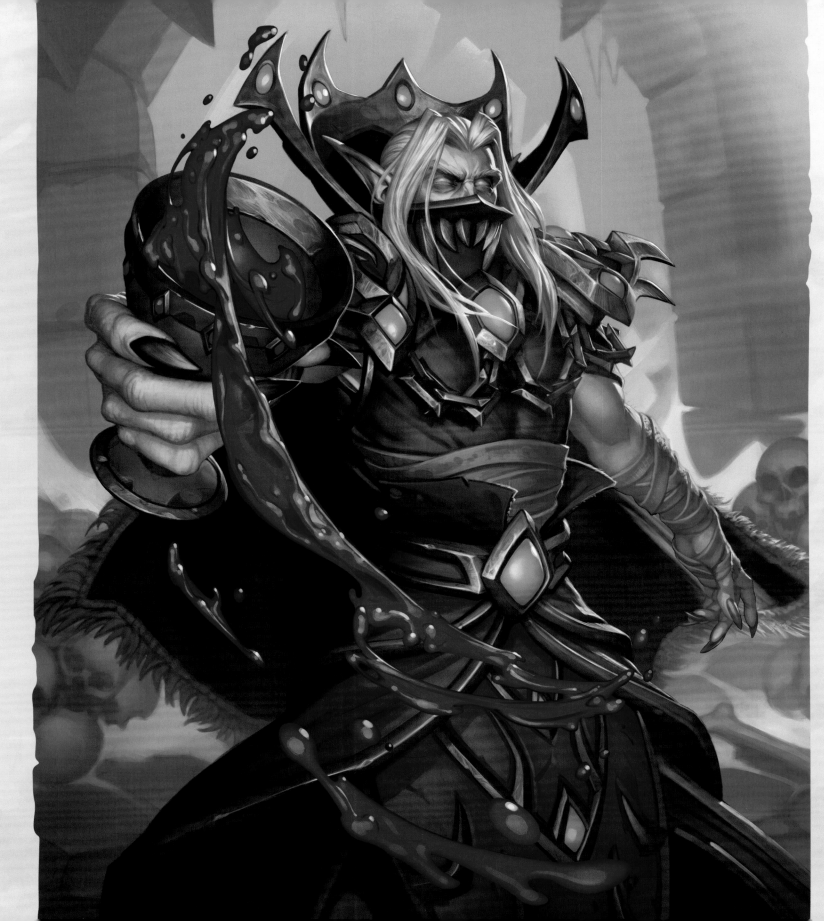

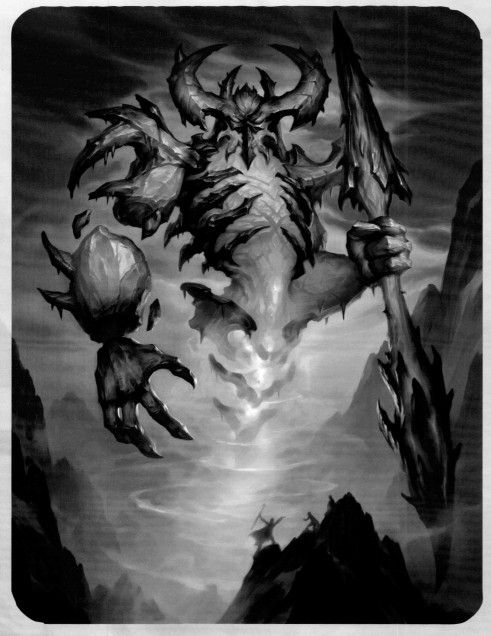

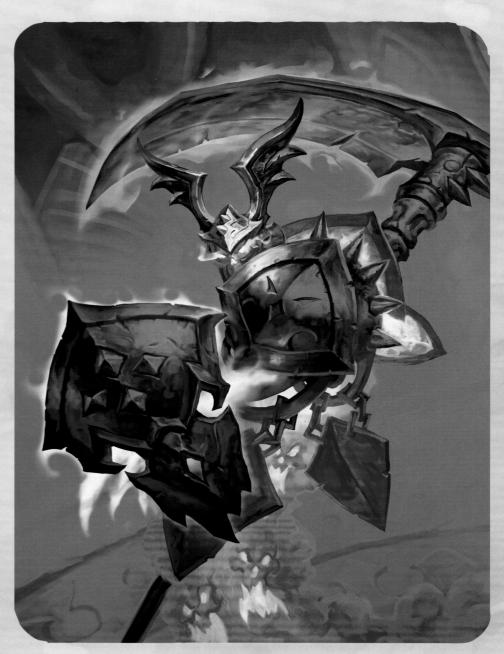

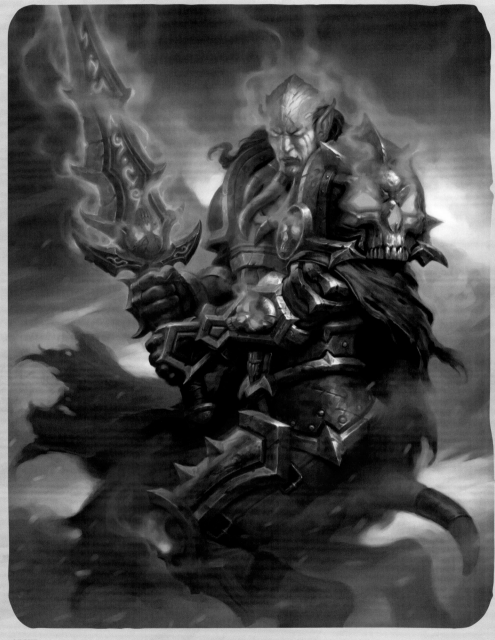

ABOVE
Blackguard
James Ryman

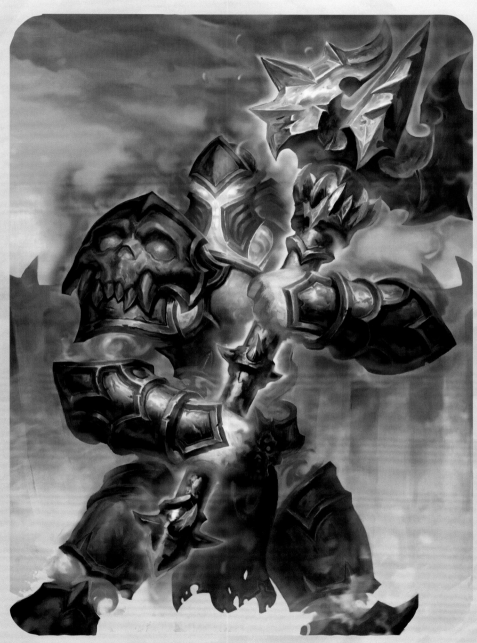

ABOVE
Animated Berserker
Konstantin Turovec

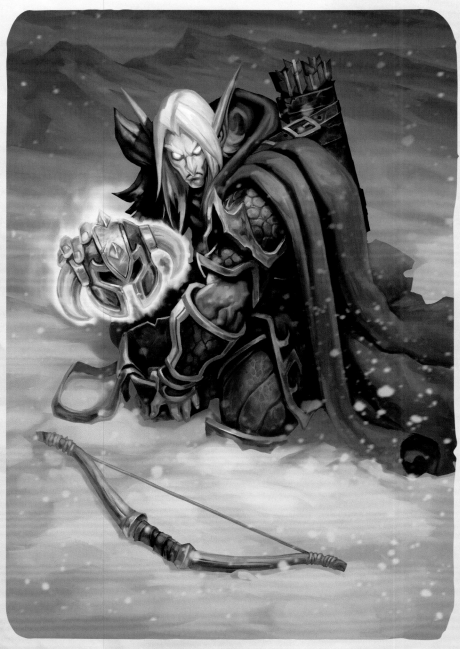

ABOVE
Needy Hunter
Konstantin Turovec

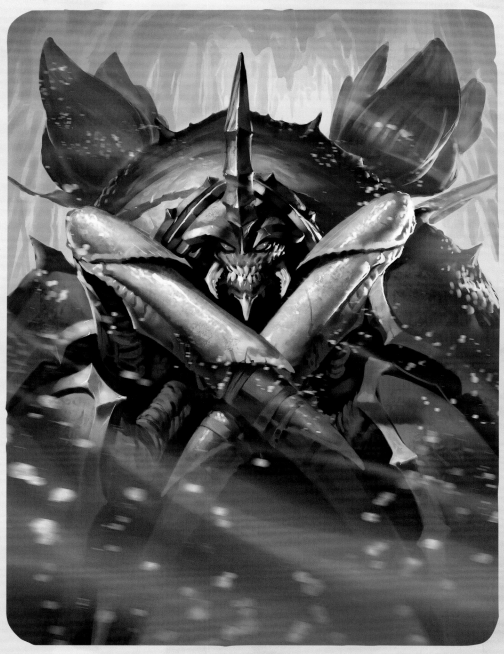

ABOVE
Scarab Beetle
Slawomir Maniak

OPPOSITE
Despicable Dreadlord
Konstantin Turovec

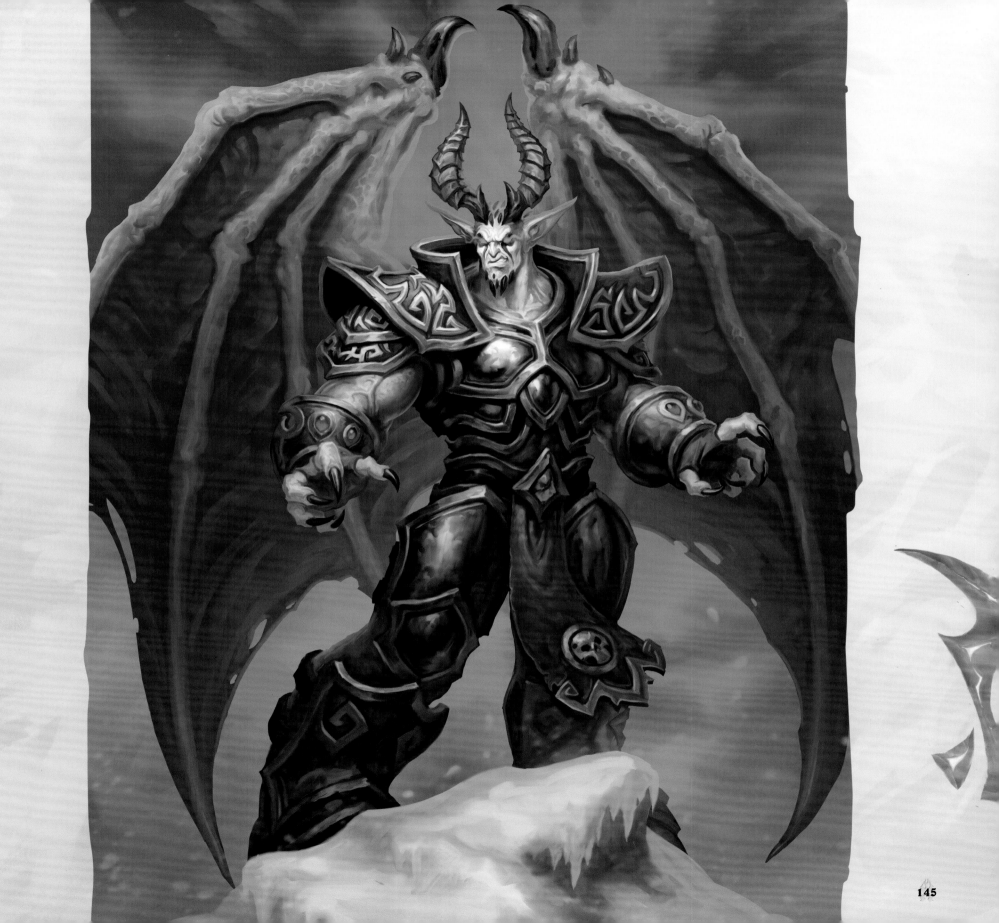

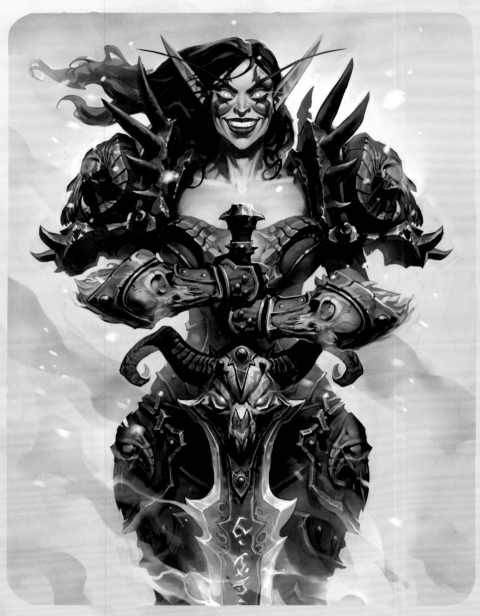

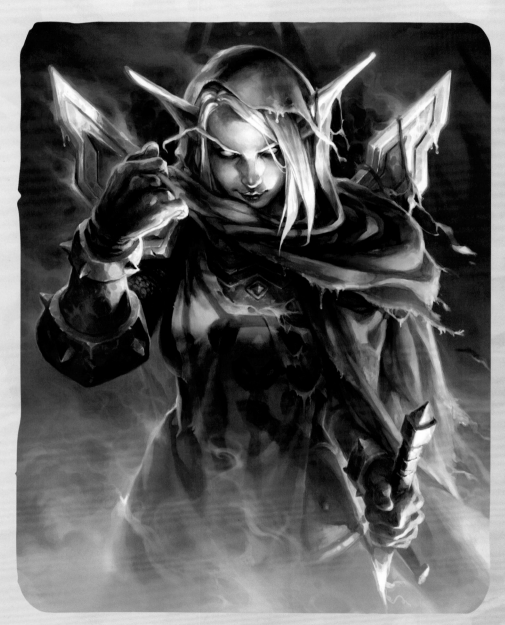

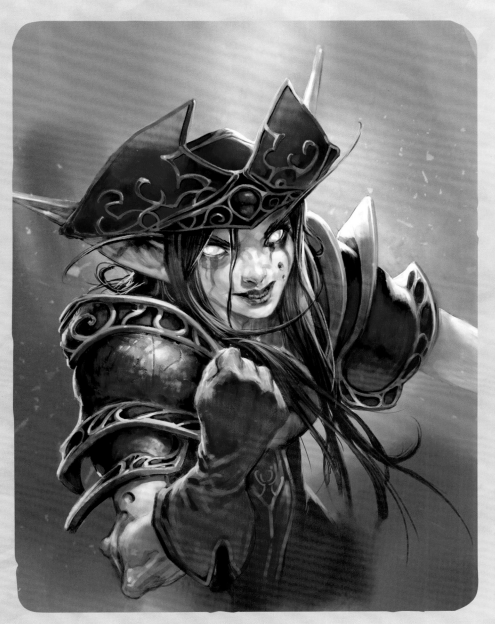

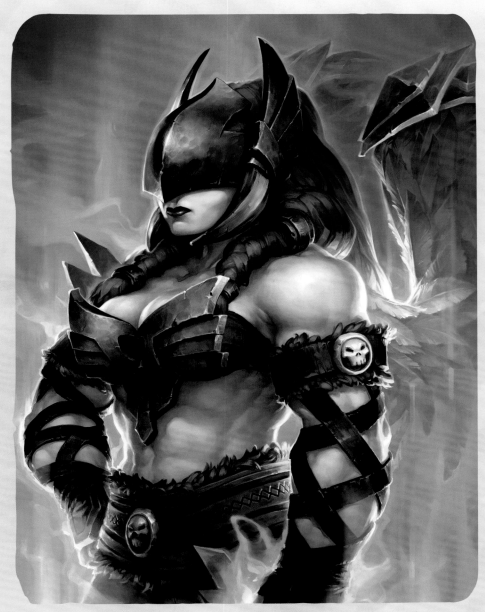

ABOVE
Tainted Zealot
Jesper Ejsing

ABOVE
Val'kyr Shadowguard
J. Axer

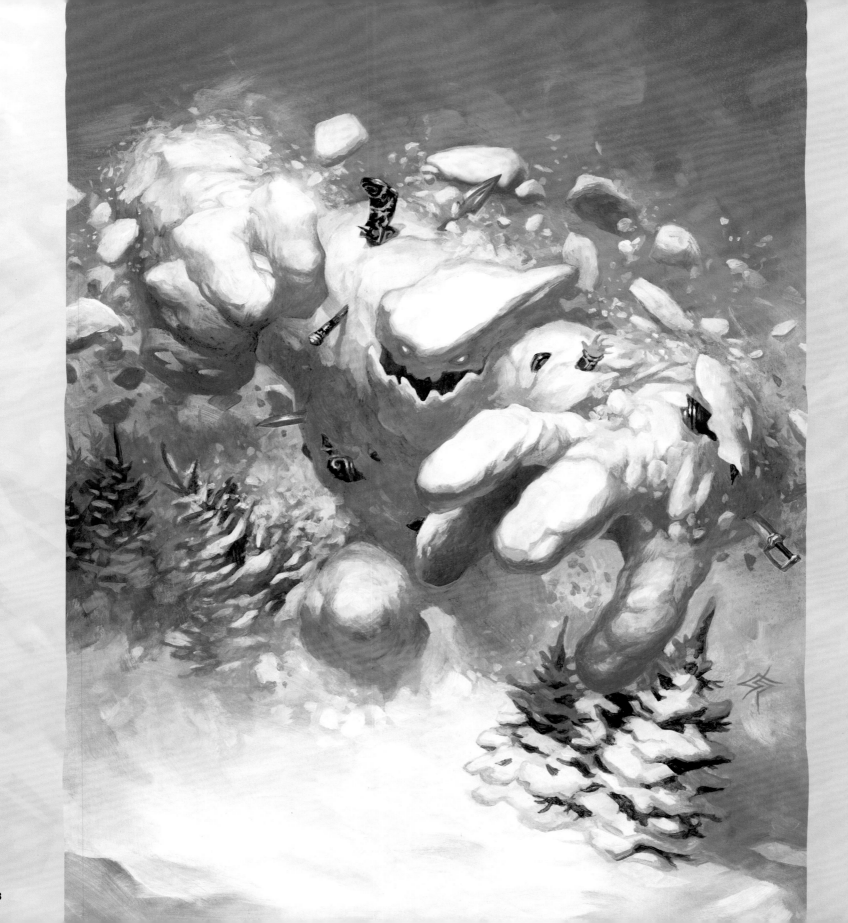

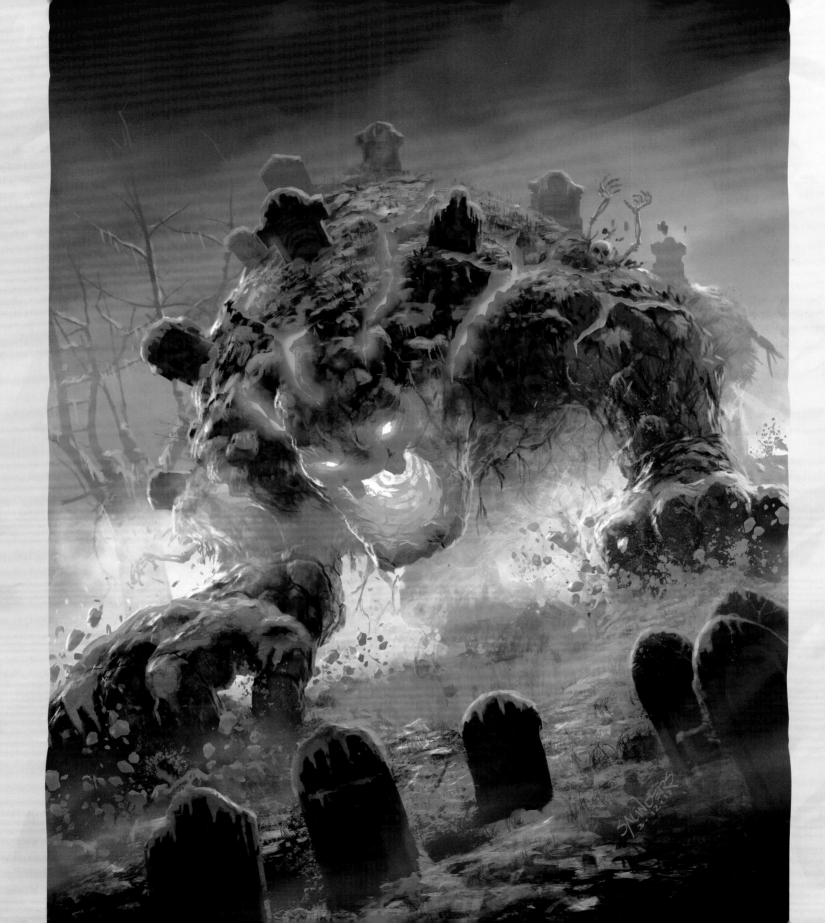

149

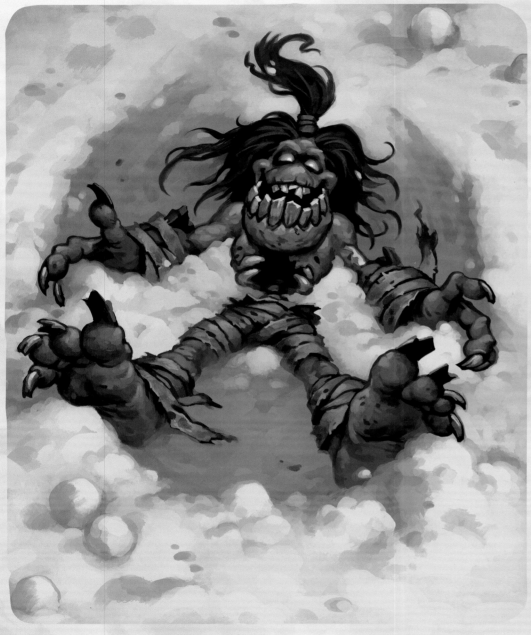

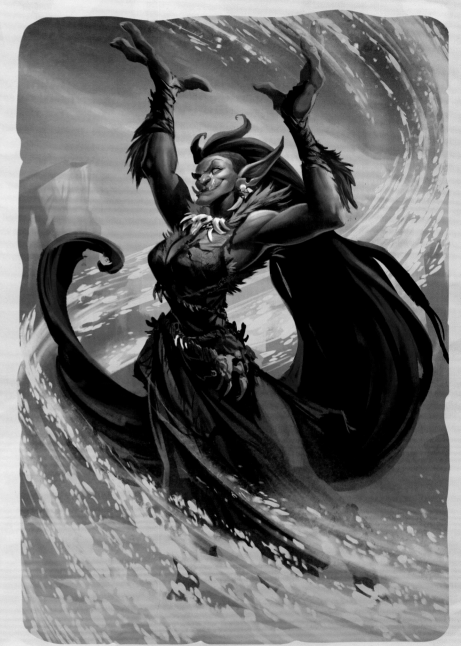

ABOVE
Happy Ghoul
Matt Dixon

ABOVE
Voodoo Hexxer
Sean McNally

OPPOSITE
Dead Man's Hand
Konstantin Turovec

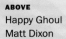

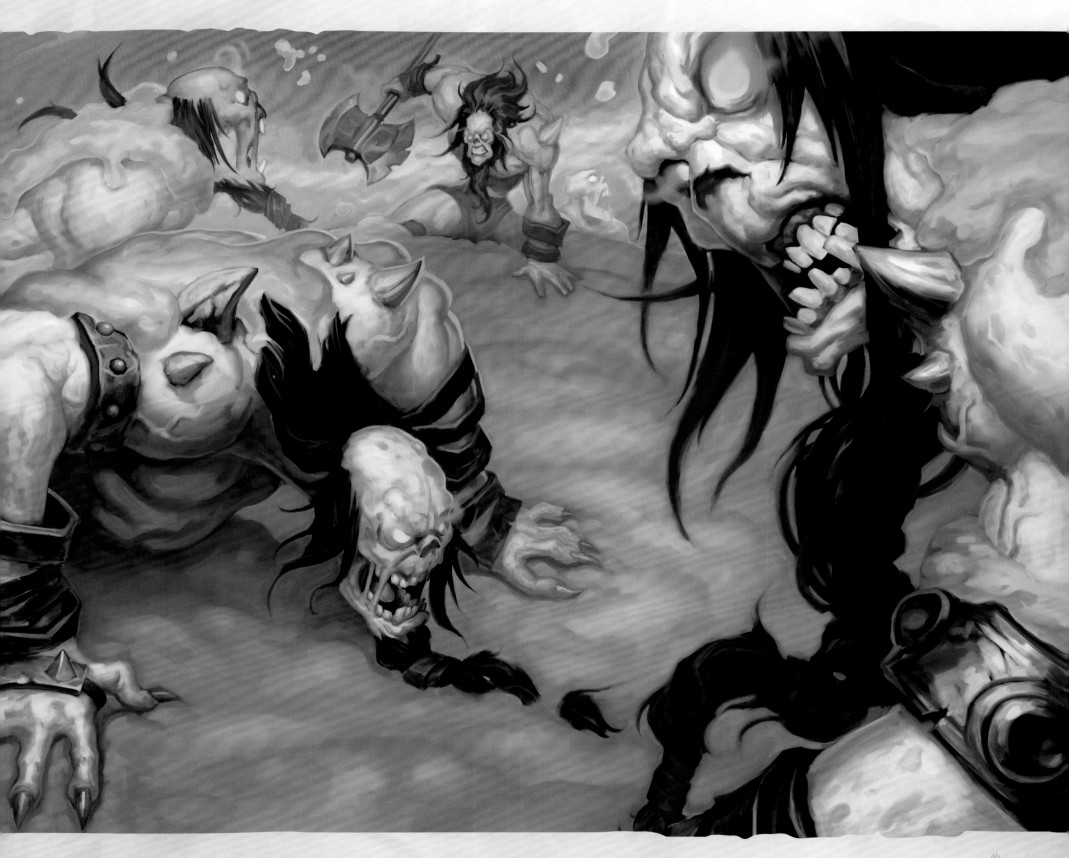

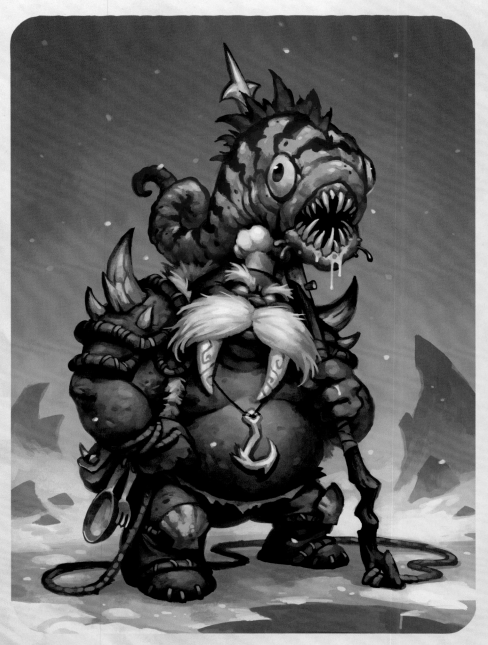

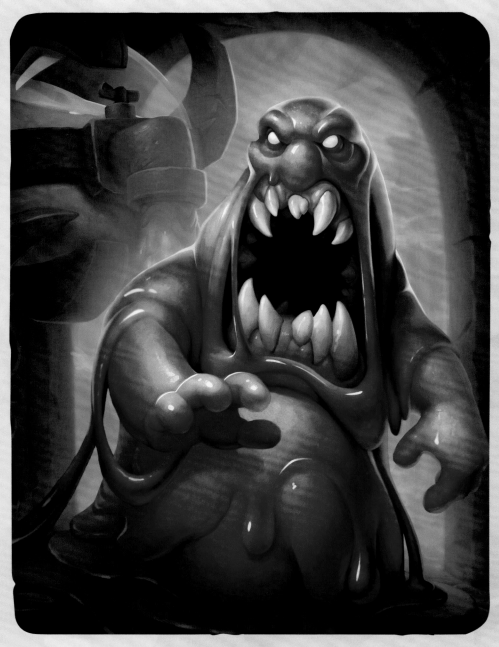

ABOVE
Ghoul
J. Axer

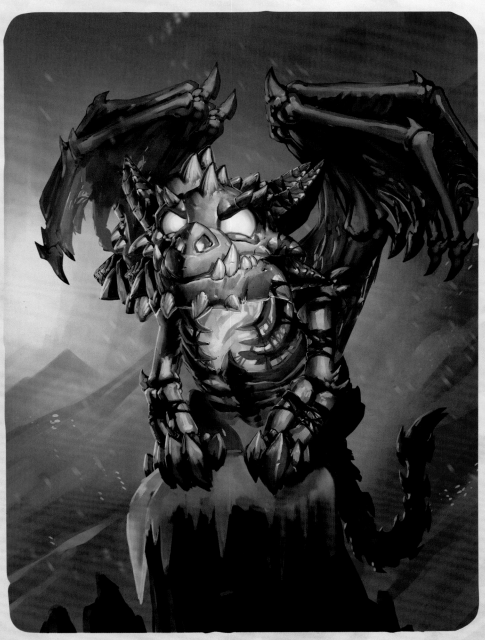

ABOVE
Bone Drake
Peter Stapleton

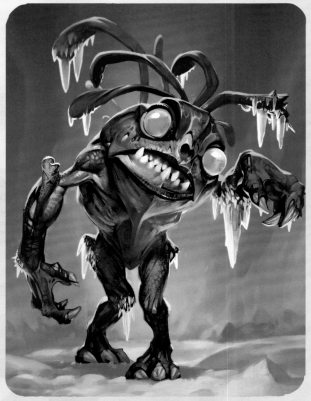

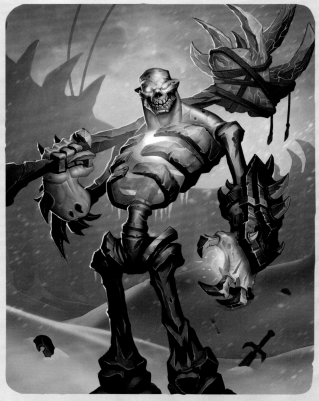

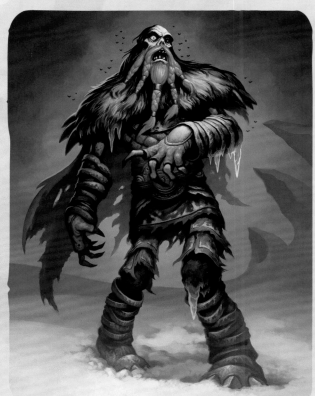

TOP LEFT
Brrrloc
Jaemin Kim

TOP RIGHT
Skeletal Enforcer
A.J. Nazzaro

BOTTOM LEFT
Vryghoul
Jim Nelson

BOTTOM RIGHT
Frozen Champion
Matthew O'Connor

OPPOSITE
Obsidian Statue
A.J. Nazzaro

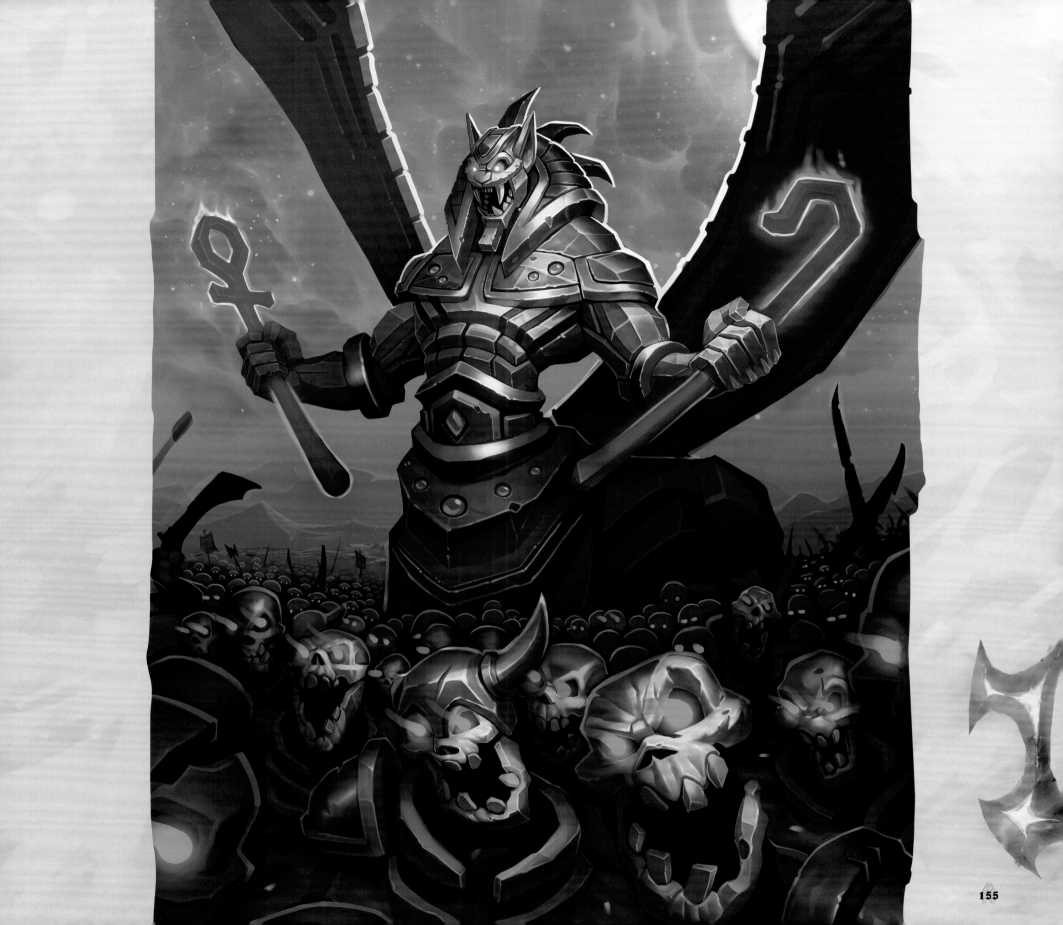

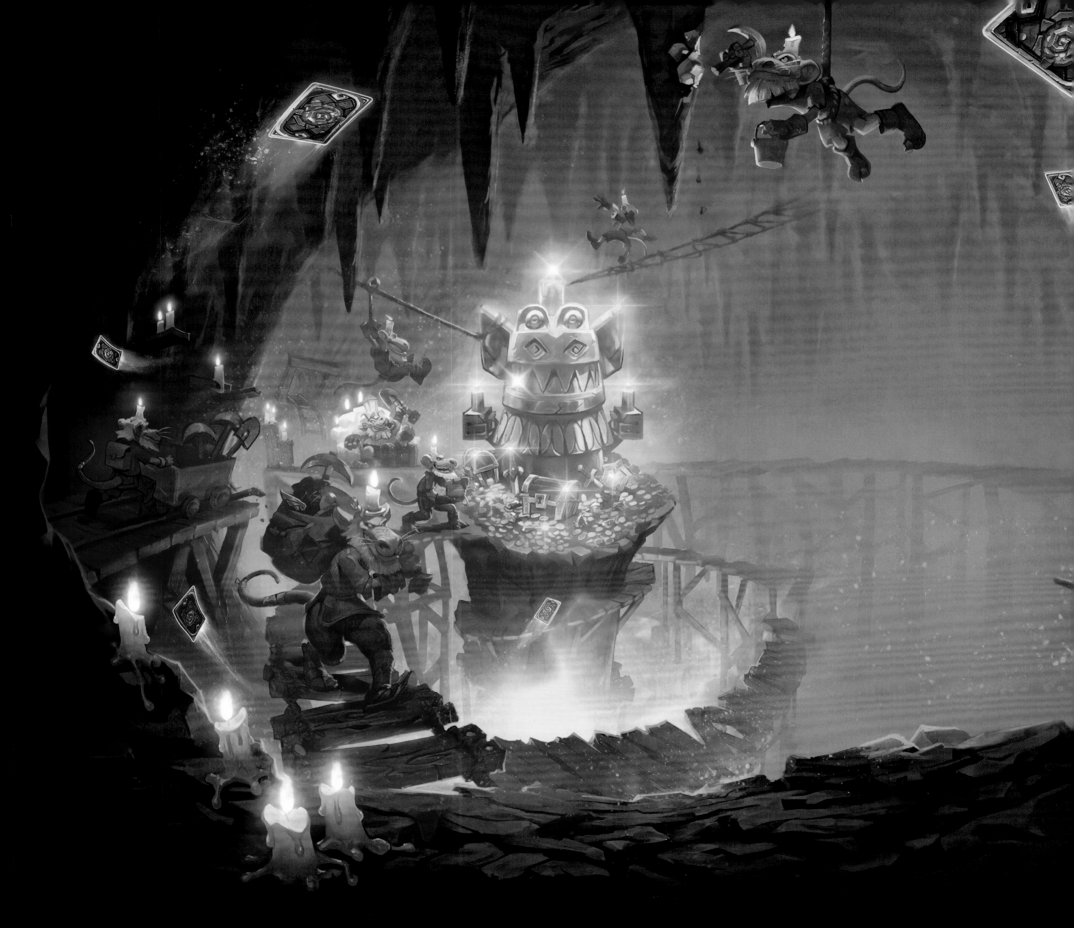

KOBOLDS & CATACOMBS

Trespass with care, there's sure to be something rare, you can grab all the loot that you can handle! Such riches you'll own, but leave one thing alone . . .

YOU NO TAKE CANDLE!

—Adventuring Song

ROGUELIKE GONE ROGUE

When it comes to tone, the *Hearthstone* team quickly learned the importance of contrast. Very dark themes in one set will give way to sillier concepts in the next, and even the goofiest expansion will still have minions and mechanics that are meant to be truly intimidating.

"Our game is based on *Warcraft*, so there needs to be an epic foundation. Our game is also a lot different, so we can embrace the lighter side more," said creative director Ben Thompson. "In general, we don't want to release two serious expansions in a row, so we knew our Icecrown set was going to be followed by something much less grim."

Journey to Un'Goro had been inspired by a love of gigantic dinosaurs, and *Knights of the Frozen Throne* had adapted some of Warcraft's most iconic villains, but the third and final expansion of the Year of the Mammoth was built on a completely different foundation.

Hearthstone's newly formed Missions team had created a new way to play the game, prototyping a replayable single-player format. Players would start with a small number of cards, face off against computer-controlled opponents, and choose new loot after each victory, slowly constructing a more powerful deck to face more dangerous enemies. Lose once? Start over. It was *Hearthstone*'s version of a "roguelike"—a type of game, which focuses on feeling new every time you play.

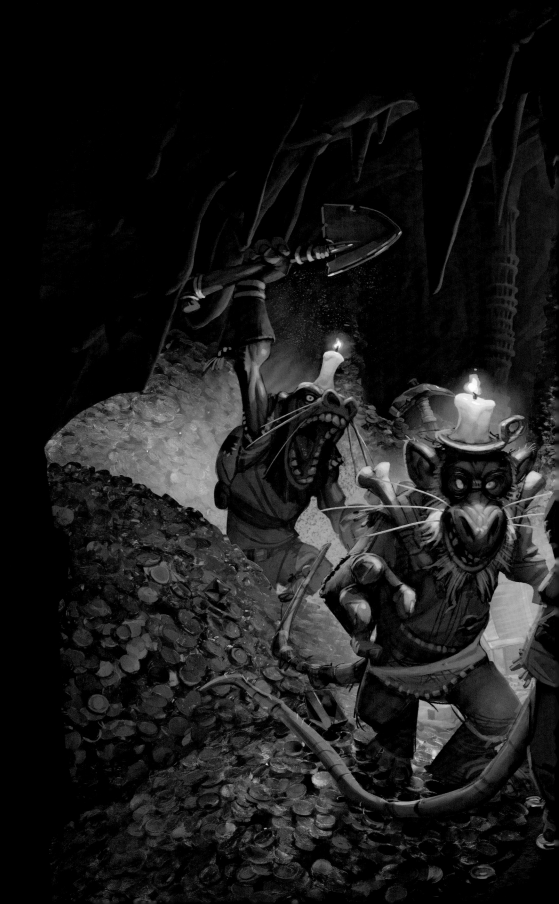

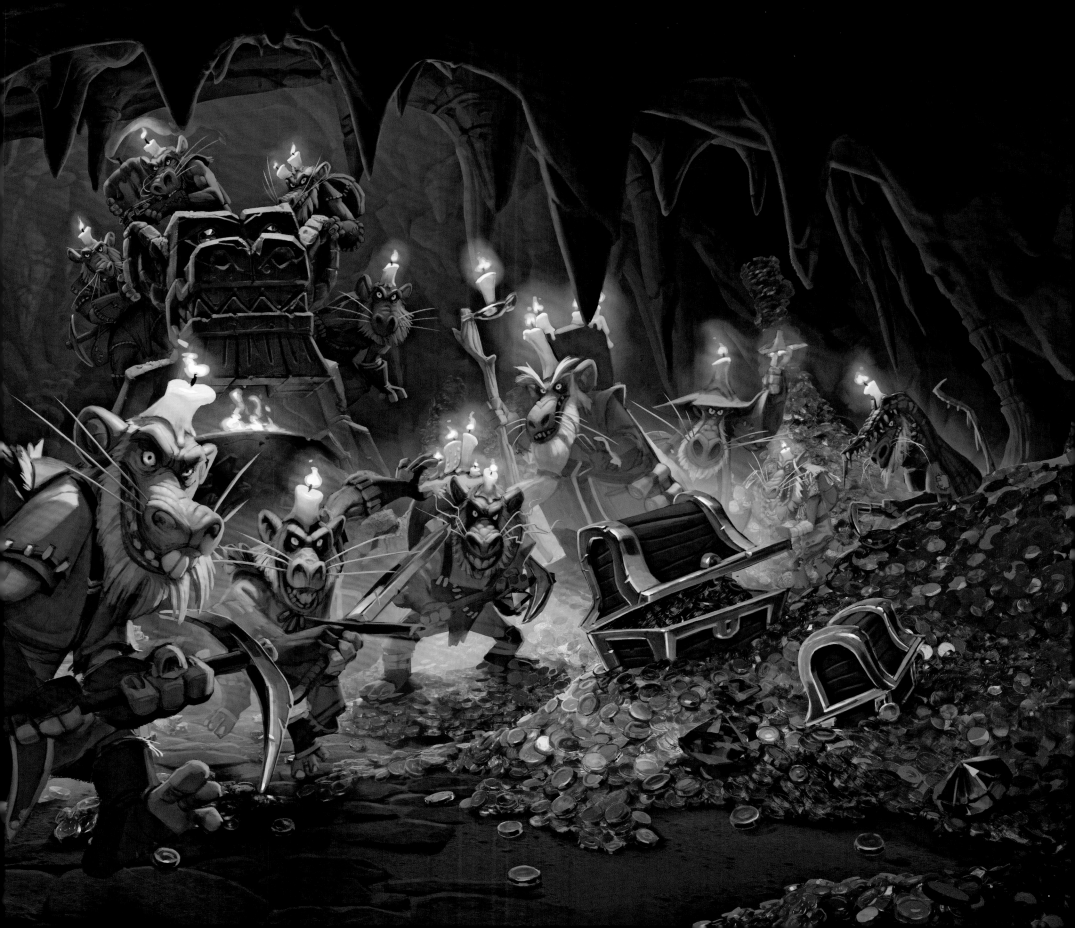

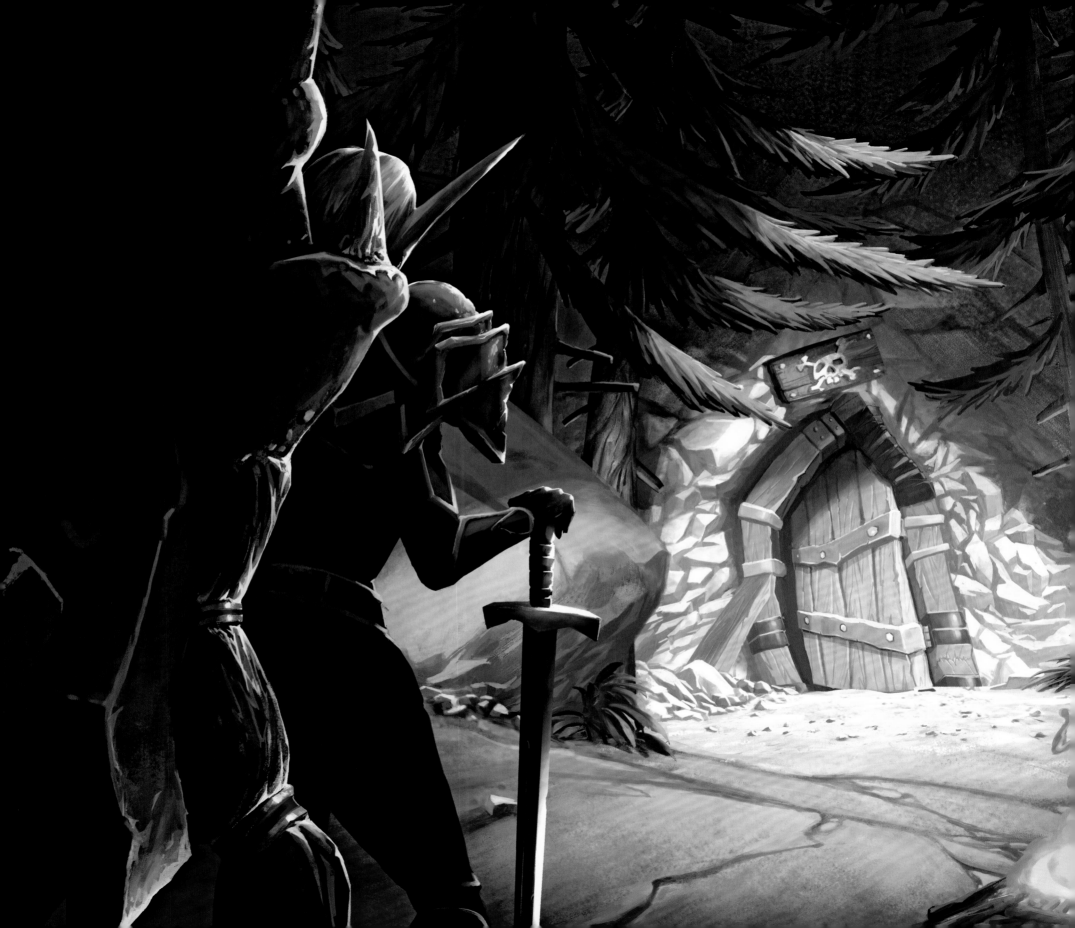

But the quest for ever-better loot reminded team developers of another classic game genre: the tabletop role-playing game. There's no shortage of pen-and-paper RPG fans at Blizzard; many dice have been rolled in the conference rooms scattered around the company's global offices.

Hearthstone's new game mode was therefore called Dungeon Run, and the third expansion of 2017 was built around it.

"A huge reason we wanted to do a dungeons-and-loot expansion at all was because of this mode," said lead designer Peter Whalen. "It was the perfect moment."

Thus began the production of *Kobolds & Catacombs*, Blizzard's love letter to one of its favorite pastimes.

You've signed up the best, you're on a great quest to find the mighty motherlode.

—ADVENTURING SONG

LEFT
Sam Nielsen and David Satchwell

161

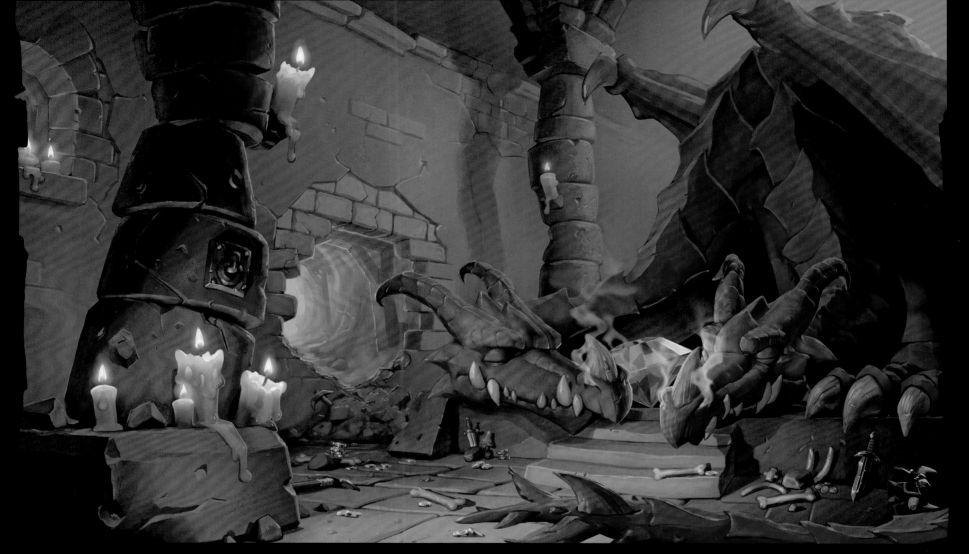

ABOVE
Peter Stapleton, Sam Nielsen,
and David Satchwell

OPPOSITTE
Sam Nielsen and David Satchwell

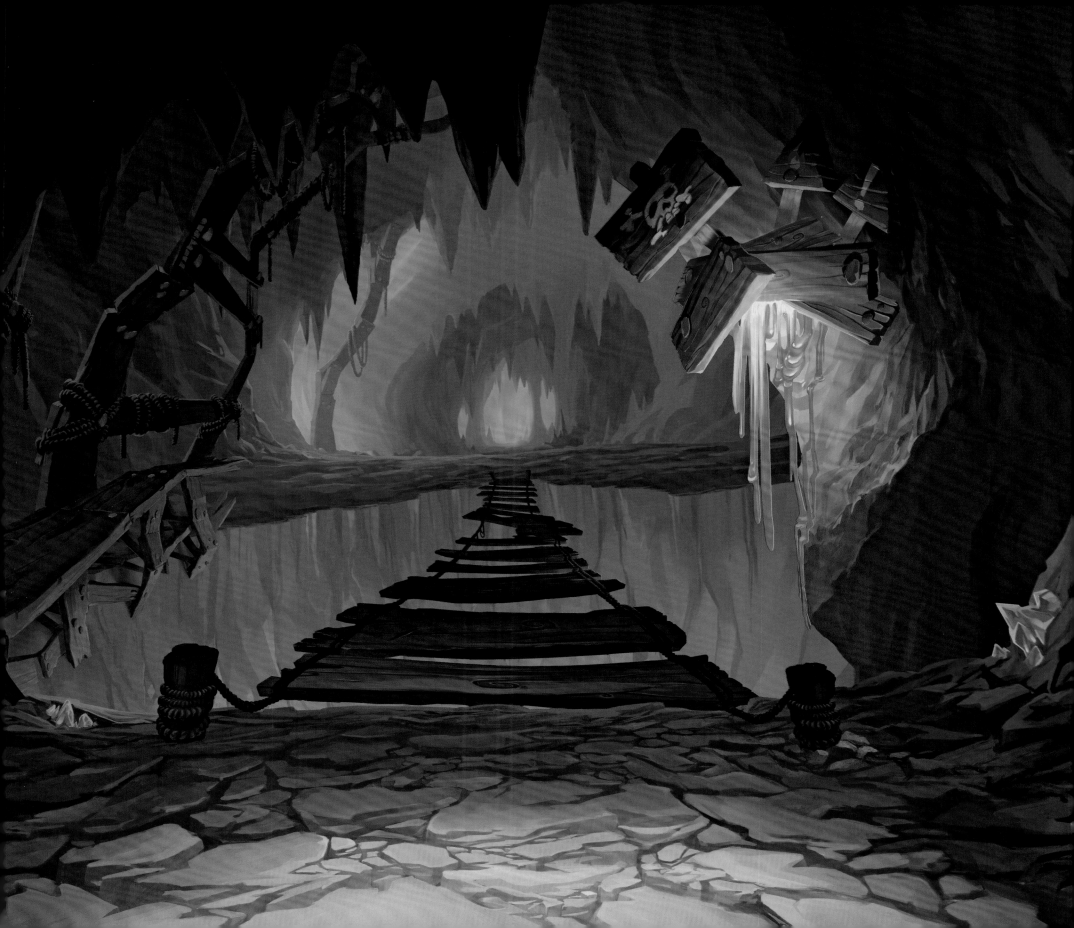

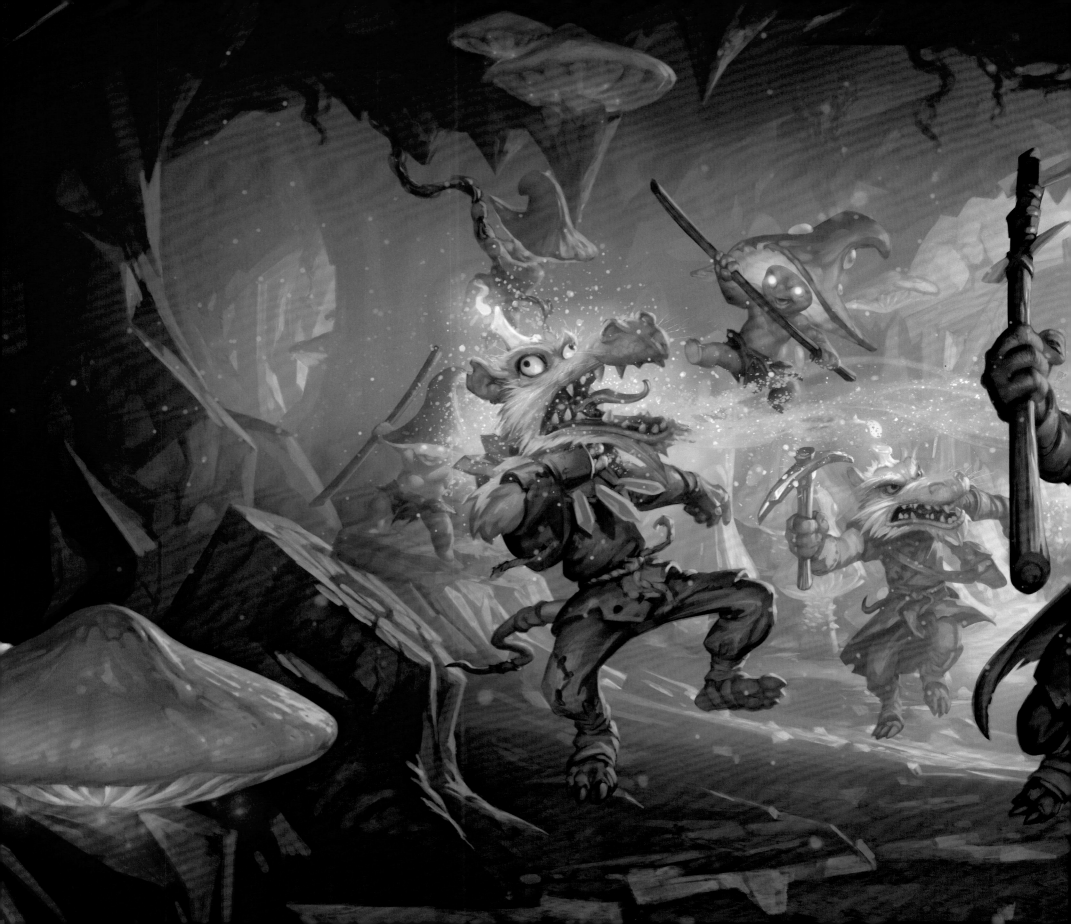

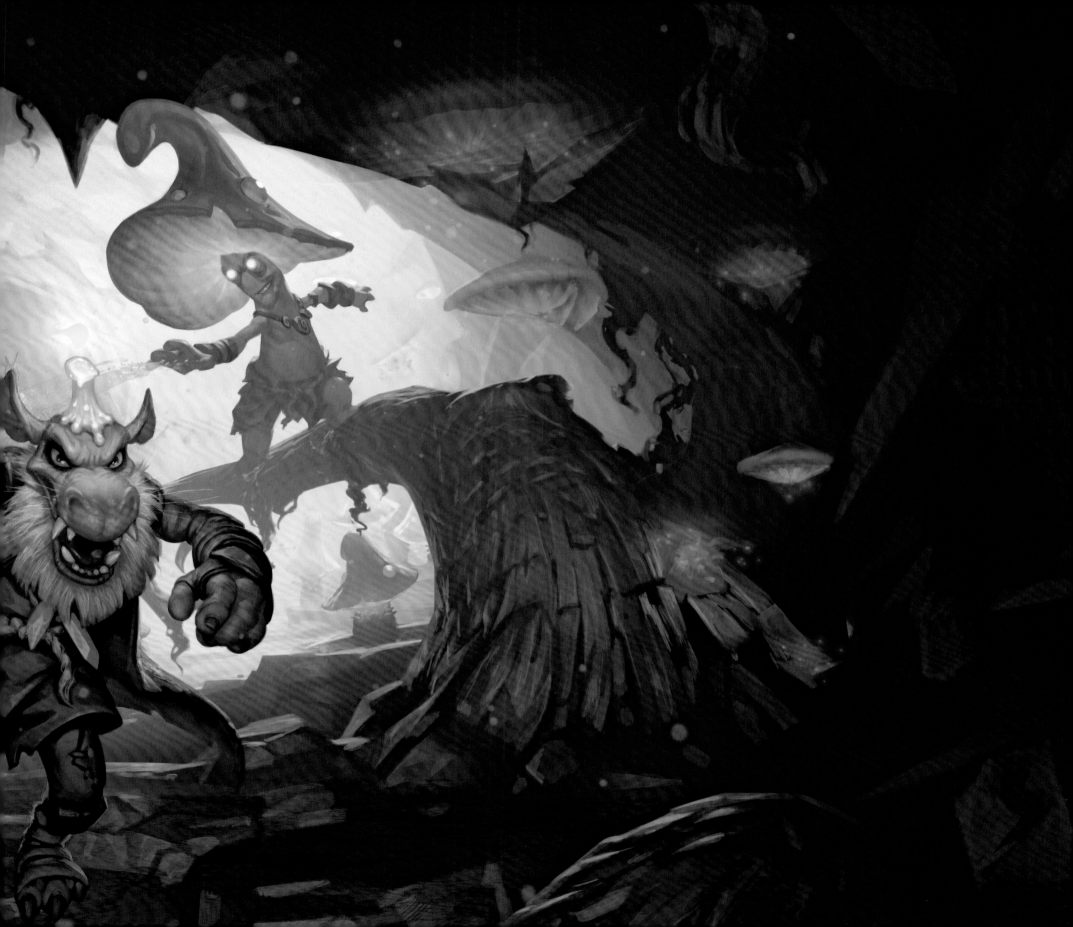

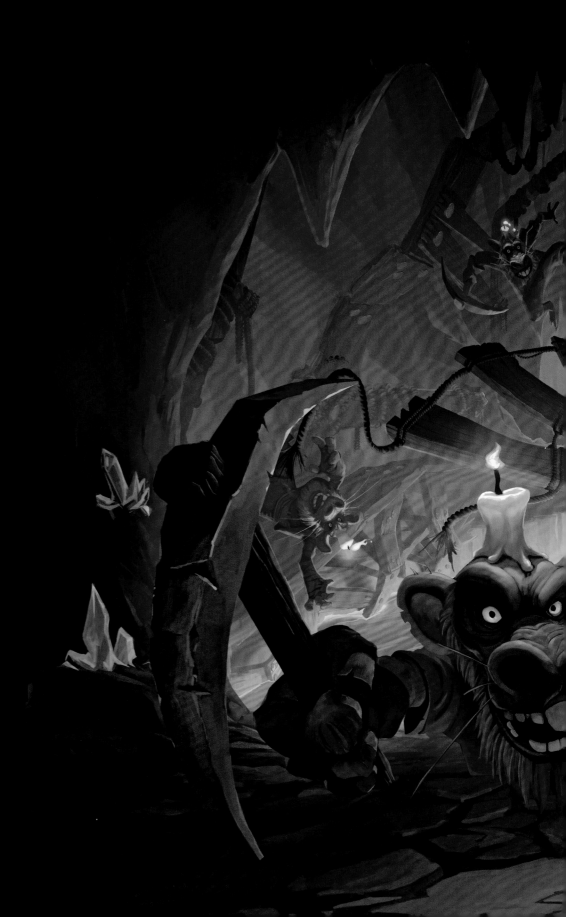

You've sought after wealth,
will you lose all your health . . .
to Kobolds and Catacombs?

—A<small>DVENTURING</small> S<small>ONG</small>

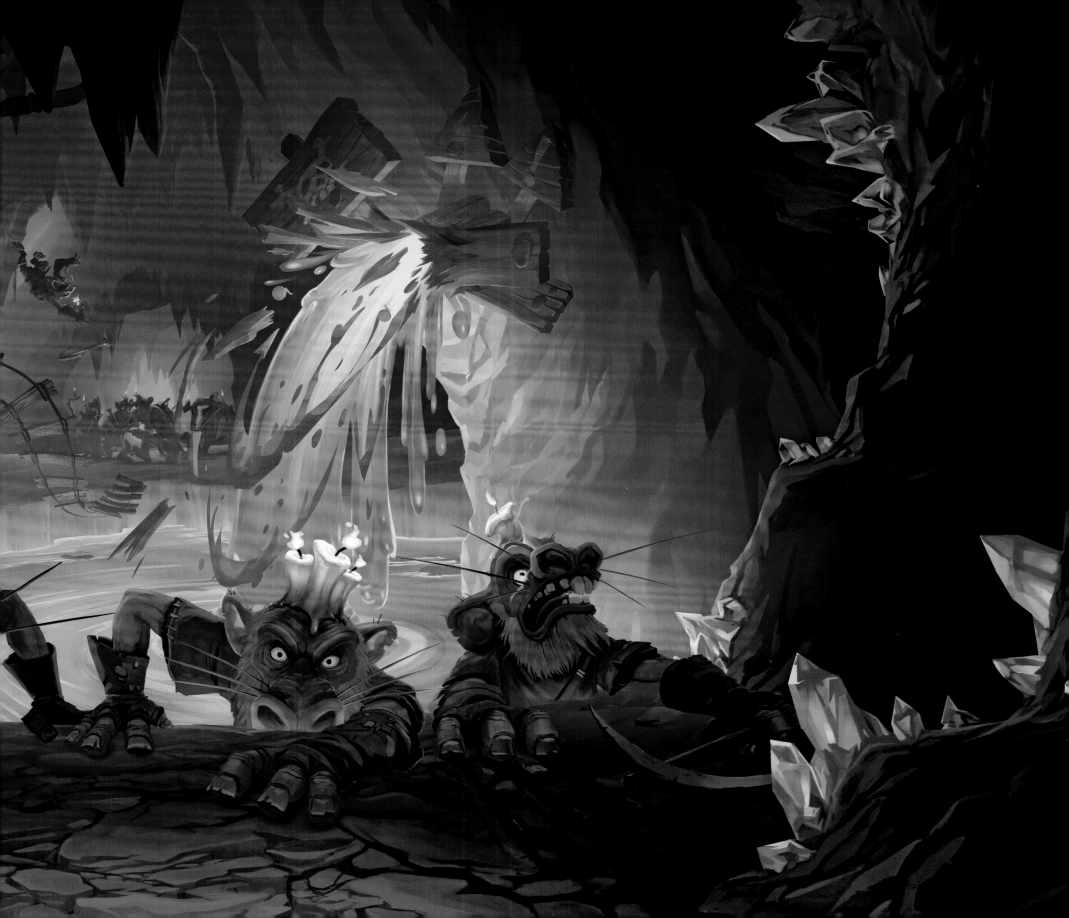

OPPOSITE
Ideation on *Kobolds & Catacombs* logo

RIGHT
The final *Kobolds & Catacombs*
card pack art

TOP
Randomized contents inside the
game board treasure chest

ABOVE
Kobolds & Catacombs store interface

OPPOSITE
Final *Kobolds & Catacombs* game board

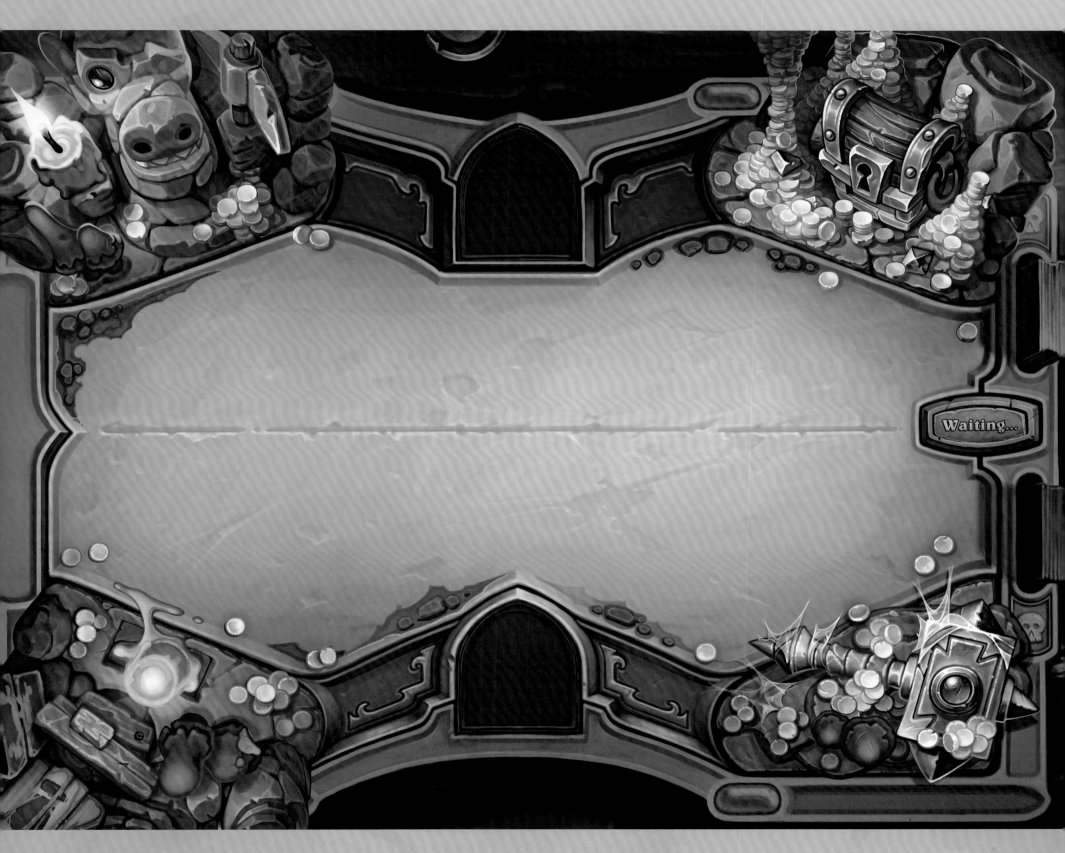

Waiting...

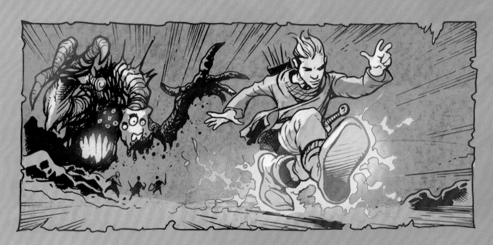
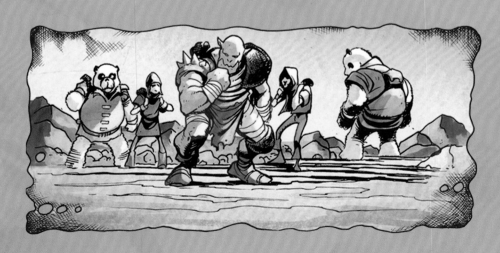
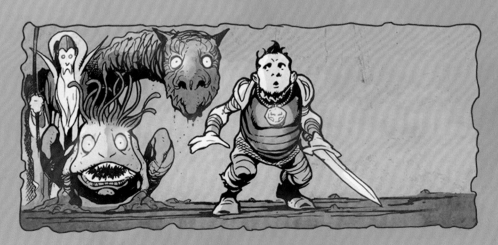

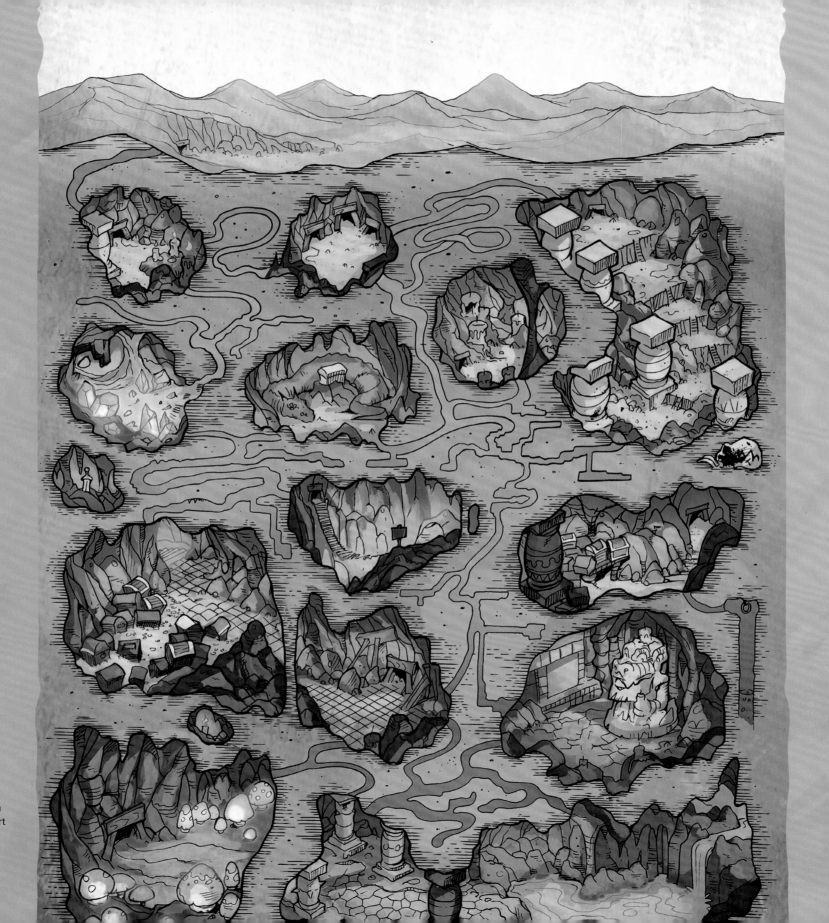

THE ALL-DUNGEON

Following up *Knights of the Frozen Throne* with *Kobolds & Catacombs* was a deliberate shift in tone. The *Hearthstone* team had just sent players to the top of Icecrown Citadel, and now they were dropping them into the depths of haphazard tunnels ruled by kobolds. It felt instantly funny. "To us, anyway," said senior art manager Jeremy Cranford. "But it gave us the perfect environment for the set."

In Warcraft, kobolds are fodder. They're easy enemies for low-level players, teaching them how to handle combat in Azeroth while showing them the dangers of engaging too many at once. They're also very, very persistent at getting where they want to go, and they have the uncanny ability to pop out of the ground where you'd least expect.

"The kobolds you ran into previously in *WoW* were just the ones at the top of the anthill. They're a tunneling race," said creative director Ben Thompson. "Imagine what a kingdom, an *empire*, built by kobolds would look like. They'd dig in every direction just because they could. They'd steal whatever they could steal. They wouldn't know what to do with it, but that was fine with us . . . and for anyone coming to steal it back from them."

Did you find a room full of lava? The kobolds must have dug too deep. A sleeping dragon protecting its hoard? The kobolds must have tunneled into its lair and wisely retreated without taking too many shinies. A room packed with legendary weapons? The kobolds must have been ordered to bring them here after stealing them for His Eminent Waxiness, **King Togwaggle**.

The possibilities were endless and allowed for a gigantic amount of freedom for artists and designers.

"Not many of the characters in this set already existed in Warcraft," said senior concept artist Charlène Le Scanff. "We had to be very faithful for *Knights of the Frozen Throne*, but here, we just had to set some design boundaries."

Those boundaries consisted mostly of environment and character explorations in the style guide. *World of Warcraft* players were only used to the look of one basic kind of kobold: a pickax-wielding, candle-hat-wearing, squat little creature. The style guide showed how different tribes of kobolds might have adopted different looks or fighting abilities from their different underground environments.

"The environments needed to have discarded pickaxes or other digging tools visible to show that kobolds had been there," said Le Scanff. "Players don't need to know the backstory of every piece of art, but keeping to some sort of internal logic helps with consistency."

The dungeon took shape with many classic RPG ingredients: dangerous enemies, rival adventurers, sweet loot, and traps. Hearthstone's artists brought them all to life—one crazy illustration at a time.

"It needed to be a grab bag of art. You might encounter *anything* down here," said Cranford.

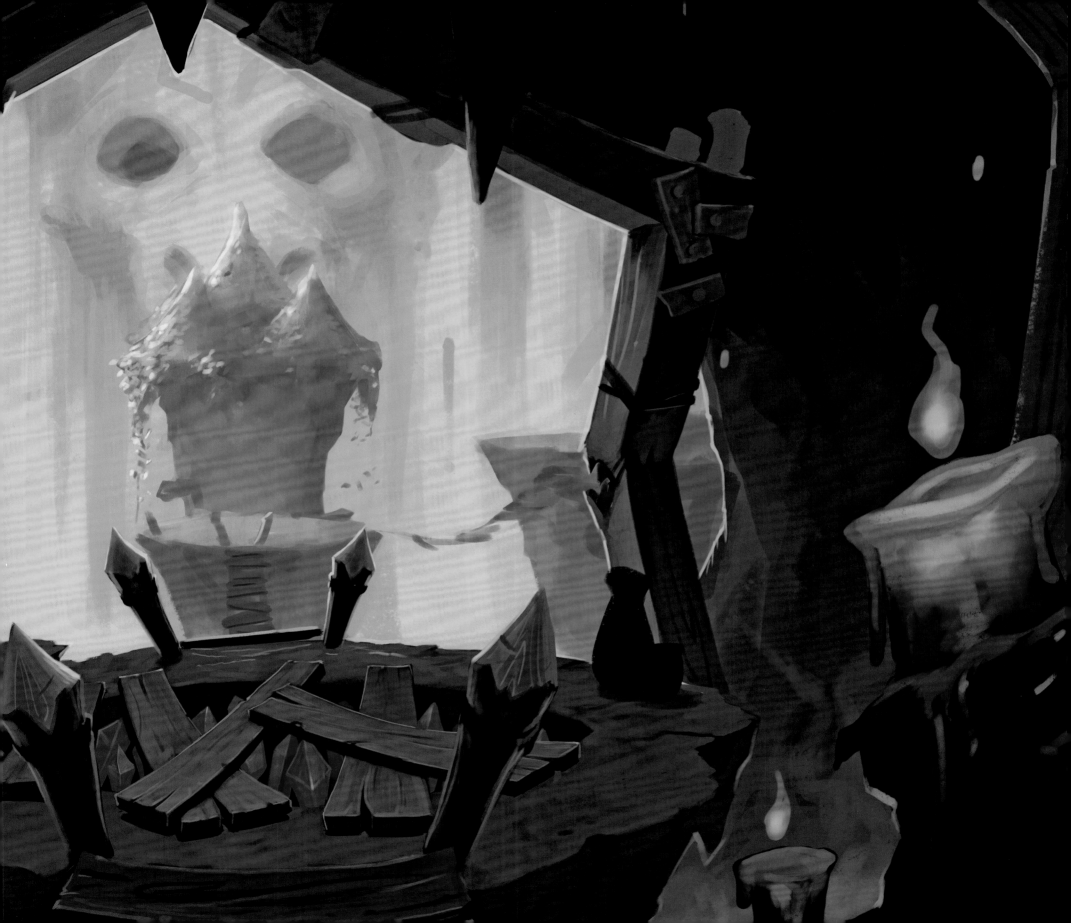

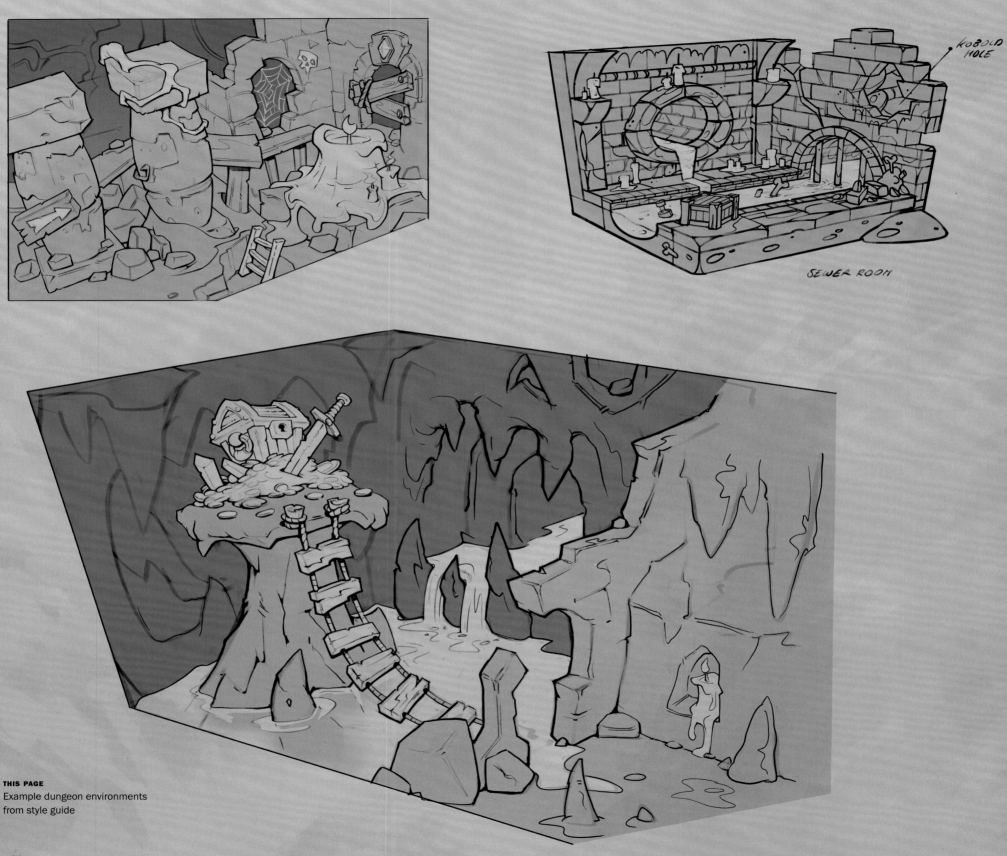

KOBOLD HOLE

SEWER ROOM

THIS PAGE
Example dungeon environments
from style guide

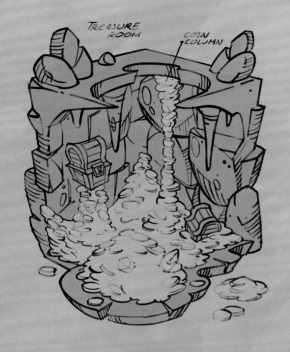

TREASURE ROOM

COIN COLUMN

GIANT MUSHROOMS CAVE

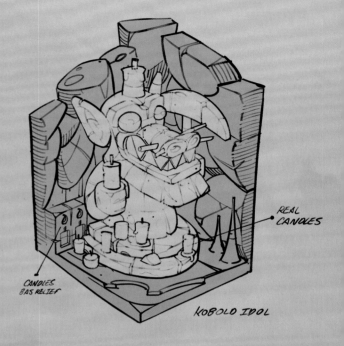

REAL CANDLES

CANDLES BAS RELIEF

KOBOLD IDOL

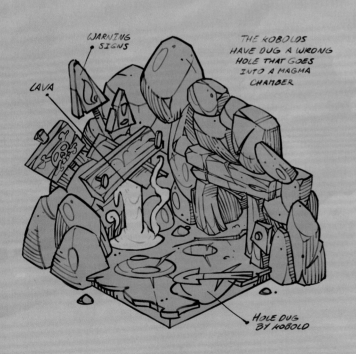

WARNING SIGNS

LAVA

THE KOBOLDS HAVE DUG A WRONG HOLE THAT GOES INTO A MAGMA CHAMBER

HOLE DUG BY KOBOLD

GIANT CRYSTALS CAVE

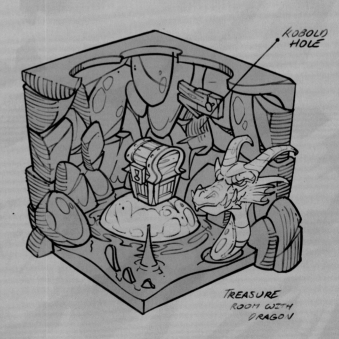

KOBOLD HOLE

TREASURE ROOM WITH DRAGON

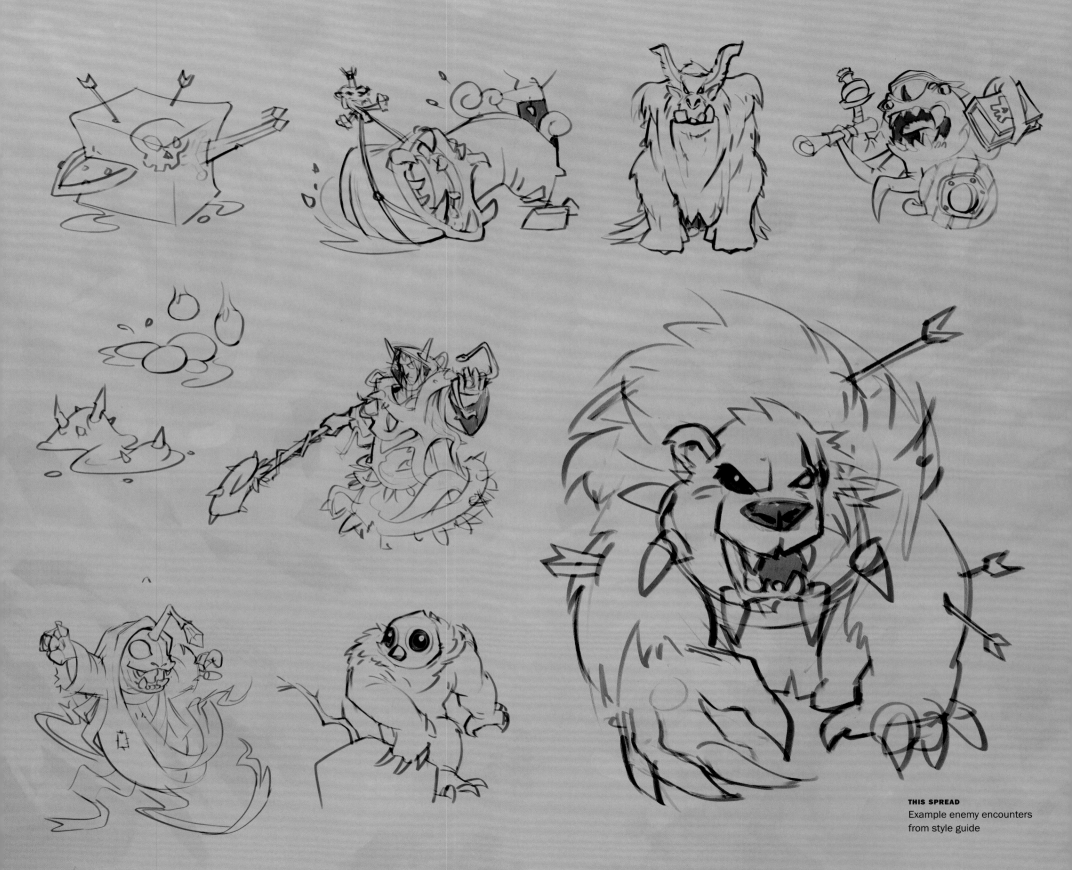

THIS SPREAD
Example enemy encounters
from style guide

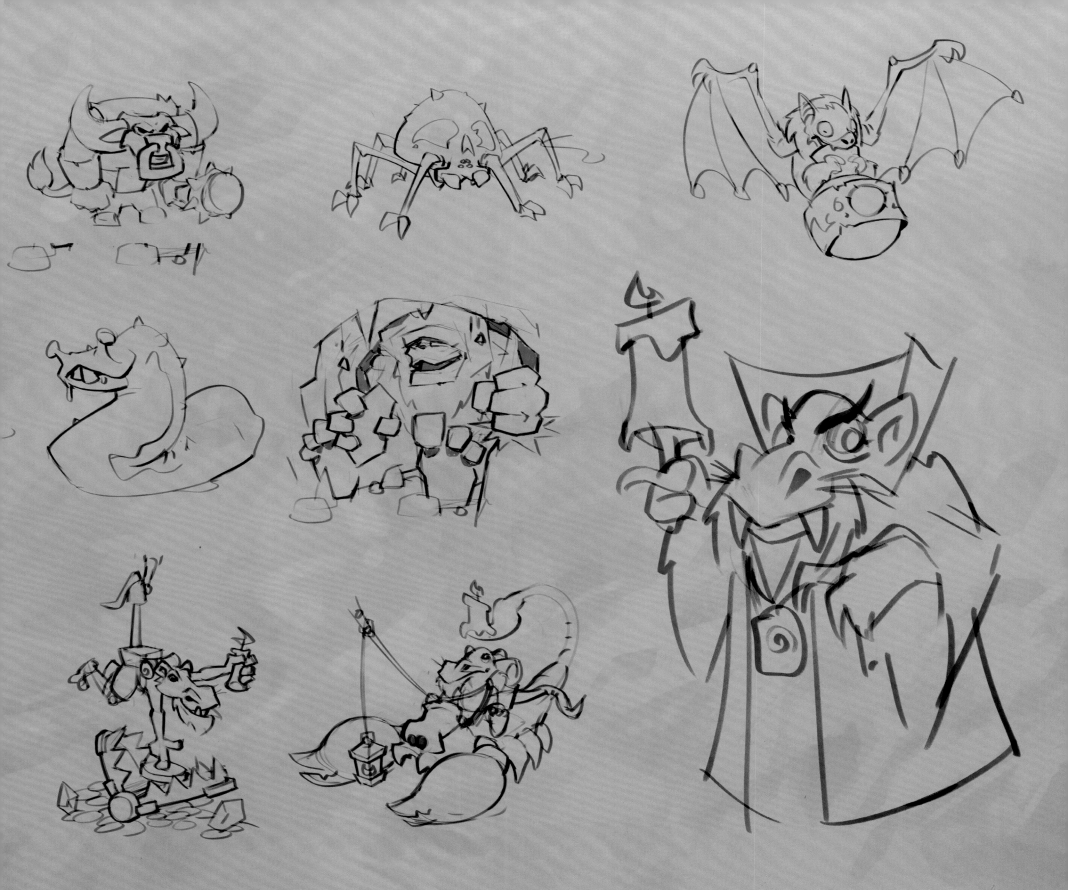

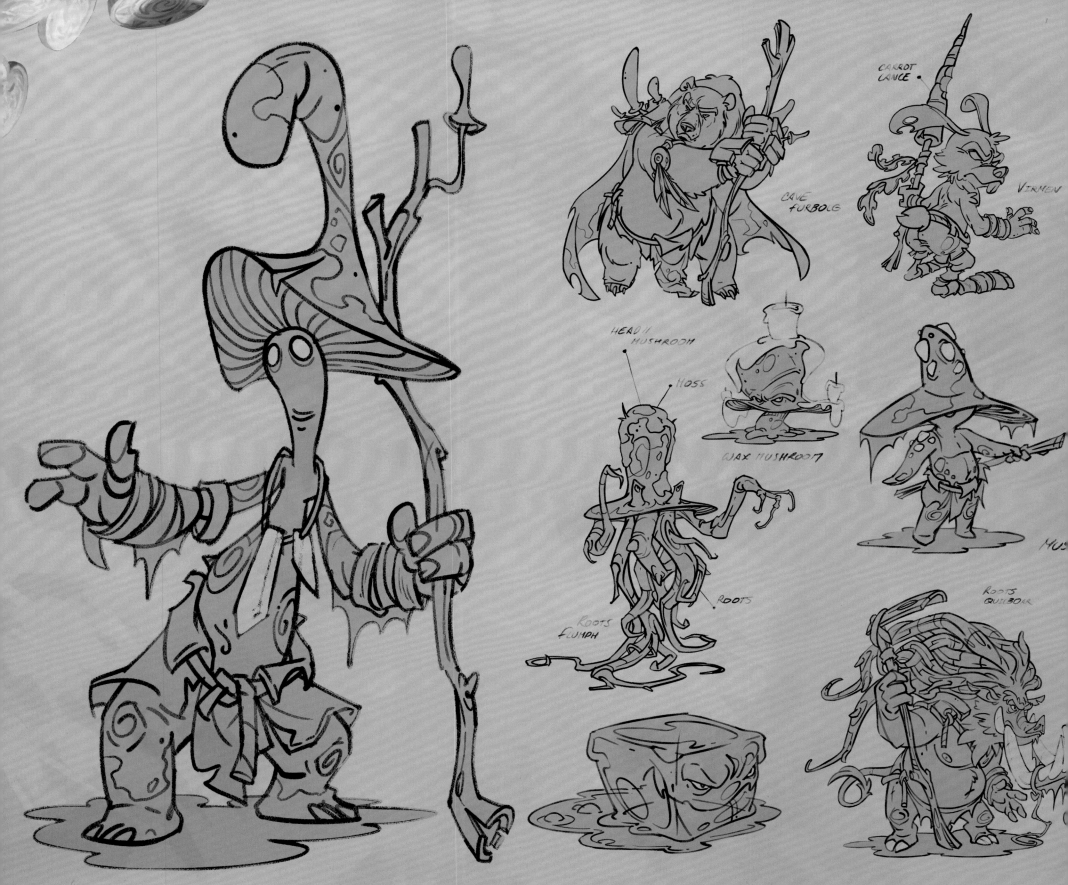

CAVE
FURBOLG

CARROT
LANCE

VIRMEN

HEAD"
MUSHROOM

MOSS

WAX MUSHROOM

ROOTS

ROOTS
FLUMPH

ROOTS
QUILBOAR

MUS

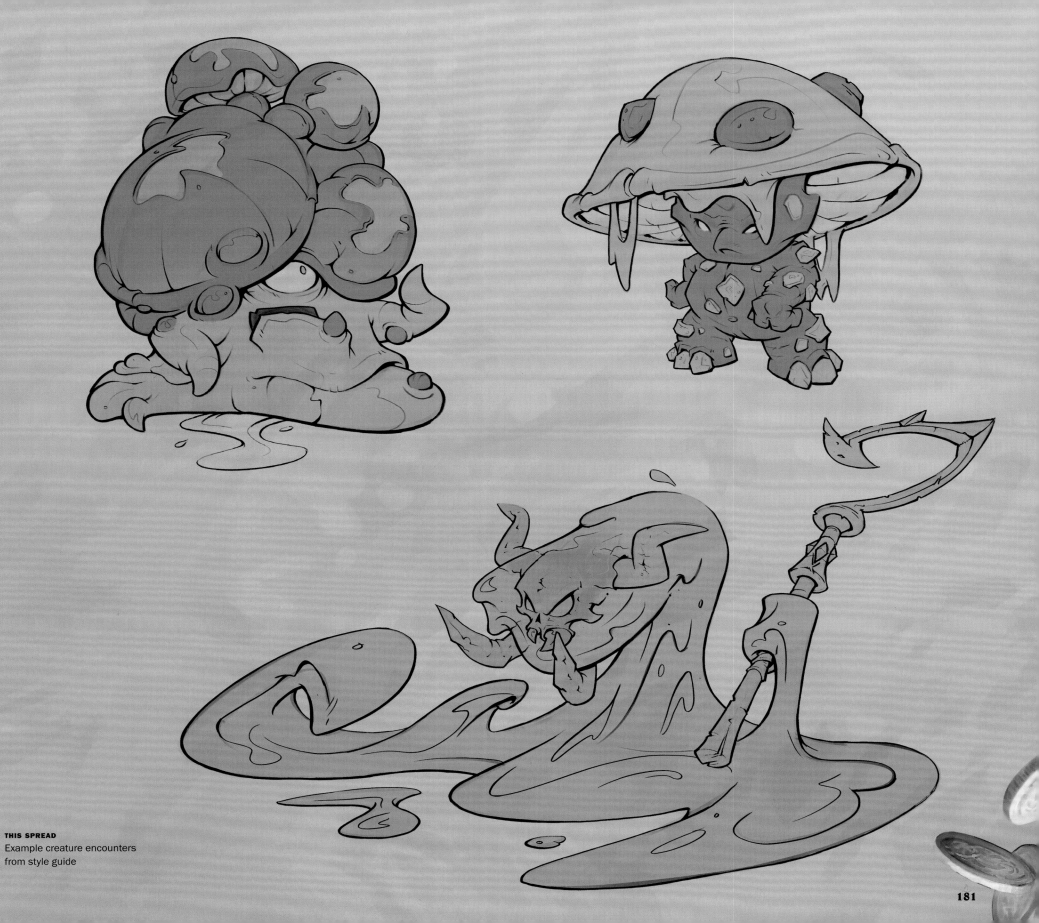

THIS SPREAD
Example creature encounters
from style guide

181

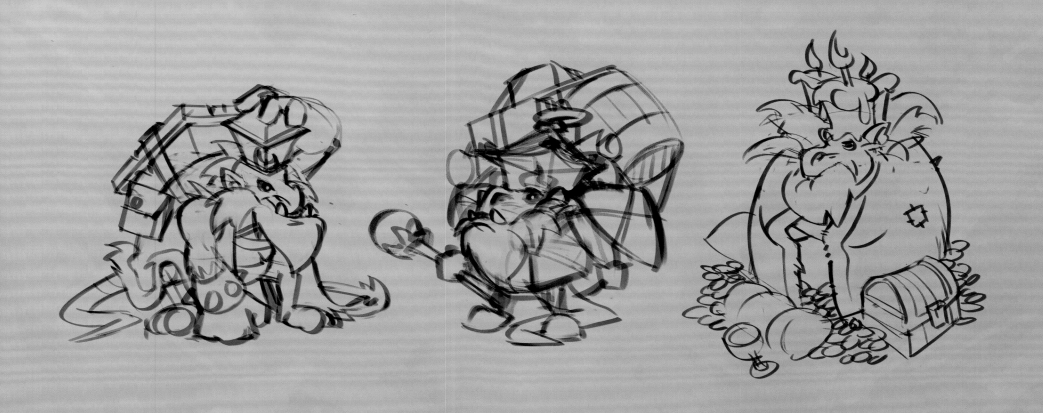

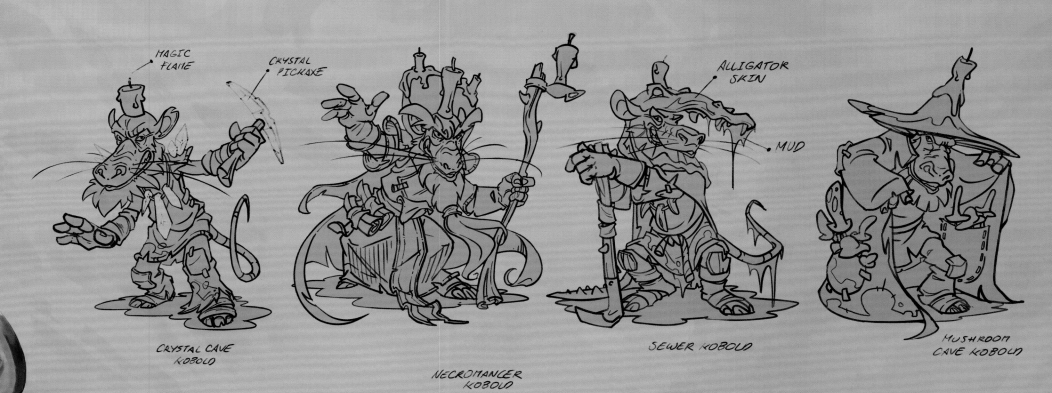

MAGIC FLAME

CRYSTAL PICKAXE

ALLIGATOR SKIN

MUD

CRYSTAL CAVE KOBOLD

NECROMANCER KOBOLD

SEWER KOBOLD

MUSHROOM CAVE KOBOLD

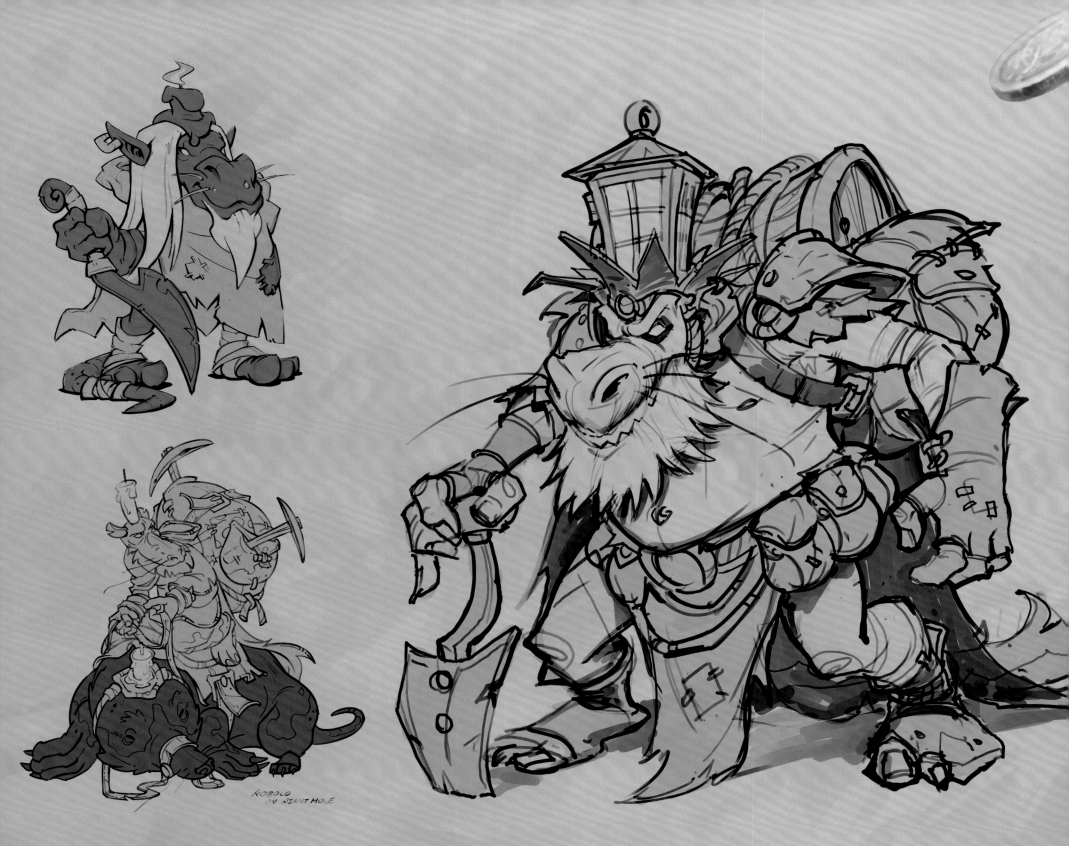

KOBOLD
ON GIANT MOLE

THIS SPREAD
Kobold ideation from style guide

GIMME THE LOOT!

Many of the illustrations used in the collectible card set pulled double duty in the final release of the game. Legendary minion **The Darkness** was not just one of the most unusual cards ever released into Standard mode but was also one of the final bosses of the Dungeon Run mode.

"I was warned that it would be a very powerful card, which put a little pressure on me," said Ludo Lullabi, who worked on the art with Konstantin Turovec. When it came to establishing the character's massive size, finding the correct pose and composition were key. "For this type of illustration, I try to occupy as much space as possible. You can also play with scale by adding elements to the foreground. For example, on The Darkness, I added a suspension bridge in front of him to emphasize his greatness."

Nicola Saviori, the artist who created the illustration for **Azari, the Devourer**, said she knew this expansion would use illustrations in unusual ways but was surprised to learn Azari would be used as one of the terrifying final bosses of Dungeon Run.

"They provided me with a new frame in which the image had to work, as well as the usual oval format of Hearthstone's creatures, so I suspected that this image would have a dual purpose," said Saviori. "Fortunately, the different formats are quite similar to each other, and it was not difficult to create an image that would be good for both."

Since most of the cards that would find a second life as dungeon bosses needed to be villainous in nature, establishing their danger upon first glance was always the biggest priority.

"These are portraits, so there's no room for big staging," said Lullabi. "We focus on the character by giving him maximum charisma."

"Attention is everything in this situation," added Turovec. "Players have to understand in a second what kind of card they see. They have no time to think and look on every detail."

Illustrator A. J. Nazzaro, who created cards like **Rin, the First Disciple** and **Xol, the Unscathed**, has a special love for fashioning dark, menacing characters.

"With a character that will be a boss or a legendary card, I can completely cut loose and get lost in all the wonderfully evil details," said Nazzaro. "I like to match the music I listen to while painting to the subject matter. I have playlists galore for these types of characters!"

ABOVE
Murloc Hydra ideation from style guide

OPPOSITE
Cave Lurker concept from style guide

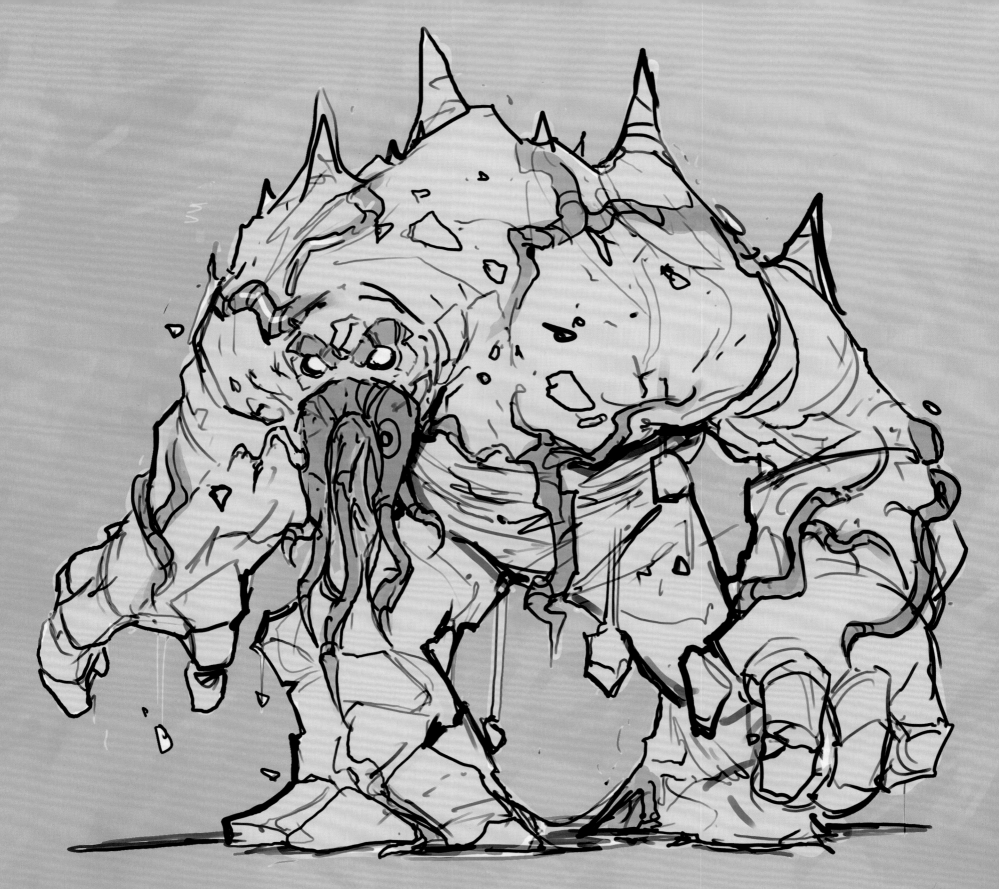

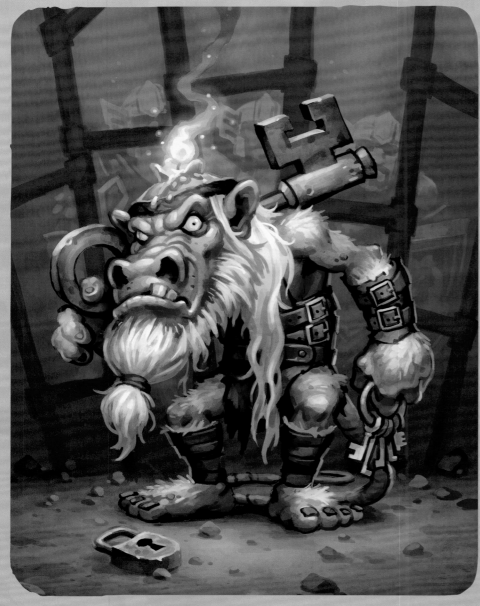

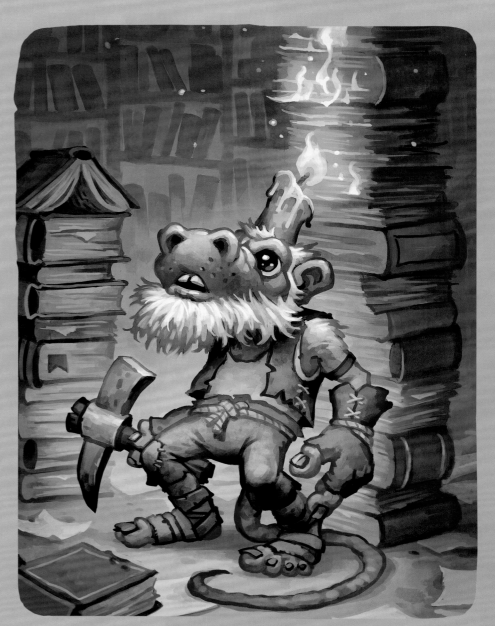

ABOVE
Drycgulch Jailor
Matt Dixon

ABOVE
Kobold Librarian
Matt Dixon

OPPOSITE
Drywhisker Armorer
Jim Nelson

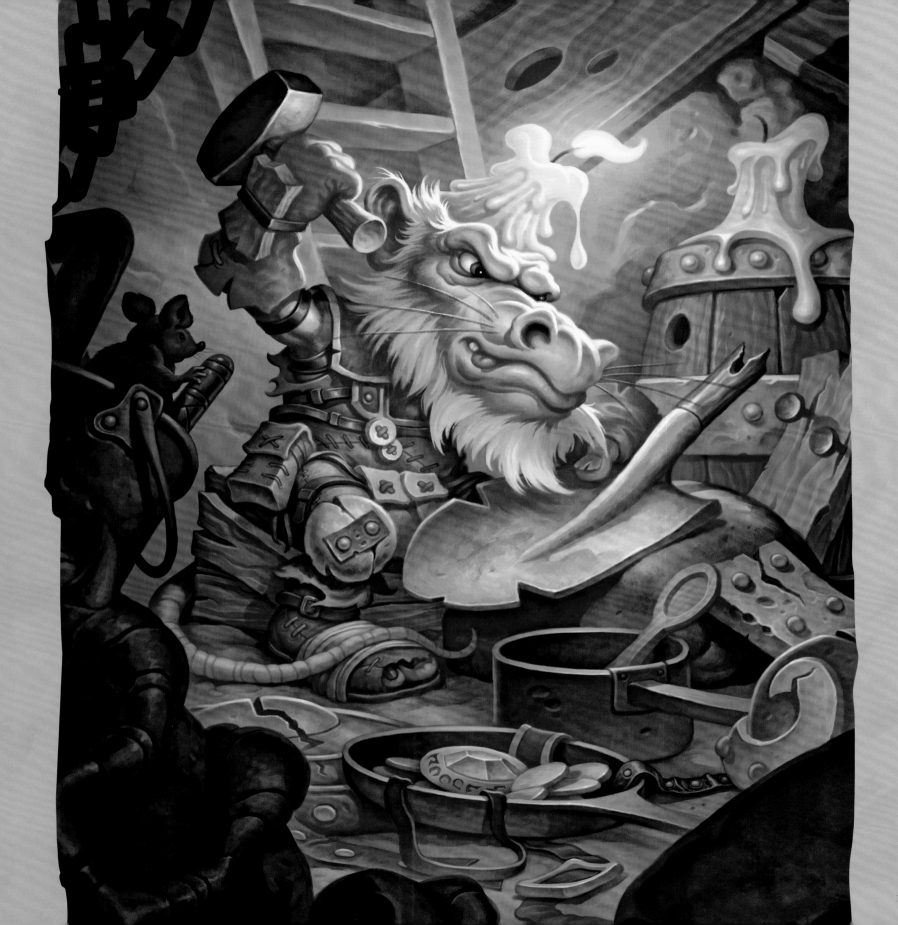

187

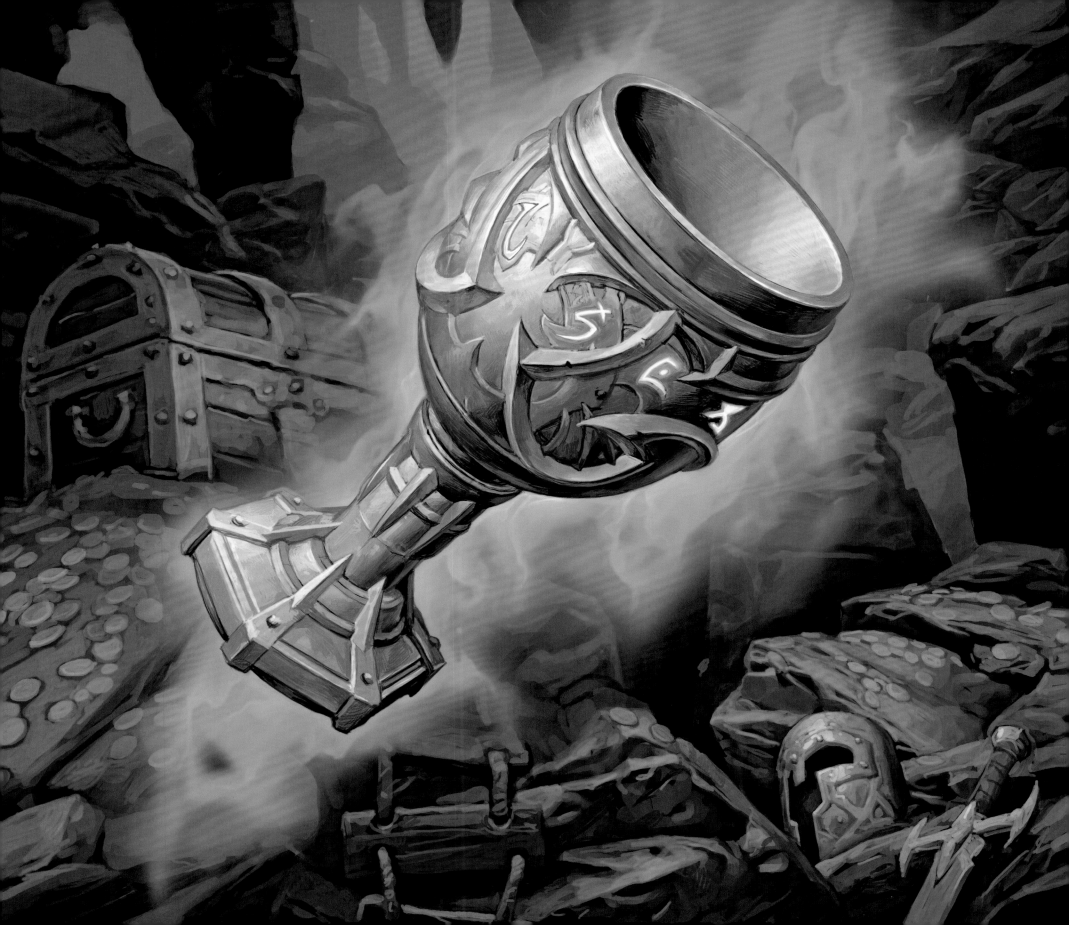

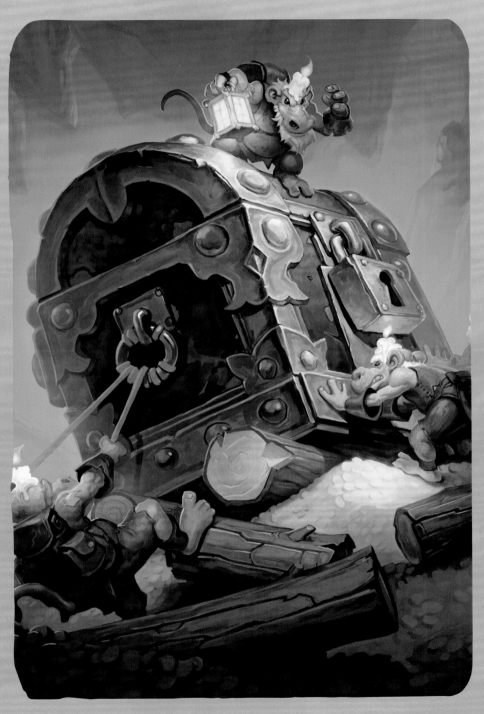

ABOVE
Master Chest
Ludo Lullabi and Konstantin Turovec

OPPOSITE
Tolin's Goblet
Zoltan Boros

ABOVE
Golden Kobold
Zoltan Boros

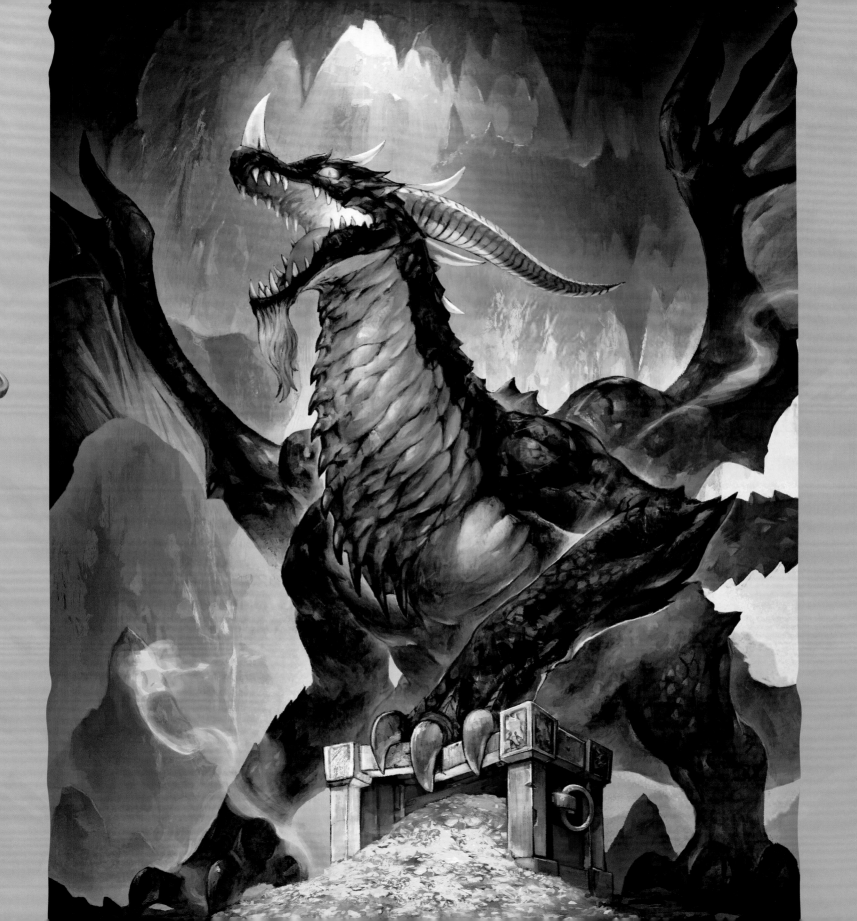

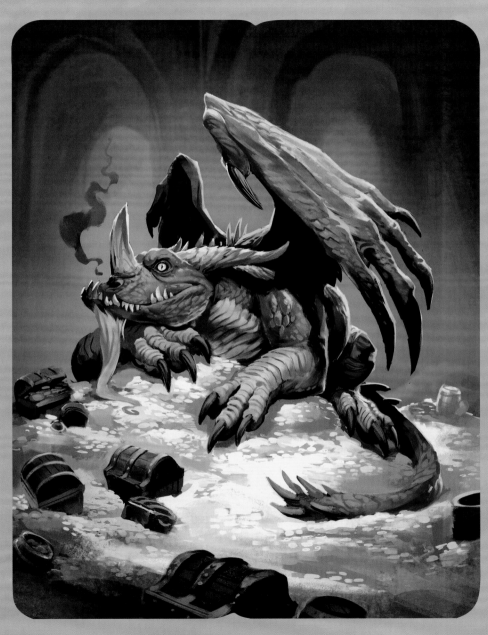

ABOVE
Sleepy Dragon
Sean McNally

OPPOSITE
Hoarding Dragon
Hideaki Takamura

ABOVE
Duskbreaker
Alex Horley

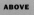

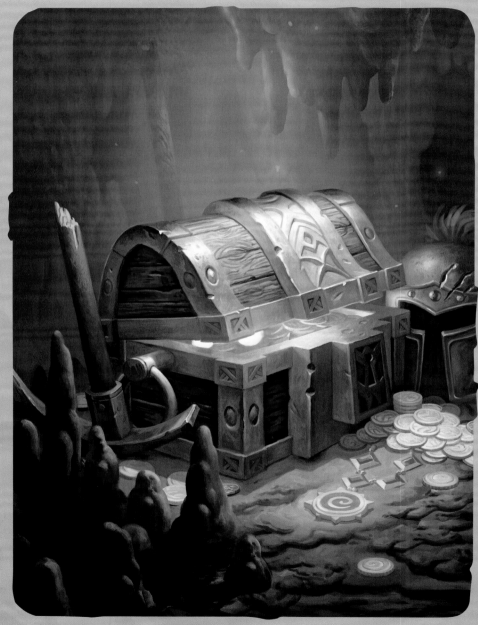

ABOVE
Closed Toothy Chest
Jakub Kasper

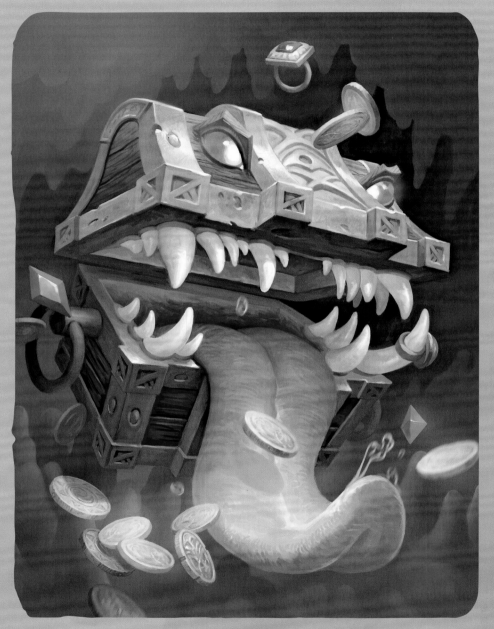

ABOVE
Toothy Chest
Jakub Kasper

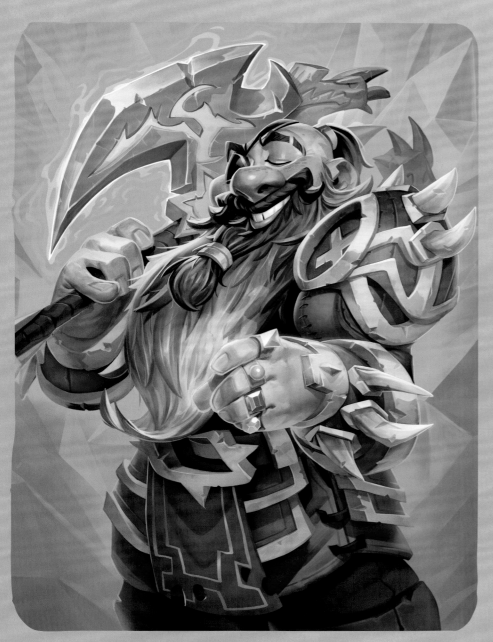

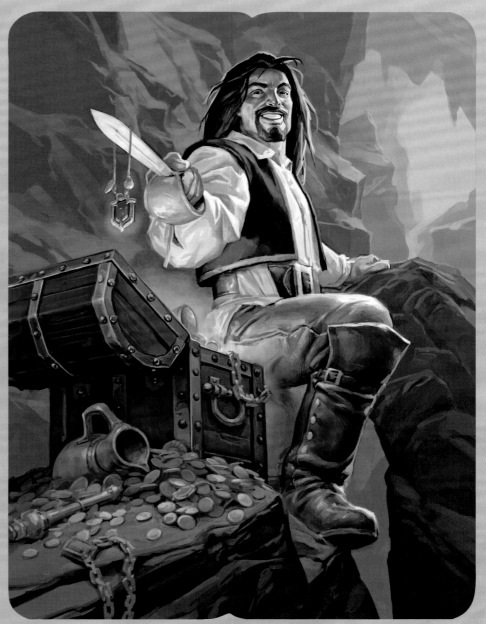

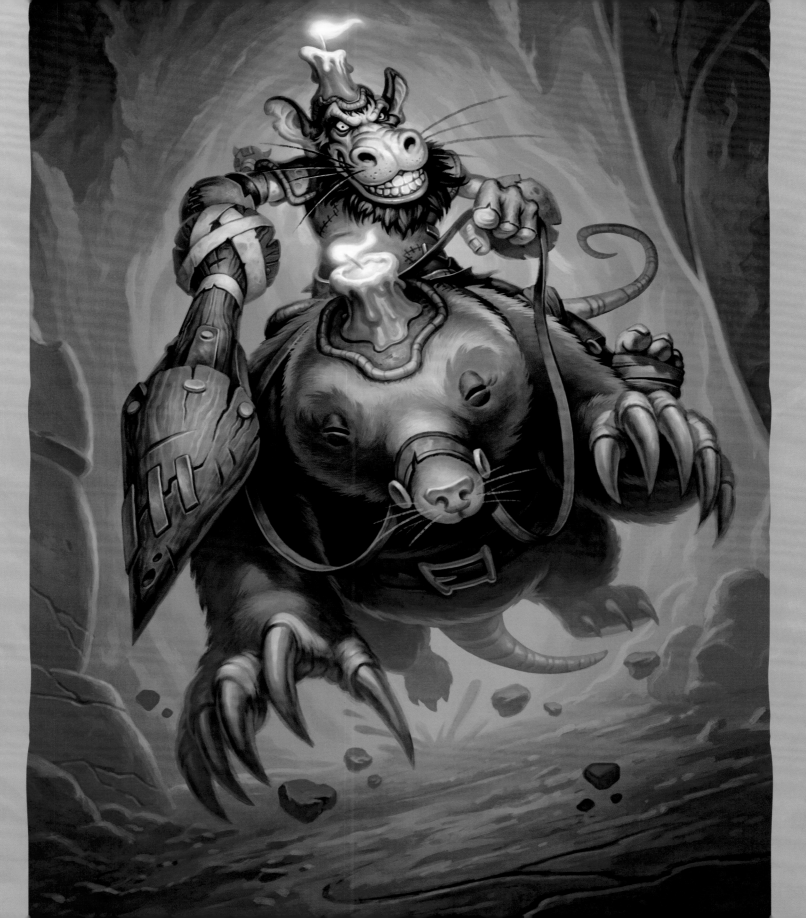

LEFT
Gravelsnout Knight
Jim Nelson

OPPOSITE
King's Ransom
Daria Tuzova

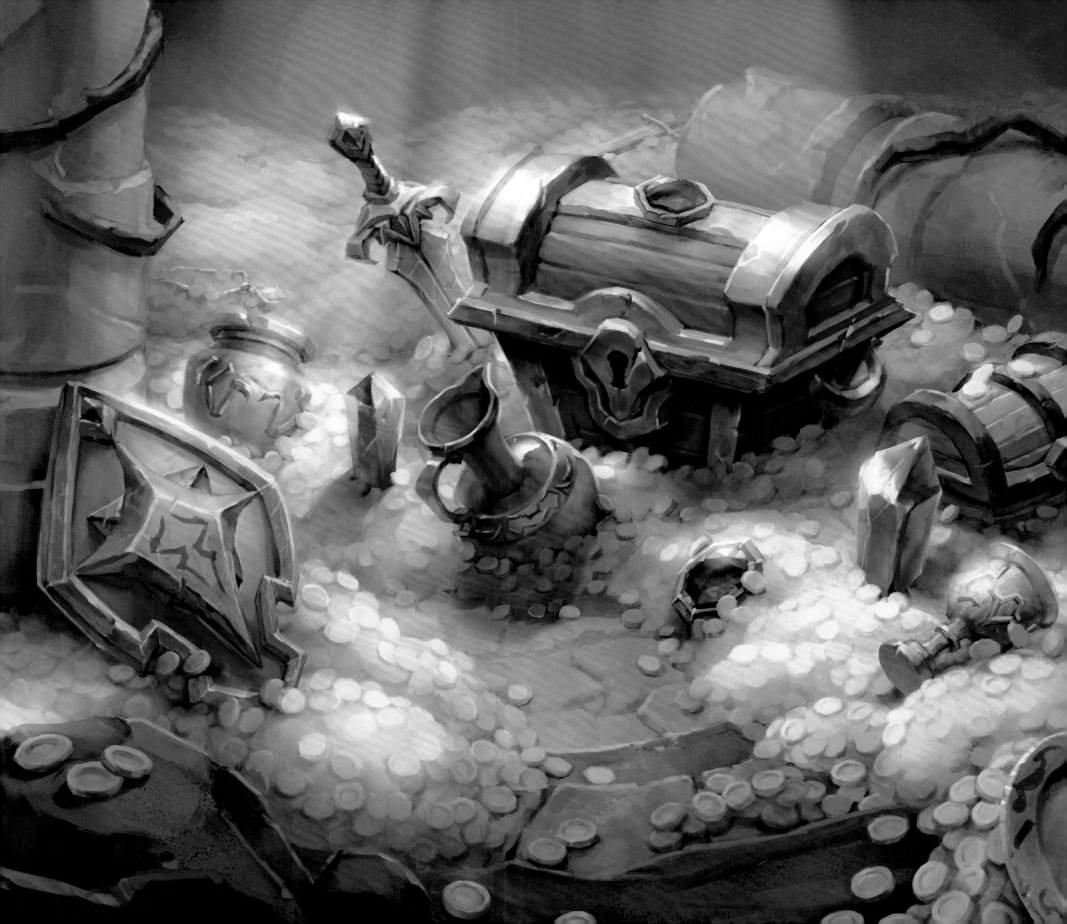

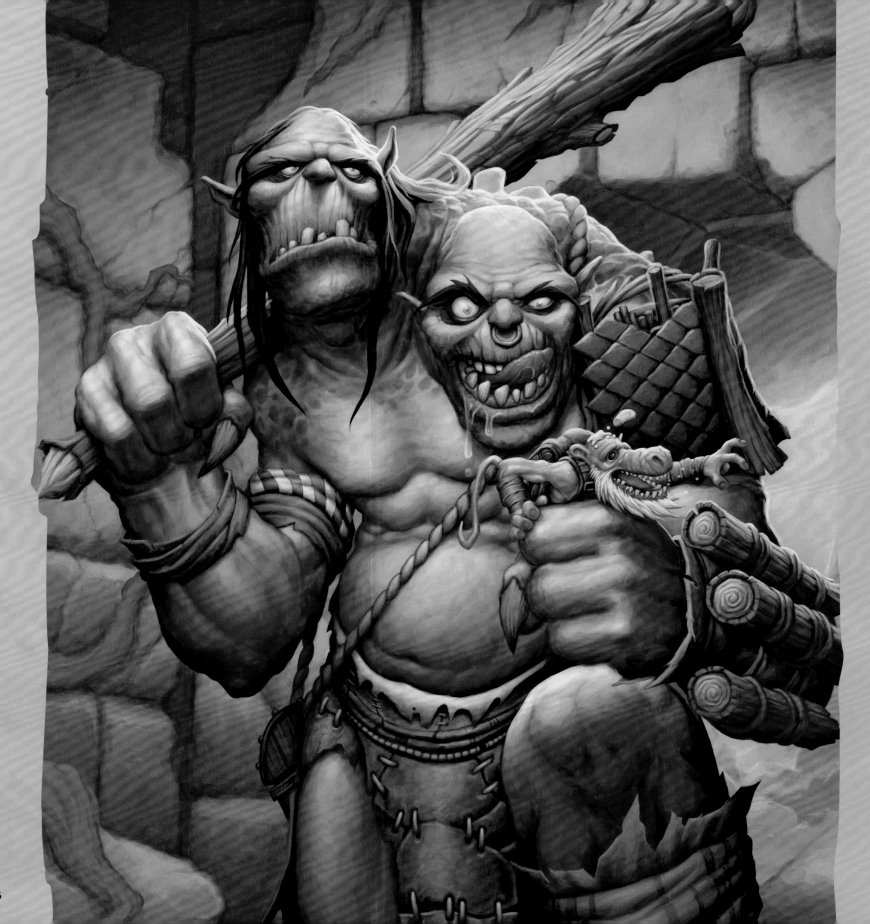

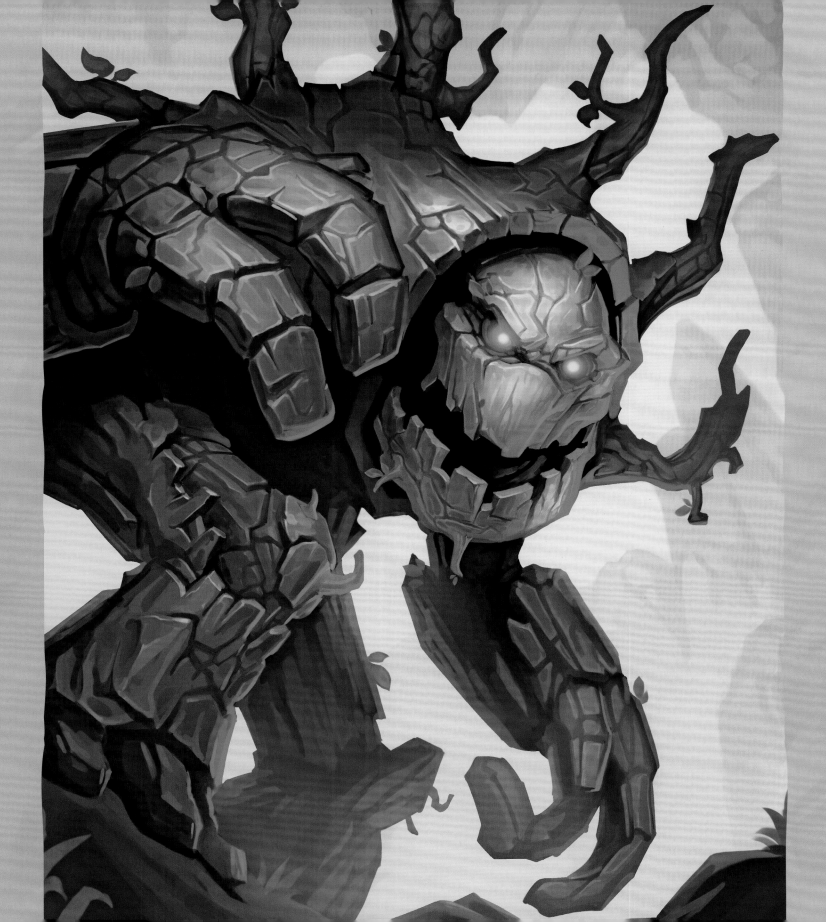

OPPOSITE
Hungry Ettin
Dave Allsop

RIGHT
Ironwood Golem
Ludo Lullabi and
Konstantin Turovec

197

ABOVE
Shrieking Shroom
Matt Dixon

ABOVE
Wax Elemental
Steve Prescott

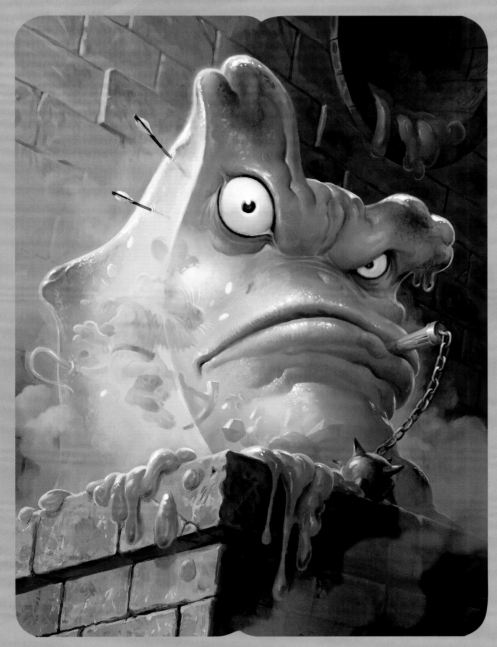

ABOVE
Carnivorous Cube
Jakub Kasper

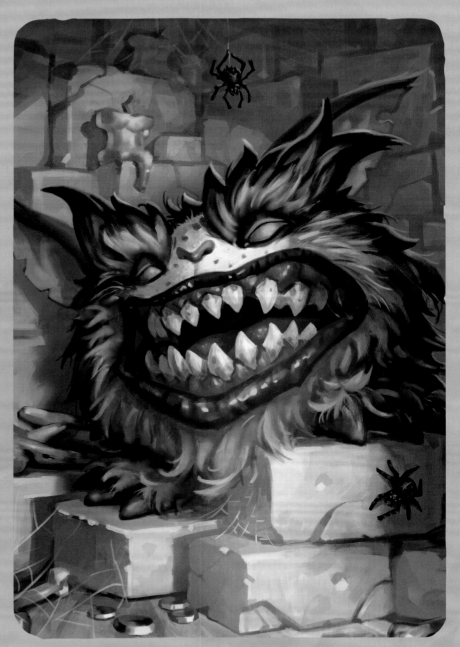

ABOVE
Feral Gibberer
Anton Zemskov

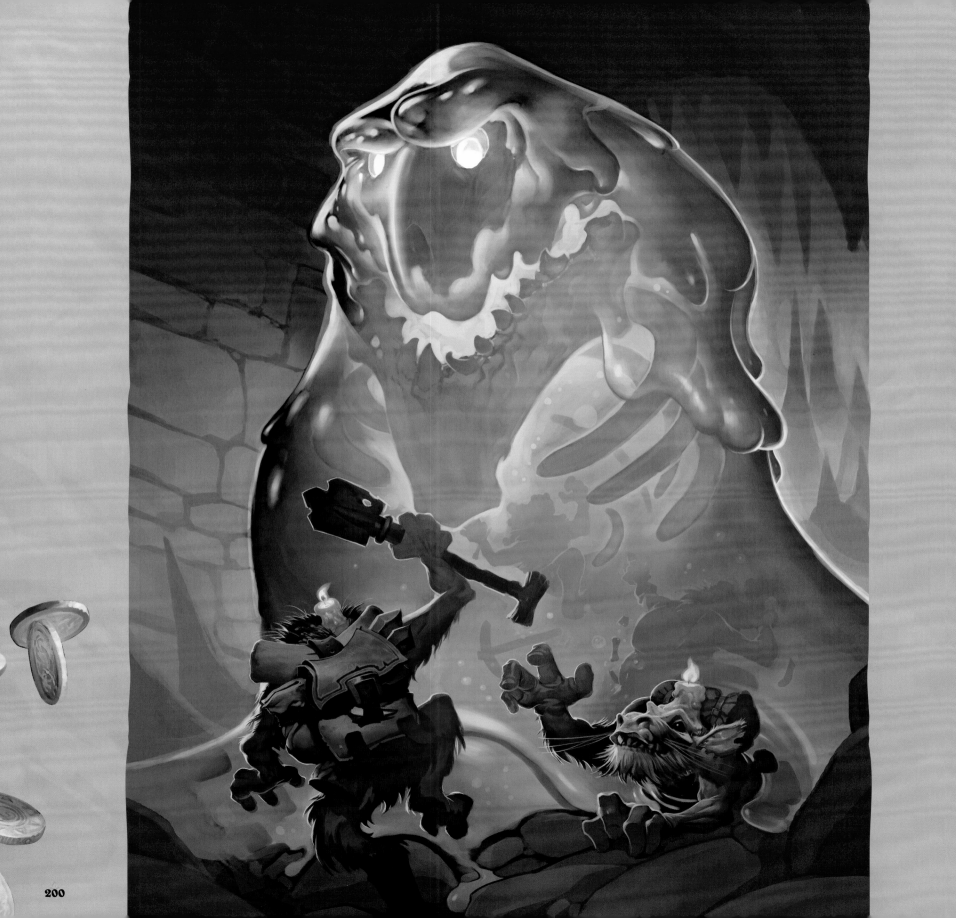

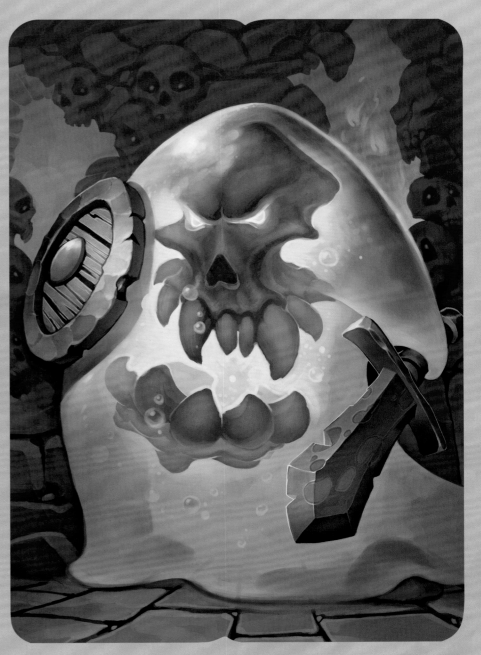

ABOVE
Deadly Spore
Mike Sass

OPPOSITE
Green Jelly
Anton Kagounkin

ABOVE
Green Ooze
Anton Kagounkin

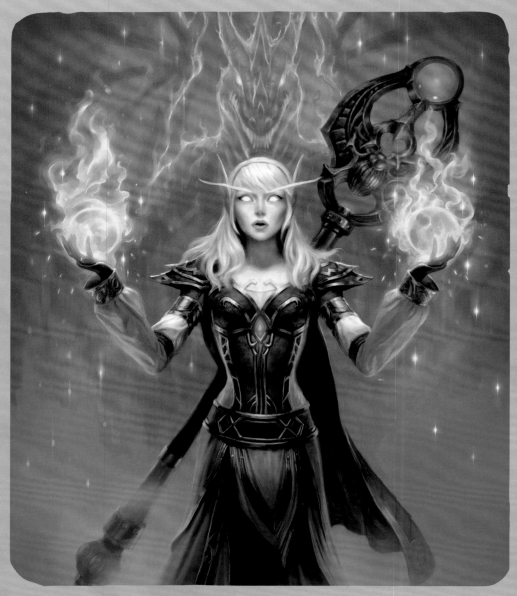

Dragoncaller Alanna
James Ryman

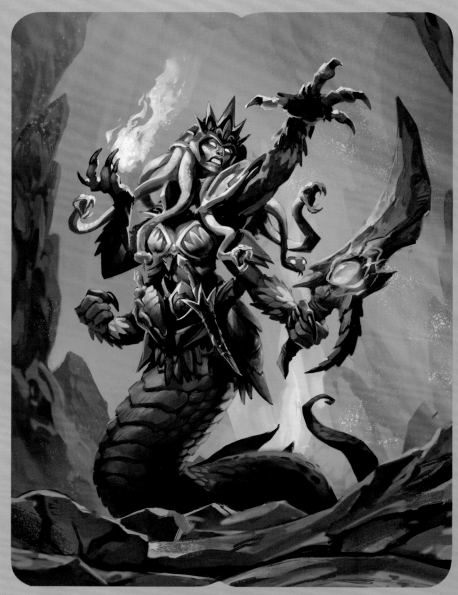

Zola the Gorgon
Sean McNally

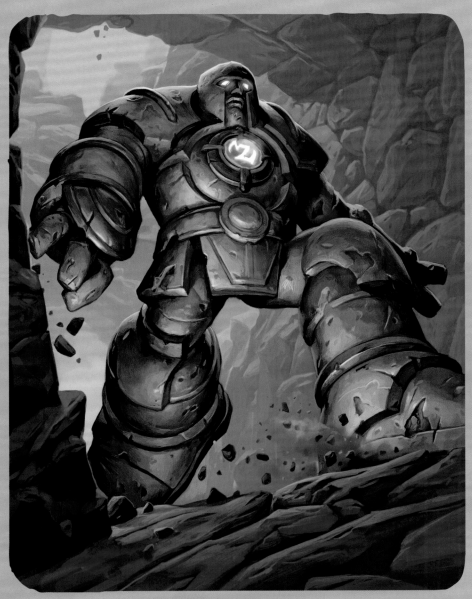

Iron Golem
Zoltan Boros

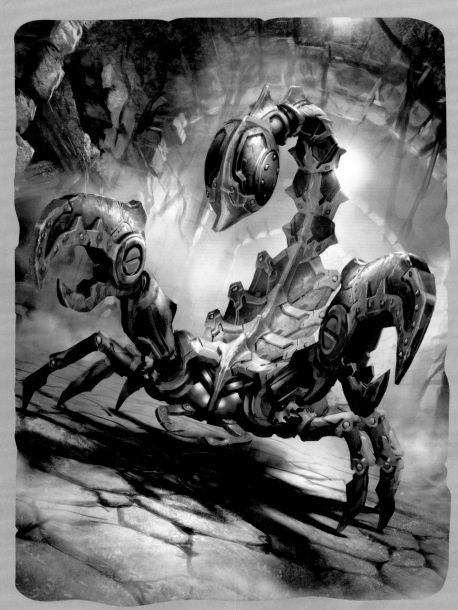

Scorp-o-matic
Phil Saunders

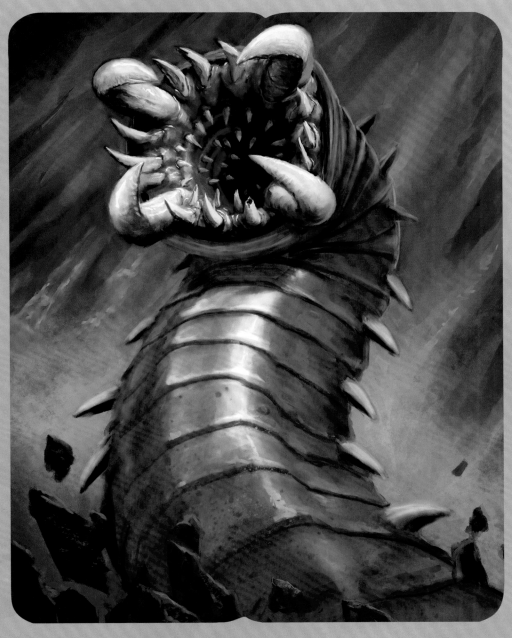

ABOVE
Violet Wurm
Jeremy Cranford

OPPOSITE
Gnosh the Greatworm
Jaemin Kim

ABOVE
Grub
Vladimir Kafanov

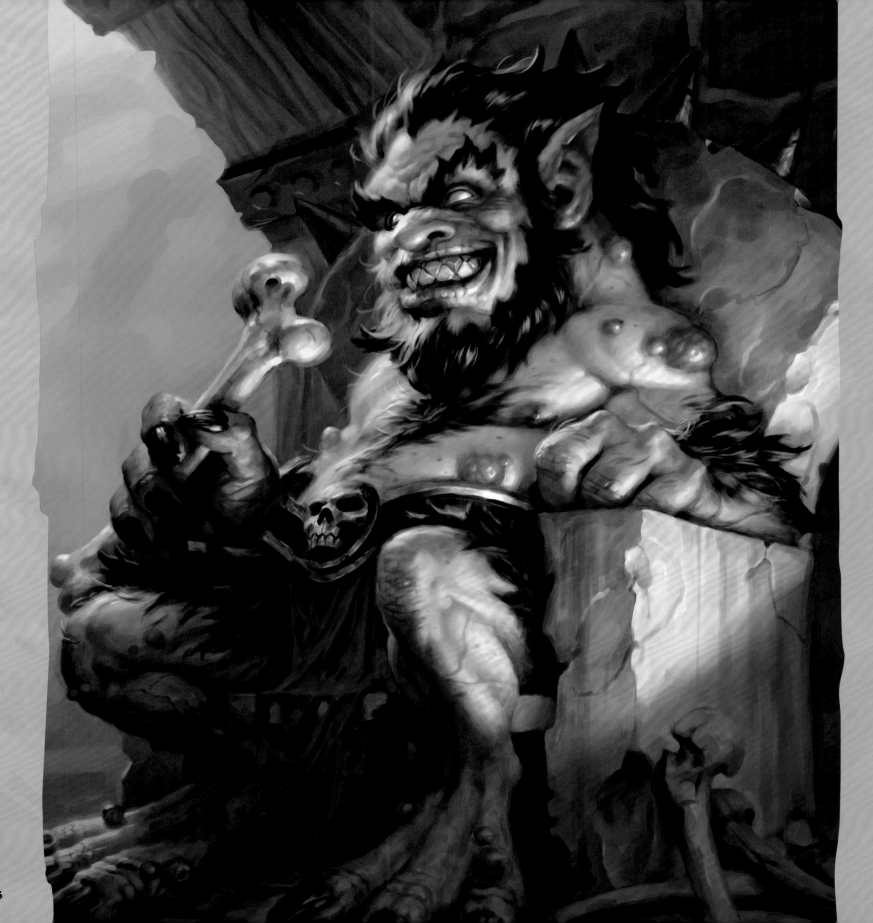

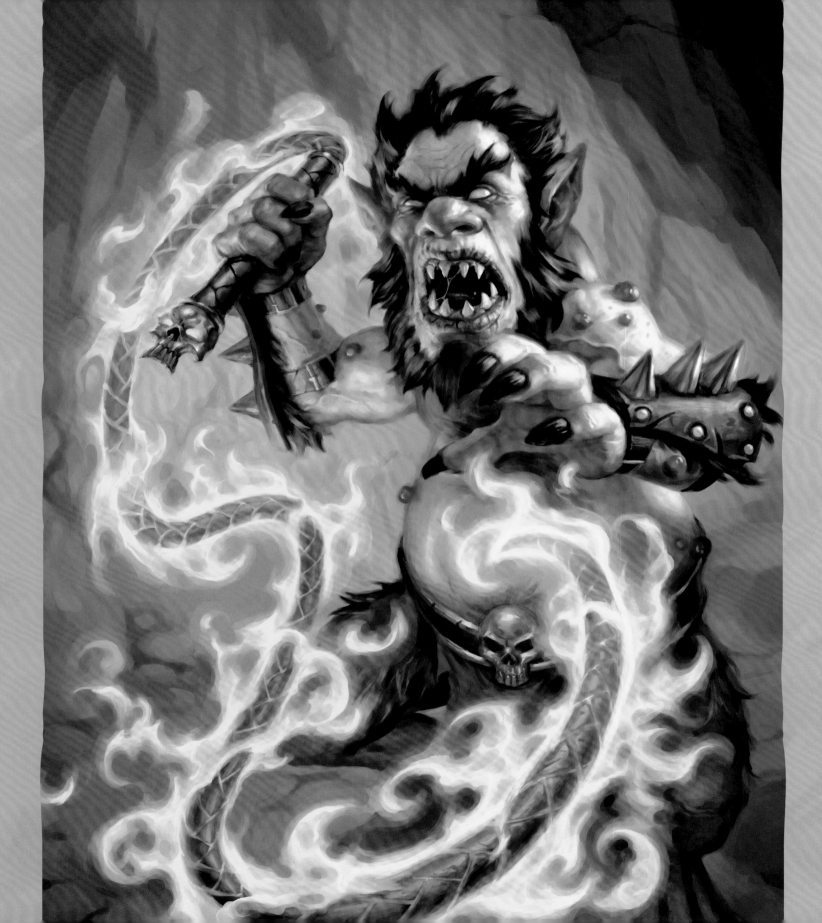

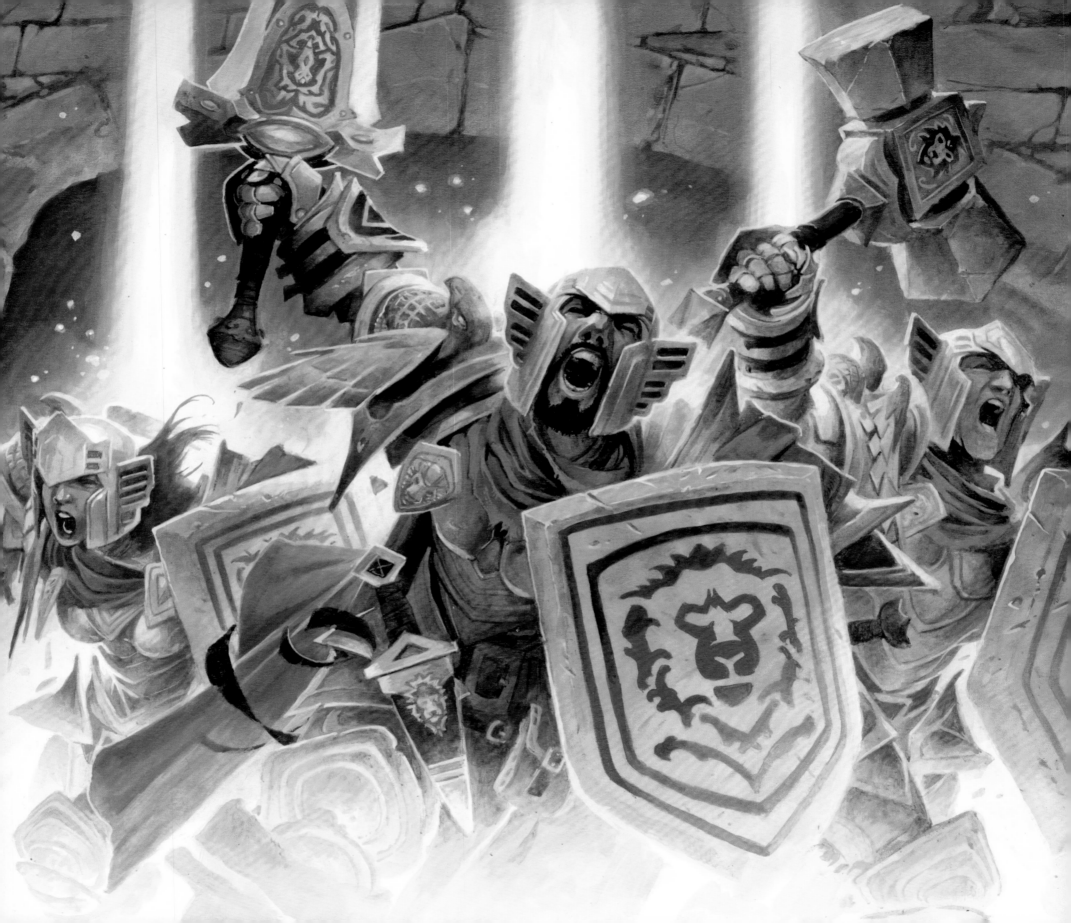

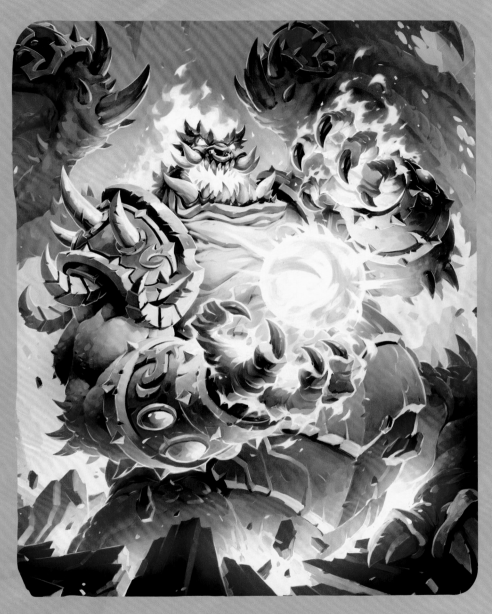

ABOVE
Azari, the Devourer
Nicola Saviori

OPPOSITE
Level Up!
Wayne Reynolds

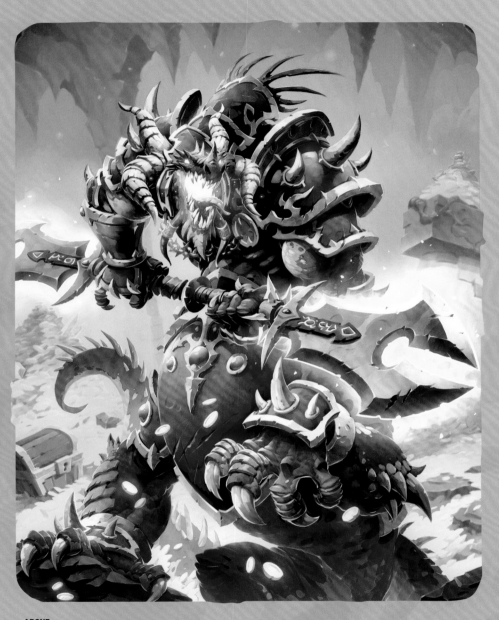

ABOVE
Ebon Dragonsmith
Nicola Saviori

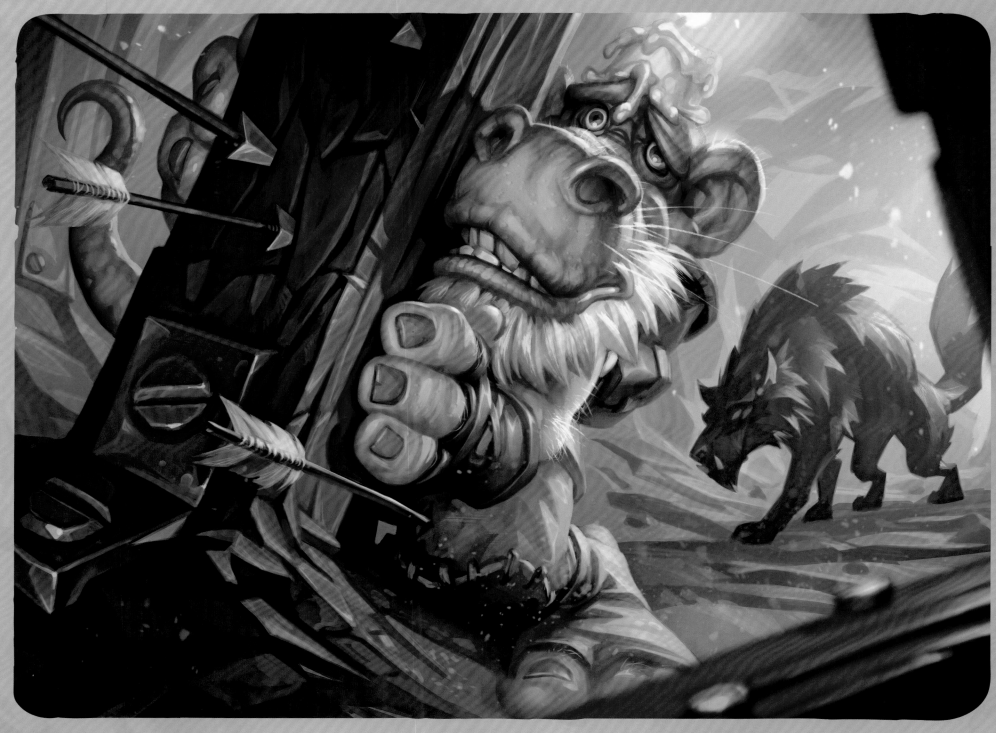

ABOVE
Flanking Strike
Ludo Lullabi and Arthur Bozonnet

OPPOSITE
To My Side!
Peter Stapleton

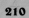

ABOVE
Sewer Crawler
Andrew Hou

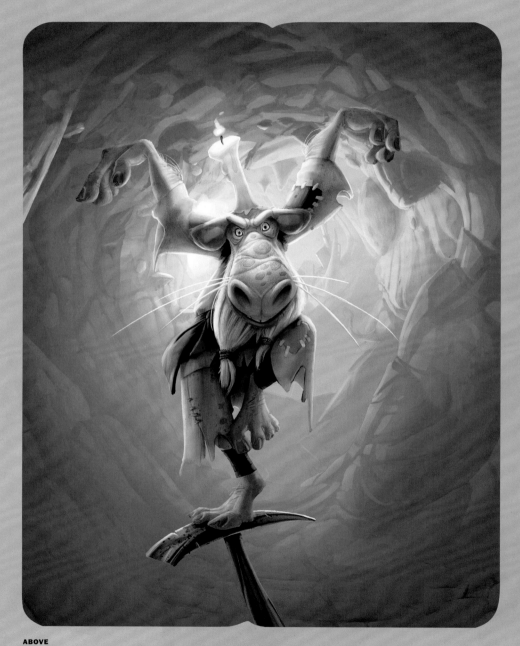

ABOVE
Kobold Monk
Sam Nielsen

OPPOSITE
King Togwaggle
Konstantin Turovec

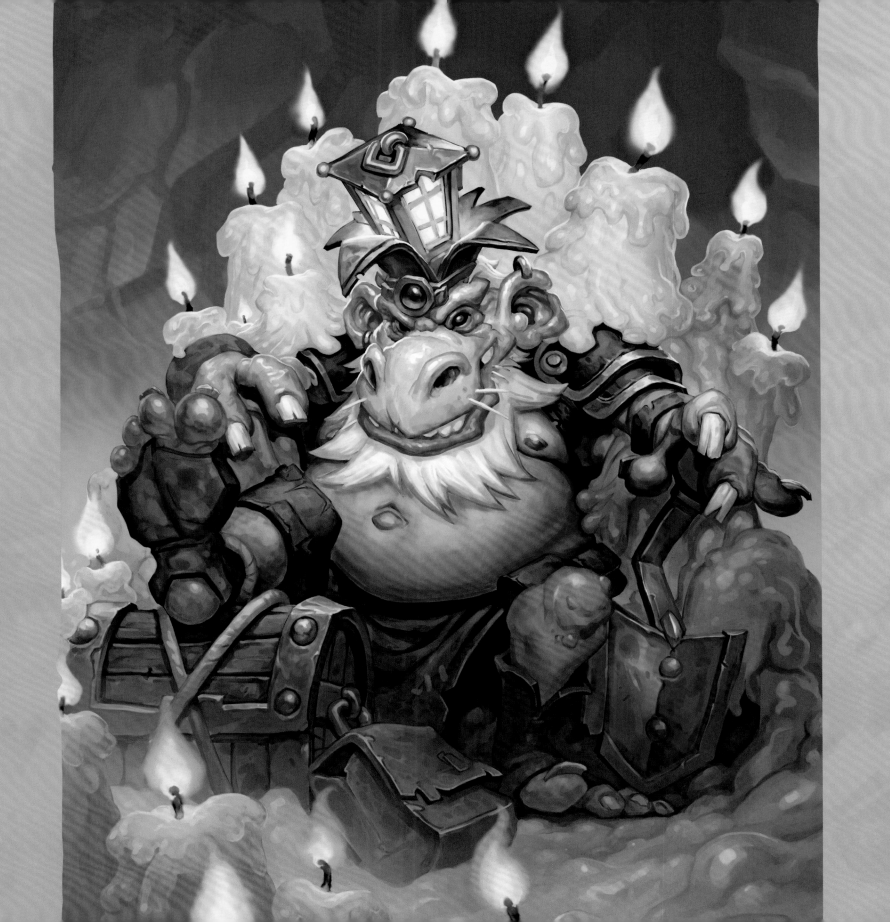

ABOVE
Twilight Acolyte
Tooth

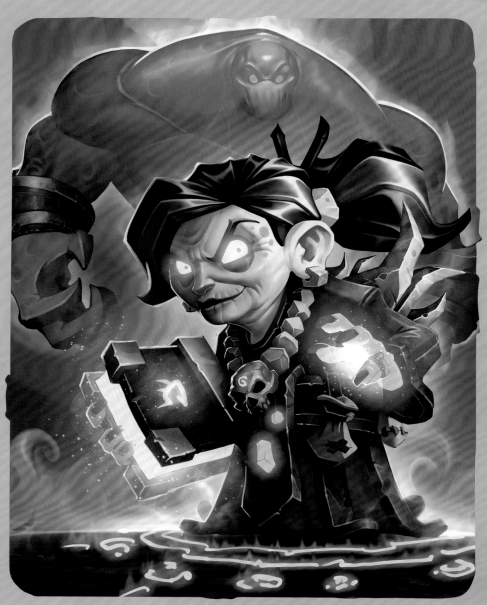

ABOVE
Rin, the First Disciple
A.J. Nazzaro

OPPOSITE
Dark Pact
Slawomir Maniak

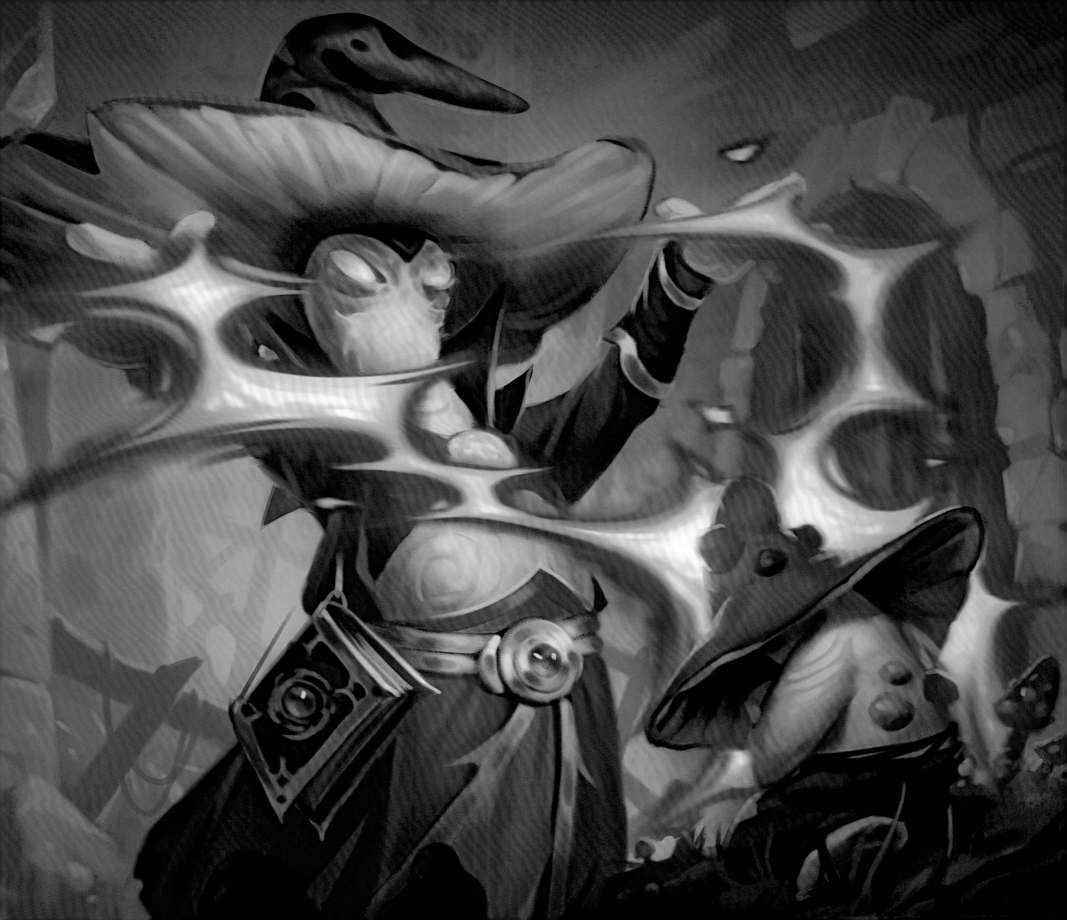

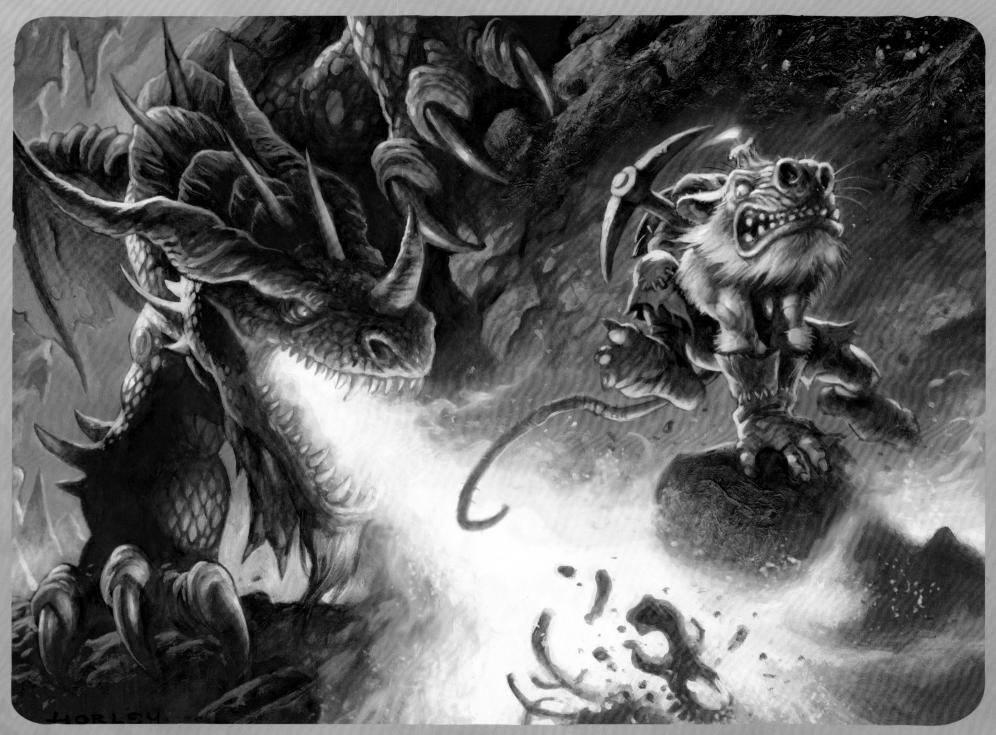

ABOVE
Cheat Death
Alex Horley Orlandelli

OPPOSITE
Dragon's Fury
Chris Seaman

216

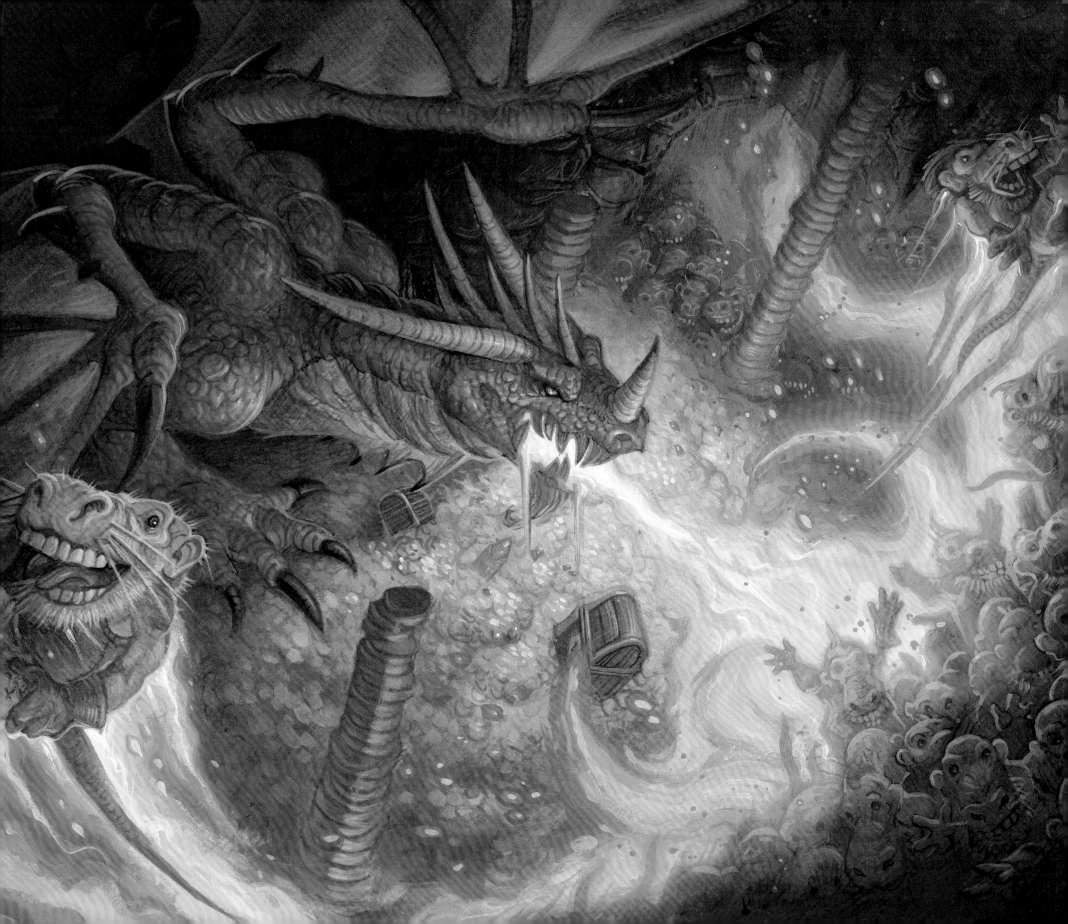

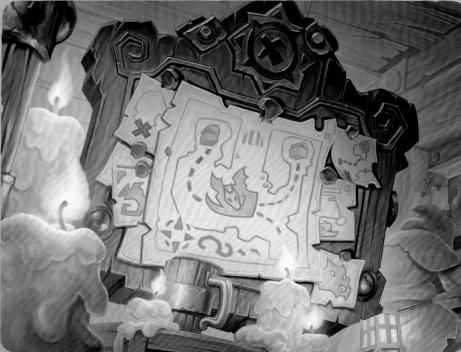

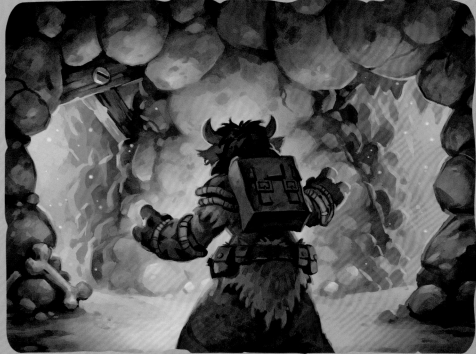

TOP LEFT
Explore the Darkness
Matt Dixon

BOTTOM LEFT
Gather Your Party
Ludo Lullabi and Konstantin Turovec

TOP RIGHT
Eat the Mushroom
Matt Dixon

BOTTOM RIGHT
Branching Paths
Matt Dixon

OPPOSITE
Call to Arms
Ludo Lullabi and Konstantin Turovec

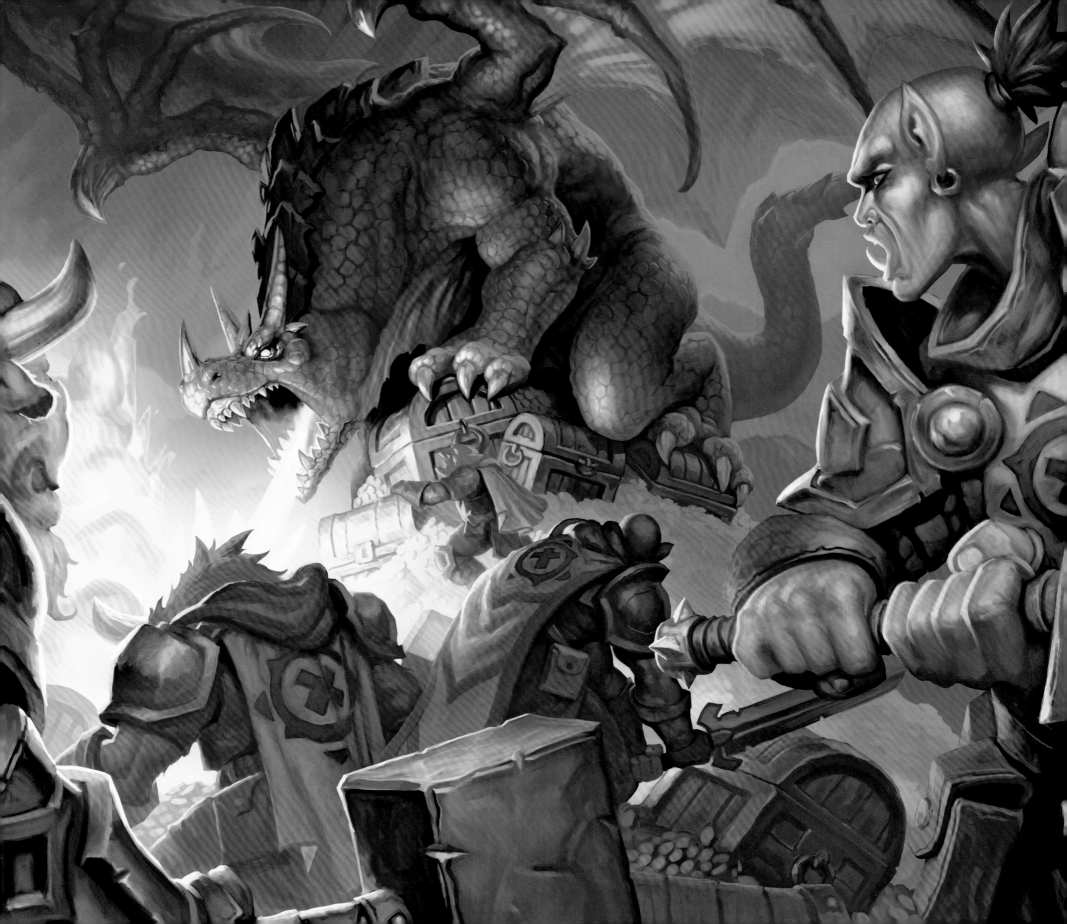

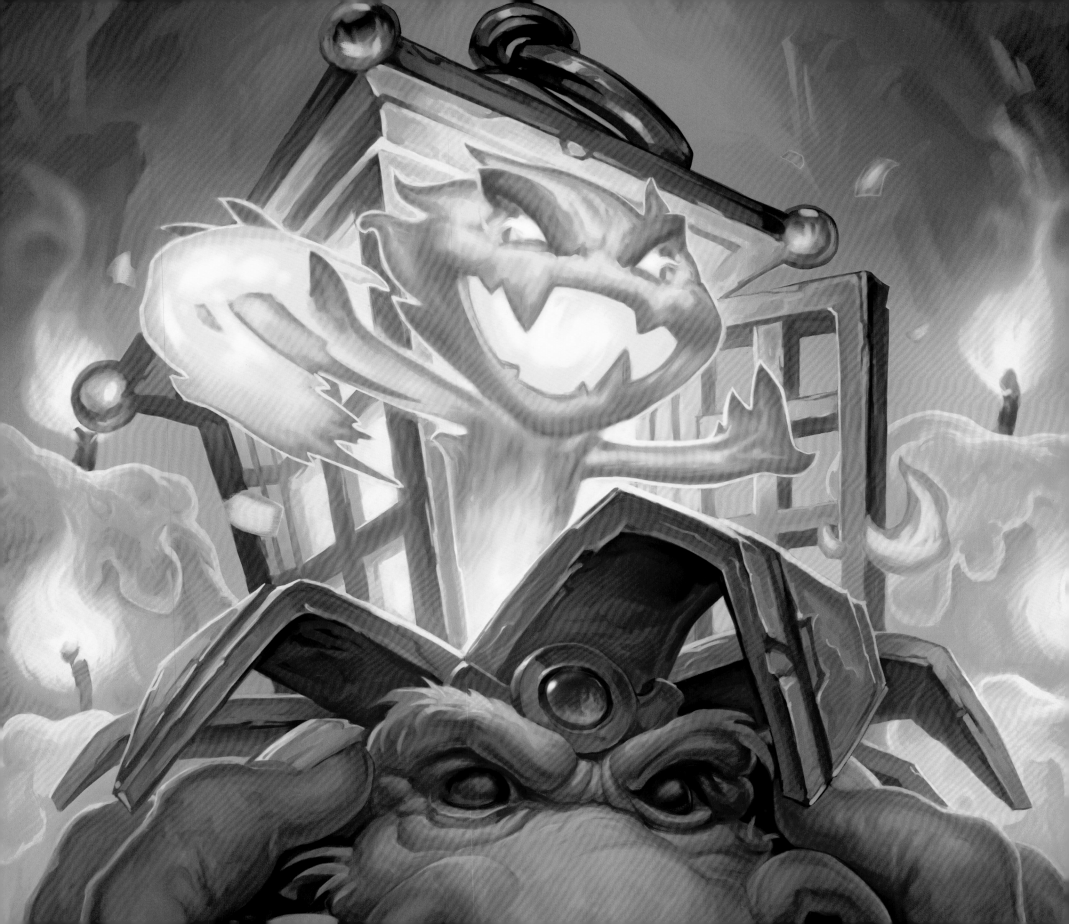

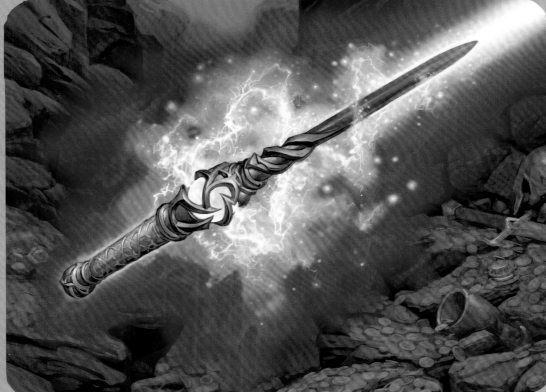

LEFT ABOVE
Zarog's Crown
Zoltan Boros

LEFT BOTTOM
Wondrous Wand
Zoltan Boros

OPPOSITE
Rakanishu
Ludo Lullabi and
Konstantin Turovec

ABOVE
Sudden Betrayal
Matt Dixon

OPPOSITE
Cataclysm
Andew Ho

5

SINGLE PLAYER MODE

You will beg for my mercy.
You will press the "concede" button,
and I will deny you.

—The Lich King

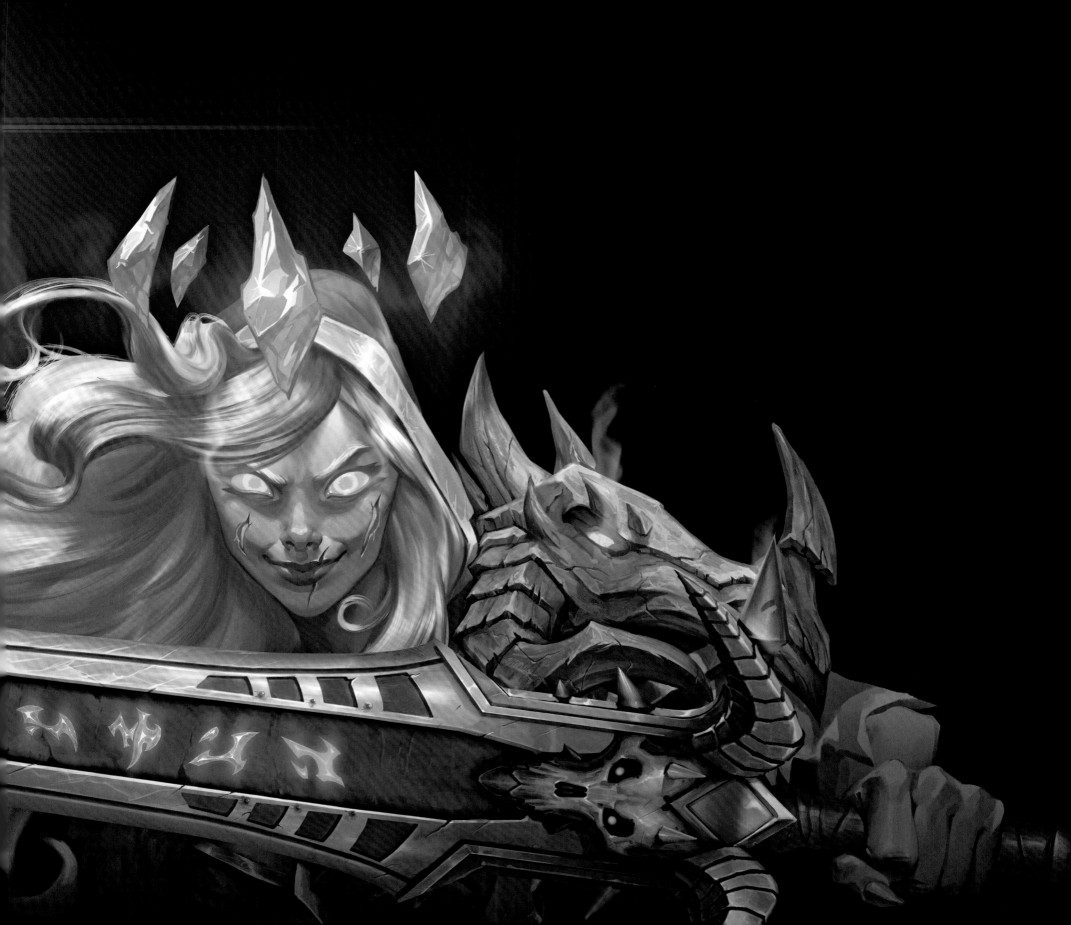

THE BATTLE FOR ICECROWN
Adjusting Course

All the way through the Year of the Kraken, *Hearthstone*'s cards had been released almost entirely through two formats: the expansion set and the single-player adventure. The larger expansion sets drop a huge payload of cards through card packs, but the structured adventure campaigns had doled out a smaller set of cards—between forty and forty-five—through a sequence of boss fights.

For the Year of the Mammoth, the Hearthstone development team decided to stop releasing single-player adventures on their own. It wasn't because the format was unpopular—quite the opposite—but players and designers alike noticed that adventure releases rarely shook up the competitive ladder the way they hoped.

Hearthstone simply needed more cards each year for its meta to feel healthy.

Perhaps most importantly, designers faced certain restrictions in how they constructed each boss fight. The only way to obtain adventure cards was to defeat enemies in a linear order. If a player found one boss too difficult to beat, they were stopped dead in their tracks. The rest of the cards would remain locked. "Not the happiest of situations for someone who paid for those cards," said creative director Ben Thompson. The only real solution was to make the normal boss fights relatively easy to complete and keep the challenging fights to Heroic mode.

By 2017, the development team had grown large enough to try something they had hoped to achieve for years: releasing single-player content and full expansions together, allowing them to shake up the *Hearthstone* experience with new stories and rule sets while also delivering a satisfying avalanche of new cards.

The first marquee single-player content of 2017 came during its second set, *Knights of the Frozen Throne*. Featuring eight bosses, including the iconic Lich King, the Icecrown campaign hearkened back to one of the most widely lauded raids in *World of Warcraft*'s history.

It also introduced one of Warcraft's most well-known villains. In Hearthstone's own fashion, of course.

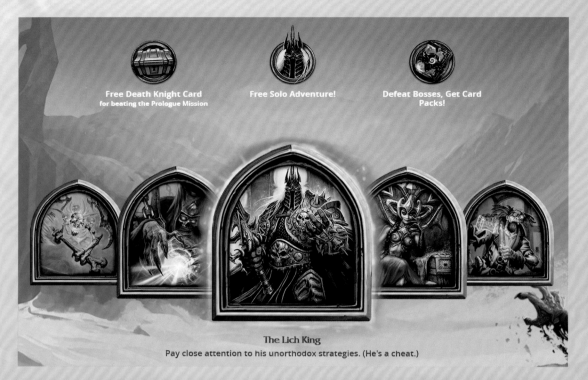

Free Death Knight Card
for beating the Prologue Mission

Free Solo Adventure!

Defeat Bosses, Get Card Packs!

The Lich King
Pay close attention to his unorthodox strategies. (He's a cheat.)

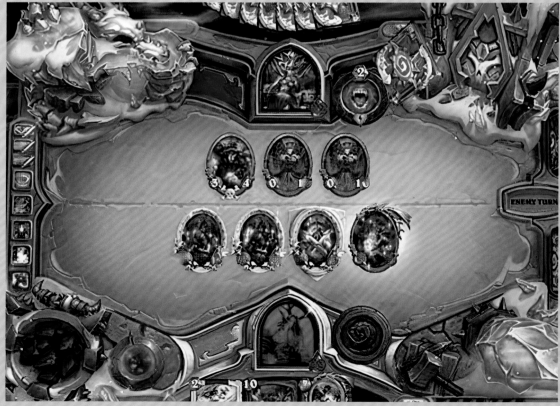

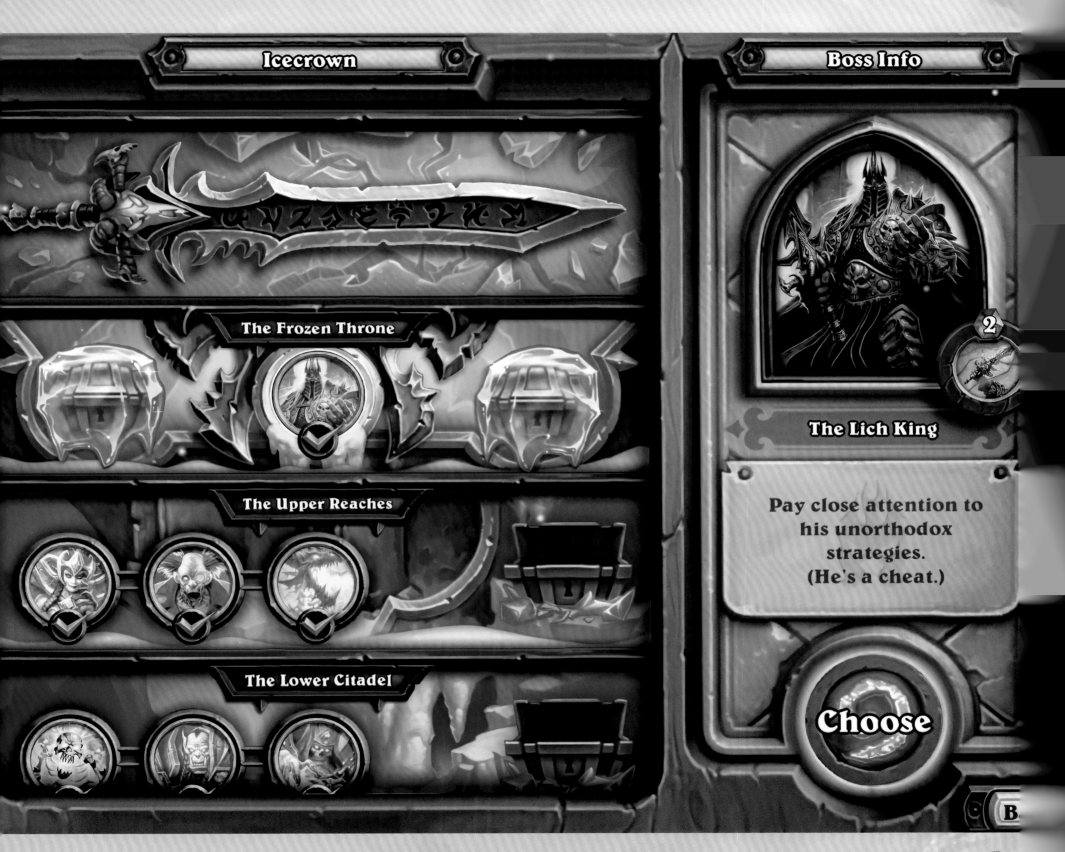

The Frozen Throne

The Upper Reaches

The Lower Citadel

The Lich King

Pay close attention to his unorthodox strategies. (He's a cheat.)

Choose

ARTHAS À LA HEARTHSTONE

Hearthstone's very first adventure, *Curse of Naxxramas*, had also featured a mighty lord of undeath looming over the player's invasion of his fortress. Kel'Thuzad had not only been the first character to get a spotlight narrative role in *Hearthstone*, he had also shown the development team how entertaining it was to shift serious, brooding characters toward a lighter tone.

"We saw how much it worked to give him a heightened personality," said Ben Thompson. "We just had to find the right approach to do the same for Arthas. Kel'Thuzad was petty and snarky, and that wasn't going to feel right for the Lich King."

Characters don't get much more serious than the Lich King. He's a brooding, sinister, slow-speaking force of undeath who commands a vast army by his will alone. These features are so foundational to the Lich King that the designers decided not to touch them. They left his voice, his cadence, and his icy rage exactly where it was.

"What they did adjust," said lead narrative designer Dave Kosak, "was what the Lich King would speak *about*. Rather than trying to conquer the world, he tries to conquer the game board. Applying that intense seriousness to relatively low-stakes things made for some truly hilarious interactions."

And to top it off, he's an extremely toxic opponent. Try to greet the Lich King, and you'll get responses like, "Your suffering will be legendary. Your rank will not."

"He's a *Hearthstone* player, like you, so he talks about game mechanics in his elevated language. But he cheats," said Kosak. "That formula worked very well for us because it made the Lich King a terrifying opponent . . . and really funny."

The other bosses of the Icecrown campaign were a collection of the greatest hits from the *World of Warcraft* raid. Designers interpreted the best (or at least the most feared) mechanics from each of the bosses, giving them new life on the *Hearthstone* board. **Blood-Queen Lana'thel** turns you into a vampire and forces you to feed on your own minions, **Deathbringer Saurfang** can only be harmed via physical damage (weapons), and so on.

"We even tried to create a phase of the Lich King fight where your soul gets sucked into Frostmourne," said Kosak. "An entirely new game board would have opened up; you would have had to fight in there for a while. It was just hilariously confusing, so we dropped it."

Each class faced a different challenge against the Lich King himself, but the reward for thoroughly flexing on him with all nine classes was a new paladin hero portrait: Arthas Menethil, uncorrupted and optimistic about where life would take him.

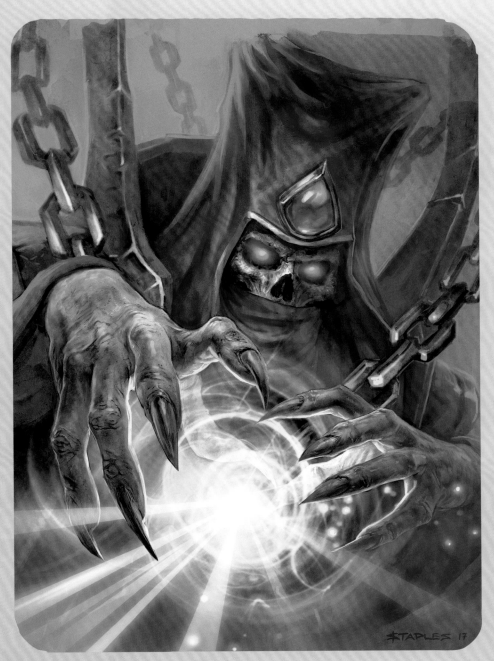

ABOVE
Lady Deathwhisper
Greg Staples

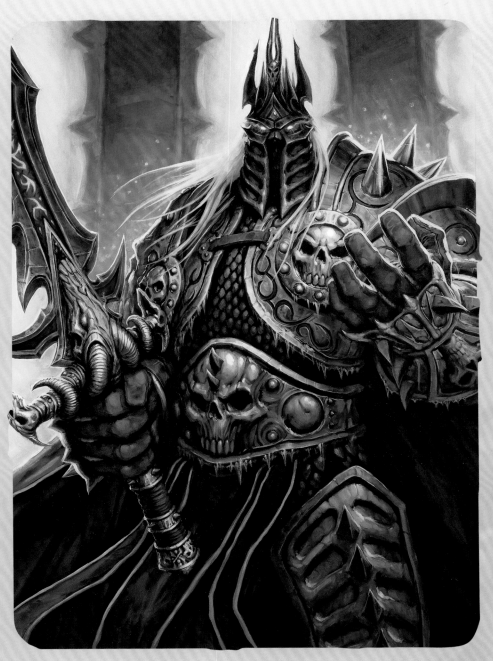

ABOVE
The Lich King
Glenn Rane

DUNGEON RUN
Enter the Dungeon

The earliest prototypes of the *Kobolds & Catacombs* single-player mode go back years before its 2017 release. Very soon after *Hearthstone*'s launch, the team had played around with ideas to create a single-player mode that was more replayable than the adventure campaigns they were building.

"Adventures take a *lot* more work than you'd expect," said lead designer Peter Whalen, "and in the end, people only end up playing it for a couple hours. And we were even worried that people might just get bored of adventures if that's all we did."

The development team periodically holds internal hackathons, where people can spend time testing out wild and crazy new ideas for the game or the technology behind it. In 2015, one of those hackathons yielded an interesting new idea.

Prototyped on pen and paper, it was a simple game mode. A player would start with only a couple of cards, they would face an easy boss, and then they would take its loot before challenging harder enemies. It had shades of "roguelike" game design, it had an interesting progression mechanic, and it felt very, very interesting, even in that early format. It was extendible by design: randomize the loot and your opponents, and you'd face a consistently different challenge every time you played it. When *Hearthstone* team members started staying very late after hours just to play it, it was clear this approach had some merit.

"One of the first pitches for that mode was, and I'm not kidding, the story of Arthas," said Whalen. He added, "This was *long* before we were thinking about *Knights of the Frozen Throne*, by the way."

The game mode would have had players following in Arthas's footsteps in *Warcraft III*, just fighting randomized enemies and collecting unusual weapons along the way. But that narrative context didn't last long, in part because the team wanted the mode to include more classes besides just paladins.

"When we applied that design to all of our classes, we started chatting about how the game felt and what situation would match it," said Whalen.

A huge part of the prototype's fun was choosing which new cards to take into the next fight, so perhaps a loot-centered expansion would be appropriate. Another early pitch called this game mode (and perhaps the entire expansion) "Blingtron's Vault." Players would break through the party robot's defenses and steal more and more of his loot.

"I'm not sure we ever thought the Blingtron thing would make it across the finish line, but it did help us figure out that we did want to focus this expansion on loot runs," said Kosak. "That led us to the 'dungeon crawl' idea, and eventually to the Dungeon Run name."

The entire expansion of *Kobolds & Catacombs* became an homage to the pen-and-paper RPG, a celebration of loot and adventuring. And the Dungeon Run mode was about to become one of its most popular features.

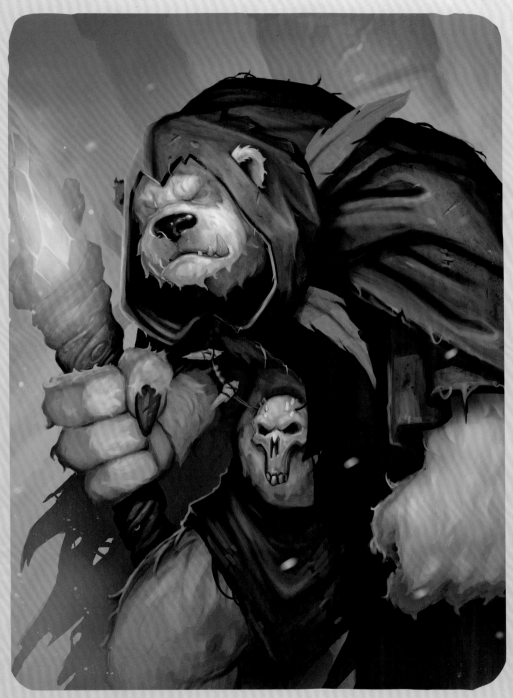

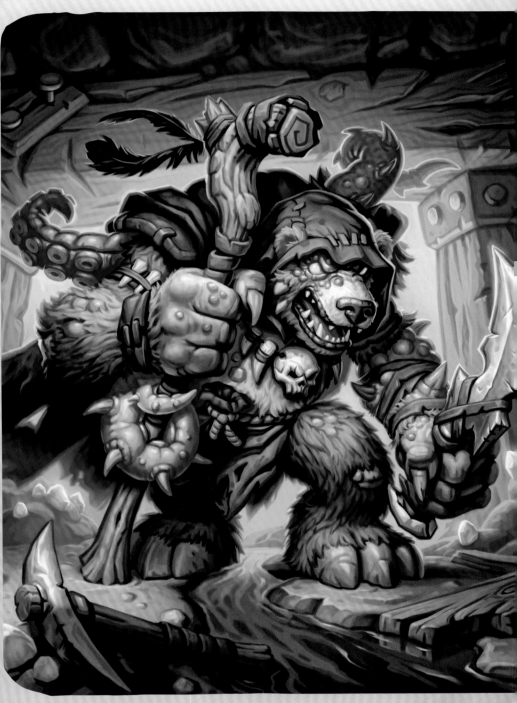

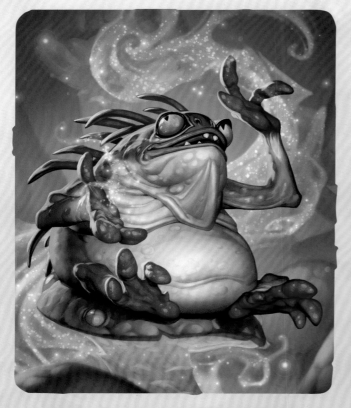

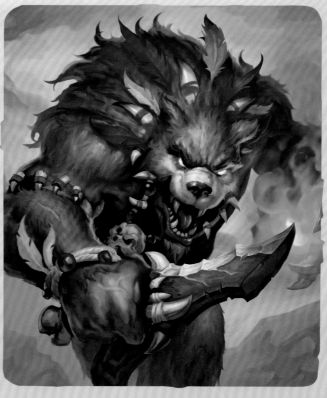

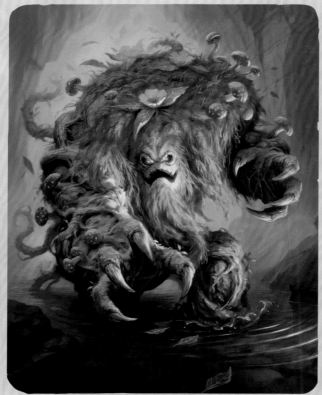

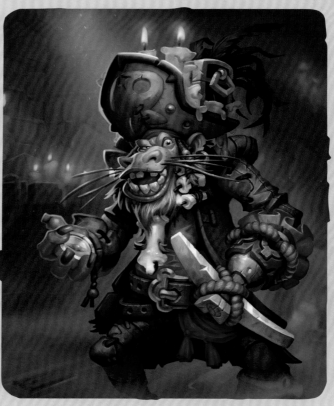

TOP LEFT
Fungalmancer Flurgl
Arthur Bozonnet

TOP RIGHT
Elder Jari
Konstantin Turovec

BOTTOM LEFT
Ixlid
James Ryman

BOTTOM RIGHT
Candlebeard
Anton Zemsko

OPPOSITE
The Darkness
Ludo Lullabi
and Konstantin Turovec

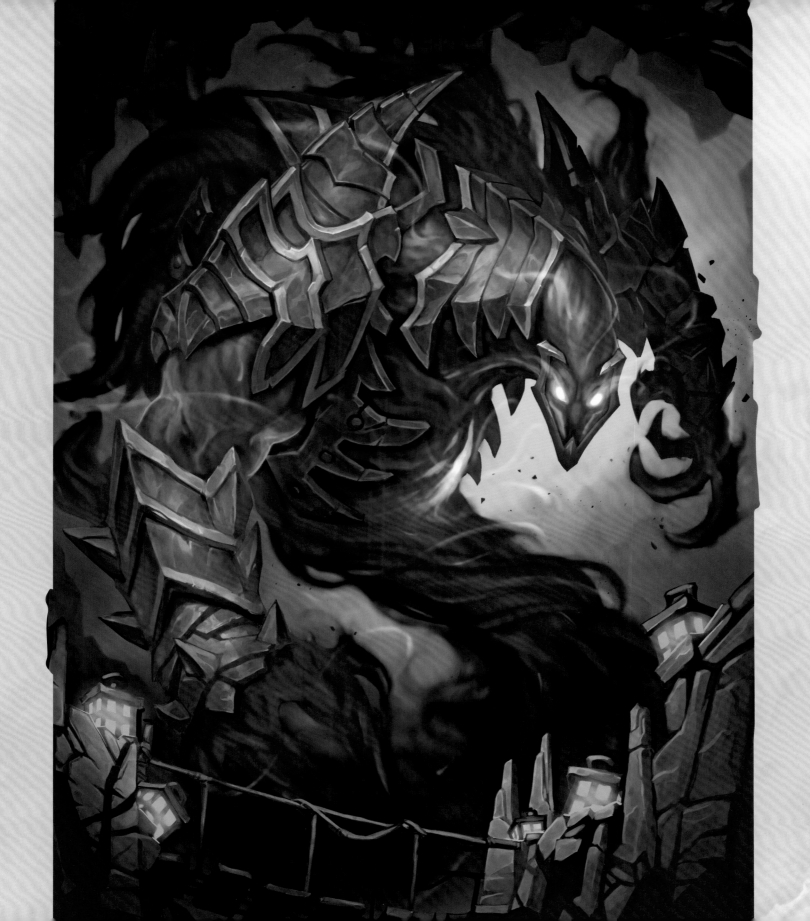

DIGGING OUT THE DUNGEON

This new game mode required designers and engineers to make thousands of decisions about the proper way to make an infinitely replayable experience. Plenty of good practices could only be found by figuring out what decisions felt bad to play.

"You can pick active or passive treasures after certain victories," said Whalen. Active treasures were weapons, spells, or minions that were hilariously powerful, while passive treasures were permanent buffs to your hero, hero power, or minions. "And we learned that passive treasures are almost always better. So we learned to offer the player *only* active or *only* passive choices."

Designers also got to unleash their most overpowered ideas as new cards the players could earn. Cards like **Gloves of Mugging** steal three cards from your opponent's hand—a mechanic so flat-out mean that most human players might quit the game forever if it were ever used against them. But computers don't complain much (yet), so it was open season on the *Hearthstone* AI.

A total of forty-eight boss fights were released with this mode, creating a gigantic number of possible combinations in each player's eight-boss run. Most of the bosses were

scalable, becoming more difficult as you progressed in your Dungeon Run. Developers eventually built four different endgame bosses that you might face, each with wildly terrifying abilities and cards. Players couldn't count on building toward a particular final boss; they had to build a deck that could theoretically match *any* of them.

One of those climactic characters became the narrator of the entire game mode. **King Togwaggle**, a kobold who sits on a waxy throne, was conceived as the ruler of the kobold empire and was given a personality to match. Always looking for shinies to steal, Togwaggle rose to power not because of his magnificently good looks but because of his big brain. Like all kobolds, Togwaggle wears a candle on his head. But his candle has a lantern protecting it. And that was the secret to his power.

"What makes him king? He was smart *enough* to put a lantern around his candle so nobody can blow out the flame," said senior art manager Jeremy Cranford. "He's unstoppable! No kobold can take him down! All the other kobolds just let him be in charge."

"But just because Togwaggle's vocabulary consisted of more than 'You no take candle!' didn't mean he could speak the Queen's English," said Kosak. "We needed Togwaggle to be a

little more articulate but still speak in a way that showed he was smart among kobolds . . . but not that smart in general."

The other bosses were almost exclusively villains or rival adventurers seeking your loot. There were exceptions, of course. The **Trapped Room** is just an uninhabited room, but its secrets are so deadly that one of the most effective strategies is to do nothing at all for several turns—a lesson most players will learn the first time they face it.

Then there was the most unexpectedly popular boss of the entire expansion, **A. F. Kay**, a returning character from a mission in *Knights of the Frozen Throne*. True to her name (which means "Away From Keyboard"), Kay does nothing the first few turns, seemingly unaware that a fight is happening. But once turn six comes around, she unleashes a wall of gigantic minions that will likely destroy the player the very next turn.

"Some players had no idea how dangerous she was," said Whalen. "They beat her by turn four a couple times, and they assumed she was an easy win. Then they get cocky and let the clock run out, and suddenly, it's a disaster."

Artists had a chance to invent brand-new characters for many of the Dungeon

Run bosses, simply because so few of them were known in *Warcraft* lore. One boss fight, **George and Karl**, consisted of two scuffed paladins who had gotten lost in the catacombs and wind up fighting the player.

Artist Peter Stapleton said the two characters had not been visually designed when he began work, so he tried to show how they had adapted to their terrifying situation. (Not well, in short.) "I pushed their wild, unhinged expressions and added small things like the candle on Karl's head," said Stapleton. "It was fun to add a personal touch to the characters."

"By the time Dungeon Run shipped out to players late in 2017, the entire *Hearthstone* team knew they had created something special. And they knew they weren't done with it," said creative director Ben Thompson. "We wanted to find a new way to play. We wanted to feel true to the set and true to the game, but we thought we had found a new idea that was so much fun that we could spend years exploring it."

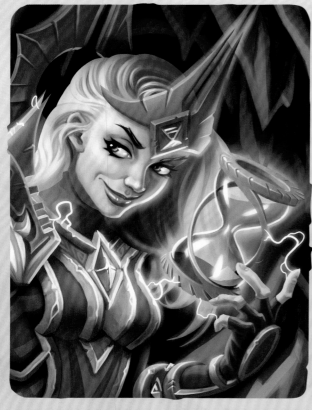

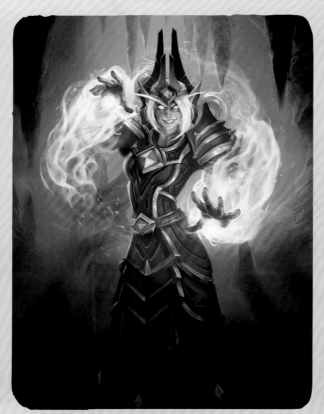

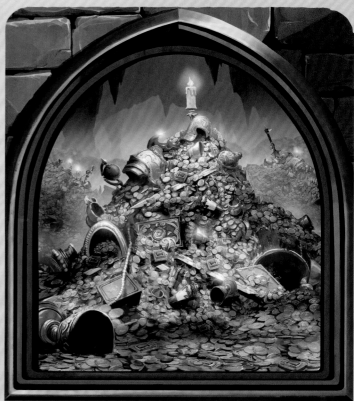

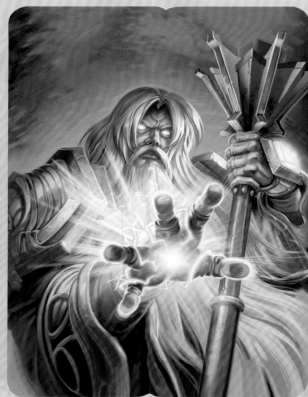

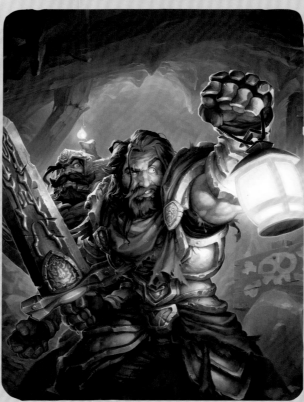

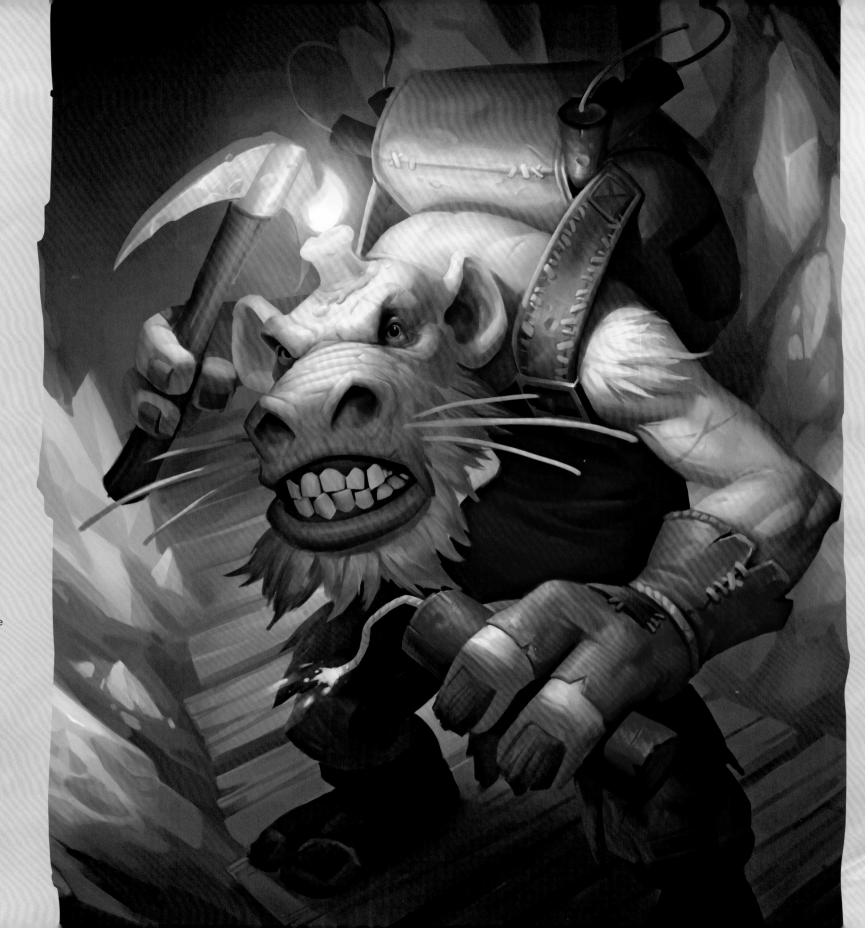

6

HEARTH
AND HOME

Hearthstone is home!

—The Tavern Chorus

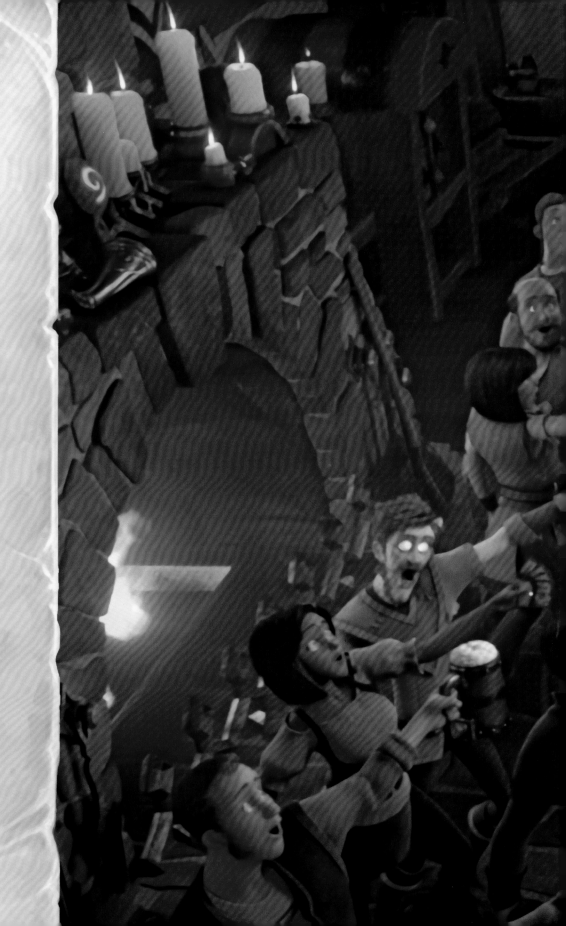

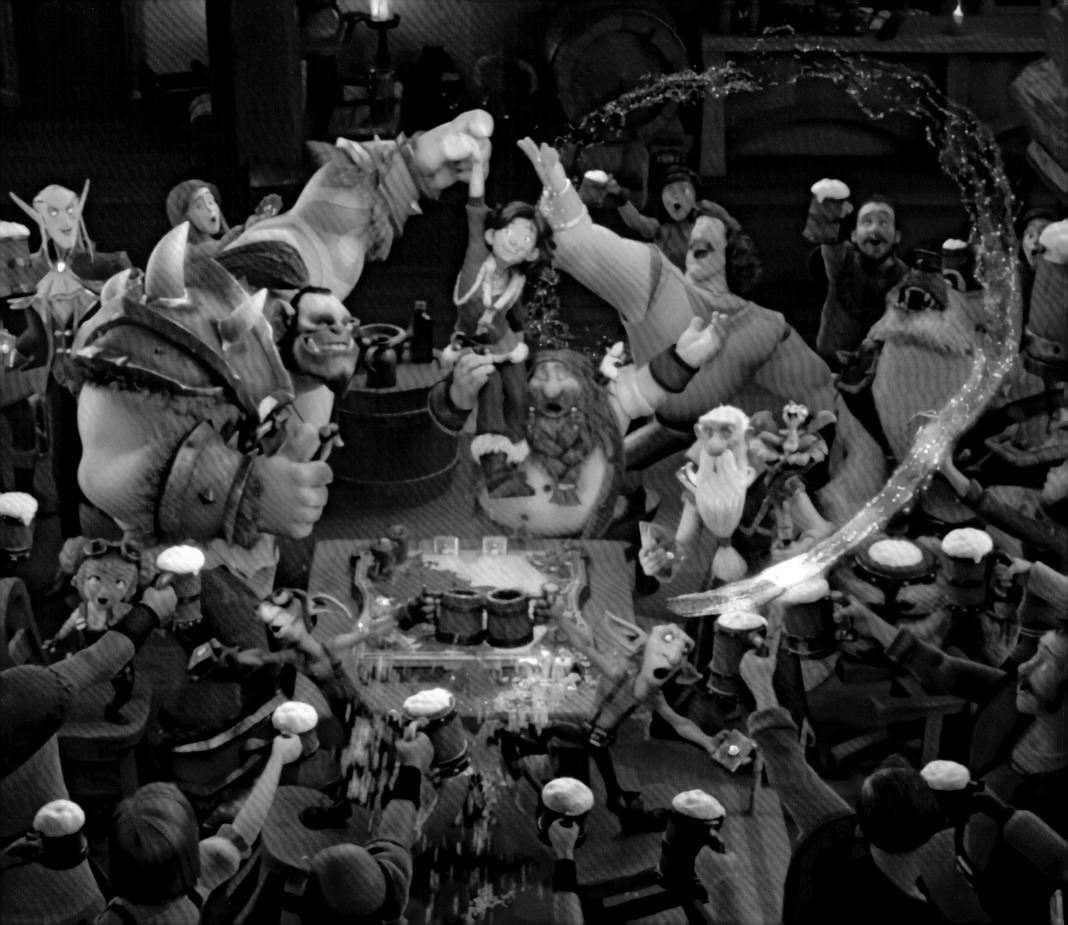

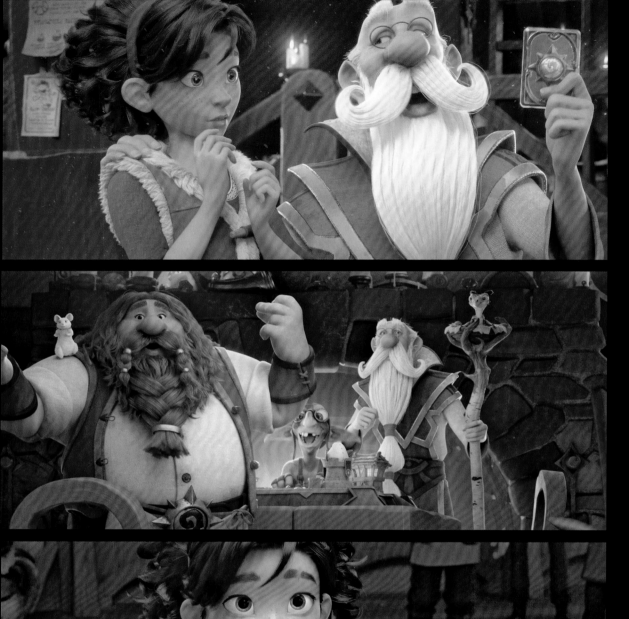

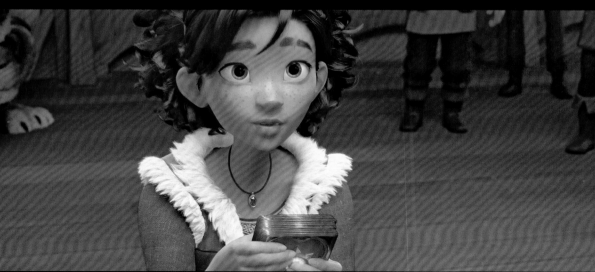

PREVIOUS PAGE AND THIS PAGE
Hearth and Home
Story and Franchise Development

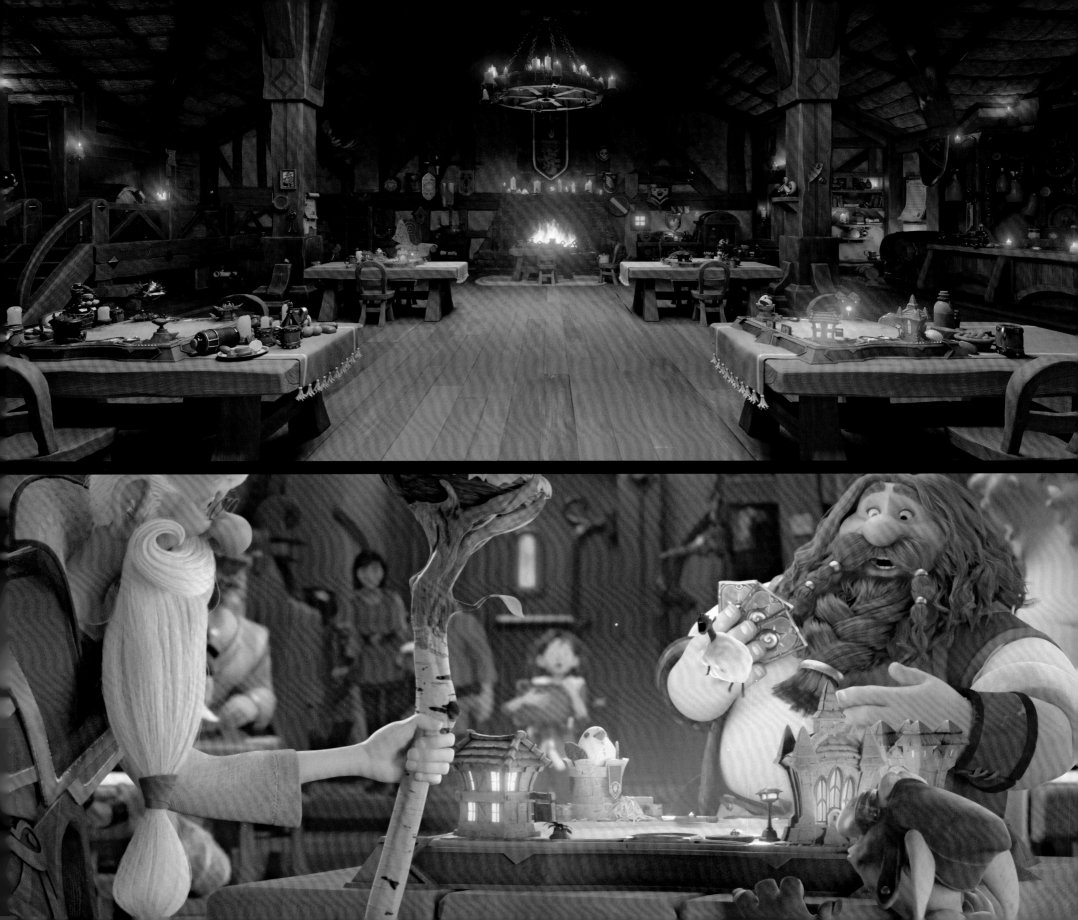

From its earliest days in development, *Hearthstone* was intended to be a warm, inviting experience. Every player is welcomed to the game by innkeeper Harth Stonebrew, a jolly old fellow who loves nothing more than a busy night filled with laughter and tall tales.

Harth wasn't just a mascot but the only person from the world of Hearthstone that players would interact with regularly. He was the host, the friend, the person who remembered you, and he was happy to see you return. But with few exceptions, players never got a chance to see the twinkle in his eye or the broad smile beneath his hefty beard.

In 2017, it was time to change that. *Hearth and Home* was Hearthstone's first fully 3-D cinematic, which explored Harth's tavern through the eyes of a newcomer, a young woman named Ava.

It was also the next step in Hearthstone's love affair with the musical medium. Featuring paladins with glorious hair, giggling gnolls, ogres, murlocs, and a perfectly timed **Deathwing** top-deck, the cinematic brought the tavern to life in a way Blizzard had never attempted.

③

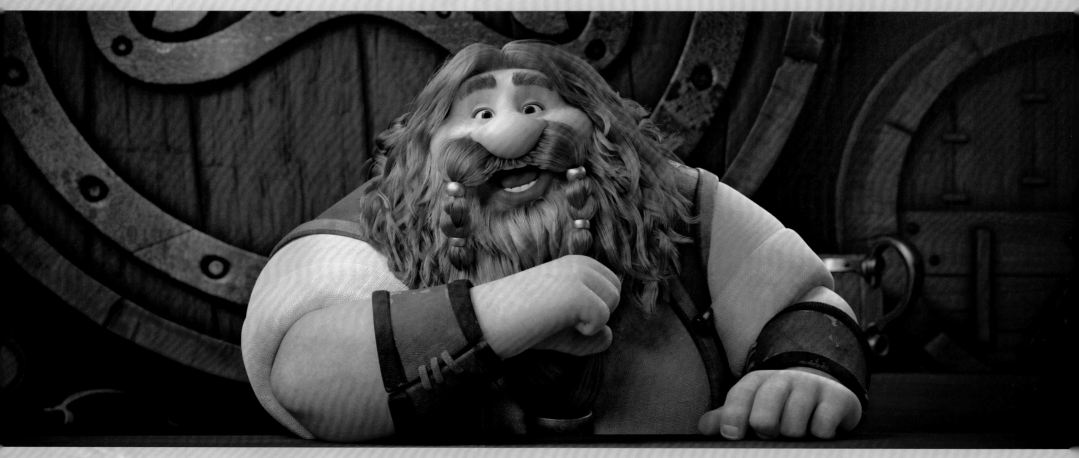

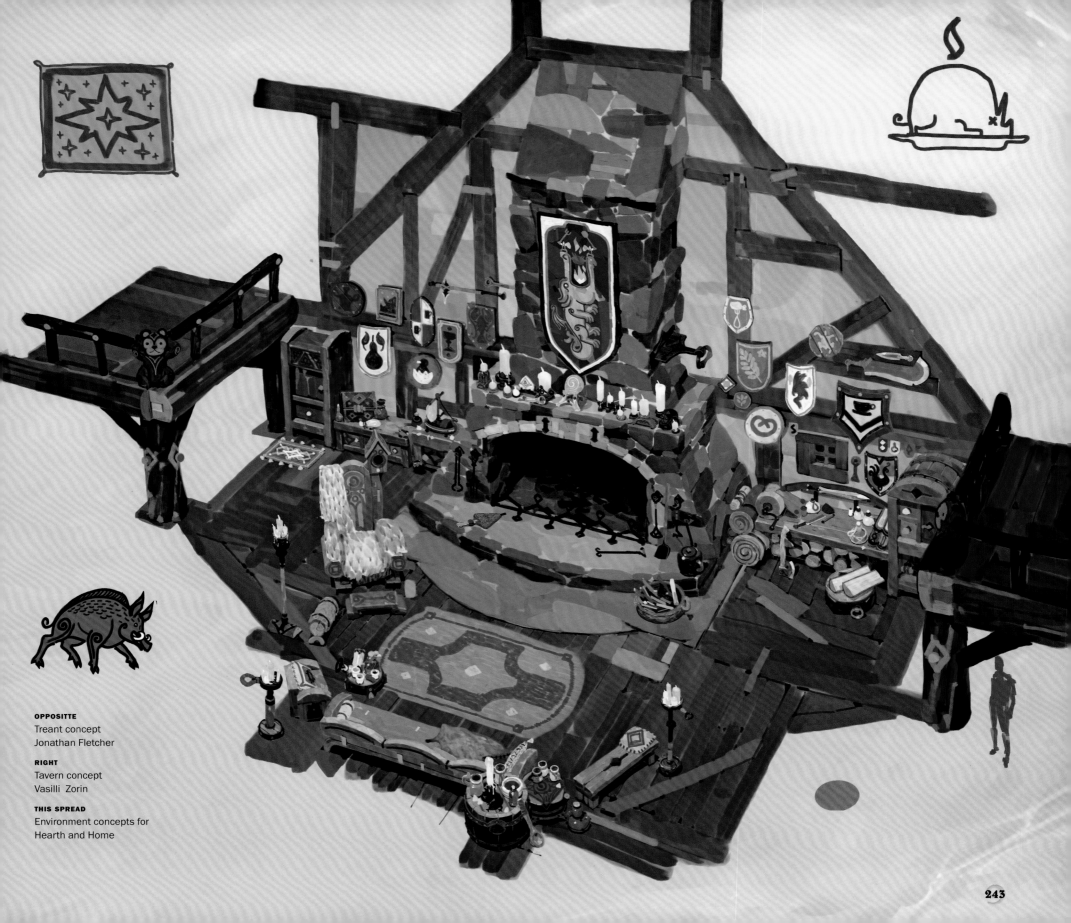

OPPOSITTE
Treant concept
Jonathan Fletcher

RIGHT
Tavern concept
Vasilli Zorin

THIS SPREAD
Environment concepts for
Hearth and Home

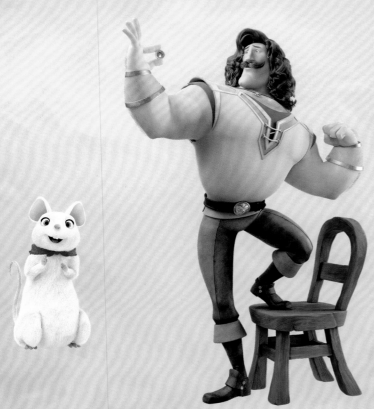

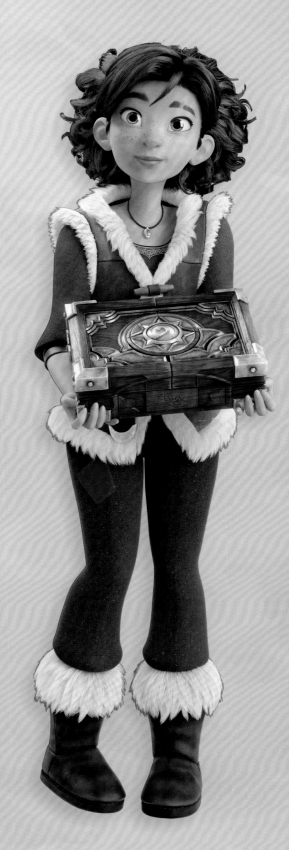

THIS SPREAD
Character renderings for *Hearth and Home*
Story and Franchise Development

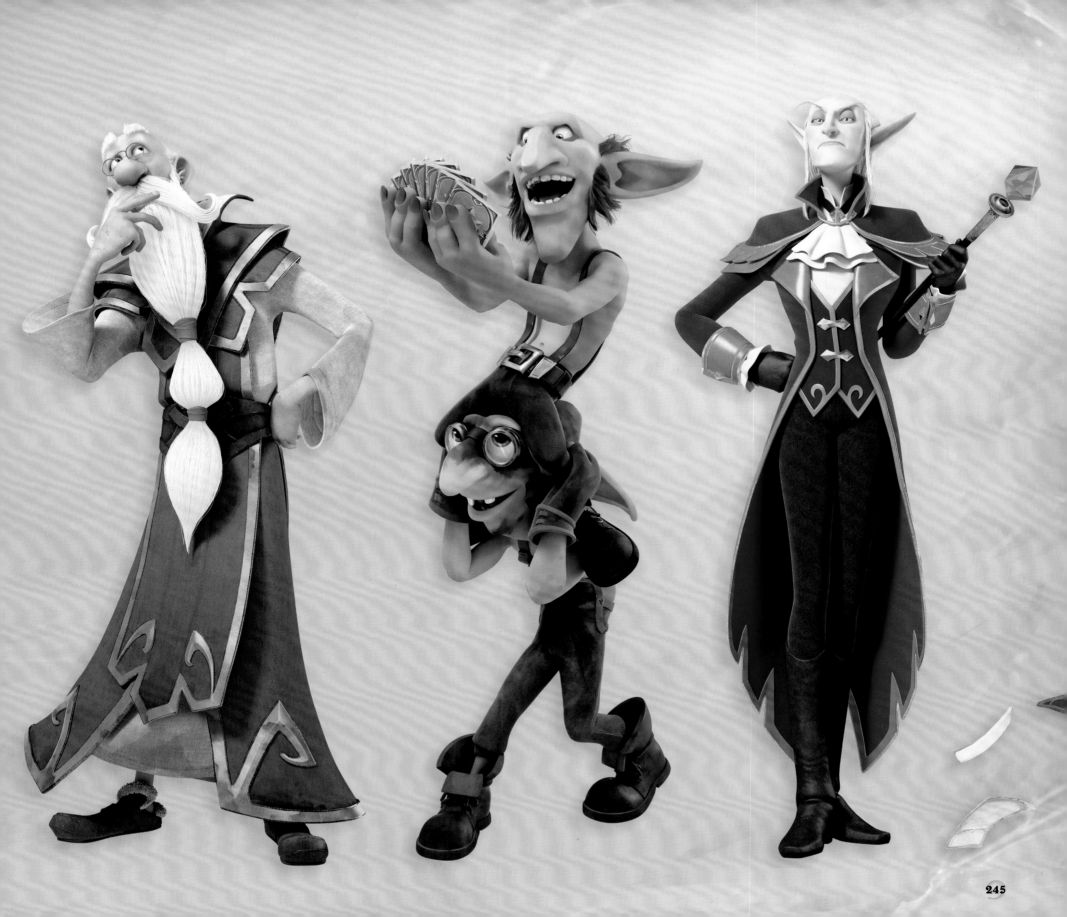

CONCLUSION

Look at you! Haven't seen someone carrying that much shiny loot since that rogues' guild came through. You'd think thieves would be terrible tippers; not at all! Guess you feel generous spending other people's coin.

You look like you'd know all about that. I saw those armfuls of treasure you carried out of the catacombs. It sure seemed like a nice haul—just watch where you swing that corrupted sword. You're in for a whole heaping helping of trouble if you nick your finger with that!

I love seeing new lands, meeting new people. That's probably why I opened my tavern in the first place. If I can't travel all the time, at least I can host those that can! But the Year of the Mammoth was perfect for me. I got to smell the jungle air, I got to feel the Northrend chill, and I got to hang out in Togwaggle's house for a spell. Not too much to complain about.

I think the Mammoth is ready for another hibernating spell too. The stars in the sky say his year has ended, and another will soon come.

What sort of creature will rule the next year? I suspect you already know.

And if you don't, listen carefully. I can hear it spreading its wings now, preparing to take flight . . .

—HARTH STONEBREW, THE INNKEEPER

YEAR OF
THE MAMMOTH
Cardbacks

The Magic of Dalaran
Charlene Le Scanff

Frostmourne
Jomaro Kindred

Candle King
Jomaro Kindred

Catacomber
Charlene Le Scanff

Frostfire
Jerry Mascho

Frost Knight
Charlene Le Scanff

Sunwell
Jerry Mascho

Thrill of Victory
Jerry Mascho

Gone Fishin
Charlene Le Scanff

HearthS'mores
Charlene Le Scanff

Blood Knight
Jerry Mascho

Azeroth is Burning
Jomaro Kindred

Sparkles
Charlene Le Scanff

For the Hoard!
Jerry Mascho

Unholy Knight
Jerry Mascho

Un'Goro Mystery
Charlene Le Scanff

Fossil
Charlene Le Scanff

Call of the Void
Jomaro Kindred

Call of the Light
Jomaro Kindred

Year of the Kraken
Jomaro Kindred